Peregrine Books

Meaning in the Visual Arts

ERWIN PANOFSKY was born on 30 March 1892, in Hanover, Germany, and gained a Ph.D. degree from the University of Freiburg in 1914. In 1921 he became *Privatdozent* at the University of Hamburg, and from 1926 until he was forced to leave his post by the Nazis in 1933, he was Professor of History of Art there. After emigrating to the United States, he taught at New York University until 1935, when he joined the Institute for Advanced Study in Princeton as permanent professor. He was Professor Emeritus there from 1962, and continued teaching at New York University and at Princeton University until his death on 14 March 1968. Dr Panofsky was Charles Eliot Norton Professor at Harvard (1947–8), and was made Samuel F. B. Morse Professor of the Literature of the Arts of Design at New York University in 1962.

Erwin Panofsky

Meaning
in the
Visual Arts

Penguin Books

PENGUIN BOOKS

Published by the Penguin Group
27 Wrights Lane, London W8 5TZ, England
Viking Penguin Inc., 40 West 23rd Street, New York, New York 10010, USA
Penguin Books Australia Ltd, Ringwood, Victoria, Australia
Penguin Books Canada Ltd, 2801 John Street, Markham, Ontario, Canada L3R 1B4
Penguin Books (NZ) Ltd, 182–190 Wairau Road, Auckland 10, New Zealand

Penguin Books Ltd, Registered Offices: Harmondsworth, Middlesex, England

First published in the USA by Doubleday 1955
Published in Great Britain in Peregrine Books 1970
10 9 8 7 6 5 4

Copyright © Erwin Panofsky, 1955
All rights reserved

Printed and bound in Great Britain by
Cox & Wyman Ltd, Reading
Set in Monotype Garamond

Chapter 1, from *Studies in Iconology*, by Erwin Panofsky.
Copyright 1939 by Oxford University Press, Inc.

Chapter 3, from *Abbot Suger on the Abbey Church of
St-Denis and Its Art Treasures*, edited and translated
by Erwin Panofsky, reprinted by permission of
Princeton University Press.

Chapter 7, from *Philosophy and History, Essays
Presented to Ernst Cassirer*, and reproduced by
permission of the Clarendon Press, Oxford.

The Epilogue, published as 'The History of Art',
from *The Cultural Migration: The European Scholar in
America*, edited by W. R. Crawford. reprinted by
permission of University of Pennsylvania Press.

Except in the United States of America, this book is sold subject
to the condition that it shall not, by way of trade or otherwise, be lent,
re-sold, hired out, or otherwise circulated without the
publisher's prior consent in any form of binding or cover other than
that in which it is published and without a similar condition
including this condition being imposed on the subsequent purchaser

Contents

Preface

The essays collected in this little volume have been chosen for variety rather than consistency. They range over a period of more than thirty years and deal with general problems as well as special topics involving archaeological facts, aesthetic attitudes, iconography, style, and even that 'theory of art', now largely obsolete, which in certain periods played a role analogous to that of harmonics or counterpoint in music.

These essays fall into three classes: first, *Revised Versions of Earlier Articles*, completely rewritten and, as far as possible, brought up to date by incorporating both the subsequent contributions of others and some afterthoughts of my own (Sections 4 and 7); second, *Reprints of Pieces Published in English within the Last Fifteen Years* (Introduction, Epilogue, Sections 1 and 3); third, *Translations from the German* (Sections 2, 5, 6).

In contrast to the 'revised versions', the 'reprints' have not been changed materially except for the correction of errors and inaccuracies and for a few occasional asides which have been enclosed in brackets. The same applies to the 'translations from the German', though here some further liberties have been taken with the original texts; I have felt free to translate less literally than I should have dared when dealing with the work of someone else, to indulge in a certain amount of editing and, in two places, to make substantial deletions.[1] No attempt, however, has been made to

1. In Section 5 a lengthy digression on the style of the drawings reproduced in Plates 46 and 47 has been suppressed (pp. 28–32 of the original); in Section 6 a second Excursus has been amputated (pp. 86–92 of the original).

change the character of the originals. Neither have I tried to make them appear less pedantic by expunging scholastic argument and documentation (if anything at all can be gained from reading essays like these, it is a certain respect for Flaubert's conviction that ' le bon Dieu est dans le détail '); nor have I tried to make them appear more perceptive by pretending to have known more than I did when they were written, except, again, for one or two asides in brackets. It must be left to the reader – if so inclined – to check the contents of the 'reprints' and 'translations from the German' against the results of more recent research, and for this purpose the following bibliographical hints may be welcome.

FOR SECTION 1, 'Iconography and Iconology', see:

J. Seznec, *The Survival of the Pagan Gods: The Mythological Tradition and Its Place in Renaissance Humanism and Art* (Bollingen Series, XXXVIII), New York, 1953 (reviewed by W. S. Heckscher in *Art Bulletin*, XXXVI, 1954, p. 306 ff.)

FOR SECTION 2, 'The History of the Theory of Human Proportions', see:

H. A. Frankfort, *Arrest and Movement: An Essay on Space and Time in the Representational Art of the Ancient Near East*, Chicago, 1951

R. Hahnloser, *Villard de Honnecourt*, Vienna, 1935 (particularly p. 272 ff. and Figs. 98–154)

E. Iversen, *Canon and Proportions in Egyptian Art*, London, 1955

H. Koch, *Vom Nachleben des Vitruv* (*Deutsche Beiträge zur Altertumswissenschaft*), Baden-Baden, 1951

E. Panofsky, *The Codex Huygens and Leonardo da Vinci's Art Theory* (Studies of the Warburg Institute, XIII), London, 1940, pp. 19–57, 106–28

F. Saxl, *Verzeichnis astrologischer und mythologischer illustrierter Handschriften des lateinischen Mittelalters, II; Die Handschriften der National-Bibliothek in Wien* (*Sitzungs-*

Berichte der Heidelberger Akademie der Wissenschaften, phil.-hist. Klasse, 1925/6, 2), Heidelberg, 1927, p. 40 ff.

W. Ueberwasser, *Von Mass und Macht der alten Kunst*, Leipzig, 1933

K. Steinitz, 'A Pageant of Proportion in Illustrated Books of the 15th and 16th Century in the Elmer Belt Library of Vinciana', *Centaurus*, I, 1950/51, p. 309 ff.

K. M. Swoboda, 'Geometrische Vorzeichnungen romanischer Wandgemälde', *Alte und neue Kunst (Wiener kunstwissenschaftliche Blätter)*, II, 1953, p. 81 ff.

W. Ueberwasser, 'Nach rechtem Mass', *Jahrbuch der preussischen Kunstsammlungen*, LVI, 1935, p. 250 ff.

FOR SECTION 3, 'Abbot Suger', see:

M. Aubert, *Suger*, Paris, 1950

S. McK. Crosby, *L'Abbaye royale de Saint-Denis*, Paris, 1953

L. H. Loomis, 'The Oriflamme of France and the War-Cry "Monjoie" in the Twelfth Century', *Studies in Art and Literature for Belle da Costa Greene*, Princeton, 1954, p. 67 ff.

E. Panofsky, 'Postlogium Sugerianum', *Art Bulletin*, XXIX, 1947, p. 119 ff.

FOR SECTION 5, 'The First Page of Giorgio Vasari's *Libro*', see:

K. Clark, *The Gothic Revival: An Essay on the History of Taste*, London, 1950

H. Hoffmann, *Hochrenaissance, Manierismus, Frühbarock*, Leipzig and Zurich, 1938

P. Sanpaolesi, *La Cupola di Santa Maria del Fiore*, Rome, 1941 (reviewed by J. P. Coolidge, *Art Bulletin*, XXXIV, 1952, p. 165 ff.)

Studi Vasariani, Atti del Congresso Internazionale per il IV Centenario della Prima Edizione delle Vite del Vasari, Florence, 1952

R. Wittkower, *Architectural Principles in the Age of Humanism*, 2nd ed., London, 1952 (with instructive 'Bibliographical Note' on p. 139 ff.)

G. Zucchini, *Disegni antichi e moderni per la facciata di S. Petronio di Bologna*, Bologna, 1933

J. Ackerman, 'The Certosa of Pavia and the Renaissance in Milan', *Marsyas*, V, 1947/9, p. 23 ff.

E. S. de Beer, 'Gothic: Origin and Diffusion of the Term: The Idea of Style in Architecture', *Journal of the Warburg and Courtauld Institutes*, XI, 1948, p. 143 ff.

R. Bernheimer, 'Gothic Survival and Revival in Bologna', *Art Bulletin*, XXXVI, 1954, p. 263 ff.

J. P. Coolidge, 'The Villa Giulia: A Study of Central Italian Architecture in the Mid-Sixteenth Century', *Art Bulletin*, XXV, 1943, p. 177 ff.

V. Daddi Giovanozzi, 'I Modelli dei secoli XVI e XVII per la facciata di Santa Maria del Fiore', *L'Arte Nuova*, VII, 1936, p. 33 ff.

L. Hagelberg, 'Die Architektur Michelangelos', *Münchner Jahrbuch der bildenden Kunst*, new ser., VIII, 1931, p. 264 ff.

O. Kurz, 'Giorgio Vasari's "Libro"', *Old Master Drawings*, XII, 1938, pp. 1 ff., 32 ff.

N. Pevsner, 'The Architecture of Mannerism', *The Mint, Miscellany of Literature, Art and Criticism,* G. Grigson, ed., London, 1946, p. 116 ff.

R. Wittkower, 'Alberti's Approach to Antiquity in Architecture', *Journal of the Warburg and Courtauld Institutes*, IV, 1940/41, p. 1 ff.

R. Wittkower, 'Michelangelo's Biblioteca Laurenziana', *Art Bulletin*. XVI, 1934, p. 123 ff., particularly pp. 205–16

FOR SECTION 6, 'Dürer and Classical Antiquity', see:

A. M. Friend, Jr, 'Dürer and the Hercules Borghesi-Piccolomini', *Art Bulletin*, XXV, 1943, p. 40 ff.

K. Rathe, 'Der Richter auf dem Fabeltier', *Festschrift für Julius Schlosser*, Zurich, Leipzig and Vienna, 1926, p. 187 ff.

P. L. Williams, 'Two Roman Reliefs in Renaissance Disguise', *Journal of the Warburg and Courtauld Institutes*, IV, 1940/41, p. 47 ff.

Further information about the works of Dürer referred to

in this section may be found in A. Tietze and E. Tietze-Conrat, *Kritisches Verzeichnis der Werke Albrecht Dürers*, I, Augsburg, 1922, II, 1, 2, Basel and Leipzig, 1937, 1938; and in E. Panofsky, *Albrecht Dürer*, 3rd edition, Princeton, 1948 (4th edition, Princeton, 1955).

In conclusion, I should like to express my gratitude to the publishers of the books and the editors of the periodicals in which the essays here collected appeared for the first time; to Dr L. D. Ettlinger and Professor U. Middeldorf for their kind assistance in obtaining photographs: and to Mrs Willard F. King for her invaluable help in bringing this collection into shape.

Princeton, 1 July 1955 E.P.

Original Places of Publication

INTRODUCTION Published under the same title, in *The Meaning of the Humanities*, T. M. Greene, ed., Princeton, Princeton University Press, 1940, pp. 89–118.

1 Published as 'Introductory' in *Studies in Iconology: Humanistic Themes in the Art of the Renaissance*, New York, Oxford University Press, 1939, pp. 3–31.

2 Published as 'Die Entwicklung der Proportionslehre als Abbild der Stilentwicklung' in *Monatshefte für Kunstwissenschaft*, XIV, 1921, pp. 188–219.

3 Published as 'Introduction' in *Abbot Suger on the Abbey Church of St-Denis and Its Art Treasures*, Princeton, Princeton University Press, 1946, pp. 1–37.

4 Published (in collaboration with F. Saxl) as 'A Late-Antique Religious Symbol in Works by Holbein and Titian' in *Burlington Magazine*, XLIX, 1926, pp. 177–81. See also *Hercules am Scheidewege und andere antike Bildstoffe in der neueren Kunst* (Studien der Bibliothek Warburg, XVIII), Leipzig and Berlin, B. G. Teubner, 1930, pp. 1–35.

5 Published as 'Das erste Blatt aus dem "Libro" Giorgio Vasaris: eine Studie über der Beurteilung der Gotik in der italienischen Renaissance mit einem Exkurs über zwei Fassadenprojekte Domenico Beccafumis' in *Städel-Jahrbuch*, VI, 1930, pp. 25–72.

6 Published as 'Dürers Stellung zur Antike' in *Jahrbuch für Kunstgeschichte*, I, 1921/2, pp. 43–92.

7 Published as '*Et in Arcadia ego*; On the Conception of Transience in Poussin and Watteau' in *Philosophy and History, Essays Presented to Ernst Cassirer*, R. Klibansky and H. J. Paton, eds., Oxford, Clarendon Press, 1936, pp. 223–54.

EPILOGUE Published as 'The History of Art' in *The Cultural Migration: The European Scholar in America*, W. R. Crawford, ed., Philadelphia, University of Pennsylvania Press, 1953, pp. 82–111.

ABBREVIATIONS

B: A. Bartsch, *Le Peintre-graveur*, Vienna, 1803–21

L: F. Lippmann, *Zeichnungen von Albrecht Dürer in Nachbildungen*, Berlin, 1883–1929 (Vols. VI and VII, F. Winkler, ed.)

List of Plates

List of Plates

34. *Serapis*. Coin of Caracalla.

35. *Apollo*. Rome, Vatican Library [Cod. Reg. lat. 1290, fol. 1 v]. *c.* 1420.

36. *Apollo and the Three Graces*. Paris, Bibliothèque Nationale [MS. fr. 143, fol. 39]. Late fifteenth century.

37. Giovanni Zacchi, *Fortune*. Medal of the Doge Andrea Gritti. Dated 1536.

38. *Allegory of Music*. Frontispiece of Franchinus Gaforius, *Practica musicae*, Milan, 1496.

39. Hans Holbein the Younger, *Allegory of Time*. Frontispiece of J. Eck, *De primatu Petri*, Paris, 1521.

40. *Serapis*. Engraving from Vincenzo Cartari, *Imagini dei Dei degli Antichi*, Padua, 1603.

41. *Allegory of Good Counsel*. Woodcut from Cesare Ripa, *Iconologia*, Venice, 1643, s. v. 'Consiglio'.

42. Jan Collaert after Giovanni Stradano, *Sol-Apollo* (engraving).

43. Artus Quellinus the Elder, *Allegory of Good Counsel*. Amsterdam, Paleis (after J. van Campen, *Afbeelding van't Stad-Huys van Amsterdam*, 1664–8).

44. Titian, *Self-Portrait*. Madrid, Prado.

45. Titian (and helpers), *Mater Misericordiae* (detail). Florence, Palazzo Pitti.

46. Drawing formerly ascribed to Cimabue, in frame by Giorgio Vasari (recto). Paris, École des Beaux-Arts.

47. Drawing formerly ascribed to Cimabue, in frame by Giorgio Vasari (verso). Paris, École des Beaux-Arts.

48. Drawing formerly ascribed to Vittore Carpaccio, in frame by Giorgio Vasari. London, British Museum.

49. Mainz Cathedral seen from the west.

50. Paul Decker, *Entrance to a Moat*. From *Gothic Architecture*, London, 1759.

51. *The Hellespontine Sibyl* (Florentine engraving). Fifteenth century.

52. Milan Cathedral, Crossing Tower.

71. *Roman Mercury*. Augsburg, Maximilian-Museum.

72. *Roman Mercury*. Engraving after Plate 71, from M. Welser, *Rerum Augustanarum libri VIII*, Augsburg, 1594, p. 209.

73. *Roman Mercury*. Woodcut after Plate 71, from Conrad Peutinger, *Inscriptiones . . .*, Mayence, 1520.

74. *Roman Mercury*. Woodcut after Plate 71, from Petrus Apianus, *Inscriptiones sacrosanctae vetustatis*, Ingolstadt, 1534, p. 422.

75. Albrecht Dürer, *Aesculapius* or *Apollo Medicus* (drawing L.181). Berlin, Kupferstichkabinett.

76. Albrecht Dürer, *Sol-Apollo and Diana* (drawing L.223). London, British Museum.

77. *The Apollo Belvedere*. Drawing in *Codex Escurialensis* [fol. 64].

78. *Helios Pantokrator*. Coin of Aizenis in Phrygia.

79. Andrea Mantegna, *Bacchanal with the Vat* (detail of engraving B.19).

80. Albrecht Dürer, *The Fall of Man* (engraving B.1). Dated 1504.

81. Albrecht Dürer, *The Resurrection* (woodcut B.45).

82. Albrecht Dürer, *Sol Iustitiae* (engraving B.79).

83. *Sol*. Capital from the Palace of the Doges in Venice. Early fifteenth century.

84. *Sol*. Woodcut from the Frankfurt Calendar of 1547.

85. Albrecht Dürer, *Nude Warrior* (drawing L.351). Bayonne, Musée Bonnat.

86. *Athlete from the Helenenberg*. Vienna, Kunsthistorisches Museum.

87. *Athlete from the Helenenberg*. Woodcut after Plate 86, from Petrus Apianus, *Inscriptiones sacrosanctae vetustatis*, p. 413.

88. Pseudo-classical relief produced at Venice about 1525–30. Vienna, Kunsthistorisches Museum.

89. Francesco Traini, *The Legend of the Three Quick and the Three Dead* (detail of mural). Pisa, Camposanto.

90. Giovanni Francesco Guercino, '*Et in Arcadia ego*'. Rome, Galleria Corsini.

List of Plates

List of Text Figures

List of Text Figures

Introduction: The History of Art as a Humanistic Discipline

I

Nine days before his death Immanuel Kant was visited by his physician. Old, ill and nearly blind, he rose from his chair and stood trembling with weakness and muttering unintelligible words. Finally his faithful companion realized that he would not sit down again until the visitor had taken a seat. This he did, and Kant then permitted himself to be helped to his chair and, after having regained some of his strength, said, 'Das Gefühl für Humanität hat mich noch nicht verlassen' – 'The sense of humanity has not yet left me.'[1] The two men were moved almost to tears. For, though the word *Humanität* had come, in the eighteenth century, to mean little more than politeness or civility, it had, for Kant, a much deeper significance, which the circumstances of the moment served to emphasize; man's proud and tragic consciousness of self-approved and self-imposed principles, contrasting with his utter subjection to illness, decay and all that is implied in the word 'mortality'.

Historically the word *humanitas* has had two clearly distinguishable meanings, the first arising from a contrast between man and what is less than man; the second, between man and what is more. In the first case *humanitas* means a value, in the second a limitation.

1. E. A. C. Wasianski, *Immanuel Kant in seinen letzten Lebensjahren (Ueber Immanuel Kant*, 1804, Vol. III), reprinted in *Immanuel Kant, Sein Leben in Darstellungen von Zeitgenossen*, Deutsche Bibliothek, Berlin, 1912, p. 298.

The concept of *humanitas* as a value was formulated in the circle around the younger Scipio, with Cicero as its belated, yet most explicit, spokesman. It meant the quality which distinguishes man, not only from animals, but also, and even more so, from him who belongs to the species *homo* without deserving the name of *homo humanus*: from the barbarian or vulgarian who lacks *pietas* and παιδεία – that is, respect for moral values and that gracious blend of learning and urbanity which we can only circumscribe by the discredited word 'culture'.

In the Middle Ages this concept was displaced by the consideration of humanity as being opposed to divinity rather than to animality or barbarism. The qualities commonly associated with it were therefore those of frailty and transience: *humanitas fragilis, humanitas caduca*.

Thus the Renaissance conception of *humanitas* had a twofold aspect from the outset. The new interest in the human being was based both on a revival of the classical antithesis between *humanitas* and *barbaritas*, or *feritas*, and on a survival of the medieval antithesis between *humanitas* and *divinitas*. When Marsilio Ficino defines man as a 'rational soul participating in the intellect of God, but operating in a body', he defines him as the one being that is both autonomous and finite. And Pico's famous 'speech', 'On the Dignity of Man', is anything but a document of paganism. Pico says that God placed man in the centre of the universe so that he might be conscious of where he stands, and therefore free to decide 'where to turn'. He does not say that man *is* the centre of the universe, not even in the sense commonly attributed to the classical phrase, 'man the measure of all things'.

It is from this ambivalent conception of *humanitas* that humanism was born. It is not so much a movement as an attitude which can be defined as the conviction of the dignity of man, based on both the insistence on human values (rationality and freedom) and the acceptance of human limitations (fallibility and frailty): from this two postulates result – responsibility and tolerance.

Small wonder that this attitude has been attacked from two opposite camps whose common aversion to the ideas of responsibility and tolerance has recently aligned them in a united front. Entrenched in one of these camps are those who deny human values: the determinists, whether they believe in divine, physical or social predestination, the authoritarians, and those 'insectolatrists' who profess the all-importance of the hive, whether the hive be called group, class, nation or race. In the other camp are those who deny human limitations in favour of some sort of intellectual or political libertinism, such as aestheticists, vitalists, intuitionists and hero-worshippers. From the point of view of determinism, the humanist is either a lost soul or an ideologist. From the point of view of authoritarianism, he is either a heretic or a revolutionary (or a counter-revolutionary). From the point of view of 'insectolatry', he is a useless individualist. And from the point of view of libertinism he is a timid bourgeois.

Erasmus of Rotterdam, the humanist *par excellence*, is a typical case in point. The church suspected and ultimately rejected the writings of this man who had said: 'Perhaps the spirit of Christ is more largely diffused than we think, and there are many in the community of saints who are not in our calendar.' The adventurer Ulrich von Hutten despised his ironical scepticism and his unheroic love of tranquillity. And Luther, who insisted that 'no man has power to think anything good or evil, but everything occurs in him by absolute necessity', was incensed by a belief which manifested itself in the famous phrase: 'What is the use of man as a totality [that is, of man endowed with both a body and a soul], if God would work in him as a sculptor works in clay, and might just as well work in stone?'[2]

2. For the quotations from Luther and Erasmus of Rotterdam see the excellent monograph *Humanitas Erasmiana* by R. Pfeiffer, Studien der Bibliothek Warburg, XXII, 1931. It is significant that Erasmus and Luther rejected judicial or fatalistic astrology for totally different reasons: Erasmus refused to believe that human destiny depends on the unalterable movements of the celestial bodies, because such a

II

The humanist, then, rejects authority. But he respects tradition. Not only does he respect it, he looks upon it as upon something real and objective which has to be studied and, if necessary, reinstated: '*nos vetera instauramus, nova non prodimus*', as Erasmus puts it.

The Middle Ages accepted and developed rather than studied and restored the heritage of the past. They copied classical works of art and used Aristotle and Ovid much as they copied and used the works of contemporaries. They made no attempt to interpret them from an archaeological, philological or 'critical', in short, from an historical, point of view. For, if human existence could be thought of as a means rather than an end, how much less could the records of human activity be considered as values in themselves.[3]

belief would amount to a denial of human free will and responsibility; Luther, because it would amount to a restriction of the omnipotence of God. Luther therefore believed in the significance of *terata*, such as eight-footed calves, etc., which God can cause to appear at irregular intervals.

3. Some historians seem to be unable to recognize continuities and distinctions at the same time. It is undeniable that humanism, and the entire Renaissance movement, did not spring forth like Athena from the head of Zeus. But the fact that Lupus of Ferrières emended classical texts, that Hildebert of Lavardin had a strong feeling for the ruins of Rome, that the French and English scholars of the twelfth century revived classical philosophy and mythology, and that Marbod of Rennes wrote a fine pastoral poem on his small country estate, does not mean that their outlook was identical with that of Petrarch, let alone of Ficino or Erasmus. No medieval man could see the civilization of antiquity as a phenomenon complete in itself and historically detached from the contemporary world; as far as I know, medieval Latin has no equivalent to the humanistic '*antiquitas*' or '*sacrosancta vetustas*'. And just as it was impossible for the Middle Ages to elaborate a system of perspective based on the realization of a fixed distance between the eye and the object, so it was equally impossible for this period to evolve an idea of historical disciplines based on the realization of a fixed distance between the present and the classical past. See

In medieval scholasticism there is, therefore, no basic distinction between natural science and what we call the humanities, *studia humaniora*, to quote again an Erasmian phrase. The practice of both, so far as it was carried on at all, remained within the framework of what was called philosophy. From the humanistic point of view, however, it became reasonable, and even inevitable, to distinguish, within the realm of creation, between the sphere of *nature* and the sphere of *culture*, and to define the former with reference to the latter, i.e., nature as the whole world accessible to the senses, except for the *records left by man*.

Man is indeed the only animal to leave records behind him, for he is the only animal whose products 'recall to mind' an idea distinct from their material existence. Other animals use signs and contrive structures, but they use signs without 'perceiving the relation of signification',[4] and they contrive structures without perceiving the relation of construction.

To perceive the relation of signification is to separate the idea of the concept to be expressed from the means of expression. And to perceive the relation of construction is to separate the idea of the function to be fulfilled from the means of fulfilling it. A dog announces the approach of a stranger by a bark quite different from that by which he makes known his wish to go out. But he will not use this particular bark to convey the idea that a stranger *has* called during the absence of his master. Much less will an animal, even if it were physically able to do so, as apes indubitably are, ever attempt to represent anything in a picture. Beavers build dams. But they are unable, so far as we know, to

E. Panofsky and F. Saxl, 'Classical Mythology in Mediaeval Art', *Studies of the Metropolitan Museum*, IV, 2, 1933, p. 228 ff., particularly p. 236 ff., and recently the interesting article by W. S. Heckscher, 'Relics of Pagan Antiquity in Medieval Settings', *Journal of the Warburg Institute*, I, 1937, p. 204 ff.

4. See J. Maritain, 'Sign and Symbol', *Journal of the Warburg Institute*, I, 1937, p. 1 ff.

separate the very complicated actions involved from a premeditated *plan* which might be laid down in a drawing instead of being materialized in logs and stones.

Man's signs and structures are records because, or rather in so far as, they express ideas separated from, yet realized by, the processes of signalling and building. These records have therefore the quality of emerging from the stream of time, and it is precisely in this respect that they are studied by the humanist. He is, fundamentally, an historian.

The scientist, too, deals with human records, namely with the works of his predecessors. But he deals with them not as something to be investigated, but as something which helps him to investigate. In other words, he is interested in records not in so far as they emerge from the stream of time, but in so far as they are absorbed in it. If a modern scientist reads Newton or Leonardo da Vinci in the original, he does so not as a scientist, but as a man interested in the history of science and therefore of human civilization in general. In other words, he does it as a *humanist*, for whom the works of Newton or Leonardo da Vinci have an autonomous meaning and a lasting value. From the humanistic point of view, human records do not age.

Thus, while science endeavours to transform the chaotic variety of natural phenomena into what may be called a cosmos of nature, the humanities endeavour to transform the chaotic variety of human records into what may be called a cosmos of culture.

There are, in spite of all the differences in subject and procedure, some very striking analogies between the methodical problems to be coped with by the scientist, on the one hand, and by the humanist, on the other.[5]

5. See E. Wind, *Das Experiment und die Metaphysik*, Tübingen, 1934, and 'Some Points of Contact between History and Natural Science', *Philosophy and History Essays Presented to Ernst Cassirer*, Oxford, 1936, p. 255 ff. (with a very instructive discussion of the relationship between phenomena, instruments and the observer, on the one hand, and historical facts, documents and the historian, on the other).

In both cases the process of investigation seems to begin with observation. But both the observer of a natural phenomenon and the examiner of a record are not only confined to the limits of their range of vision and to the available material; in directing their attention to *certain* objects they obey, knowingly or not, a principle of pre-selection dictated by a theory in the case of the scientist and by a general historical conception in the case of the humanist. It may be true that 'nothing is in the mind except what was in the senses'; but it is at least equally true that much is in the senses without ever penetrating into the mind. We are chiefly affected by that which we allow to affect us; and just as natural science involuntarily selects what it calls the phenomena, the humanities involuntarily select what they call the historical facts. Thus the humanities have gradually widened their cultural cosmos and in some measure have shifted the accents of their interests. Even he who instinctively sympathizes with the simple definition of the humanities as 'Latin and Greek' and considers this definition as essentially valid as long as we use such ideas and expressions as, for instance, 'idea' and 'expression' – even he has to admit that it has become a trifle narrow.

Furthermore, the world of the humanities is determined by a cultural theory of relativity, comparable to that of the physicists: and since the cosmos of culture is so much smaller than the cosmos of nature, cultural relativity prevails within terrestrial dimensions, and was observed at a much earlier date.

Every historical concept is obviously based on the categories of space and time. The records, and what they imply, have to be dated and located. But it turns out that these two acts are in reality two aspects of one. If I date a picture about 1400, this statement would be meaningless if I could not indicate *where* it could have been produced at that date; conversely, if I ascribe a picture to the Florentine school, I must be able to tell *when* it could have been produced in that school. The cosmos of culture, like the cosmos of nature, is a

spatio-temporal structure. The year 1400 means something different in Venice from what it means in Florence, to say nothing of Augsburg, or Russia, or Constantinople. Two historical phenomena are simultaneous, or have a determinable temporal relation to each other, only in so far as they can be related within one 'frame of reference', in the absence of which the very concept of simultaneity would be as meaningless in history as it would in physics. If we knew by some concatenation of circumstances that a certain Negro sculpture had been executed in 1510, it would be meaningless to say that it was 'contemporaneous' with Michelangelo's Sistine ceiling.[6]

Finally, the succession of steps by which the material is organized into a natural or cultural cosmos is analogous, and the same is true of the methodical problems implied by this process. The first step is, as has already been mentioned, the observation of natural phenomena and the examination of human records. Then the records have to be 'decoded' and interpreted, as must the 'messages from nature' received by the observer. Finally the results have to be classified and coordinated into a coherent system that 'makes sense'.

Now we have seen that even the selection of the material *for* observation and examination is predetermined, to some extent, by a theory, or by a general historical conception. This is even more evident in the procedure itself, as every step made towards the system that 'makes sense' presupposes not only the preceding but also the succeeding ones.

When the scientist observes a phenomenon he uses *instruments* which are themselves subject to the laws of nature which he wants to explore. When the humanist examines a record he uses *documents* which are themselves produced in the course of the process which he wants to investigate.

Let us suppose that I find in the archives of a small town in the Rhineland a contract dated 1471, and complemented

6. See, e.g., E. Panofsky, 'Ueber die Reihenfolge der vier Meister von Reims' (Appendix), *Jahrbuch für Kunstwissenschaft*, II, 1927, p. 77 ff.

by records of payments, by which the local painter 'Johannes *qui et* Frost' was commissioned to execute for the Church of St James in that town an altarpiece with the Nativity in the centre and Saints Peter and Paul on the wings; and let us further suppose that I find in the Church of St James an altarpiece corresponding to this contract. That would be a case of documentation as good and simple as we could possibly hope to encounter, much better and simpler than if we had to deal with an 'indirect' source such as a letter, or a description in a chronicle, biography, diary, or poem. Yet several questions would present themselves.

The document may be an original, a copy or a forgery. If it is a copy, it may be a faulty one, and even if it is an original, some of the data may be wrong. The altarpiece in turn may be the one referred to in the contract; but it is equally possible that the original monument was destroyed during the iconoclastic riots of 1535 and was replaced by an altarpiece showing the same subjects, but executed around 1550 by a painter from Antwerp.

To arrive at any degree of certainty we would have to 'check' the document against other documents of similar date and provenance, and the altarpiece against other paintings executed in the Rhineland around 1470. But here two difficulties arise.

First, 'checking' is obviously impossible without our knowing what to 'check'; we would have to single out certain features or criteria such as some forms of script, or some technical terms used in the contract, or some formal or iconographic peculiarities manifested in the altarpiece. But since we cannot analyse what we do not understand, our examination turns out to presuppose decoding and interpretation.

Secondly, the material against which we check our problematic case is in itself no better authenticated than the problematic case in hand. Taken individually, any other signed and dated monument is just as doubtful as the altarpiece ordered from 'Johannes *qui et* Frost' in 1471. (It is

self-evident that a signature on a picture can be, and often is, just as unreliable as a document connected with a picture.) It is only on the basis of a whole group or class of data that we can decide whether our altarpiece was stylistically and iconographically 'possible' in the Rhineland around 1470. But classification obviously presupposes the idea of a whole to which the classes belong – in other words, the general historical conception which we try to build up from our individual cases.

However we may look at it, the beginning of our investigation always seems to presuppose the end, and the documents which should explain the monuments are just as enigmatical as the monuments themselves. It is quite possible that a techical term in our contract is a ἅπαξ λεγόμενον which can only be explained by this one altarpiece; and what an artist has said about his own works must always be interpreted in the light of the works themselves. We are apparently faced with a hopeless vicious circle. Actually it is what the philosophers call an 'organic situation'.[7] Two legs without a body cannot walk, and a body without legs cannot walk either, yet a man can walk. It is true that the individual monuments and documents can only be examined, interpreted and classified in the light of a general historical concept, while at the same time this general historical concept can only be built up on individual monuments and documents; just as the understanding of natural phenomena and the use of scientific instruments depends on a general physical theory and vice versa. Yet this situation is by no means a permanent deadlock. Every discovery of an unknown historical fact, and every new interpretation of a known one, will either 'fit in' with the prevalent general conception, and thereby corroborate and enrich it, or else it will entail a subtle, or even a fundamental change in the prevalent general conception, and thereby throw new light on all that has been known before. In both cases the 'system

7. I am indebted for this term to Professor T. M. Greene.

that makes sense' operates as a consistent yet elastic organism, comparable to a living animal as opposed to its single limbs; and what is true of the relationship between monuments, documents and a general historical concept in the humanities is evidently equally true of the relationship between phenomena, instruments and theory in the natural sciences.

III

I have referred to the altarpiece of 1471 as a 'monument' and to the contract as a 'document'; that is to say, I have considered the altarpiece as the object of investigation, or 'primary material', and the contract as an instrument of investigation, or 'secondary material'. In doing this I have spoken as an art historian. For a palaeographer or an historian of law, the contract would be the 'monument', or 'primary material', and both may use pictures for documentation.

Unless a scholar is exclusively interested in what is called 'events' (in which case he would consider all the available records as 'secondary material' by means of which he might reconstruct the 'events'), everyone's 'monuments' are everyone else's 'documents', and vice versa. In practical work we are even compelled actually to annex 'monuments' rightfully belonging to our colleagues. Many a work of art has been interpreted by a philologist or by an historian of medicine; and many a text has been interpreted, and could only have been interpreted, by an historian of art.

An art historian, then, is a humanist whose 'primary material' consists of those records which have come down to us in the form of works of art. But what is a work of art?

A work of art is not always created exclusively for the purpose of being enjoyed, or, to use a more scholarly expression, of being experienced aesthetically. Poussin's statement that 'la fin de l'art est la délectation' was quite a

revolutionary one,[8] for earlier writers had always insisted that art, however enjoyable, was also, in some manner, useful. But a work of art always *has* aesthetic significance (not to be confused with aesthetic value): whether or not it serves some practical purpose, and whether it is good or bad, it demands to be experienced aesthetically.

It is possible to experience every object, natural or man-made, aesthetically. We do this, to express it as simply as possible, when we just look at it (or listen to it) without relating it, intellectually or emotionally, to anything outside of itself. When a man looks at a tree from the point of view of a carpenter, he will associate it with the various uses to which he might put the wood; and when he looks at it from the point of view of an ornithologist he will associate it with the birds that might nest in it. When a man at a horse race watches the animal on which he has put his money, he will associate its performance with his desire that it may win. Only he who simply and wholly abandons himself to the object of his perception will experience it aesthetically.[9]

Now, when confronted with a natural object, it is an exclusively personal matter whether or not we choose to experience it aesthetically. A man-made object, however, either demands or does not demand to be so experienced, for

8. A. Blunt, 'Poussin's Notes on Painting', *Journal of the Warburg Institute*, I, 1937, p. 344 ff., claims (p. 349) that Poussin's 'La fin de l'art est la délectation' was more or less 'medieval', because 'the theory of *delectatio* as the sign by which beauty is recognized is the key of all St Bonaventura's aesthetic, and it may well be from there, probably by means of some populariser, that Poussin drew the definition.' However, even if the wording of Poussin's phrase was influenced by a medieval source, there is a great difference between the statement that *delectatio* is a *distinctive quality* of everything *beautiful*, whether man-made or natural, and the statement that *delectatio* is the end ('*fin*') of *art*.

9. See M. Geiger, 'Beiträge zur Phänomenologie des aesthetischen Genusses', *Jahrbuch für Philosophie*, I, Part 2, 1922, p. 567 ff. Furthermore, E. Wind, *Aesthetischer und kunstwissenschaftlicher Gegenstand*, Diss. phil. Hamburg, 1923, partly reprinted as 'Zur Systematik der künstlerischen Probleme', *Zeitschrift für Aesthetik und allgemeine Kunstwissenschaft*, XVIII, 1925, p. 438 ff.

it has what the scholastics call an 'intention'. Should I choose, as I might well do, to experience the redness of a traffic light aesthetically, instead of associating it with the idea of stepping on my brakes, I should act against the 'intention' of the traffic light.

Those man-made objects which do not demand to be experienced aesthetically, are commonly called 'practical', and may be divided into two classes: vehicles of communication, and tools or apparatuses. A vehicle of communication is 'intended' to transmit a concept. A tool or apparatus is 'intended' to fulfil a function (which function, in turn, may be the production or transmission of communications, as is the case with a typewriter or with the previously mentioned traffic light).

Most of the objects which do demand to be experienced aesthetically, that is to say, works of art, also belong in one of these two classes. A poem or an historical painting is, in a sense, a vehicle of communication; the Pantheon and the Milan candlesticks are, in a sense, apparatuses; and Michelangelo's tombs of Lorenzo and Giuliano de' Medici are, in a sense, both. But I have to say 'in a sense', because there is this difference: in the case of what might be called a 'mere vehicle of communication' and a 'mere apparatus', the intention is definitely fixed on the idea of the work, namely, on the meaning to be transmitted, or on the function to be fulfilled. In the case of a work of art, the interest in the idea is balanced, and may even be eclipsed, by an interest in form.

However, the element of 'form' is present in every object without exception, for every object consists of matter and form; and there is no way of determining with scientific precision to what extent, in a given case, this element of form bears the emphasis. Therefore one cannot, and should not, attempt to define the precise moment at which a vehicle of communication or an apparatus begins to be a work of art. If I write to a friend to ask him to dinner, my letter is primarily a communication. But the more I shift the emphasis to the form of my script, the more nearly does it become a work

of calligraphy; and the more I emphasize the form of my language (I could even go so far as to invite him by a sonnet), the more nearly does it become a work of literature or poetry.

Where the sphere of practical objects ends, and that of 'art' begins, depends, then, on the 'intention' of the creators. This 'intention' cannot be absolutely determined. In the first place, 'intentions' are, *per se*, incapable of being defined with scientific precision. In the second place, the 'intentions' of those who produce objects are conditioned by the standards of their period and environment. Classical taste demanded that private letters, legal speeches and the shields of heroes should be 'artistic' (with the possible result of what might be called fake beauty), while modern taste demands that architecture and ash trays should be 'functional' (with the possible result of what might be called fake efficiency).[10]

10. 'Functionalism' means, strictly speaking, not the introduction of a new aesthetic principle, but a narrower delimitation of the aesthetic sphere. When we prefer the modern steel helmet to the shield of Achilles, or feel that the 'intention' of a legal speech should be definitely focused on the subject matter and should not be shifted to the form ('more matter with less *art*', as Queen Gertrude rightly puts it), we merely demand that arms and legal speeches should not be treated as works of art, that is, aesthetically, but as practical objects, that is, technically. However, we have come to think of 'functionalism' as a postulate instead of an interdict. The Classical and Renaissance civilizations, in the belief that a merely useful thing could not be 'beautiful' ('non può essere bellezza e utilità,' as Leonardo da Vinci puts it; see J. P. Richter, *The Literary Works of Leonardo da Vinci*, London, 1883, nr. 1445) are characterized by a tendency to extend the aesthetic attitude to such creations as are 'naturally' practical; we have extended the technical attitude to such creations as are 'naturally' artistic. This, too, is an infringement, and, in the case of 'stream-lining', art has taken its revenge. 'Streamlining' was, originally, a genuine functional principle based on the results of scientific research on air resistance. Its legitimate sphere was therefore the field of fast-moving vehicles and of structures exposed to wind pressure of an extra-ordinary intensity. But when this special and truly technical device came to be interpreted as a general and aesthetic principle expressing the twentieth-century ideal of 'efficiency' ('streamline your mind!'),

Finally our estimate of those 'intensions' is inevitably influenced by our own attitude, which in turn depends on our individual experiences as well as on our historical situation. We have all seen with our own eyes the transference of spoons and fetishes of African tribes from the museums of ethnology into art exhibitions.

One thing, however, is certain: the more the proportion of emphasis on 'idea' and 'form' approaches a state of equilibrium, the more eloquently will the work reveal what is called 'content'. Content, as opposed to subject matter, may be described in the words of Peirce as that which a work betrays but does not parade. It is the basic attitude of a nation, a period, a class, a religious or philosophical persuasion – all this unconsciously qualified by one personality, and condensed into one work. It is obvious that such an involuntary revelation will be obscured in proportion as either one of the two elements, idea or form, is voluntarily emphasized or suppressed. A spinning machine is perhaps the most impressive manifestation of a functional idea, and an 'abstract' painting is perhaps the most expressive manifestation of pure form, but both have a minimum of content.

IV

In defining a work of art as a 'man-made object demanding to be experienced aesthetically' we encounter for the first time a basic difference between the humanities and natural science. The scientist, dealing as he does with natural phenomena, can at once proceed to analyse them. The humanist, dealing as he does with human actions and creations, has to engage in a mental process of a synthetic and

and was applied to arm-chairs and cocktail shakers, it was felt that the original scientific streamline had to be 'beautified'; and it was finally retransferred to where it rightfully belongs in a thoroughly non-functional form. As a result, we now less often have houses and furniture functionalized by engineers, than automobiles and railroad trains de-functionalized by designers.

subjective character: he has mentally to re-enact the actions and to re-create the creations. It is in fact by this process that the real objects of the humanities come into being. For it is obvious that historians of philosophy or sculpture are concerned with books and statues not in so far as these books and sculptures exist materially, but in so far as they have a meaning. And it is equally obvious that this meaning can only be apprehended by re-producing, and thereby, quite literally, 'realizing', the thoughts that are expressed in the books and the artistic conceptions that manifest themselves in the statues.

Thus the art historian subjects his 'material' to a rational archaeological analysis at times as meticulously exact, comprehensive and involved as any physical or astronomical research. But he constitutes his 'material' by means of an intuitive aesthetic re-creation,[11] including the perception and

11. However, when speaking of 're-creation' it is important to emphasize the prefix 're'. Works of art are both manifestations of artistic 'intentions' and natural objects, sometimes difficult to isolate from their physical surroundings and always subject to the physical processes of ageing. Thus, in experiencing a work of art aesthetically we perform two entirely different acts which, however, psychologically merge with each other into one *Erlebnis*: we build up our aesthetic object both by re-creating the work of art according to the 'intention' of its maker, and by freely creating a set of aesthetic values comparable to those with which we endow a tree or a sunset. When abandoning ourselves to the impression of the weathered sculptures of Chartres, we cannot help enjoying their lovely mellowness and patina as an aesthetic value; but this value, which implies both the sensual pleasure in a peculiar play of light and colour and the more sentimental delight in 'age' and 'genuineness', has nothing to do with the objective, or artistic, value with which the sculptures were invested by their makers. From the point of view of the Gothic stone carvers the processes of ageing were not merely irrelevant but positively undesirable: they tried to protect their statues by a coat of colour which, had it been preserved in its original freshness, would probably spoil a good deal of our aesthetic enjoyment. As a private person, the art historian is entirely justified in not destroying the psychological unity of *Alters-und-Echtheits-Erlebnis* and *Kunst-Erlebnis*. But as a 'professional man' he has to separate, as far as possible, the re-creative experience of the

appraisal of 'quality', just as any 'ordinary' person does when he or she looks at a picture or listens to a symphony.

How, then, is it possible to build up art history as a respectable scholarly discipline, if its very objects come into being by an irrational and subjective process?

This question cannot be answered, of course, by referring to the scientific methods which have been, or may be, introduced into art history. Devices such as chemical analysis of materials, X-rays, ultra-violet rays, infra-red rays and macrophotography are very helpful, but their use has nothing to do with the basic methodical problem. A statement to the effect that the pigments used in an allegedly medieval miniature were not invented before the nineteenth century may settle an art-historical question, but it is not an art-historical statement. Based as it is on chemical analysis plus the history of chemistry, it refers to the miniature not *qua* work of art but *qua* physical object, and may just as well refer to a forged will. The use of X-rays, macrophotographs, etc., on the other hand, is methodically not different from the use of spectacles or of a magnifying glass. These devices enable the art historian to see more than he could see without them, but *what* he sees has to be interpreted 'stylistically', like that which he perceives with the naked eye.

The real answer lies in the fact that intuitive aesthetic re-creation and archaeological research are interconnected so as to form, again, what we have called an 'organic situation'. It is not true that the art historian first constitutes his object by means of re-creative synthesis and then begins his archaeological investigation – as though first buying a ticket and then boarding a train. In reality the two processes do not succeed each other, they interpenetrate; not only does the re-creative synthesis serve as a basis for the archaeological

intentional values imparted to the statue by the artist from the creative experience of the accidental values imparted to a piece of aged stone by the action of nature. And this separation is often not as easy as it might seem.

investigation, the archaeological investigation in turn serves as a basis for the re-creative process; both mutually qualify and rectify one another.

Anyone confronted with a work of art, whether aesthetically re-creating or rationally investigating it, is affected by its three constituents: materialized form, idea (that is, in the plastic arts, subject matter) and content. The pseudo-impressionistic theory according to which 'form and colour tell us of form and colour, that is all', is simply not true. It is the unity of those three elements which is realized in the aesthetic experience, and all of them enter into what is called aesthetic enjoyment of art.

The re-creative experience of a work of art depends, therefore, not only on the natural sensitivity and the visual training of the spectator, but also on his cultural equipment. There is no such thing as an entirely 'naïve' beholder. The 'naïve' beholder of the Middle Ages had a good deal to learn, and something to forget, before he could appreciate classical statuary and architecture, and the 'naïve' beholder of the post-Renaissance period had a good deal to forget, and something to learn, before he could appreciate medieval, to say nothing of primitive, art. Thus the 'naïve' beholder not only enjoys but also, unconsciously, appraises and interprets the work of art; and no one can blame him if he does this without caring whether his appraisal and interpretation are right or wrong, and without realizing that his own cultural equipment, such as it is, actually contributes to the object of his experience.

The 'naïve' beholder differs from the art historian in that the latter is conscious of the situation. He *knows* that his cultural equipment, such as it is, would not be in harmony with that of people in another land and of a different period. He tries, therefore, to make adjustments by learning as much as he possibly can of the circumstances under which the objects of his studies were created. Not only will he collect and verify all the available factual information as to medium, condition, age, authorship, destination, etc., but he will also

compare the work with others of its class, and will examine such writings as reflect the aesthetic standards of its country and age, in order to achieve a more 'objective' appraisal of its quality. He will read old books on theology or mythology in order to identify its subject matter, and he will further try to determine its historical locus, and to separate the individual contribution of its maker from that of forerunners and contemporaries. He will study the formal principles which control the rendering of the visible world, or, in architecture, the handling of what may be called the structural features, and thus build up a history of 'motifs'. He will observe the interplay between the influences of literary sources and the effect of self-dependent representational traditions, in order to establish a history of iconographic formulae or 'types'. And he will do his best to familiarize himself with the social, religious and philosophical attitudes of other periods and countries, in order to correct his own subjective feeling for content.[12] But when he does all this, his aesthetic perception as such will change accordingly, and will more and more adapt itself to the original 'intention' of the works. Thus what the art historian, as opposed to the 'naïve' art lover, does, is not to erect a rational superstructure on an irrational foundation, but to develop his re-creative experiences so as to conform with the results of his archaeological research, while continually checking the results of his archaeological research against the evidence of his re-creative experiences.[13]

12. For the technical terms used in this paragraph, see the Introduction to E. Panofsky, *Studies in Iconology*, here reprinted on pp. 51–81.

13. The same applies, of course, to the history of literature and of other forms of artistic expression. According to Dionysius Thrax (*Ars Grammatica*, ed. P. Uhlig, XXX, 1883, p. 5 ff.; quoted in Gilbert Murray, *Religio Grammatici, The Religion of a Man of Letters*, Boston and New York, 1918, p. 15), γραμματική (history of literature, as we would say) is an ἐμπειρία (knowledge based on experience) of that which has been said by the poets and prose writers. He divides it into six parts, all of which can be paralleled in art history:

1) ἀνάγνωσις ἐντριβὴς κατὰ προσῳδίαν (expert reading aloud according to prosody): this is, in fact, the synthetic aesthetic re-creation of a work of literature and is comparable to the visual 'realization' of a work of art.

2) ἐξήγησις κατὰ τοὺς ἐνυπάρχοντας ποιητικοὺς τρόπους (explanation of such figures of speech as may occur): this would be comparable to the history of iconographic formulae or 'types'.

3) γλωσσῶν τε καὶ ἱστοριῶν πρόχειρος ἀπόδοσις (offhand rendering of obsolete words and themes): identification of iconographic subject matter.

4) ἐτυμολογίας εὕρησις (discovery of etymologies): derivation of 'motifs'.

5) ἀναλογίας ἐκλογισμός (explanation of grammatical forms): analysis of compositional structure.

6) κρίσις ποιημάτων, ὃ δὴ κάλλιστόν ἐστι πάντων τῶν ἐν τῇ τέχνῃ (literary criticism, which is the most beautiful part of that which is comprised by γραμματική): critical appraisal of works of art.

The expression 'critical appraisal of works of art' raises an interesting question. If the history of art admits a scale of values, just as the history of literature or political history admits degrees of excellence or 'greatness', how can we justify the fact that the methods here expounded do not seem to allow for a differentiation between first, second and third rate works of art? Now a scale of values is partly a matter of personal reactions and partly a matter of tradition. Both these standards, of which the second is the comparatively more objective one, have continually to be revised, and every investigation, however specialized, contributes to this process. But just for this reason the art historian cannot make an a priori distinction between his approach to a 'masterpiece' and his approach to a 'mediocre' or 'inferior' work of art – just as a student of classical literature cannot investigate the tragedies by Sophocles in any other manner than the tragedies by Seneca. It is true that the methods of art history, *qua* methods, will prove as effective when applied to Dürer's *Melencolia* as when applied to an anonymous and rather unimportant woodcut. But when a 'masterpiece' is compared and connected with as many 'less important' works of art as turn out, in the course of the investigation, to be comparable and connectable with it, the originality of its invention, the superiority of its composition and technique, and whatever other features make it 'great', will automatically become evident – not in spite but because of the fact that the whole group of materials has been subjected to one and the same method of analysis and interpretation.

Leonardo da Vinci has said: 'Two weaknesses leaning against one another add up to one strength.'[14] The halves of an arch cannot even stand upright; the whole arch supports a weight. Similarly, archaeological research is blind and empty without aesthetic re-creation, and aesthetic re-creation is irrational and often misguided without archaeological research. But, 'leaning against one another', these two can support the 'system that makes sense', that is, an historical synopsis.

As I have said before, no one can be blamed for enjoying works of art 'naïvely' – for appraising and interpreting them according to his lights and not caring any further. But the humanist will look with suspicion upon what might be called 'appreciationism'. He who teaches innocent people to understand art without bothering about classical languages, boresome historical methods and dusty old documents, deprives naïveté of its charm without correcting its errors.

'Appreciationism' is not to be confused with 'connoisseur-ship' and 'art theory'. The connoisseur is the collector, museum curator or expert who deliberately limits his contribution to scholarship to identifying works of art with respect to date, provenance and authorship, and to evaluating them with respect to quality and condition. The difference between him and the art historian is not so much a matter of principle as a matter of emphasis and explicitness, comparable to the difference between a diagnostician and a researcher in medicine. The connoisseur tends to emphasize the re-creative aspect of the complex process which I have tried to describe, and considers the building up of an historical conception as secondary; the art historian in the narrower, or academic, sense is inclined to reverse these accents. But the simple diagnosis 'cancer', if correct, implies everything which the researcher could tell us about cancer, and therefore claims to be verifiable by subsequent scientific analysis; similarly the simple diagnosis 'Rembrandt around

14. *Il codice atlantico di Leonardo da Vinci nella Biblioteca Ambrosiana di Milano*, ed. G. Piumati, Milan, 1894–1903, fol. 244 v.

1650', if correct, implies everything which the historian of art could tell us about the formal values of the picture, about the interpretation of the subject, about the way it reflects the cultural attitude of seventeenth-century Holland, and about the way it expresses Rembrandt's personality; and this diagnosis, too, claims to live up to the criticism of the art historian in the narrower sense. The connoisseur might thus be defined as a laconic art historian, and the art historian as a loquacious connoisseur. In point of fact the best representatives of both types have enormously contributed to what they themselves do not consider their proper business.[15]

Art theory, on the other hand – as opposed to the philosophy of art or aesthetics – is to art history as poetics and rhetoric are to the history of literature.

Because of the fact that the objects of art history come into being by a process of re-creative aesthetic synthesis, the art historian finds himself in a peculiar difficulty when trying to characterize what might be called the stylistic structure of the works with which he is concerned. Since he has to describe these works, not as physical bodies or as substitutes for physical bodies, but as objects of an inward experience, it would be useless – even if it were possible – to express shapes, colours, and features of construction in terms of geometrical formulae, wave lengths and statical equations, or to describe the postures of a human figure by way of anatomical analysis. On the other hand, since the inward experience of the art historian is not a free and subjective one, but has been outlined for him by the purposeful activities of an artist, he must not limit himself to describing his personal impressions of the work of art as a poet might describe his impressions of a landscape or of the song of a nightingale.

15. See M. J. Friedländer, *Der Kenner*, Berlin, 1919, and E. Wind, *Aesthetischer und kunstwissenschaftlicher Gegenstand*, loc. cit. Friedländer justly states that a good art historian is, or at least develops into, a *Kenner wider Willen*. Conversely, a good connoisseur might be called an art historian *malgré lui*.

The objects of art history, then, can only be characterized in a terminology which is as re-constructive as the experience of the art historian is re-creative: it must describe the stylistic peculiarities, neither as measurable or otherwise determinable data, nor as stimuli of subjective reactions, but as that which bears witness to artistic 'intentions'. Now 'intentions' can only be formulated in terms of alternatives: a situation has to be supposed in which the maker of the work had more than one possibility of procedure, that is to say, in which he found himself confronted with a problem of choice between various modes of emphasis. Thus it appears that the terms used by the art historian interpret the stylistic peculiarities of the works as specific solutions of generic 'artistic problems'. This is not only the case with our modern terminology, but even with such expressions as *rilievo, sfumato*, etc., found in sixteenth-century writing.

When we call a figure in an Italian Renaissance picture 'plastic', while describing a figure in a Chinese painting as 'having volume but no mass' (owing to the absence of 'modelling'), we interpret these figures as two different solutions of a problem which might be formulated as 'volumetric units (bodies) *v.* illimited expanse (space)'. When we distinguish between a use of line as 'contour' and, to quote Balzac, a use of line as 'le moyen par lequel l'homme se rend compte de l'effet de la lumière sur les objets', we refer to the same problem, while placing special emphasis upon another one; 'line *v.* areas of colour'. Upon reflection it will turn out that there is a limited number of such primary problems, interrelated with each other, which on the one hand beget an infinity of secondary and tertiary ones, and on the other hand can be ultimately derived from one basic antithesis: differentiation *v.* continuity.[16]

To formulate and to systematize the 'artistic problems' –

16. See E. Panofsky, 'Ueber das Verhältnis der Kunstgeschichte zur Kunsttheorie', *Zeitschrift für Aesthetik und allgemeine Kunstwissenschaft*, XVIII, 1925, p. 129 ff., and E. Wind, 'Zur Systematik der künstlerischen Probleme', ibid., p. 438 ff.

which are of course not limited to the sphere of purely formal values, but include the 'stylistic structure' of subject matter and content as well – and thus to build up a system of '*Kunstwissenschaftliche Grundbegriffe*' is the objective of art theory and not of art history. But here we encounter, for the third time, what we have called an 'organic situation'. The art historian, as we have seen, cannot describe the objects of his re-creative experience without re-constructing artistic intentions in terms which imply generic theoretical concepts. In doing this, he will, consciously or unconsciously, contribute to the development of art theory, which, without historical exemplification, would remain a meagre scheme of abstract universals. The art theorist, on the other hand, whether he approaches the subject from the standpoint of Kant's *Critique*, of neo-scholastic epistemology, or of *Gestaltpsychologie*,[17] cannot build up a system of generic concepts without referring to works of art which have come into being under specific historical conditions; but in doing this he will, consciously or unconsciously, contribute to the development of art history, which, without theoretical orientation, would remain a congeries of unformulated particulars.

When we call the connoisseur a laconic art historian and the art historian a loquacious connoisseur, the relation between the art historian and the art theorist may be compared to that between two neighbours who have the right of shooting over the same district, while one of them owns the gun and the other all the ammunition. Both parties would be well advised if they realized this condition of their partnership. It has rightly been said that theory, if not received at the door of an empirical discipline, comes in through the chimney like a ghost and upsets the furniture. But it is no less true that history, if not received at the door of a theoretical discipline dealing with the same set of phenomena, creeps into the cellar like a horde of mice and undermines the groundwork.

17. Cf. H. Sedlmayr, 'Zu einer strengen Kunstwissenschaft', *Kunstwissenschaftliche Forschungen*, I, 1931, p. 7 ff.

V

It may be taken for granted that art history deserves to be counted among the humanities. But what is the use of the humanities as such? Admittedly they are not practical, and admittedly they concern themselves with the past. Why, it may be asked, should we engage in impractical investigations, and why should we be interested in the past?

The answer to the first question is: because we are interested in reality. Both the humanities and the natural sciences, as well as mathematics and philosophy, have the impractical outlook of what the ancients called *vita contemplativa* as opposed to *vita activa*. But is the contemplative life less real or, to be more precise, is its contribution to what we call reality less important, than that of the active life?

The man who takes a paper dollar in exchange for twenty-five apples commits an act of faith, and subjects himself to a theoretical doctrine, as did the medieval man who paid for indulgence. The man who is run over by an automobile is run over by mathematics, physics and chemistry. For he who leads the contemplative life cannot help influencing the active, just as he cannot prevent the active life from influencing his thought. Philosophical and psychological theories, historical doctrines and all sorts of speculations and discoveries, have changed, and keep changing, the lives of countless millions. Even he who merely transmits knowledge or learning participates, in his modest way, in the process of shaping reality – of which fact the enemies of humanism are perhaps more keenly aware than its friends.[18] It is

18. In a letter to the *New Statesman and Nation*, XIII, 19 June 1937, a Mr Pat Sloan defends the dismissal of professors and teachers in Soviet Russia by stating that 'a professor who advocates an antiquated pre-scientific philosophy as against a scientific one may be as powerful a reactionary force as a soldier in an army of intervention.' And it turns out that by 'advocating' he means also the mere transmission of what he calls 'pre-scientific' philosophy, for he continues as follows: 'How many minds in Britain today are being kept from ever establish-

impossible to conceive of our world in terms of action alone. Only in God is there a 'Coincidence of Act and Thought' as the scholastics put it. Our reality can only be understood as an interpenetration of these two.

But even so, why should we be interested in the past? The answer is the same: because we are interested in reality. There is nothing less real than the present. An hour ago, this lecture belonged to the future. In four minutes, it will belong to the past. When I said that the man who is run over by an automobile is run over by mathematics, physics and chemistry, I could just as well have said that he is run over by Euclid, Archimedes and Lavoisier.

To grasp reality we have to detach ourselves from the present. Philosophy and mathematics do this by building systems in a medium which is by definition not subject to time. Natural science and the humanities do it by creating those spatio-temporal structures which I have called the 'cosmos of nature' and the 'cosmos of culture'. And here we touch upon what is perhaps the most fundamental difference between the humanities and the natural sciences. Natural science observes the time-bound processes of nature and tries to apprehend the timeless laws according to which they unfold. Physical observation is only possible where something 'happens', that is, where a change occurs or is made to occur by way of experiment. And it is these changes which are finally symbolized by mathematical formulae. The humanities, on the other hand, are not faced by the task of arresting what otherwise would slip away, but of enlivening what otherwise would remain dead. Instead of dealing with temporal phenomena, and causing time to stop, they penetrate into a region where time has stopped of its

ing contact with Marxism by the simple process of loading them to capacity with the works of Plato and other philosophers? These works play not a neutral, but an anti-Marxist role in such circumstances, and Marxists recognize this fact.' Needless to say, the works of 'Plato and other philosophers' also play an anti-Fascist role 'in such circumstances', and Fascists too, 'recognize this fact'.

own accord, and try to reactivate it. Gazing as they do at those frozen, stationary records of which I have said that they 'emerge from the stream of time', the humanities endeavour to capture the processes in the course of which those records were produced and became what they are.[19]

In thus endowing static records with dynamic life, instead of reducing transitory events to static laws, the humanities do not conflict with, but complement, the natural sciences. In fact these two presuppose and demand each other. Science – here understood in the true sense of the term, namely, as a serene and self-dependent pursuit of knowledge, not as something subservient to 'practical' ends – and the humanities are sisters, brought forth as they are by that movement which has rightly been called the discovery (or, in a larger historical perspective, rediscovery) of both the world and man. And as they were born and reborn together, they will also die and be resurrected together if destiny so wills. If the anthropocratic civilization of the Renaissance is headed, as it seems to be, for a 'Middle Ages in reverse' – a satanocracy as opposed to the medieval theocracy – not only the humanities but also the natural sciences, as we know them, will disappear, and nothing will be left but what serves the dictates of the subhuman. But even this will not mean the end of humanism. Prometheus could be bound and tortured, but the fire lit by his torch could not be extinguished.

A subtle difference exists in Latin between *scientia* and

19. For the humanities it is not a romantic ideal but a methodological necessity to 'enliven' the past. They can express the fact that the records A, B and C are 'connected' with each other only in statements to the effect that the man who produced the record A must have been acquainted with the records B and C, or with records of the type B and C, or with a record X which was in turn the source of B and C, or that he must have been acquainted with B while the maker of B must have been acquainted with C, etc. It is just as inevitable for the humanities to think and to express themselves in terms of 'influences', 'lines of evolution', etc., as it is for the natural sciences to think and to express themselves in terms of mathematical equations.

eruditio, and in English between knowledge and learning. *Scientia* and knowledge, denoting a mental possession rather than a mental process, can be identified with the natural sciences; *eruditio* and learning, denoting a process rather than a possession, with the humanities. The ideal aim of science would seem to be something like mastery, that of the humanities something like wisdom.

Marsilio Ficino wrote to the son of Poggio Bracciolini:

History is necessary, not only to make life agreeable, but also to endow it with a moral significance. What is mortal in itself, achieves immortality through history; what is absent becomes present; old things are rejuvenated; and young men soon equal the maturity of old ones. If a man of seventy is considered wise because of his experience, how much wiser he whose life fills a span of a thousand or three thousand years! For indeed, a man may be said to have *lived* as many millennia as are embraced by the span of his knowledge of history.[20]

20. Marsilio Ficino, Letter to Giacomo Bracciolini (*Marsilii Ficini Opera omnia*, Leyden, 1676, I, p. 658): 'res ipsa [sci., historia] est ad vitam non modo oblectandam, verumtamen moribus instituendam summopere necessaria. Si quidem per se mortalia sunt, immortalitatem ab historia consequuntur, quae absentia, per eam praesentia fiunt, vetera iuvenescunt, iuvenes cito maturitatem senis adaequant. Ac si senex septuaginta annorum ob ipsarum rerum experientiam prudens habetur, quanto prudentior, qui annorum mille, et trium milium implet aetatem! Tot vero annorum milia vixisse quisque videtur quot annorum acta didicit ab historia.'

I

Iconography and Iconology: An Introduction to the Study of Renaissance Art

I

Iconography is that branch of the history of art which concerns itself with the subject matter or meaning of works of art, as opposed to their form. Let us, then, try to define the distinction between subject matter or meaning on the one hand, and form on the other.

When an acquaintance greets me on the street by lifting his hat, what I see from a formal point of view is nothing but the change of certain details within a configuration forming part of the general pattern of colour, lines and volumes which constitutes my world of vision. When I identify, as I automatically do, this configuration as an object (gentleman), and the change of detail as an event (hat-lifting), I have already overstepped the limits of purely formal perception and entered a first sphere of subject matter or meaning. The meaning thus perceived is of an elementary and easily understandable nature, and we shall call it the factual meaning; it is apprehended by simply identifying certain visible forms with certain objects known to me from practical experience, and by identifying the change in their relations with certain actions or events.

Now the objects and events thus identified will naturally produce a certain reaction within myself. From the way my acquaintance performs his action I may be able to sense whether he is in a good or bad humour, and whether his feelings towards me are indifferent, friendly or hostile. These

psychological nuances will invest the gestures of my acquaintance with a further meaning which we shall call expressional. It differs from the factual one in that it is apprehended, not by simple identification, but by 'empathy'. To understand it, I need a certain sensitivity, but this sensitivity is still part of my practical experience, that is, of my everyday familiarity with objects and events. Therefore both the factual and the expressional meaning may be classified together: they constitute the class of primary or natural meanings.

However, my realization that the lifting of the hat stands for a greeting belongs in an altogether different realm of interpretation. This form of salute is peculiar to the Western world and is a residue of medieval chivalry: armed men used to remove their helmets to make clear their peaceful intentions and their confidence in the peaceful intentions of others. Neither an Australian bushman nor an ancient Greek could be expected to realize that the lifting of a hat is not only a practical event with certain expressional connotations, but also a sign of politeness. To understand this significance of the gentleman's action I must not only be familiar with the practical world of objects and events, but also with the more-than-practical world of customs and cultural traditions peculiar to a certain civilization. Conversely, my acquaintance could not feel impelled to greet me by lifting his hat were he not conscious of the significance of this act. As for the expressional connotations which accompany his action, he may or may not be conscious of them. Therefore, when I interpret the lifting of a hat as a polite greeting, I recognize in it a meaning which may be called secondary or conventional; it differs from the primary or natural one in that it is intelligible instead of being sensible, and in that it has been consciously imparted to the practical action by which it is conveyed.

And finally: besides constituting a natural event in space and time, besides naturally indicating moods or feelings, besides conveying a conventional greeting, the action of my

acquaintance can reveal to an experienced observer all that goes to make up his 'personality'. This personality is conditioned by his being a man of the twentieth century, by his national, social and educational background, by the previous history of his life and by his present surroundings; but it is also distinguished by an individual manner of viewing things and reacting to the world which, if rationalized, would have to be called a philosophy. In the isolated action of a polite greeting all these factors do not manifest themselves comprehensively, but nevertheless symptomatically. We could not construct a mental portrait of the man on the basis of this single action, but only by coordinating a large number of similar observations and by interpreting them in connexion with our general information as to his period, nationality, class, intellectual traditions and so forth. Yet all the qualities which this mental portrait would show explicitly are implicitly inherent in every single action; so that, conversely, every single action can be interpreted in the light of those qualities.

The meaning thus discovered may be called the intrinsic meaning or content; it is essential where the two other kinds of meaning, the primary or natural and the secondary or conventional, are phenomenal. It may be defined as a unifying principle which underlies and explains both the visible event and its intelligible significance, and which determines even the form in which the visible event takes shape. This intrinsic meaning or content is, normally, as much above the sphere of conscious volition as the expressional meaning is beneath this sphere.

Transferring the results of this analysis from everyday life to a work of art, we can distinguish in its subject matter or meaning the same three strata;

1. *Primary or natural subject matter*, subdivided into *factual* and *expressional*. It is apprehended by identifying pure forms, that is: certain configurations of line and colour, or certain peculiarly shaped lumps of bronze or stone, as representations of natural objects such as human beings, animals,

plants, houses, tools and so forth; by identifying their mutual relations as events; and by perceiving such expressional qualities as the mournful character of a pose or gesture, or the homelike and peaceful atmosphere of an interior. The world of pure forms thus recognized as carriers of primary or natural meanings may be called the world of artistic motifs. An enumeration of these motifs would be a pre-iconographical description of the work of art.

2. *Secondary or conventional subject matter.* It is apprehended by realizing that a male figure with a knife represents St Bartholomew, that a female figure with a peach in her hand is a personification of veracity, that a group of figures seated at a dinner table in a certain arrangement and in certain poses represents the Last Supper, or that two figures fighting each other in a certain manner represent the Combat of Vice and Virtue. In doing this we connect artistic motifs and combinations of artistic motifs (compositions) with themes or concepts. Motifs thus recognized as carriers of a secondary or conventional meaning may be called images, and combinations of images are what the ancient theorists of art called *invenzioni*; we are wont to call them stories and allegories.[1] The identification of such images, stories and

1. Images conveying the idea, not of concrete and individual persons or objects (such as St Bartholomew, Venus, Mrs Jones, or Windsor Castle), but of abstract and general notions such as Faith, Luxury, Wisdom, etc., are called either personifications or symbols (not in the Cassirerian, but in the ordinary sense, e.g., the Cross, or the Tower of Chastity). Thus allegories, as opposed to stories, may be defined as combinations of personifications and/or symbols. There are, of course, many intermediary possibilities. A person A may be portrayed in the guise of the person B (Bronzino's Andrea Doria as Neptune: Dürer's Lucas Paumgärtner as St George), or in the customary array of a personification (Joshua Reynolds' Mrs Stanhope as 'Contemplation'); portrayals of concrete and individual persons, both human or mythological, may be combined with personifications, as is the case in countless representations of a eulogistic character. A story may convey, in addition, an allegorical idea, as is the case with the illustrations of the *Ovide Moralisé*, or may be conceived as the 'prefiguration' of another

allegories is the domain of what is normally referred to as 'iconography'. In fact, when we loosely speak of 'subject matter as opposed to form', we chiefly mean the sphere of secondary or conventional subject matter, viz., the world of specific themes or concepts manifested in images, stories and allegories, as opposed to the sphere of primary or natural subject matter manifested in artistic motifs. 'Formal analysis' in Wölfflin's sense is largely an analysis of motifs and combinations of motifs (compositions); for a formal analysis in the strict sense of the word would even have to avoid such expressions as 'man', 'horse', or 'column', let alone such evaluations as 'the ugly triangle between the legs of Michelangelo's David' or 'the admirable clarification of the joints in a human body'. It is obvious that a correct iconographical analysis presupposes a correct identification of the motifs. If the knife that enables us to identify a St Bartholomew is not a knife but a corkscrew, the figure is not a St Bartholomew. Furthermore, it is important to note that the statement 'this figure is an image of St Bartholomew' implies the conscious intention of the artist to represent St Bartholomew, while the expressional qualities of the figure may well be unintentional.

3. *Intrinsic meaning or content*. It is apprehended by ascertaining those underlying principles which reveal the basic attitude of a nation, a period, a class, a religious or philosophical persuasion – qualified by one personality and condensed into one work. Needless to say, these principles are manifested by, and therefore throw light on, both 'compositional methods' and 'iconographical significance'. In the

story, as in the *Biblia Pauperum* or in the *Speculum Humanae Salvationis*. Such superimposed meanings either do not enter into the content of the work at all, as is the case with the *Ovide Moralisé* illustrations, which are visually indistinguishable from non-allegorical miniatures illustrating the same Ovidian subjects; or they cause an ambiguity of content, which can, however, be overcome or even turned into an added value if the conflicting ingredients are molten in the heat of a fervent artistic temperament as in Rubens' 'Galerie de Médicis'.

fourteenth and fifteenth centuries, for instance (the earliest examples can be dated around 1300), the traditional type of the Nativity with the Virgin Mary reclining in bed or on a couch was frequently replaced by a new one which shows the Virgin kneeling before the Child in adoration. From a compositional point of view this change means, roughly speaking, the substitution of a triangular scheme for a rectangular one; from an iconographical point of view, it means the introduction of a new theme to be formulated in writing by such authors as Pseudo-Bonaventure and St Bridget. But at the same time it reveals a new emotional attitude peculiar to the later phases of the Middle Ages. A really exhaustive interpretation of the intrinsic meaning or content might even show that the technical procedures characteristic of a certain country, period, or artist, for instance Michelangelo's preference for sculpture in stone instead of in bronze, or the peculiar use of hatchings in his drawings, are symptomatic of the same basic attitude that is discernible in all the other specific qualities of his style. In thus conceiving of pure forms, motifs, images, stories and allegories as manifestations of underlying principles, we interpret all these elements as what Ernst Cassirer has called 'symbolical' values. As long as we limit ourselves to stating that Leonardo da Vinci's famous fresco shows a group of thirteen men around a dinner table, and that this group of men represents the Last Supper, we deal with the work of art as such, and we interpret its compositional and iconographical features as its own properties or qualifications. But when we try to understand it as a document of Leonardo's personality, or of the civilization of the Italian High Renaissance, or of a peculiar religious attitude, we deal with the work of art as a symptom of something else which expresses itself in a countless variety of other symptoms, and we interpret its compositional and iconographical features as more particularized evidence of this 'something else'. The discovery and interpretation of these 'symbolical' values (which are often unknown to the artist himself and may even emphatically differ from what he

consciously intended to express) is the object of what we may call 'iconology' as opposed to 'iconography'.

[The suffix 'graphy' derives from the Greek verb *graphein*, 'to write'; it implies a purely descriptive, often even statistical, method of procedure. Iconography is, therefore, a description and classification of images much as ethnography is a description and classification of human races: it is a limited and, as it were, ancillary study which informs us as to when and where specific themes were visualized by which specific motifs. It tells us when and where the crucified Christ was draped with a loincloth or clad in a long garment; when and where He was fastened to the Cross with four nails or with three; how the Virtues and Vices were represented in different centuries and environments. In doing all this, iconography is an invaluable help for the establishment of dates, provenance and, occasionally, authenticity; and it furnishes the necessary basis for all further interpretation. It does not, however, attempt to work out this interpretation for itself. It collects and classifies the evidence but does not consider itself obliged or entitled to investigate the genesis and significance of this evidence: the interplay between the various 'types'; the influence of theological, philosophical or political ideas; the purposes and inclinations of individual artists and patrons; the correlation between intelligible concepts and the visible form which they assume in each specific case. In short, iconography considers only a part of all those elements which enter into the intrinsic content of a work of art and must be made explicit if the perception of this content is to become articulate and communicable.

It is because of these severe restrictions which common usage, especially in this country, places upon the term 'iconography' that I propose to revive the good old word 'iconology' wherever iconography is taken out of its isolation and integrated with whichever other method, historical, psychological or critical, we may attempt to use in solving the riddle of the sphinx. For as the suffix 'graphy' denotes something descriptive, so does the suffix 'logy' – derived

from *logos*, which means 'thought' or 'reason' – denote something interpretative. 'Ethnology', for instance, is defined as a '*science* of human races' by the same *Oxford Dictionary* that defines 'ethnography' as a '*description* of human races', and Webster explicitly warns against a confusion of the two terms inasmuch as 'ethnography is properly restricted to the purely descriptive treatment of peoples and races while ethnology denotes their comparative study.' So I conceive of iconology as an iconography turned interpretative and thus becoming an integral part of the study of art instead of being confined to the role of a preliminary statistical survey. There is, however, admittedly some danger that iconology will behave, not like ethnology as opposed to ethnography, but like astrology as opposed to astrography.]

Iconology, then, is a method of interpretation which arises from synthesis rather than analysis. And as the correct identification of motifs is the prerequisite of their correct iconographical analysis, so is the correct analysis of images, stories and allegories the prerequisite of their correct iconological interpretation – unless we deal with works of art in which the whole sphere of secondary or conventional subject matter is eliminated and a direct transition from motifs to content is effected, as is the case with European landscape painting, still life and genre, not to mention 'non-objective' art.

Now, how do we achieve 'correctness' in operating on these three levels, pre-iconographical description, iconographical analysis, and iconological interpretation?

In the case of a pre-iconographical description, which keeps within the limits of the world of motifs, the matter seems simple enough. The objects and events whose representation by lines, colours and volumes constitutes the world of motifs can be identified, as we have seen, on the basis of our practical experience. Everybody can recognize the shape and behaviour of human beings, animals and plants, and everybody can tell an angry face from a jovial one. It is, of course, possible that in a given case the range of our personal

experience is not wide enough, for instance when we find ourselves confronted with the representation of an obsolete or unfamiliar tool, or with the representation of a plant or animal unknown to us. In such cases we have to widen the range of our practical experience by consulting a book or an expert; but we do not leave the sphere of practical experience as such, which informs us, needless to say, as to what kind of expert to consult.

Yet even in this sphere we encounter a peculiar problem. Setting aside the fact that the objects, events and expressions depicted in a work of art may be unrecognizable owing to the incompetence or malice aforethought of the artist, it is, on principle, impossible to arrive at a correct pre-iconographical description, or identification of primary subject matter, by indiscriminately applying our practical experience to the work of art. Our practical experience is indispensable, as well as sufficient, as material for a pre-iconographical description, but it does not guarantee its correctness.

A pre-iconographical description of Roger van der Weyden's *Three Magi* in the Kaiser Friedrich Museum at Berlin (Plate 1) would, of course, have to avoid such terms as 'Magi', 'Infant Jesus', etc. But it would have to mention that the apparition of a small child is seen in the sky. How do we know that this child is meant to be an apparition? That it is surrounded with a halo of golden rays would not be sufficient proof of this assumption, for similar halos can often be observed in representations of the Nativity where the Infant Jesus is real. That the child in Roger's picture is meant to be an apparition can only be deduced from the additional fact that he hovers in mid-air. But how do we know that he hovers in mid-air? His pose would be no different were he seated on a pillow on the ground; in fact, it is highly probable that Roger used for his painting a drawing from life of a child seated on a pillow. The only valid reason for our assumption that the child in the Berlin picture is meant to be an apparition is the fact that he is depicted in space with no visible means of support.

But we can adduce hundreds of representations in which human beings, animals and inanimate objects seem to hang loose in space in violation of the law of gravity, without thereby pretending to be apparitions. For instance, in a miniature in the *Gospels of Otto III* in the Staatsbibliothek of Munich, a whole city is represented in the centre of an empty space while the figures taking part in the action stand on solid ground (Plate 2).[2] An inexperienced observer may well assume that the town is meant to be suspended in mid-air by some sort of magic. Yet in this case the lack of support does not imply a miraculous invalidation of the laws of nature. The city is the real city of Nain where the resurrection of the youth took place. In a miniature of around 1000 'empty space' does not count as a real three-dimensional medium, as it does in a more realistic period, but serves as an abstract, unreal background. The curious semicircular shape of what should be the base line of the towers bears witness to the fact that, in the more realistic prototype of our miniature, the town had been situated on a hilly terrain, but was taken over into a representation in which space had ceased to be thought of in terms of perspective realism. Thus, while the unsupported figure in the van der Weyden picture counts as an apparition, the floating city in the Ottonian miniature has no miraculous connotation. These contrasting interpretations are suggested to us by the 'realistic' qualities of the painting and the 'unrealistic' qualities of the miniature. But that we grasp these qualities in the fraction of a second and almost automatically must not induce us to believe that we could ever give a correct pre-iconographical description of a work of art without having divined, as it were, its historical 'locus'. While we believe that we are identifying the motifs on the basis of our practical experience pure and simple, we really are reading 'what we see' according to the manner in which objects and events are expressed by forms under varying historical

2. G. Leidinger, *Das sogenannte Evangeliar Ottos III*, Munich, 1912, Pl. 36.

conditions. In doing this, we subject our practical experience to a corrective principle which may be called the history of style.[3]

Iconographical analysis, dealing with images, stories and allegories instead of with motifs, presupposes, of course, much more than that familiarity with objects and events which we acquire by practical experience. It presupposes a familiarity with specific themes or concepts as transmitted through literary sources, whether acquired by purposeful reading or by oral tradition. Our Australian bushman would be unable to recognize the subject of a Last Supper; to him, it would only convey the idea of an excited dinner party. To understand the iconographical meaning of the picture he would have to familiarize himself with the content of the Gospels. When it comes to representations of themes other than Biblical stories or scenes from history and mythology which happen to be known to the average 'educated person', all of us are Australian bushmen. In such cases we, too, must try to familiarize ourselves with what the authors of those

3. To correct the interpretation of an individual work of art by a 'history of style', which in turn can only be built up by interpreting individual works, may look like a vicious circle. It is, indeed, a circle, though not a vicious, but a methodical one (cf. E. Wind, *Das Experiment und die Metaphysik*, cited above, Note 5, p. 28; idem, 'Some Points of Contact between History and Science', cited *ibid.*). Whether we deal with historical or natural phenomena, the individual observation assumes the character of a 'fact' only when it can be related to other, analogous observations in such a way that the whole series 'makes sense'. This 'sense' is, therefore, fully capable of being applied, as a control, to the interpretation of a new individual observation within the same range of phenomena. If, however, this new individual observation definitely refuses to be interpreted according to the 'sense' of the series, and if an error proves to be impossible, the 'sense' of the series will have to be reformulated to include the new individual observation. This *circulus methodicus* applies, of course, not only to the relationship between the interpretation of motifs and the history of style, but also to the relationship between the interpretation of images, stories and allegories and the history of types, and to the relationship between the interpretation of intrinsic meanings and the history of cultural symptoms in general.

representations had read or otherwise knew. But again, while an acquaintance with specific themes and concepts transmitted through literary sources is indispensable and sufficient material for an iconographical analysis, it does not guarantee its correctness. It is just as impossible for us to give a correct iconographical analysis by indiscriminately applying our literary knowledge to the motifs, as it is for us to give a correct pre-iconographical description by indiscriminately applying our practical experience to the forms,

A picture by the Venetian seventeenth-century painter Francesco Maffei, representing a handsome young woman with a sword in her left hand, and in her right a charger on which rests the head of a beheaded man (Plate 3), has been published as a portrayal of Salome with the head of John the Baptist.[4] In fact the Bible states that the head of St John the Baptist was brought to Salome on a charger. But what about the sword? Salome did not decapitate St John the Baptist with her own hands. Now the Bible tells us about another handsome woman in connexion with the decapitation of a man, namely Judith. In this case the situation is exactly reversed. The sword in Maffei's picture would be correct because Judith beheaded Holofernes with her own hand, but the charger would not agree with the Judith theme because the text explicitly states that the head of Holofernes was put into a sack. Thus we have two literary sources applicable to our picture with equal right and equal inconsistency. If we should interpret it as a portrayal of Salome the text would account for the charger, but not for the sword; if we should interpret it as a portrayal of Judith the text would account for the sword, but not for the charger. We should be entirely at a loss were we to depend on the literary sources alone. Fortunately we do not. As we could supplement and correct our practical experience by inquiring into the manner in which, under varying historical conditions, objects and events were expressed by forms, viz., into the history of

4. G. Fiocco, *Venetian Painting of the Seicento and the Settecento*, Florence and New York, 1929, Pl. 29.

style, just so can we supplement and correct our knowledge of literary sources by inquiring into the manner in which, under varying historical conditions, specific themes or concepts were expressed by objects and events, viz., into the history of types.

In the case at hand we shall have to ask whether there were, before Francesco Maffei painted his picture, any unquestionable portrayals of Judith (unquestionable because they would include, for instance, Judith's maid) with unjustified chargers; or any unquestionable portrayals of Salome (unquestionable because they would include, for instance, Salome's parents) with unjustified swords. And lo! while we cannot adduce a single Salome with a sword, we encounter, in Germany and North Italy, several sixteenth-century paintings depicting Judith with a charger;[5] there was a 'type' of 'Judith with a Charger', but there was no 'type' of 'Salome with a Sword'. From this we can safely conclude that Maffei's picture, too, represents Judith, and not, as had been assumed, Salome.

We may further ask why artists felt entitled to transfer the motif of the charger from Salome to Judith, but not the motif of the sword from Judith to Salome. This question can be answered, again by inquiring into the history of types, with two reasons. One reason is that the sword was an established and honorific attribute of Judith, of many martyrs, and of such virtues as Justice, Fortitude, etc.; thus it could

5. One of the North Italian pictures is ascribed to Romanino and is preserved in the Berlin Museum, where it was formerly listed as '*Salome*' in spite of the maid, a sleeping soldier, and the city of Jerusalem in the background (No. 155); another is ascribed to Romanino's pupil Francesco Prato da Caravaggio (listed in the Berlin Catalogue), and a third is by Bernardo Strozzi, who was a native of Genoa but active at Venice about the same time as Francesco Maffei. It is very possible that the type of 'Judith with a Charger' originated in Germany. One of the earliest known instances (by an anonymous master of around 1530 related to Hans Baldung Grien) has been published by G. Poensgen, 'Beiträge zu Baldung und seinem Kreis', *Zeitschrift für Kunstgeschichte*, VI, 1937, p. 36 ff.

not be transferred with propriety to a lascivious girl. The other reason is that during the fourteenth and fifteenth centuries the charger with the head of St John the Baptist had become an isolated devotional image (*Andachtsbild*) especially popular in the northern countries and in North Italy (Plate 4); it had been singled out from a representation of the Salome story in much the same way as the group of St John the Evangelist resting on the bosom of the Lord had come to be singled out from the Last Supper, or the Virgin in child-bed from the Nativity. The existence of this devotional image established a fixed association of ideas between the head of a beheaded man and a charger, and thus the motif of a charger could more easily be substituted for the motif of a sack in an image of Judith, than the motif of a sword could have penetrated into an image of Salome.

Iconological interpretation, finally, requires something more than a familiarity with specific themes or concepts as transmitted through literary sources. When we wish to get hold of those basic principles which underlie the choice and presentation of motifs, as well as the production and inter-pretation of images, stories and allegories, and which give meaning even to the formal arrangements and technical pro-cedures employed, we cannot hope to find an individual text which would fit those basic principles as John 13:21 ff. fits the iconography of the Last Supper. To grasp these princi-ples we need a mental faculty comparable to that of a diag-nostician – a faculty which I cannot describe better than by the rather discredited term 'synthetic intuition', and which may be better developed in a talented layman than in an erudite scholar.

However, the more subjective and irrational this source of interpretation (for every intuitive approach will be condi-tioned by the interpreter's psychology and '*Weltanschauung*'), the more necessary the application of those correctives and controls which proved indispensable where only icono-graphical analysis and pre-iconographical description were concerned. When even our practical experience and our

knowledge of literary sources may mislead us if indiscriminately applied to works of art, how much more dangerous would it be to trust our intuition pure and simple! Thus, as our practical experience had to be corrected by an insight into the manner in which, under varying historical conditions, objects and events were expressed by forms (history of style); and as our knowledge of literary sources had to be corrected by an insight into the manner in which, under varying historical conditions, specific themes and concepts were expressed by objects and events (history of types); just so, or even more so, must our synthetic intuition be corrected by an insight into the manner in which, under varying historical conditions, the general and essential tendencies of the human mind were expressed by specific themes and concepts. This means what may be called a history of cultural symptoms – or 'symbols' in Ernst Cassirer's sense – in general. The art historian will have to check what he thinks is the intrinsic meaning of the work, or group of works, to which he devotes his attention, against what he thinks is the intrinsic meaning of as many other documents of civilization historically related to that work or group of works, as he can master: of documents bearing witness to the political, poetical, religious, philosophical, and social tendencies of the personality, period or country under investigation. Needless to say that, conversely, the historian of political life, poetry, religion, philosophy, and social situations should make analogous use of works of art. It is in the search for intrinsic meanings or content that the various humanistic disciplines meet on a common plane instead of serving as handmaidens to each other.

In conclusion: when we wish to express ourselves very strictly (which is of course not always necessary in our normal talk or writing, where the general context throws light on the meaning of our words), we have to distinguish between three strata of subject matter or meaning, the lowest of which is commonly confused with form, and the second of which is the special province of iconography as opposed

OBJECT OF INTERPRETATION	ACT OF INTERPRETATION	EQUIPMENT FOR INTERPRETATION	CORRECTIVE PRINCIPLE OF INTERPRETATION (*History of Tradition*)
I *Primary* or *natural* subject matter – (A) factual, (B) expressional – constituting the world of artistic motifs.	*Pre-iconographical description* (and pseudo-formal analysis).	*Practical experience* (familiarity with *objects* and *events*).	History of *style* (insight into the manner in which, under varying historical conditions, *objects* and *events* were expressed by *forms*).
II *Secondary* or *conventional* subject matter, constituting the world of *images, stories* and *allegories*.	*Iconographical analysis*.	*Knowledge of literary sources* (familiarity with specific *themes* and *concepts*).	History of *types* (insight into the manner in which, under varying historical conditions, specific *themes* or *concepts* were expressed by *objects* and *events*).
III *Intrinsic meaning* or *content*, constituting the world of '*symbolical*' *values*.	*Iconological interpretation*.	*Synthetic intuition* (familiarity with the essential tendencies of the *human mind*), conditioned by personal psychology and '*Weltanschauung*'.	History of *cultural symptoms* or '*symbols*' in general (insight into the manner in which, under varying historical conditions, *essential tendencies of the human mind* were expressed by specific *themes* and *concepts*).

to iconology. In whichever stratum we move, our identifications and interpretations will depend on our subjective equipment, and for this very reason will have to be supplemented and corrected by an insight into historical processes the sum total of which may be called tradition.

I have summarized in a synoptical table what I have tried to make clear thus far. But we must bear in mind that the neatly differentiated categories, which in this synoptical table seem to indicate three independent spheres of meaning, refer in reality to aspects of one phenomenon, namely, the work of art as a whole. So that, in actual work, the methods of approach which here appear as three unrelated operations of research merge with each other into one organic and indivisible process.

II

Turning now from the problems of iconography and iconology in general to the problems of Renaissance iconography and iconology in particular, we shall naturally be most interested in that phenomenon from which the very name of the Renaissance is derived: the rebirth of classical antiquity.

The earlier Italian writers about the history of art, such as Lorenzo Ghiberti, Leone Battista Alberti, and especially Giorgio Vasari, thought that classical art was overthrown at the beginning of the Christian era, and that it did not revive until it served as the foundation of the Renaissance style. The reasons for this overthrow, as those writers saw it, were the invasions of barbarous races and the hostility of early Christian priests and scholars.

In thinking as they did the early writers were both right and wrong. They were wrong in so far as there had not been a complete break of tradition during the Middle Ages. Classical conceptions, literary, philosophical, scientific and artistic, had survived throughout the centuries, particularly after they had been deliberately revived under Charlemagne and his followers. The early writers were, however, right in

so far as the general attitude towards antiquity was fundamentally changed when the Renaissance movement set in.

The Middle Ages were by no means blind to the visual values of classical art, and they were deeply interested in the intellectual and poetic values of classical literature. But it is significant that, just at the height of the medieval period (thirteenth and fourteenth centuries), classical motifs were not used for the representation of classical themes while, conversely, classical themes were not expressed by classical motifs.

For instance, on the façade of St Mark's in Venice can be seen two large reliefs of equal size, one a Roman work of the third century A.D., the other executed in Venice almost exactly one thousand years later (Plates 5, 6).[6] The motifs are so similar that we are forced to suppose that the medieval stone carver deliberately copied the classical work in order to produce a counterpart of it. But while the Roman relief represents Hercules carrying the Erymanthean boar to King Euristheus, the medieval master, by substituting billowy drapery for the lion's skin, a dragon for the frightened king, and a stag for the boar, transformed the mythological story into an allegory of salvation. In Italian and French art of the twelfth and thirteenth centuries we find a great number of similar cases; viz., direct and deliberate borrowings of classical motifs while the pagan themes were changed into Christian ones. Suffice it to mention the most famous specimens of this so-called proto-Renaissance movement: the sculptures of St Giles and Arles; the celebrated *Visitation* at Rheims Cathedral, which for a long time was held to be a sixteenth-century work; or Nicolo Pisano's *Adoration of the Magi*, in which the group of the Virgin Mary and the Infant Jesus shows the influence of a Phaedra Sarcophagus still preserved in the Camposanto at Pisa. Even more frequent, however, than such direct copies are instances of a continuous and traditional survival of classical motifs, some of which were used in succession for quite a variety of Christian images.

6. Illustrated in E. Panofsky and F. Saxl, 'Classical Mythology in Mediaeval Art', *Metropolitan Museum Studies*, IV, 2, 1933, p. 228 ff., p. 231.

As a rule such reinterpretations were facilitated or even suggested by a certain iconographical affinity, for instance when the figure of Orpheus was employed for the representation of David, or when the type of Hercules dragging Cerberus out of Hades was used to depict Christ pulling Adam out of Limbo.[7] But there are cases in which the relationship between the classical prototype and its Christian adaptation is a purely compositional one.

On the other hand, when a Gothic illuminator had to illustrate the story of Laocoön, Laocoön becomes a wild and bald old man in contemporary costume who attacks the sacrificial bull with what should be an axe, while the two little boys float around at the bottom of the picture, and the sea snakes briskly emerge from a pool of water.[8] Aeneas and Dido are shown as a fashionable medieval couple playing chess, or may appear as a group resembling the Prophet Nathan before David, rather than as a classical hero before his paramour (Plate 7). And Thisbe awaits Pyramus on a Gothic tombstone which bears the inscription '*Hic situs est Ninus rex*', preceded by the usual cross (Plate 8).[9]

When we ask the reason for this curious separation between classical motifs invested with a non-classical meaning, and classical themes expressed by non-classical figures in a non-classical setting, the obvious answer seems to lie in the difference between representational and textual tradition. The artists who used the motif of a Hercules for an image of Christ, or the motif of an Atlas for the images of the Evangelists (Plates 9, 10),[10] acted under the impression of visual

7. See K. Weitzmann, 'Das Evangelion im Skevophylakion zu Lawra', *Seminarium Kondakovianum*, VII, 1936, p. 83 ff.

8. Cod. Vat. lat. 2761, illustrated in Panofsky and Saxl, op. cit., p. 259.

9. Paris, Bibliothèque Nationale, MS. lat. 15158, dated 1289, illustrated in Panofsky and Saxl, op. cit., p. 272.

10. C. Tolnay, 'The Visionary Evangelists of the Reichenau School', *Burlington Magazine*, LXIX, 1936, p. 257 ff., has made the important discovery that the impressive images of the Evangelists seated on a globe and supporting a heavenly glory (occurring for the first time in Cod. Vat. Barb. lat. 711; our Plate 9), combine the features of Christ in

models which they had before their eyes, whether they directly copied a classical monument or imitated a more recent work derived from a classical prototype through a series of intermediary transformations. The artists who represented Medea as a medieval princess, or Jupiter as a medieval judge, translated into images a mere description found in literary sources.

Majesty with those of a Graeco-Roman celestial divinity. However, as Tolnay himself points out, the Evangelists in Cod. Barb. 711 'support with obvious effort a mass of clouds which does not in the least look like a spiritual aura but like a material weight consisting of several segments of circles, alternately blue and green, the outline of the whole forming a circle. . . . It is a misunderstood representation of *heaven in the form of spheres*' (italics mine). From this we can infer that the classical prototype of these images was not Coelus who holds without effort a billowing drapery (the *Weltenmantel*) but Atlas who labours under the weight of the heavens (cf. G. Thiele, *Antike Himmelsbilder*, Berlin, 1898, p. 19 ff.). The St Matthew in Cod. Barb. 711 (Tolnay, Pl. I, *a*), with his head bowed down under the weight of the sphere and his left hand still placed near his left hip, is particularly reminiscent of the classical type of Atlas, and another striking example of the characteristic Atlas pose applied to an Evangelist is found in Clm. 4454, fol. 86, v. (illustrated in A. Goldschmidt, *German Illumination*, Florence and New York, 1928, Vol. II, Pl. 40). Tolnay (Notes 13 and 14) has not failed to notice this similarity and cites the representations of Atlas and Nimrod in Cod. Vat. Pal. lat. 1417, fol. 1 (illustrated in F. Saxl, *Verzeichnis astrologischer und mythologischer Handschriften des lateinischen Mittelalters in römischen Bibliotheken* [*Sitzungsberichte der Heidelberger Akademie der Wissenschaften*, phil.-hist. Klasse, VI, 1915, Pl. XX, Fig. 42]; our Plate 10); but he seems to consider the Atlas type as a mere derivative of the Coelus type. Yet even in ancient art the representations of Coelus seem to have developed from those of Atlas, and in Carolingian, Ottonian and Byzantine art (particularly in the Reichenau school) the figure of Atlas, in its genuine classical form, is infinitely more frequent than that of Coelus, both as a personification of cosmological character and as a kind of caryatid. From an iconographical point of view, too, the Evangelists are comparable to Atlas, rather than to Coelus. Coelus was believed to rule the heavens. Atlas was believed to support them and, in an allegorical sense, to 'know' them; he was held to have been a great astronomer who transmitted the *scientia coeli* to Hercules (Servius, *Comm. in Aen.*, VI, 395; later on, e.g., Isidorus, *Etymologiae*, III, 24, 1; Mythographus III, 13, 4, in G. H.

This is very true, and the textual tradition through which the knowledge of classical themes, particularly of classical mythology, was transmitted to and persisted during the Middle Ages is of the utmost importance, not only for the medievalist but also for the student of Renaissance iconography. For even in the Italian Quattrocento, it was from this complex and often very corrupt tradition, rather than from genuine classical sources, that many people drew their notions of classical mythology and related subjects.

Limiting ourselves to classical mythology, the paths of this tradition can be outlined as follows. The later Greek philosophers had already begun to interpret the pagan gods and demigods as mere personifications either of natural forces or moral qualities, and some of them had gone so far as to explain them as ordinary human beings subsequently deified. In the last century of the Roman Empire these tendencies greatly increased. While the Christian Fathers endeavoured to prove that the pagan gods were either illusions or malignant demons (thereby transmitting much valuable information about them), the pagan world itself had become so estranged from its divinities that the educated public had to read up on them in encyclopedias, in didactic poems or novels, in special treatises on mythology, and in commentaries on the classic poets. Important among these late-antique writings in which the mythological characters were interpreted in an allegorical way, or 'moralized', to use the medieval expression, were Martianus Capella's *Nuptiae Mercurii et Philologiae*, Fulgentius' *Mitologiae*, and, above all, Servius' admirable Commentary on Virgil which is three or four

Bode, *Scriptorum rerum mythicarum tres Romae nuper reperti*, Celle, 1834, p. 248). It was therefore consistent to use the type of Coelus for the representation of God (see Tolnay, Pl. I, *c*), and it was equally consistent to use the type of Atlas for the Evangelists who, like him, 'knew' the heavens but did not rule them. While Hibernus Exul says of Atlas *Sidera quem coeli cuncta notasse volunt* (*Monumenta Germaniae, Poetarum latinorum medii aevi*, Berlin, 1881–1923, Vol. I, p. 410), Alcuin thus apostrophizes St John the Evangelist: *Scribendo penetras caelum tu, mente, Johannes* (ibid., p. 293).

times as long as the text and was perhaps more widely read.

During the Middle Ages these writings and others of their kind were thoroughly exploited and further developed. The mythographical information thus survived, and became accessible to medieval poets and artists. First, in the encyclopedias, the development of which began with such early writers as Bede and Isidorus of Seville, was continued by Hrabanus Maurus (ninth century), and reached a climax in the enormous high-medieval works by Vincentius of Beauvais, Brunetto Latini, Bartholomaeus Anglicus, and so forth. Second, in the medieval commentaries on classical and late-antique texts, especially on Martianus Capella's *Nuptiae*, which was annotated by Irish scholars such as Johannes Scotus Erigena and was authoritatively commented upon by Remigius of Auxerre (ninth century).[11] Third, in special treatises on mythology such as the so-called *Mythographi I* and *II*, which are still rather early in date and are mainly based on Fulgentius and Servius.[12] The most important work of this kind, the so-called *Mythographus III*, has been tentatively identified with an Englishman, the great scholastic Alexander Neckham (died 1217);[13] his treatise, an impressive survey of whatever information was available around 1200, deserves to be called the conclusive compendium of high-medieval mythography, and was even used by Petrarch when he described the images of pagan gods in his poem *Africa*.

Between the times of the *Mythographus III* and Petrarch a further step in the moralization of classical divinities had been taken. The figures of ancient mythology were not only interpreted in a general moralistic way but were quite definitely related to the Christian faith, so that, for instance, Pyramus was interpreted as Christ, Thisbe as the human soul,

11. See H. Liebeschütz, *Fulgentius Metaforalis* ... (Studien der Bibliothek Warburg, IV), Leipzig, 1926, p. 15 and p. 44 ff.; cf. also Panofsky and Saxl, op. cit., especially p. 253 ff.

12. Bode, op. cit., p. 1 ff.

13. Bode, ibid., p. 152 ff. As to the question of authorship, see H. Liebeschütz, op. cit., p. 16 ff. and *passim*.

and the lion as Evil defiling its garments; while Saturn served as an example, both in a good and in a bad sense, for the behaviour of clergymen. Instances of this type of writings are the French *Ovide Moralisé*,[14] John Ridewall's *Fulgentius Metaforalis*,[15] Robert Holcott's *Moralitates*, the *Gesta Romanorum* and, above all, the *Moralized Ovid* in Latin, written around 1340 by a French theologian called Petrus Berchorius or Pierre Bersuire, who was personally acquainted with Petrarch.[16] His work is preceded by a special chapter on the pagan gods, mainly based on the *Mythographus III*, but enriched by specifically Christian moralizations, and this introduction, with the moralizations cut out for brevity's sake, attained great popularity under the name of *Albricus, Libellus de Imaginibus Deorum*.[17]

A fresh and highly important start was made by Boccaccio. In his *Genealogia Deorum*[18] he not only gave a new survey of the material, greatly enlarged since about 1200, but also tried consciously to revert to the genuine Antique sources and carefully collate them with one another. His treatise marks the beginning of a critical or scientific attitude towards classical antiquity, and may be called a forerunner of such truly scholarly Renaissance treatises as the *De diis gentium ... Syntagmata* by L. G. Gyraldus, who, from his point of view, was fully entitled to look down upon his most popular medieval predecessor as a 'proletarian and unreliable writer'.[19]

It will be noticed that up to Boccaccio's *Genealogia Deorum* the focal point of medieval mythography was a

14. Ed. by C. de Boer, 'Ovide Moralisé', *Verhandelingen der kon. Akademie van Wetenschapen, Afd. Letterkunde*, new ser., XV, 1915; XXI, 1920; XXX, 1931–2.

15. Ed. H. Leibeschütz, op. cit.

16. 'Thomas Walleys' (or Valeys), *Metamorphosis Ovidiana moraliter explanata*, here used in the Paris edition of 1515.

17. Cod. Vat. Reg. 1290, ed. H. Liebeschütz, op. cit., p. 117 ff., with the complete set of illustrations.

18. Here used in the Venice edition of 1511.

19. L. G. Gyraldus, *Opera Omnia*, Leyden, 1696, Vol. I, col. 153: '*Ut scribit Albricus, qui auctor mihi proletarius est, nec fidus satis.*'

region widely remote from direct Mediterranean tradition: Ireland, Northern France and England. This is also true of the Trojan Cycle, the most important epic theme transmitted by classical antiquity to posterity; its first authoritative medieval redaction, the *Roman de Troie*, which was frequently abridged, summarized and translated into the other vernacular languages, is due to Benoît de Ste More, a native of Brittany. We are in fact entitled to speak of a proto-humanistic movement, viz., an active interest in classical themes regardless of classical motifs, centred in the northern region of Europe, as opposed to the proto-Renaissance movement, viz., an active interest in classical motifs regardless of classical themes, centred in Provence and Italy. It is a memorable fact which we must bear in mind in order to understand the Renaissance movement proper, that Petrarch, when describing the gods of his Roman ancestors, had to consult a compendium written by an Englishman, and that the Italian illuminators who illustrated Virgil's *Aeneid* in the fifteenth century had to have recourse to the miniatures in manuscripts of the *Roman de Troie* and its derivatives. For these, being a favourite reading matter of noble laymen, had been amply illustrated long before the Virgil text proper, read by scholars and schoolboys, and had attracted the attention of professional illuminators.[20]

20. The same applies to Ovid: there are hardly any illustrated Latin Ovid manuscripts in the Middle Ages. As to Virgil's *Aeneid*, I know only two really 'illustrated' Latin manuscripts between the sixth-century codex in the Vatican Library and the fifteenth-century Riccardianus: Naples, Bibl. Nazionale, Cod. olim Vienna 58 (brought to my attention by Professor Kurt Weitzmann, to whom I am also indebted for permission to reproduce one miniature in Plate 7) of the tenth century; and Cod. Vat. lat. 2761 (cf. R. Förster, 'Laocoön im Mittelalter und in der Renaissance', *Jahrbuch der Königlich Preussischen Kunstsammlungen*, XXVII, 1906, p. 149 ff.) of the fourteenth. [Another fourteenth-century manuscript (Oxford, Bodleian Library, MS. Can. Class. lat. 52, described in F. Saxl and H. Meier, *Catalogue of Astrological and Mythological Manuscripts of the Latin Middle Ages, III, Manuscripts in English Libraries*, London, 1953, p. 320 ff.) has only some historiated initials.]

It is indeed easy to see that the artists who from the end of the eleventh century tried to translate into images those proto-humanistic texts could not but depict them in a manner utterly different from classical traditions. One of the earliest instances is among the most striking: a miniature of about 1100, probably executed in the school of Regensburg, depicting the classical divinities according to the descriptions in Remigius' *Commentary on Martianus Capella* (Plate 11).[21] Apollo is seen riding in a peasant's cart and holding in his hand a kind of nosegay with the busts of the Three Graces. Saturn looks like a Romanesque jamb-figure rather than like the father of the Olympian gods, and the raven of Jupiter is equipped with a tiny halo like the eagle of St John the Evangelist or the dove of St Gregory.

Nevertheless, the contrast between representational and textual tradition alone, important though it is, cannot account for the strange dichotomy of classical motifs and classical themes characteristic of high-medieval art. For even when there had been a representational tradition in certain fields of classical imagery, this representational tradition was deliberately relinquished in favour of representations of an entirely non-classical character as soon as the Middle Ages had achieved a style entirely their own.

Instances of this process are found, first, in classical images incidentally occurring in representations of Christian subjects, such as the personifications of natural forces in, for example, the Utrecht Psalter, or the sun and the moon in the Crucifixion. While Carolingian ivories still show the perfectly classical types of the *Quadriga Solis* and the *Biga Lunae*,[22] these classical types are replaced by non-classical ones in Romanesque and Gothic representations. The personifications of nature tended to disappear; only the pagan idols frequently found in scenes of martyrdom preserved their

21. Clm. 14271, illustrated in Panofsky and Saxl, op. cit., p. 260.
22. A. Goldschmidt, *Die Elfenbeinskulpturen aus der Zeit der karolingischen und sächsischen Kaiser*, Berlin, 1914–26, Vol. I, Pl. XX, No. 40, illustrated in Panofsky and Saxl, op. cit., p. 257.

classical appearance longer than other images because they were the symbols par excellence of paganism. Secondly, what is much more important, genuine classical images appear in the illustrations of such texts as had already been illustrated in late-antique times, so that visual models were available to the Carolingian artists: the Comedies of Terence, the texts incorporated into Hrabanus Maurus' *De Universo*, Prudentius' *Psychomachia*, and scientific writings, particularly treatises on astronomy, where mythological images appear both among the constellations (such as Andromeda, Perseus, Cassiopeia) and as planets (Saturn, Jupiter, Mars, Sol, Venus, Mercury, Luna).

In all these cases we can observe that the classical images were faithfully though often clumsily copied in Carolingian manuscripts and lingered on in their derivatives, but that they were abandoned and replaced by entirely different ones in the thirteenth and fourteenth centuries at the latest.

In the ninth-century illustrations of an astronomical text, such mythological figures as Boötes (Plate 15), Perseus, Hercules or Mercury are rendered in a perfectly classical fashion, and the same is true of the pagan divinities appearing in Hrabanus Maurus' Encyclopedia.[23] With all their clumsiness, which is chiefly due to the incompetence of the poor eleventh-century copyist of the lost Carolingian manuscript, the figures in the Hrabanus illustrations are evidently not concocted from mere textual descriptions but are connected with Antique prototypes by a representational tradition (Plates 12, 13).

However, some centuries later these genuine images had fallen into oblivion and were replaced by others – partly newly invented, partly derived from oriental sources – which no modern spectator would ever recognize as classical divinities. Venus is shown as a fashionable young lady playing the lute or smelling a rose, Jupiter as a judge with his

23. Cf. A. M. Amelli, *Miniature sacre e profane dell'anno 1023, illustranti l'enciclopedia medioevale di Rabano Mauro*, Montecassino, 1896.

gloves in his hand, and Mercury as an old scholar or even as a bishop (Plate 14).[24] It was not before the Renaissance proper that Jupiter reassumed the appearance of the classical Zeus, and that Mercury reacquired the youthful beauty of the classical Hermes.[25]

All this shows that the separation of classical themes from classical motifs took place, not only for want of a representational tradition, but even in spite of a representational tradition. Wherever a classical image, that is, a fusion of a classical theme with a classical motif, had been copied during the Carolingian period of feverish assimilation, this classical image was abandoned as soon as medieval civilization had reached its climax, and was not reinstated until the Italian Quattrocento. It was the privilege of the Renaissance proper to reintegrate classical themes with classical motifs after what might be called a zero hour.

For the medieval mind, classical antiquity was too far removed and at the same time too strongly present to be conceived as an historical phenomenon. On the one hand an unbroken continuity of tradition was felt in so far as, for example, the German emperor was considered the direct successor of Caesar and Augustus, while the linguists looked upon Cicero and Donatus as their forefathers, and the mathematicians traced their ancestry back to Euclid. On the other hand, it was felt that an insurmountable gap existed between a pagan civilization and a Christian one.[26] These two

24. Clm. 10268 (fourteenth century), illustrated in Panofsky and Saxl, op. cit., p. 251, and the whole group of other illustrations based on the text by Michael Scotus. For the oriental sources of these new types, see ibid., p. 239 ff., and F. Saxl, 'Beiträge zu einer Geschichte der Planetendarstellungen in Orient und Occident', *Der Islam*, III, 1912, p. 151 ff.

25. For an interesting prelude of this reinstatement (resumption of Carolingian and archaic Greek models), see Panofsky and Saxl, op. cit., pp. 247 and 258.

26. A similar dualism is characteristic of the medieval attitude towards the *aera sub lege*: on the one hand the Synagogue was represented as blind and associated with Night, Death, the devil and impure

tendencies could not as yet be balanced so as to permit a feeling of historical distance. In many minds the classical world assumed a distant, fairy-tale character like the contemporary pagan East, so that Villard de Honnecourt could call a Roman tomb '*la seouture d'un sarrazin*', while Alexander the Great and Virgil came to be thought of as oriental magicians. For others, the classical world was the ultimate source of highly appreciated knowledge and time-honoured institutions. But no medieval man could see the civilization of antiquity as a phenomenon complete in itself, yet belonging to the past and historically detached from the contemporary world – as a cultural cosmos to be investigated and, if possible, to be reintegrated, instead of being a world of living wonders or a mine of information. The scholastic philosophers could use the ideas of Aristotle and merge them with their own system, and the medieval poets could borrow freely from the classical authors, but no medieval mind could think of classical philology. The artists could employ, as we have seen, the motifs of classical reliefs and classical statues, but no medieval mind could think of classical archaeology. Just as it was impossible for the Middle Ages to elaborate the modern system of perspective, which is based on the realization of a fixed distance between the eye and the object and thus enables the artist to build up comprehensive and consistent images of visible things; so was it impossible for them to evolve the modern idea of history, based on the realization of an intellectual distance between the present and the past which enables the scholar to build up comprehensive and consistent concepts of bygone periods.

We can easily see that a period unable and unwilling to realize that classical motifs and classical themes structurally belonged together, actually avoided preserving the union of

animals; and on the other hand the Jewish prophets were considered as inspired by the Holy Ghost, and the personages of the Old Testament were venerated as the ancestors of Christ.

these two. Once the Middle Ages had established their own standards of civilization and found their own methods of artistic expression, it became impossible to enjoy or even to understand any phenomenon which had no common denominator with the phenomena of the contemporary world. The high-medieval beholder could appreciate a beautiful classical figure when presented to him as a Virgin Mary, and he could appreciate a Thisbe depicted as a girl of the thirteenth century sitting by a Gothic tombstone. But a Venus or Juno classical in form as well as significance would have been an execrable, pagan idol while a Thisbe attired in classical costume and sitting by a classical mausoleum would have been an archaeological reconstruction entirely beyond his possibilities of approach. In the thirteenth century even classical script was felt as something utterly 'foreign': the explanatory inscriptions in the Carolingian *Cod. Leydensis Voss. lat. 79*, written in a beautiful *Capitalis Rustica*, were copied, for the benefit of less erudite readers, in angular High Gothic script (Plate 15).

However, this failure to realize the intrinsic 'oneness' of classical themes and classical motifs can be explained, not only by a lack of historical feeling, but also by the emotional disparity between the Christian Middle Ages and pagan antiquity. Where Hellenic paganism – at least as reflected in classical art – considered man as an integral unity of body and soul, the Jewish-Christian conception of man was based on the idea of the 'clod of earth' forcibly, or even miraculously, united with an immortal soul. From this point of view, the admirable artistic formulae which in Greek and Roman art had expressed organic beauty and animal passions, seemed admissible only when invested with a more-than-organic and more-than-natural meaning; that is, when made subservient to Biblical or theological themes. In secular scenes, on the contrary, these formulae had to be replaced by others, conforming to the medieval atmosphere of courtly manners and conventionalized sentiments, so that heathen divinities and heroes mad with love or cruelty appeared as

fashionable princes and damsels whose looks and behaviour were in harmony with the canons of medieval social life.

In a miniature from a fourteenth-century *Ovide Moralisé*, the Rape of Europa is enacted by figures which certainly express little passionate agitation (Plate 16).[27] Europa, clad in late-medieval costume, sits on her inoffensive little bull like a young lady taking a morning ride, and her companions, similarly attired, form a quiet little group of spectators. Of course, they are meant to be anguished and to cry out, but they don't, or at least they don't convince us that they do, because the illuminator was neither able nor inclined to visualize animal passions.

A drawing by Dürer, copied from an Italian prototype probably during his first stay in Venice, emphasizes the emotional vitality which was absent in the medieval representation (Plate 65). The literary source of Dürer's Rape of Europa is no longer a prosy text where the bull was compared to Christ, and Europa to the human soul, but the pagan verses of Ovid himself as revived in two delightful stanzas by Angelo Poliziano:

You can admire Jupiter transformed into a beautiful bull by the power of love. He dashes away with his sweet, terrified load, and she turns back her face to the lost shore, her beautiful golden hair fluttering in the wind which blows back her gown. With one hand she grasps the horn of the bull, while the other clings to his back. She draws up her feet as if afraid that the sea might wet them, and thus crouching down with pain and fear, she cries for help in vain. For her sweet companions remain on the flowery shore, each of them crying 'Europa, come back.' The whole seashore resounds with 'Europa, come back', and the bull looks round [or 'swims on'] and kisses her feet.[28]

27. Lyon, Bibl. de la Ville, MS. 742, fol. 40; illustrated in Saxl and Panofsky, op. cit., p. 274.

28. L.456, also illustrated in Saxl and Panofsky, op. cit., p. 275. Angelo Poliziano's stanzas (*Giostra* I, 105, 106) read as follows:

> Nell'altra in un formoso e bianco tauro
> Si vede Giove per amor converso
> Portarne il dolce suo ricco tesauro,
> E lei volgere il viso al lito perso

Dürer's drawing actually gives life to this sensual description. The crouching position of Europa, her fluttering hair, her clothes blown back by the wind and thus revealing her graceful body, the gesture of her hands, the furtive movement of the bull's head, the seashore scattered with the lamenting companions: all this is faithfully and vividly depicted; and, even more, the beach itself rustles with the life of *aquatici monstriculi*, to speak in the terms of another Quattrocento writer,[29] while satyrs hail the abductor.

This comparison illustrates the fact that the reintegration of classical themes with classical motifs which seems to be characteristic of the Italian Renaissance as opposed to the numerous sporadic revivals of classical tendencies during the Middle Ages, is not only a humanistic but also a human occurrence. It is a most important element of what Burckhardt and Michelet called 'the discovery both of the world and of man'.

On the other hand, it is self-evident that this reintegration could not be a simple reversion to the classical past. The intervening period had changed the minds of men, so that they could not turn into pagans again; and it had changed their tastes and productive tendencies, so that their art could not simply renew the art of the Greeks and Romans. They had to strive for a new form of expression, stylistically and iconographically different from the classical, as well as from the medieval, yet related and indebted to both.

> *In atto paventoso: e i be' crin d'auro*
> *Scherzon nel petto per lo vento avverso:*
> *La veste ondeggia e in drieto fa ritorno:*
> *L'una man tien al dorso, e l'altra al corno.*
>
> *Le ignude piante a se ristrette accoglie*
> *Quasi temendo il mar che lei non bagne:*
> *Tale atteggiata di paura e doglie*
> *Par chiami in van le sue dolci compagne;*
> *Le qual rimase tra fioretti e foglie*
> *Dolenti ' Europa' ciascheduna piagne.*
> *' Europa,' sona il lito, ' Europa, riedi' –*
> *E'l tor nota, e talor gli bacia i piedi.*

29. See below, Note 22, p. 284.

2

The History of the Theory of
Human Proportions as a Reflection
of the History of Styles

Studies on the problem of proportions are generally received with scepticism or, at most, with little interest. Neither attitude is surprising. The mistrust is based upon the fact that the investigation of proportions all too frequently succumbs to the temptation of reading out of the objects just what it has put into them; the indifference is explained by the modern, subjective viewpoint that a work of art is something utterly irrational. A modern spectator, still under the influence of this Romantic interpretation of art, finds it uninteresting, if not distressing, when the historian tells him that a rational system of proportions, or even a definite geometrical scheme, underlies this or that representation.

Nevertheless, it is not unrewarding for the art historian (provided that he limit himself to positive data and be willing to work with meagre rather than dubious material) to examine the history of canons of proportions. Not only is it important to know whether particular artists or periods of art did or did not tend to adhere to a system of proportions, but the how of their mode of treatment is of real significance. For it would be a mistake to assume that theories of proportions *per se* are constantly one and the same. There is a fundamental difference between the method of the Egyptians and the method of Polyclitus, between the procedure of Leonardo and the procedure of the Middle Ages – a difference so great and, above all, of such a character, that it reflects the basic differences between the art of Egypt and that of classical antiquity, between the art of Leonardo and that

of the Middle Ages. If, in considering the various systems of proportions known to us, we try to understand their meaning rather than their appearance, if we concentrate not so much on the solution arrived at as on the formulation of the problem posed, they will reveal themselves as expressions of the same 'artistic intention' (*Kunstwollen*) that was realized in the buildings, sculptures and paintings of a given period or a given artist. The history of the theory of proportions is the reflection of the history of style; furthermore, since we may understand each other unequivocally when dealing with mathematical formulations, it may even be looked upon as a reflection which often surpasses its original in clarity. One might assert that the theory of proportions expresses the frequently perplexing concept of the *Kunstwollen* in clearer or, at least, more definable fashion than art itself.

I

By a theory of proportions, if we are to begin with a definition, we mean a system of establishing the mathematical relations between the various members of a living creature, in particular of human beings, in so far as these beings are thought of as subjects of an artistic representation. From this definition we can foresee on what varied paths the studies of proportions could travel. The mathematical relations could be expressed by the division of a whole as well as by the multiplication of a unit; the effort to determine them could be guided by a desire for beauty as well as by an interest in the 'norm', or, finally, by a need for establishing a convention; and, above all, the proportions could be investigated with reference to the object of the representation as well as with reference to the representation of the object. There is a great difference between the question: 'What is the normal relationship between the length of the upper arm and the length of the entire body in a person standing quietly before me?' and the question: 'How shall I scale the length of what corresponds to the upper arm, in relation to

the length of what corresponds to the entire body, on my canvas or block of marble?' The first is a question of 'objective' proportions – a question whose answer precedes the artistic activity. The second is a question of 'technical' proportions – a question whose answer lies in the artistic process itself; and it is a question that can be posed and re-solved only where the theory of proportions coincides with (or is even subservient to) a theory of construction.

There were, therefore, three fundamentally different possi-bilities of pursuing a 'theory of human measurements'. This theory could aim either at the establishment of the 'ob-jective' proportions, without troubling itself about their relation to the 'technical'; or at the establishment of the 'technical' proportions, without troubling itself about their relation to the 'objective'; or, finally, it could consider itself exempt from either choice, viz., where 'technical' and 'ob-jective' proportions coincide with each other.

This last-mentioned possibility was realized, in pure form, only once: in Egyptian art.[1]

There are three conditions which hinder the coincidence of 'technical' and 'objective' dimensions, and Egyptian art – so far as special circumstances did not create ephemeral exceptions – fundamentally nullified, or, better yet, com-pletely ignored, all three. First, the fact that within an organic body each movement changes the dimensions of the moving limb as well as those of the other parts; second, the fact that the artist, in accordance with normal conditions of vision, sees the subject in a certain foreshortening; third, the fact that a potential beholder likewise sees the finished work in a foreshortening which, if considerable (e.g., with sculp-tures placed above eye level), must be compensated for by a deliberate departure from the objectively correct propor-tions.

Not one of these conditions obtains in Egyptian art. The 'optical refinements' which correct the visual impression of

1. And, to a certain extent, in the stylistically analogous art of Asia and archaic Greece.

the beholder (the *temperaturae* upon which, according to Vitruvius, the 'eurhythmic' effect of the work depends) are rejected as a matter of principle. The movements of the figures are not organic but mechanical, i.e., they consist of purely local changes in the positions of specific members, changes affecting neither the form nor the dimensions of the rest of the body. And even foreshortening (as well as modelling, which accomplishes by light and shade what foreshortening achieves by design) was deliberately rejected at this phase. Both painting and relief – and for this reason neither is stylistically different from the other in Egyptian art – renounced that apparent extension of the plane into depth which is required by optical naturalism *(σκιαγραφια)*; and sculpture refrained from that apparent flattening of the three-dimensional volumes which is required by Hildebrand's principle of *Reliefhaftigkeit*. In sculpture, as in painting and relief, the subject is thus represented in an aspect which, strictly speaking, is no *aspectus* ('view') at all, but a geometrical plan. All the parts of the human figure are so arrayed that they present themselves either in a completely frontal projection or else in pure profile.[2] This applies to sculpture in the round as well as to the two-dimensional arts, with the one difference that sculpture in the round, operating

2. A notable exception can be observed, as far as painting and relief are concerned, only at the portion above the hip; but even here we are not faced with a genuine foreshortening, i.e., the naturalistic rendering of a portion of the body 'in movement'; rather we are confronted with a graphic transition between the frontal elevation of the chest and the profile elevation of the legs – a form that resulted almost automatically when these two elevations were joined by contours. It was left to Greek art to replace this graphic configuration by a form expressing actual torsion, that is to say, a 'change' effecting a fluid transition between two 'states': as Greek mythology cherished metamorphosis, so did Greek art stress those transitional – or, as Aristoxenus would say, 'critical' – movements which we are wont to designate as *contrapposto*. This is especially evident in reclining figures; compare, e.g., the Egyptian Earth-God Keb with such figures hurled to the ground as the Giants in the pediment of the 'Second Temple of Athena'.

with many-surfaced blocks, can convey to us all the projections in their entirety but separated from each other; whereas the two-dimensional arts convey them incompletely, but in one image: they portray head and limbs in pure profile while chest and arms are rendered in pure front view.

In completed sculptural works (where all the forms are rounded off) this geometrical quality, reminiscent of an architect's plan, is not so evident as in paintings and reliefs; but we can recognize from many unfinished pieces that even in sculpture the final form is always determined by an underlying geometrical plan originally sketched on the surfaces of the block. It is evident that the artist drew four separate designs on the vertical surfaces of the block (supplementing them on occasion by a fifth, viz., by the ground plan entered on the upper, horizontal surface);[3] that he then evolved the figure by working away the surplus mass of stone so that the form was bounded by a system of planes meeting at right angles and connected by slopes; and that, finally, he removed the sharply defined edges resulting from the process (Plate 17). In addition to such unfinished pieces, there is a sculptor's working drawing, a papyrus formerly in the Berlin Museum, that illustrates the mason-like method of these sculptors even more clearly: as if he were constructing a house, the sculptor drew up plans for his sphinx in frontal elevation, ground plan and profile elevation (only a minute portion of this last is preserved) so that even today the figure could be executed according to plan (Plate 18).[4]

Under these circumstances the Egyptian theory of proportions could, as a matter of course, dispense with the decision whether it aimed at establishing the 'objective' or the

3. The ground plan was necessary where the main dimensions of the figure were horizontal rather than vertical, as in representations of animals, sphinxes, or reclining humans, and in groups composed of several individual figures.

4. *Amtliche Berichte aus den königlichen Kunstsammlungen*, XXXIX, 1917, col. 105 ff. (Borchardt).

'technical' dimensions, whether it purported to be anthropometry or theory of construction: it was, necessarily, both at the same time. For to determine the 'objective' proportions of a subject, i.e., to reduce its height, width and depth to measurable magnitudes, means nothing else but ascertaining its dimensions in frontal elevation, side elevation and ground plan. And since an Egyptian representation was limited to these three plans (except that the sculptor juxtaposed while the master of a two-dimensional art fused them), the 'technical' proportions could not but be identical with the 'objective'. The relative dimensions of the natural object, as contained in the front elevation, the side elevation and the ground plan, could not but coincide with the relative dimensions of the artifact: if the Egyptian artist assumed the total length of a human figure to be divided into 18 or 22 units and, in addition, knew that the length of the foot amounted to 3 or $3\frac{1}{2}$ such units, and the length of the calf to 5,[5] he also knew what magnitudes he had to mark off on his painting ground or on the surfaces of his block.

From many examples preserved to us[6] we know that the Egyptians effected this subdivision of the stone or wall surface by means of a finely meshed network of equal squares; this they employed not only for the representation of human

5. The subdivision into eighteen squares characterizes the 'earlier canon', that into twenty-two the 'later'. But in both, the upper part of the head (the portion above the *os frontale* in the 'earlier' canon, the portion above the hairline in the 'later') is not taken into account, since the diversity of the coiffure and headdress demanded a certain freedom here. See H. Schäfer, *Von ägyptischer Kunst*, Leipzig, 1919, II, p. 236, Note 105, and the most illuminating article by C. C. Edgar, 'Remarks on Egyptian "Sculptors' Models"', in *Recueil de travaux relatifs à la philologie ... égyptienne*, XXVII, p. 137 ff.; cf. also *idem*, Introduction to *Catalogue Général des Antiquités Egyptiennes du Musée du Caire*, XXV, *Sculptors' Studies and Unfinished Works*, Cairo, 1906.

6. Especially numerous in the Cairo Museum; see also the interesting wall-painting cycle of Ptolemy I in the Pelizaeus Museum at Hildesheim.

beings but also for that of the animals which play so promin-
ent a role in their art.[7] The purpose of this network will be
best understood if we compare it with the deceptively
similar system of squares used by the modern artist to trans-
fer his composition from a smaller to a larger surface (*mise
au carreau*). While this procedure presupposes a preparatory
drawing – in itself bound to no quadrature – on which hori-
zontal and vertical lines are subsequently superimposed in
arbitrarily selected places, the network used by the Egyptian
artist precedes the design and predetermines the final pro-
duct. With its more significant lines permanently fixed on
specific points of the human body, the Egyptian network
immediately indicates to the painter or sculptor how to
organize his figure: he will know from the outset that he
must place the ankle on the first horizontal line, the knee
on the sixth, the shoulders on the sixteenth, and so on
(Text Fig. 1).

In short, the Egyptian network does not have a transfer-
ential significance, but a constructional one, and its useful-
ness extended from the establishment of dimensions to the
definition of movement. Since such actions as striding forth
or striking out were expressed only in stereotyped alterations
of position, and not in changing anatomical displacements,
even movement could be adequately determined by purely
quantitative data. It was, for instance, agreed that in a figure
considered to be in a lunging position the length of pace
(measured from the tip of one foot to the tip of the other)
should amount to $10\frac{1}{2}$ units, while this distance in a figure
quietly standing was set at $4\frac{1}{2}$ or $5\frac{1}{2}$ units.[8] Without too
much exaggeration one could maintain that, when an Egypt-
ian artist familiar with this system of proportions was set the
task of representing a standing, sitting or striding figure, the

7. Edgar, *Catalogue*, p. 53; cf. also A. Erman, in *Amtliche Berichte
aus den königlichen Kunstsammlungen*, XXX, 1908, p. 197 ff.

8. Cf., e.g., E. Mackay, in *Journal of Egyptian Archaeology*, IV, 1917,
Pl. XVII. In other respects, however, Mackay's article does not seem
to attain the solidity of Edgar's works.

result was a foregone conclusion once the figure's absolute size was determined.[9]

This Egyptian method of employing a theory of proportions clearly reflects their *Kunstwollen*, directed not toward the variable, but toward the constant, not toward the symbolization of the vital present, but toward the realization of a timeless eternity. The human figure created by a Periclean artist was supposed to be invested with a life that was only apparent, but – in the Aristotelian sense – 'actual'; it is only an image but one which mirrors the organic function of the human being. The human figure created by an Egyptian was supposed to be invested with a life that was real, but – in the Aristotelian sense – only 'potential'; it reproduces the form, but not the function, of the human being in a more durable replica. In fact, we know that the Egyptian tomb statue was not intended to simulate a life of its own but to serve as the material substratum of another life, the life of the spirit 'Kā'. To the Greeks the plastic effigy commemorates a human being that lived; to the Egyptians it is a body that waits to be re-enlivened. For the Greeks, the work of art exists in a sphere of aesthetic ideality; for the Egyptians, in a sphere of magical reality. For the former, the goal of the artist is imitation $(\mu\iota\mu\eta\sigma\iota\varsigma)$; for the latter, reconstruction.

Let us turn once more to that preparatory drawing for a sculpture of a sphinx. No fewer than three different networks are used, and had to be used, since this particular sphinx, holding the small figure of a goddess between his paws, is composed of three heterogeneous parts, each of which requires its own system of construction: the body of a lion, whose proportioning adheres to the canon suitable for this breed of animal; the human head, which is subdivided according to the scheme of the so-called Royal Heads (in

9. Conversely, the absolute size is, of course, determined by a single square of the network, thus making it possible for the Egyptologist to reconstruct the whole figure from the merest fragment of such a network.

Cairo alone more than forty models are preserved); and the small goddess, which is based upon the customary canon of twenty-two squares prescribed for the whole human figure.[10] Thus the creature to be represented is a pure 'reconstruction', assembled from three components each of which is conceived and proportioned exactly as though it were standing alone. Even where he had to combine three heterogeneous elements into one image, the Egyptian artist did not find it necessary to modify the rigidity of the three special systems of proportion in favour of an organic unity which, in Greek art, asserts itself even in a Chimaera.

II

We can foresee from the foregoing paragraphs that the classical art of the Greeks had to free itself completely from the Egyptian system of proportions. The principles of archaic Greek art were still similar to those of the Egyptians; the advance of the classical style beyond the archaic consisted in its accepting as positive artistic values precisely those factors which the Egyptians had neglected or denied. Classical Greek art took into account the shifting of the dimensions as a result of organic movement; the foreshortening resulting from the process of vision; and the necessity of correcting, in certain instances, the optical impression of the beholder by 'eurhythmic' adjustments.[11]

10. It is this 'peculiar deviation from other network drawings' that lends special importance to the Berlin Sphinx Papyrus: that three different systems of proportions were employed – an anomaly easily explained by the fact that the organism in question is not a homogeneous but a heterogeneous one – conclusively proves that the Egyptian system of equal squares was not a method of transfer, but a canon. For the purpose of a mere *mise au carreau*, artists always use, of course, a uniform grid.

11. Cf. the oft-cited story of an *Athena* by Phidias, where the lower part of the body, although 'objectively' too short, nevertheless appeared 'correct' when the statue was placed high above eye level (J.

Hence, the Greeks could not start out with a system of proportions which, in stipulating the 'objective' dimensions, also irrevocably set down the 'technical' ones. They could admit a theory of proportions only in so far as it allowed the artist the freedom to vary the 'objective' dimensions from case to case by a free rearrangement – in short, only in so far as it was limited to the role of anthropometry.

We are, therefore, much less exactly informed of the Greek theory of proportions, as developed and applied in classical times, than of the Egyptian system. Once the 'technical' and 'objective' dimensions have ceased to be identical, the system or systems can no longer be directly perceived in the works of art;[12] we can glean, on the other hand, some information from literary sources, frequently

Overbeck, *Die antiken Schriftquellen zur Geschichte der bildenden Kunst bei den Griechen*, Leipzig, 1868, No. 772). Very interesting also, is the little-noticed passage in Plato's *Sophistes*, 235E/236A: Οὔκουν ὅσοι γε τῶν μεγάλων πού τι πλάττουσιν ἔργων ἢ γράφουσιν. εἰ γὰρ ἀποδιδοῖεν τὴν τῶν καλῶν ἀληθινὴν συμμετρίαν, οἶσθ' ὅτι σμικρότερα μὲν τοῦ δέοντος τὰ ἄνω, μείζω δὲ τὰ κάτω φαίνοιτ' ἂν διὰ τὸ τὰ μὲν πόρρωθεν, τὰ δ' ἐγγύθεν ὑφ' ἡμῶν ὁρᾶσθαι. ἆρ' οὖν οὐ χαίρειν τὸ ἀληθὲς ἐάσαντες οἱ δημιουργοὶ νῦν οὐ τὰς οὔσας συμμετρίας, ἀλλὰ τὰς δοξούσας εἶναι καλὰς τοῖς εἰδώλοις ἐναπεργάζονται; In English, according to the translation by H. N. Fowler, *Plato* (Loeb Classical Library), II, p. 335: 'Not only those who produce some large work of sculpture or painting [sc., use 'illusion']. For if they reproduced the true proportions of beautiful forms, the upper parts, you know, would seem smaller and the lower parts larger than they ought because we see the former from a distance, the latter from near at hand. ... So the artists abandon the truth and give their figures not the actual proportions but those which seem to be beautiful, do they not?'

12. The well-known Metrological Relief at Oxford (*Journal of Hellenic Studies*, IV, 1883, p. 335 ff.) has nothing to do with the theory of proportions in art, but solely serves to standardize what may be called commercial measurements: 1 fathom (ὀργυία) = 7 feet (πόδες) = 2·07 m., each foot being 0·296 m. Hence, no attempt is made to divide proportionally the human figure which here demonstrates these measurements.

linked to the name of Polyclitus – the father, or at least the formulator, of classical Greek anthropometry.[13]

We read, for example, in Galen's *Placita Hippocratis et Platonis*: τὸ δὲ κάλλος οὐκ ἐν τῇ τῶν στοιχείων, ἀλλ' ἐν τῇ τῶν μορίων συμμετρίᾳ συνίσταθαι νομίζει [Χρύσιππος], δακτύλου πρὸς δάκτυλον δηλονότι καὶ συμπάντων αὐτῶν πρός τε μετακάρπιον καὶ καρπόν, καὶ τούτων πρὸς πῆχυν, καὶ πήχεως πρὸς βραχίονα, καὶ πάντων πρὸς πάντα, καθάπερ ἐν τῷ Πολυκλείτου κανόνι γέγραπται.[14] 'Chrysippus ... holds that beauty does not consist in the elements but in the harmonious proportion of the parts, the proportion of one finger to the other, of all the fingers to the rest of the hand, of the rest of the hand to the wrist, of these to the forearm, of the forearm to the whole arm, in fine, of all parts to all others, as it is written in the canon of Polyclitus.'

In the first place, this passage confirms what had been suspected from the outset: that the Polyclitan 'canon' possessed a purely anthropometric character, i.e., that its purpose was not to facilitate the compositional treatment of stone blocks or wall surfaces, but exclusively to ascertain the 'objective' proportions of the normal human being: in no way did it predetermine the 'technical' measurements. The artist who observed this canon was not required to refrain from rendering anatomical and mimetic variations, or from employing foreshortenings, or even, when necessary, from adjusting the dimensions of his figure to the subjective visual experience of the beholder (as when the sculptor lengthens the upper portions of a figure placed high or thickens the

13. Of the theoreticians of proportions mentioned by Vitruvius – Melanthius, Pollis, Demophilus, Leonidas, Euphranor, and so forth – we know nothing but their names. Kalkmann (*Die Proportionen des Gesichts in der griechischen Kunst* [Berliner Winckelmannsprogramm, No. 53], 1893, p. 43 ff.) has, however, tried to trace the Vitruvian statements of measurements back to the canon of Euphranor. A more recent article by Foat (in *Journal of Hellenic Studies*, XXXV, 1914, p. 225 ff.) has not substantially advanced our knowledge of the antique theory of proportions.

14. Galen, *Placita Hippocratis et Platonis*, V, 3.

averted side of a face turned to three-quarter profile). In the second place, Galen's testimony characterizes the principle of the Polyclitan theory of proportions as what may be called 'organic'.

As we know, the Egyptian artist-theoretician first constructed a network of equal squares[15] and then inserted into this network the outlines of his figure – unconcerned as to whether each line of the network coincided with one of the organically significant junctures of the body. We can observe, e.g., that within the 'later canon' (Text Fig. 1) the horizontals, 2, 3, 7, 8, 9, 15 run through completely insignificant points. The Greek artist-theoretician proceeded in the opposite way. He did not start with a mechanically constructed network in which he subsequently accommodated the figure; he started, instead, with the human figure, organically differentiated into torso, limbs and parts of limbs, and subsequently tried to ascertain how these parts related to each other and to the whole. When, according to Galen, Polyclitus described the proper proportion of finger to finger, finger to hand, hand to forearm, forearm to arm and, finally, each single limb to the entire body, this means that the classical Greek theory of proportions had abandoned the idea of constructing the body on the basis of an absolute module, as though from small, equal building blocks: it sought to establish relations between the members, anatomically differentiated and distinct from each other, and the entire body. Thus it is not a principle of mechanical identity, but a principle of organic differentiation that forms the basis of the Polyclitan canon; it would have been utterly impossible to incorporate its stipulations into a network of squares.

15. The unit itself equals the height of the foot from the sole to the upper limit of the ankle [and has recently been defined as 1 'fist' or $1\frac{1}{3}$ 'handbreadths' (see Iversen, cited on p. 8)]. However, the relation of this unit to the dimensions of the individual members, even to the length of the foot itself, varies; it is, in fact, somewhat doubtful whether it was intended to establish such a relation at all. In the 'early' canon the length of the foot is generally equal to 3 units (cf., however, Edgar, *Travaux*, p. 145), in the 'later', to nearly $3\frac{1}{2}$, etc.

For an idea of the character of the lost theory of the Greeks, we must turn, not to the Egyptian system of proportions, but to the system according to which the figures in the First Book of Albrecht Dürer's treatise on human proportions are measured (Text Fig. 7).

Figure 1. The 'Later Canon' of Egyptian Art, after *Travaux relatifs à la philologie et archéologie égyptiennes*, XXVII, 905, p. 144.

The dimensions of these figures are all expressed in common fractions of the total length, and the common fraction is indeed the only legitimate mathematical symbol for the 'relations of commensurable quantities'. The passage transmitted by Galen shows that Polyclitus, too, consistently expressed the measure of a smaller part as the common fraction of a larger – and, finally, the total – quantity, and that he did not think of expressing the dimensions as multiples of a constant *modulus*. It is precisely this method – directly re-

lating the dimensions to each other and expressing them through each other, instead of separately reducing them to one, neutral unit ($x = \dfrac{y}{4}$, not $x = 1, y = 4$) – which achieves that immediately evident 'Vergleichlichkeit Eins gegen dem Andern' (Dürer) which is characteristic of the classical theory. It is no accident when Vitruvius, the only ancient writer who handed down to us some actual, numerical data regarding human proportions (data evidently deriving from Greek sources), formulates them exclusively as common fractions of the body length,[16] and it has been established that in Polyclitus' own *Doryphoros* the dimensions of the more important parts of the body are expressible as such fractions.[17]

16. This fact has justly been stressed by Kalkmann (op. cit., p. 9 ff.) in refutation of those who would deduce from the Galen passage the description of a module system. These authors were apparently misled by the δάκτυλος (finger), which they interpreted as a unit of measurement, whereas it is the smallest part of the body to be measured.

For convenience's sake I list the Vitruvian measurements:

 a) face (from hairline to chin) = $\frac{1}{10}$ (of the total length);
 b) hand (from wrist to tip of middle finger) = $\frac{1}{10}$;
 c) head (from crown to chin) = $\frac{1}{8}$;
 d) pit of the throat to hairline = $\frac{1}{6}$;
 e) pit of the throat to crown of head = $\frac{1}{4}$;
 f) length of the foot = $\frac{1}{6}$;
 g) cubit = $\frac{1}{4}$;
 h) breadth of the chest = $\frac{1}{4}$.

Furthermore, it is specified that the face is divided into three equal parts (forehead, nose, lower part including mouth and chin), and that the entire body, when erect with arms outspread, fits into a square; and when spreadeagled, into a circle described around the navel. [For the cosmological origin of the last-named specifications, see now F. Saxl, quoted p. 8.]

Statements (a) and (c) are obviously in contradiction with statements (d) and (e), according to which $\frac{1}{12}$ instead of $\frac{1}{40}$ would remain for the upper part of the cranium. Since only the latter value can be correct, the corruption of the text must be in statement (d) or (e). Hence the Renaissance theorists, e.g., Leonardo, introduced various corrections here (cf. below, Note 83, p. 127).

17. Kalkmann, op. cit., pp. 36–7.

The anthropometric and organic character of the classical theory of proportions is intrinsically connected with a third characteristic, its pronouncedly normative and aesthetic ambition. Where the Egyptian system aims only at reducing the conventional to a fixed formula, the Polyclitan canon claims to capture beauty. Galen expressly calls it a definition of that 'wherein beauty consists' (κάλλος συνίσταθαι). Vitruvius introduces his little list of measurements as 'the dimensions of the *homo bene figuratus*'. And the only statement that can be traced back with certainty to Polyclitus himself reads as follows: τὸ γὰρ εὖ παρὰ μικρὸν διὰ πολλῶν ἀριθμῶν γίγνεσθαι,[18] 'the beautiful comes about, little by little, through many numbers.' Thus the Polyclitan canon was intended to realize a 'law' of aesthetics, and it is thoroughly characteristic of classical thought that it could imagine such a 'law' only in the form of relations expressible in terms of fractions. With the sole exception of Plotinus and his followers, classical aesthetics identified the principle of beauty with the consonance of the parts with each other and the whole.[19]

18. E. Diels, in *Archäologischer Anzeiger*, 1889, No. I, p. 10.

19. It may be in order at this point to discuss the three pertinent concepts of Vitruvius' aesthetic theory: *proportio*, *symmetria*, and *eurhythmia*. Of these, *eurhythmia* creates the least difficulty. As we have mentioned more than once (cf. also Kalkmann, op. cit., p. 9 ff., Note, as well as p. 38 ff., Note), it depends upon the appropriate application of those 'optical refinements' which, by increasing or diminishing the objectively correct dimensions, neutralize the subjective distortions of the work of art. Hence, according to Vitruvius, I, 2, *eurhythmia* is a 'venusta species commodusque aspectus' (i.e., 'a pleasing appearance and a suitable aspect'); it is the distinctive quality of what Philo Mechanicus (quoted by Kalkmann) calls τὰ ὁμόλογα τῇ ὁράσει καὶ εὔρυθμα φαινόμενα, of 'that which appears conformable and eurhythmic to the sense of sight'. In architecture this means, e.g., the thickening of the corner columns of peripteral temples which, owing to irradiation, would otherwise appear slenderer than the others; or the curvatures of stylobates and epistyles. The difference between *proportio* and *symmetria* is the more difficult to determine as both these terms are still in use but have assumed a basically different significance. In Vitruvian usage, it seems to me, *symmetria* ('symmetry' in its original

Classical Greece, then, opposed to the inflexible, mechanical, static, and conventional craftsman's code of the Egyptians an elastic, dynamic, and aesthetically relevant system of relations. And this contrast was demonstrably known to

sense) is to *proportio* as norm-definition is to norm-realization. *Symmetria*, defined (in I, 2) as 'ex ipsius operis membris conveniens consensus ex partibusque separatis ad universae figurae speciem ratae partis responsus' ('the appropriate harmony resulting from the members of the work itself, and the metrical correspondence resulting from the separate parts in relation to the aspect of the whole configuration') is what may be called the aesthetic principle: the reciprocal relation between the members and the consonance between the parts and the whole. *Proportio*, on the other hand, defined (in III, 1) as 'ratae partis membrorum in omni opere totiusque commodulatio' ('the metrical coordination, throughout the work, of the *rata pars* [module, unit] and the whole'), is the technical method by means of which these harmonious relations are, to use Dürer's words, 'put into practice': the architect assumes a module (*rata pars*, ἐμβάτης) by the multiplication of which (IV, 3) he obtains the actual, metrical dimensions of the work – as when a modern architect, having decided to build a living room proportioned at a ratio of 5:8, sets down its actual dimensions as 18′ 9″ by 30′. *Proportio*, then, is not something that determines beauty, but only ensures its practical realization, and Vitruvius is very consistent in characterizing *proportio* as that through which *symmetria efficitur*, while insisting that *proportio*, in turn, must be 'attuned to symmetry' ('*universaeque proportionis ad symmetriam comparatio*'). In short, *proportio*, best translated as 'reduction to sacale', is a method of architectural technique which, from the classical standpoint, has little relevance for the figurative arts. It is perfectly logical when Vitruvius includes his survey of human proportions, not in the exposition of *proportio*, but of *symmetria*, and when, as already noted, he expresses them not as multiples of a module, but as fractions of the total length of the body. He looks upon the use of the module, *commodulatio*, only as a method of practical mensuration; whereas he can imagine the 'appropriate harmony' of the dimensions, the determination of which must precede this *commodulatio*, only in terms of relations (expressible in fractions) which derive from the organic articulation of the body (or, for that matter, the building) itself. See also Kalkmann, op. cit., p. 9, Note 2: '*Proportio* affects only the construction with the aid of the module, the *rata pars*. *Symmetria* is an additional factor: the members must be beautifully and suitably related to each other, a postulate not as yet raised by *proportio*'; further, A. Jolles, *Vitruvs Aesthetik* (Diss., Freiburg, 1906), p. 22 ff.

antiquity itself. Diodorus of Sicily tells, in the ninety-eighth chapter of his First Book, the following story: In ancient times (that is to say, the sixth century B.C.) two sculptors, Telekles and Theodoros, made a cult statue in two separate parts; while the former prepared his portion on Samos, the latter made his in Ephesus; and on being brought together, each half matched the other perfectly. This method of working, so the story goes on, was not customary among the Greeks but among the Egyptians. For with them 'the proportions of the statue were not determined, as with the Greeks, according to visual experience' *(ἀπὸ τῆς κατὰ τὴν ὅρασιν φαντασίας)*, but as soon as the stones were quarried, split and prepared, the dimensions were 'immediately' *(τὸ τηνικαῦτα)* established, from the largest part down to the smallest.[20] In Egypt, Diodorus tells us, the entire structure of the body[21] was subdivided into $21\frac{1}{4}$ equal parts;[22] therefore, once the size of the figure to be produced had been decided upon, the artists could divide the work even if operating in different places and nevertheless achieve an accurate joining of the parts.

20. There is a remarkable correspondence between this description and the verse in Isaiah 44:13, in which the activity of the (Assyrian-Babylonian) 'maker of graven images' is described in the following way: 'The carpenter stretcheth out his rule; he marketh it out with a line; he fitteth it with planes, and he marketh it out with the compass, and maketh it after the figure of a man, according to the beauty of a man. . . .'

21. It should be noted that Diodorus, when speaking of the Greeks, says συμμετρία ('harmonious proportion'), but when of the Egyptians, κατασκευή ('structure', 'fabric').

22. This is a slight error inasmuch as there are twenty-two divisions. But the principle is quite correctly understood, particularly the fact that for the top of the head a small portion (one-quarter) is reserved outside the actual grid. Noteworthy, too, is the art-historical discernment with which Diodorus perceives the stylistic affinity between Egyptian and archaic Greek art, so that both can be treated as one in contradistinction to the classical style. Cf. also the preceding chapter, where the mythical founder of Greek sculpture is discussed: τόν τε ῥυθμὸν τῶν ἀρχαίων κατ' Αἴγυπτον ἀνδριάντων τὸν αὐτὸν εἶναι τοῖς ὑπὸ Δαιδάλου κατασκευασθεῖσι παρὰ τοῖς Ἕλλησι.

Whether the anecdotal content of this entertaining story is true or not, it displays a fine feeling for the difference, not only between Egyptian and classical Greek art, but also between the Egyptian and the classical Greek theories of proportions. Diodorus' tale is of importance, not so much in that it confirms the existence of an Egyptian canon as in that it accentuates its unique significance for the production of a work of art. Even the most highly developed canon would not have enabled two artists to do what is reported of Telekles and Theodoros as soon as the 'technical' proportions of the work of art had begun to differ from the 'objective' data laid down in the canon. Two Greek sculptors of the fifth, let alone the fourth, century, with even the most exact agreement upon both the system of proportions to be followed and the total size of the figure to be carved, could not have worked one portion independently from the other: even when strictly adhering to a stipulated canon of measurement, they would have been free with regard to the formal configuration.[23] The contrast which Diodorus wants to bring out can, therefore, hardly mean, as has been supposed, that the Greeks, as opposed to the Egyptians, had no canon at all but proportioned their figures 'by sight'[24] – apart from the fact that Diodorus, at least through tradition, must have

23. Exception must therefore be taken to Jolles, op. cit., p. 91 ff., when he relates our passage to a dichotomy supposedly existing within clasical Greek art itself – a dichotomy which he characterizes as an opposition between a 'symmetrical' and a 'eurhythmic' conception of art, the latter but not the former allegedly based upon the *κατὰ τὴν δρασιν φαντασία*. Diodorus' tale about Telekles and Theodoros does not refer to the concept of *συμμετρία* at all; in fact, he uses the expression *συμμετρία* with reference to precisely that classical – and, in relation to Telekles and Theodoros, more 'modern' – style which, according to Jolles, would mark a non-'symmetrical', i.e., 'eurhythmic', conception of art.

24. As did Wahrmund in his translation of Diodorus (1869). This view was correctly rejected by Kalkmann (op. cit., p. 38, Note) as being at variance with the very concept of *συμμετρία* which of itself implies that the work of art is not fashioned purely 'by sight', but depends upon established norms of measurement.

had knowledge of Polyclitus' efforts. What he means to convey is that for the Egyptians the canon of proportions was, of itself, sufficient to predetermine the final result (and, for this reason, could be applied 'on the spot' as soon as the stones were prepared); whereas from the Greek point of view something completely different was required in addition to the canon: visual observation. He wants to make the point that the Egyptian sculptor, like a stonemason, needed nothing more than the dimensions to manufacture his work, and, depending completely upon them, could reproduce – or, more exactly, produce – the figures in any place and in any number of parts; whereas, in contrast to this, the Greek artist could not immediately apply the canon to his block, but must, from case to case, consult with the κατὰ τὴν ὅρασιν φαντασία, i.e., with a 'visual percept' that takes into account the organic flexibility of the body to be represented, the diversity of the foreshortenings that present themselves to the artist's eye, and, possibly, even the particular circumstances under which the finished work may be seen. All this, needless to say, subjects the canonical system of measurement to countless alterations when it is put into practice.[25]

The contrast which Diodorus' story is intended to make clear, and which it does make clear with remarkable vividness, is thus a contrast between 'reconstruction' and 'imitation' (μίμησις), between an art completely governed by a mechanical and mathematical code and one within which, despite conformity to rule, there is still room for the *irrationale* of artistic freedom.[26]

25. To suppose, as does Kalkmann, that Diodorus here thinks exclusively of the 'eurhythmic' *temperaturae* appears to me to be too narrow a reading.

26. Hence Leone Battista Alberti, who, strange to say, also mentions the possibility of producing a statue in two parts and in two different places (*Leone Battista Albertis kleinere kunsttheoretische Schriften*, H. Janitschek, ed. [*Quellenschriften für Kunstgeschichte*, XI], Vienna, 1877, p. 199), considers this possibility only in connexion with the task of exactly duplicating a statue already extant; he did not envisage it in

III

The style of medieval art (except, perhaps, for the phase known as High Gothic), in contradistinction to that of classical antiquity, is customarily designated as 'planar' (*flächenhaft*). In comparison with Egyptian art, however, it ought to be characterized as merely 'planate' (*verflächigt*). For the difference between Egyptian and medieval 'planarity' is that in the former the depth motifs are totally suppressed, while in the latter they are only devaluated. Egyptian representations are planar because Egyptian art renders only that which can *de facto* be presented in the plane; medieval representations seem planar even though medieval art renders that which cannot *de facto* be presented in the plane. Where the Egyptians positively exclude the three-quarter profile and oblique directions of the torso or limbs, the medieval style, presupposing the free movement of the antique, admits the one as well as the other (in fact, the three-quarter profile is the rule while the full profile and the pure front view are the exception). However, these positions are no longer exploited so as to create an illusion of actual depth; since the optically effective means of modelling and cast shadow had been abandoned, these positions are, as a rule, expressed by a manipulation of linear contours and flat areas of colour.[27] Thus there are in medieval art all kinds of forms which, from a purely technical point of view, may be described as 'foreshortened'. But, since their effect is not supported by optical means, they do not strike us as 'foreshortenings' in the sense in which the term is commonly used. Obliquely placed feet, for example, more often than not give an impression of hanging down rather than of being

order to illustrate a method of creative artistic production but in order to stress the precision of a method of transfer which he himself had invented.

27. In the High Middle Ages even the forms of the high lights and shadows tend to freeze into purely linear elements.

seen from the front; and the three-quarter view of the shoulders, reduced to a planar expression, tends to suggest the hump of a hunchback.

Under these circumstances the theory of proportions had to be oriented towards new goals. On the one hand, the flattening of the body forms was incompatible with the antique anthropometry which presupposes the idea that the figure exists as a three-dimensional solid; on the other hand, the unrestrained mobility of these forms, an irrevocable legacy from classical art, made it impossible to accept a system which, similar to the Egyptian, would predetermine the 'technical' as well as the 'objective' dimensions. Thus the Middle Ages faced the same choice as classical Greece; but it was forced to elect the opposite alternative. The Egyptian theory of proportions, identifying the 'technical' with the 'objective' dimensions, had been able to combine the characteristics of anthropometry with those of a system of construction; the Greek theory of proportions, abolishing this identity, had been forced to renounce the ambition to determine the 'technical' dimensions; the medieval system renounced the ambition to determine the 'objective' ones: it restricted itself to organizing the planar aspect of the picture. Where the Egyptian method had been constructional, and that of classical antiquity anthropometric, that of the Middle Ages may be described as schematic.

Within this medieval theory of proportions, however, two different tendencies can be observed. They agree, to be sure, in that both are based on the principle of planimetric schematization; but they differ in that this principle is interpreted in dissimilar ways: the Byzantine and the Gothic.

The Byzantine theory of proportions which, corresponding to the enormous influence of Byzantine art, was also of extraordinary importance for the West (see Plate 19), still betrays the after-effects of the classical tradition in that it worked out its schema by taking the organic articulation of the human body as a starting point; it accepted the funda-

mental fact that the parts of the body are set off from each other by nature. But it was wholly unclassical in that the measurements of these parts were no longer expressed by common fractions but by a somewhat coarse application of the unit or module system. The dimensions of the body as appearing in a plane – whatever lay outside the plane was disregarded as a matter of course – were expressed in head- or more accuately, face-lengths (in Italian; *viso* or *faccia*, frequently referred to also as *testa*),[28] the total length of the body ordinarily amounting to nine such units. Thus, according to the *Painter's Manual of Mount Athos*, 1 unit is allotted to the face, 3 to the torso, 2 each to the upper and lower parts of the leg, ⅓ (= one nose-length) to the top of the head, ⅓ to the height of the foot, and ⅓ to the throat;[29]

28. This in itself is characteristic of the temper of the times. From the classical point of view, the metrical values of the face, the foot, the cubit, the hand, the finger, had been of equal interest; now the face, the seat of spiritual expression, is taken as the unit of measurement, 'because of its importance, beauty and divisibility', as Averlino Filarete was to put it by the middle of the fifteenth century; see *Antonio Averlino Filaretes Traktat über die Baukunst*, W. von Oettingen, ed. (*Quellenschriften für Kunstgeschichte*, new ser., III), Vienna, 1890, p. 54.

29. *Das Handbuch der Malerei vom Berge Athos*, Godehard Schäfer, ed., 1855, p. 82. In Julius v. Schlosser's masterly commentary on Ghiberti's *Commentarii* (*Lorenzo Ghibertis Denkwürdigkeiten*, Berlin, 1912, II, p. 35), there appears the statement (provided with a question mark by Schlosser himself) that the Mount Athos canon claims the 'height of the foot' to equal a whole unit; this is a slight inaccuracy, due to a confusion with the length of the foot 'from ankle to toes', which, exactly as in Cennini, does amount to one unit. The height of the foot, likewise in accord with Cennini, is expressly set down as equalling one nose-length, or ⅓ of a unit, and this, plus the neck and the top of the head (both of these also = ⅓), makes up the unit which completes the total length of the body to nine face-lengths.

The documentary value of the specifications contained in the *Painter's Manual of Mount Athos* has, in my opinion, been underestimated in recent literature. Even though the edition that has come down to us is of fairly recent date and (as indicated by such expressions as τὸ νατουράλε) reveals the influence of Italian sources, much of the basic content of the document would seem to go back to the practice

the breadth of half the chest (including the curve of the shoulders) is assumed to be $1\frac{1}{3}$ units, while the inner lengths of the forearm and arm, as well as the length of the hand, are each assumed to equal 1.

These specifications are quite similar to those transmitted by Cennino Cennini, the theoretician of the closing period of the Trecento, most of whose views were firmly rooted in Byzantinism. His statements agree with those of the Mount Athos canon in all particulars, except that the length of the torso (3 face-lengths) is subdivided by two specific points, the pit of the stomach and the navel, and that the height of the top of the head is not expressly determined as $\frac{1}{3}$ of a unit, so that – without it – a total length of only $8\frac{2}{3}$ *visi* results. From then on, this Byzantine canon of 9 face-lengths pene-

of the High Middle Ages. That this is true of the chapter on proportions is evidenced by the fact that the dimensions established in the Mount Athos canon can be substantiated by Byzantine and Byzantinizing works produced in the twelfth and thirteenth centuries and even earlier (cf. below). This applies also to statements which cannot be traced back to classical antiquity, for instance, to the division of the entire body into 9 face-lengths (according to Vitruvius, 10); to the statement that the top of the head equals one nose-length or $\frac{1}{27}$ of the total height (according to Vitruvius, $\frac{1}{40}$); and to the apportioning of only $\frac{1}{6}$ to the length of the foot (according to Vitruvius, $\frac{1}{4}$). Thus, when Cennini's proportions agree with the Mount Athos canon in all these points, it should not be concluded that the Mount Athos canon depends upon Italian sources but, rather, that a Byzantine tradition survives in Cennini.

There is, on the other hand, no denying that the *Painter's Manual* incorporates many recent, Western elements. In the instruction for illustrating the twelfth chapter of *Revelation*, for example, the artist is enjoined to show 'the Child being carried aloft in a cloth by two angels' (ed. Schäfer, p. 251), and this is, so far as I know, an innovation of Dürer's, first occurring in his woodcut B.71. [Subsequently, L. H. Heydenreich, 'Der Apokalypsenzyklus im Athosgebiet und seine Beziehungen zur deutschen Bibelillustration', *Zeitschrift für Kunstgeschichte*, VIII, 1939, p. 1 ff., has been able to show that Dürer's *Apocalypse* became familiar to the Byzantine artists through the intermediary of Holbein's woodcuts in the New Testament published at Basel (Wolff) in 1523.]

trated into the art theory of succeeding periods, where it plays an important role down to the seventeenth and eighteenth centuries[30] – at times completely unchanged, as in Pomponius Gauricus, at times with slight modifications, as in Ghiberti and Filarete.

I have no doubt that the origin of this system, achieving mensuration by way of numeration, so to speak, is to be sought in the East. True, a most questionable report of the late Renaissance (Philander) attributes to the Roman Varro[31] a canon which – dividing the total length of the body into $9\frac{1}{3}$ *teste* – seems closely related to the systems discussed so far. But apart from the fact that the ancient literature on art shows no trace of such a canon[32] and that the statements of Polyclitus and Vitruvius are based upon a completely different system (viz., that of common fractions), the antecedents of the tradition represented by the *Painter's Manual of Mount Athos* and Cennini's *Treatise* can be shown to have existed in Arabia. In the writings of the 'Brethren of Purity', an Arabian scholarly brotherhood that flourished in the ninth and

30. The Early Renaissance canons in question are cited in extract by Schlosser, op. cit. I should like to add the less well-known statements in Francesco di Giorgio Martini's *Trattato di architettura civile e militare* (C. Saluzzo, ed., Turin, 1841, I, p. 229 ff.), which are interesting in that they still reveal a marked tendency toward planimetric schematization. For the later period, one may mention, among others, Mario Equicola, Giorgio Vasari, Raffaele Borghini and Daniel Barbaro; the last-named author (*La pratica della prospettiva*, Venice, 1569, p. 179 ff.) transmits – along with the Vitruvian canon – a canon 'of his own invention' which, however, differs from the well-known nine-*teste* type only in that $\frac{1}{3}$ of a *testa* (i.e., one nose-length), is elevated to the status of a module and referred to as a *pollice* ('thumb'). Then the crown of the head equals 1 thumb, the height of the foot and the neck $1\frac{1}{2}$ thumbs each. Thus the final total amounts to $9\frac{1}{3}$ *teste*; the remaining 8 *teste* are distributed in the usual way.

31. Schlosser, op. cit., p. 35, Note. The extra third is allotted to the knee, whereby this pseudo-Varronic canon appears somewhat analogous to Ghiberti's arrangement: Ghiberti fixes the length of the thigh, including the knee, at $2\frac{1}{2}$ units; and, minus the knee, at $2\frac{1}{6}$ units; so that here, too, $\frac{1}{3}$ of a unit is left for the knee itself.

32. Kalkmann, op. cit., p. 11.

tenth centuries, we find a system of proportions that antici-
cipates the ones under consideration in expressing the
dimensions of the body by one fairly large unit or module.[33]
And even though this canon may have been derived from
still older sources,[34] its pedigree would not seem to go back
beyond the Late Hellenistic period, that is to say, to a time
when the entire picture of the world was transformed, not
without oriental influence, in the light of number mystic-
ism; and when, with a general shift from the concrete to the
abstract, ancient mathematics itself, culminating and termin-
ating in Diophantus of Alexandria, underwent its arith-
metization.[35]

The canon of the 'Brethren of Purity' has, as such, noth-
ing to do with artistic practices. Forming part of a 'harmon-
istic' cosmology, it was not supposed to furnish a method
for the pictorial rendering of the human figure, but was
intended to give insight into a vast harmony that unifies all
parts of the cosmos by numerical and musical correspond-
ences. Hence, the data transmitted here do not apply to the
adult but to the newborn child, a being who is of only
secondary significance for the representational arts but plays
a fundamental role in cosmological and astrological think-
ing.[36] But it is not by accident that the Byzantine studio
practice adopted a system of measurement formulated for an

33. F. Dieterici, *Die Propädeutik der Araber*, Leipzig, 1865, p. 135 ff.
Here, however, it is not the face-length which is the accepted unit,
but the 'span' of the hand, which amounts to $\frac{4}{5}$ of the face-length.

34. According to a kind communication from Professor Helmut
Ritter, until now no other statements regarding the proportioning of
the human body have been found in Arabic sources. Instructions for
the proportioning of letters, however, have come down to us; and
these, too, are based on a module system rather than on the principle
of common fractions.

35. M. Simon, *Geschichte der Mathematik im Altertum in Verbindung
mit antiker Kulturgeschichte*, Berlin, 1909, pp. 348, 357.

36. The newborn child is, in fact, that being in which the power of
the forces controlling the universe, in particular the influence of the
stars, is more directly and exclusively effective than in the adult, who
is determined by many other conditions.

entirely different purpose and finally forgot its cosmological origin altogether. Paradoxical though it sounds, an algebraic or numerical system of measurement, reducing the dimensions of the body to a single module, is – provided that the module is not too small – much more compatible with the medieval tendency towards schematization than the classical system of common fractions.

The 'fractional' system facilitated the objective appreciation of human proportions, but not their adequate representation in a work of art; a canon transmitting relations rather than actual quantities supplied the artist with a vivid and simultaneous idea of the three-dimensional organism, but not with a method for the successive construction of its two-dimensional image. The algebraic system, on the other hand, makes up for the loss of elasticity and animation by being immediately 'constructible'. When the artist knew, through tradition, that the multiplication of a specific unit could give him all the basic dimensions of the body, he could, by the successive use of such *moduli*, assemble, as it were, each figure on the picture plane 'with the opening of the compass unchanged', with very great speed, and almost independently of the organic structure of the body.[37] In Byzantine art this method of a schematic, graphic mastery of the planar design was preserved until modern times: Adolphe Didron, the first editor of the *Painter's Manual of Mount Athos*, saw the monastic artists of the nineteenth century still employing a method whereby they marked off the individual dimensions with the compass and immediately transferred them to the wall.

Consequently, the Byzantine theory of proportions made it its business to determine even the measurements of the

37. Once the canon is established, it can be successfully applied to seated as well as to standing figures (Plate 19). In this example, the 'face-lengths' are not counted up to the hairline, but to the edge of the kerchief: for a basically non-naturalistic style graphic appearance is more important than the anatomical data. As required by the canon, this face-length automatically determines the length of the hand.

details of the head in terms of the module system, taking the length of the nose ($= \frac{1}{3}$ the length of the face) as a unit. The length of the nose equals, according to the *Painter's Manual of Mount Athos*, not only the height of the forehead and the lower part of the face (which agrees with the canon of Vitruvius and most Renaissance canons), but also the height of the upper part of the head, the distance from the tip of the nose to the corner of the eye, and the length, down to the pit, of the throat. This reduction of the vertical and horizontal dimensions of the head to a single unit made feasible a procedure which manifests with particular clarity the medieval proclivity for planimetric schematization – a procedure by means of which not only the dimensions but even the forms could be established *geometrico more*. For, when the measurements of the head, horizontal as well as vertical, were expressible as multiples of a constant unit, the 'nose-length', it became possible to determine the entire configuration by three concentric circles which had their common centre in the root of the nose. The innermost – with 1 nose-length as radius – outlines the brow and cheeks; the second – with 2 nose-lengths as radius – gives the exterior measurements of the head (including the hair) and defines the lower limit of the face: the outermost – with 3 nose-lengths as radius – passes through the pit of the throat, and generally also forms the halo (Text Fig. 2).[38] This method automatically results in that peculiarly exaggerated height and breadth of the cranium which, in the figures of this style, so often creates the impression of a view from above, but can actually be traced back to the use of what may be called 'the Byzantine three-circle scheme' – a scheme that shows how little the medieval theory of proportions, intent upon only a handy rationalization of the 'technical' dimensions, took offence at 'objective' inaccuracy. The canon of proportions here ap-

38. In addition, the pupils of the eyes usually lie midway between the root of the nose and the periphery of the first circle, and the mouth divides the distance between the first and second circles at a ratio of either 1:1, or (in the Mount Athos canon) 1:2.

Figure 2. The 'Three-Circle Scheme' of Byzantine and Byzantinizing Art.

pears, not only as a symptom of the *Kunstwollen*, but almost as the carrier of a special stylistic force.[39]

This 'three-circle scheme' – in illustration of which we reproduce a page of the same manuscript from which we have borrowed the Madonna reproduced in Plate 19, and which contains comparatively many constructed heads (Plate 20) – was exceedingly popular in Byzantine and Byzantinizing art; in Germany[40] as well as in Austria (Plate 21),[41]

39. In Byzantine painting, even this custom of determining the contour of the head by means of the compass persisted up to modern times; see Didron, op. cit., p. 83, Note.

40. Numerous examples, e.g., in P. Clemen, *Die romanische Wandmalerei in den Rheinlanden*, Düsseldorf, 1916, *passim*.

41. See, e.g., P. Buberl, 'Die romanischen Wandmalereien im Kloster Nonnberg', *Kunstgeschichtliches Jahrbuch der K. K. Zentral-Kommission* . . ., III, 1909, p. 25 ff., Figs. 61 and 63. For better illustrations, see H. Tietze, *Die Denkmale des Stiftes Nonnberg in Salzburg* (*Oesterreichische Kunsttopographie*, VII), Vienna, 1911. To my knowledge, Buberl was the first to observe the existence of a system of construction in pre-Gothic times. [See now K. M. Swoboda's article cited p. 9.]

in France [42] as well as in Italy,[43] in monumental painting[44] as well as in the minor arts,[45] but above all in innumerable manuscript illuminations.[46] And even where – especially in works of small format – an exact construction with compass and ruler does not exist, the very character of the forms frequently indicates their derivation from the traditional scheme.[47]

In Byzantine and Byzantinizing art, the tendency toward planimetrical schematization went so far that even heads turned to three-quarter profile were constructed in analogous manner.[48] Exactly as in the case of the frontal face, the 'foreshortened' face was constructed by means of a planar scheme

42. See, e.g., *Album de Villard de Honnecourt*, authorized edition of the Bibliothèque Nationale, Pl. XXXII (strongly Byzantinizing even in style).

43. See, e.g., Pietro Cavallini's heads in S. Cecilia in Trastevere, well reproduced in F. Hermanin, *Le Galerie nazionali d'Italia*, Rome, 1902, V, particularly Pl. II.

44. Including stained-glass windows; see, e.g., the Apostle windows in the west choir of Naumburg Cathedral.

45. See, e.g., the enamel reproduced in O. Wulff, *Altchristliche und byzantinische Kunst*, Berlin-Neubabelsberg, 1914, II, p. 602, as well as numerous ivories.

46. See especially A. Haseloff, *Eine thüringisch-sächsische Malerschule des 13. Jahrhunderts*, Strassburg, 1897, particularly Figs. 18, 44, 66, 93, 94.

47. This scheme (which also occurs in an abbreviated form with only the contours of the head but not the outline of the face determined by means of a compass) was occasionally modified so as to avoid the 'unnatural' heightening of the cranium: the ratio of the radii of the three circles was not assumed to be $1:2:3$, but $1:1\frac{1}{2}:2\frac{1}{2}$. Then the height of the cranium is reduced to one unit, and the mouth does not fall in the area between the first and second circles, but lies on the second circle itself. Such is the case of the wall paintings in the Nonnberg Convent Church at Salzburg (cf. Note 41, p. 109, and Plate 21), and in several other instances, e.g. – here particularly clearly because of the deterioration of the paint – in the Late Romanesque Apostle portraits in the southern choir screen of the west (St Peter) choir in Bamberg Cathedral.

48. It occurs, e.g., in the head of the Rucellai Madonna in S. Maria Novella but not in that of the Academy Madonna by Giotto.

operating with equal modules and circles; and this scheme was made to produce the impression of an effective if quite 'incorrect' foreshortening by exploiting the fact that, in a 'picture', graphically equal distances may 'signify' objectively unequal ones.

Representing, as it were, a supplement to the 'three-circle system' employed for the frontal face, this construction of the three-quarter profile was applicable only under the assumption that the head, while being turned, must not be tilted forward but only inclined toward the right or left (Plates 22, 23).[49] Then, the vertical dimensions remaining unaltered, the task was limited to a schematic foreshortening of the horizontal dimensions, and this could be done under two conditions: first, the customary unit (1 nose-length) must continue to be valid; and, second, it must still be possible, despite the changes in quantity, to determine the contour of the head by a circle with a radius of 2 nose-lengths and the halo (if present) by means of a concentric circle with a radius of 3 nose-lengths. Because of the lateral turning, the centre of this circle, or circles, could, of course, no longer coincide with the root of the nose but had to lie within that half of the face which is turned toward us; and in order to be coincident with a characteristic point of the physiognomy, it tended to be transferred either to the outer corner of the eye or eyebrow or to the pupil. If this point, which we shall call A, is assumed to be the centre of a circle with a radius of 2 nose-lengths, this circle defines the curve of the skull and determines (at C) the breadth of the averted half of the face;[50] the effect of 'foreshortening' results from the fact that the distance AC (amounting to only 2 nose-lengths), which in the

49. Madonnas' heads are nearly always inclined toward the right (as seen by the beholder).

50. In a somewhat rudimentary form this scheme can be shown to have been used in a Romanesque head in St Mary in Capitol at Cologne (Clemen, op. cit., Pl. XVII): the circle defining the contour of the head can be seen clearly, but the artist did not adhere to it strictly during the execution.

strictly frontal view had 'signified' only one-half the breadth of the head, 'signifies' more than that in the three-quarter view, viz., as much more as point A is removed from the median of the face. A further subdivision of the horizontal dimensions can then be achieved by genuine medieval schematization, i.e., by the simple bisection and quartering of the distance AC (whereby, of course, the objective significance of the points J, D and K differs according to whether the centre of the circle lies in the corner or in the pupil of the eye).[51]

The vertical dimensions remain, as we have noted, unaltered: the nose, the lower part of the face and the neck each receive 1 nose-length. But the brow and the upper part of the head must be satisfied with a smaller dimension, for the root of the nose (B), from which the vertical dimensions are determined, is no longer level (as in the frontal head) with the centre of the circle which describes the contour of the skull; since it coincides with either the corner of the eye or with the pupil, it must necessarily lie somewhat higher. Consequently, if AE is equal to 2 nose-lengths, BL must be somewhat less than 2 nose-lengths.

For all its tendency toward schematization, the Byzantine canon was based, at least in some degree, on the organic structure of the body; and the tendency toward geometrical determination of form was still counterbalanced by an interest in dimensions. The Gothic system – one step further removed from the antique – almost exclusively serves to determine the contours and the directions of movement. What the French architect Villard de Honnecourt wants to transmit to his *confrères* as the '*art de pourtraicture*' is a

51. In the former case, D (the midpoint of AC) designates the inner corner of the left eye, in the latter, its pupil; I (the midpoint of AD) designates, in the former case, the pupil of the right eye, in the latter, its inner corner. Thus, in both cases a 'foreshortening' is suggested by the fact that technically equal quantities 'signify' a larger value on the averted side than on the side turned toward us.

'*méthode expéditive du dessin*' which has but little to do with the measurement of proportions, and from the outset ignores the natural structure of the organism. Here the figure is no longer 'measured' at all, not even according to head- or face-lengths; the schema almost completely renounced, so to speak, the object. The system of lines – often conceived from a purely ornamental point of view and at times quite comparable to the shapes of Gothic tracery – is superimposed upon the human form like an independent wire framework. The straight lines are 'guiding lines' rather than measuring lines: not always coextensive with the natural dimensions of the body, they determine the appearance of the figure only in so far as their position indicates the direction in which the limbs are supposed to move, and as their points of intersection coincide with single, characteristic loci of the figure. Thus the upright male figure (Text Fig. 3) results from a construction that has absolutely no relation to the organic

Figure 3. Construction of the frontal figure, on the basis of Villard de Honnecourt. Paris, Bibliothèque Nationale.

structure of the body: the figure (minus head and arms) is inscribed into a vertically elongated pentagram whose upper vertex is stunted and whose horizontal side AB is about one-third of the long sides AH and BG.[52] Then points A and B coincide with the joints of the shoulders; G and H with the heels; J, the midpoint of line AB, determines the location of the pit of the throat; and the points which divide the long sides into thirds (C, D, E, and F) determine respectively, the location of the hip and the knee joints.[53]

Even the heads (of humans as well as of animals) are constructed not only from such 'natural' forms as circles, but also from the triangle or even from the aforementioned pentagram, which, of itself, is wholly alien to nature.[54] The animal figures – if some kind of articulation is attempted at all – are assembled, in a thoroughly inorganic way, from triangles, squares and circular arcs (Text Fig. 5).[55] And even

52. Thus a false impression is created when, with regard to these figures by Villard, B. Haendcke, 'Dürers Selbstbildnisse und konstruierte Figuren', *Monatshefte für Kunstwissenschaft*, V, 1912, p. 185 ff. (p. 188), speaks of a 'proportional construction of the whole, eight-face figure'.

53. The magical significance of the pentagram certainly plays no more of a role in Villard's *'pourtraicture'* than does the mystical or cosmological significance of the numerical measurements in the Byzantine canon of human proportions.

54. Similar 'drawing aids' survive, incidentally, in studio practice up to modern times; see, e.g., J. Meder, *Die Handzeichnung*, Vienna, 1919, p. 254, where this habit is correctly characterized as 'medieval'. It can be observed even in Michelangelo; cf. the drawing K. Frey, *Die Handzeichnungen Michelagniolos Buonarroti*, Berlin, 1909–11, No. 290. A more complete survival of Villard de Honnecourt's *'pourtraicture'* can be observed in a French manuscript of the middle of the sixteenth century (now Washington, D.C., Congressional Library, Department of Arts, ms. 1) where all kinds of animals and humans are schematized in wholly Villardesque fashion – except that, corresponding to the date, the planimetrical method of the thirteenth century is occasionally combined with the sterometrical approach of the Renaissance theorists. [See now Panofsky, *Codex Huygens* (cited p. 8), p. 119, Figs. 97–9.]

55. Even human figures, when depicted seated or in other unusual positions, are occasionally obtained by a combination of triangles, etc.; see, e.g., Villard, Pl. XLII.

Figure 4. Construction of the figure turned to three-quarter profile, on the basis of Villard de Honnecourt. Paris, Bibliothèque Nationale.

where an interest in mere proportions seems to prevail (as when the large head reproduced in Plate 24 is set into a large square subdivided into 16 equal squares, the side of each equalling 1 nose-length as in the Mount Athos canon),[56] an upended square, made up of diagonals and inscribed into the large square (as in the typical ground plan of Gothic finials), immediately introduces a planimetrical, schematizing principle which determines the form rather than the proportions. This very head, by the way, makes us realize

56. Particularly striking is the heightening of the cranium, which, as in the Mount Athos canon, equals 1 nose-length. That one of Dürer's twenty-six types, too, shows the cranium heightened to a nose-length should not be interpreted (with V. Mortet, 'La mesure de la figure humaine et le canon des proportions d'après les dessins de Villard de Honnecourt, d'Albert Dürer et de Léonard de Vinci', in *Mélanges offerts à M. Emile Chatelain*, Paris, 1910, p. 367 ff.) as proof of an actual connexion.

that all those things are not, as one might be tempted to suppose, sheer fantasy (as closely as they frequently seem to border on this): a head from a contemporaneous stained-glass window at Rheims (Plate 25) exactly corresponds to

Figure 5. Villard de Honnecourt, constructed heads, hand and greyhound. Paris, Bibliothèque Nationale.

Villard's construction not only as regards the dimensions[57] but also in that the features of the face are clearly determined by the idea of an upended square.

Villard de Honnecourt, like the Byzantine and Byzan-

57. The only deviation consists in the relative enlargement of the eyeballs.

tinizing artists, made an interesting attempt to apply the schema devised for the construction of the frontal aspect to the three-quarter view; but he attempted to construct whole figures rather than heads and set about it in an even less differentiated and even more arbitrary way (Text Fig. 4). He utilized the pentagram schema, described above, without any alteration, except that he transferred the shoulder joint, previously coincident with point B, to point X, approximately the midpoint of the distance JB. Just as in the Byzantine construction of the three-quarter profile, the impression of 'foreshortening' is so achieved that the same length is made to 'signify', on the side averted from us, as much as half the total width of the torso, viz., the distance from the pit of the throat to the shoulder joint (JX), while on the side turned toward us it represents only one-quarter of that total width. This curious construction is perhaps the most telling example of a theory of proportions which – '*pour légièrement ouvrier*' – was exclusively concerned with a geometrical schematization of the 'technical' dimensions, whereas the classical theory, proceeding on diametrically opposite principles, had restricted itself to an anthropometric determination of the 'objective' dimensions.

IV

The practical importance of the procedures just characterized was naturally greatest where the artist was most firmly bound by tradition and the general style of his age: in Byzantine art and in Romanesque.[58] In the following period their use seems to diminish, and the Late Gothic of the fourteenth and fifteenth centuries, relying on subjective observa-

58. Even here this practical importance should not be overestimated. Precisely constructed figures are, on the whole, in a minority as against those drawn in freehand, and even where the artists were careful to construct the guide lines, they frequently digressed from them during the execution (cf., e.g., Plate 20, or the figure in St Mary in Capitol referred to in Note 50, p. 111).

tion and equally subjective sentiment, appears to have rejected all constructional aids.[59]

The Italian Renaissance, however, looked upon the theory of proportions with unbounded reverence; but it considered it, unlike the Middle Ages, no longer as a technical expedient but as the realization of a metaphysical postulate.

The Middle Ages, it is true, were thoroughly familiar with a metaphysical interpretation of the structure of the human body. We have seen an example of this way of thinking in the theories of the 'Brethren of Purity', and cosmological speculations, centred around the God-ordained correspondence between the universe and man (and, therefore, the ecclesiastical edifice), played an enormous role in the philosophy of the twelfth century. In the writings of St Hildegard of Bingen a lengthy exposition has been pointed out where the proportions of the human being are thus explained by the harmonious plan of God's creation.[60] However, in so far as the medieval theory of proportions followed the line of harmonistic cosmology, it had no relation to art; and in so far as it stood in relation to art, it had degenerated into a code of practical rules[61] which had lost all connexion with harmonistic cosmology.[62]

59. The fairly frequent indication of a central vertical which, as it were, supports the figure cannot be looked upon as either an aid to construction or as an expedient for determining the proportions.

60. Pater Ildefons Herwegen, 'Ein mittelalterlicher Kanon des menschlichen Körpers', *Repertorium für Kunstwissenschaft*, XXXII, 1909, p. 445 ff. Cf. also the Chronicle of St-Trond (G. Weise in *Zeitschrift für Geschichte der Architektur*, IV, 1910–11, p. 126). There is hardly any doubt that a more thorough investigation of the sources would bring to light much more of the same in the West.

61. Cf., once more, Villard's phrase '*manière pour légièrement ouvrier*'. It is characteristic of the medieval theory of proportions that the *Painter's Manual of Mount Athos* furnishes specific information as to how much the width of the clothed figure should exceed that of the unclothed ($\frac{1}{2}$ of a unit 'should be added' for the draperies).

62. That originally there had been such a connexion is plausible on historical grounds (cf. above, p. 106). Even the change from a ten-

Only in the Italian Renaissance did the two currents merge again. In an era in which sculpture and painting began to achieve the position of *artes liberales*, and in which practising artists tried to assimilate the entire scientific culture of their epoch (while, conversely, scholars and men of letters sought to understand the work of art as a manifestation of the highest and most universal laws), it was only natural that even the practical theory of proportions should be reinvested with metaphysical meaning. The theory of human proportions was seen as both a prerequisite of artistic production and an expression of the pre-established harmony between microcosm and macrocosm; and it was seen, moreover, as the rational basis of beauty. The Renaissance fused, we may say, the cosmological interpretation of the theory of proportions, current in Hellenistic times and in the Middle Ages, with the classical notion of 'symmetry' as the fundamental principle of aesthetic perfection.[63] As a synthesis was sought between

face type in favour of a nine-face type may have been based on number mysticism or cosmological lines of thought (theory of the spheres ?). [See now F. Saxl, cited p. 8.]

63. Julius von Schlosser has shown that one of the earliest post-classical champions of this doctrine, Ghiberti, derived it – possibly through a Western intermediary, for which see below – from an Arabic source, the *Optica* of Alhazen. Even more interesting, however, is the fact that Ghiberti, while drawing from Alhazen, yet promoted the idea of proportionality to an entirely different status. Alhazen does not look upon proportionality as 'the' fundamental principle of beauty; rather he mentions it, as one might say, *en passant*. In his remarkable excursus on what we would call aesthetics, he enumerates no fewer than twenty-one principles or criteria of beauty because, according to him, there is no category of optical perception (such as light, colour, size, position, continuity, etc.) which cannot operate as an aesthetic criterion under certain conditions; and in the context of this long list there appears, quite inorganically connected with the other 'categories', the paean to the 'relationship of the parts'. Ghiberti, then, ignored all the other categories and – with a remarkable instinct for that which is classical – appropriated only the passage in which the catchword 'proportionality' occurs.

Alhazen's aesthetics is remarkable, by the way, not only for the division of the beautiful into as many criteria as there are categories

the mystical spirit and the rational, between Neo-Platonism and Aristotelianism, so was the theory of proportions interpreted both from the point of view of harmonistic cosmology and normative aesthetics; it seemed to bridge the gap between Late-Hellenistic fantasy and classical, Polyclitan order. Perhaps the theory of proportions appeared so infinitely valuable to the thinking of the Renaissance precisely because only this theory – mathematical and speculative at the same time – could satisfy the disparate spiritual needs of the age.

Thus doubly and trebly sanctified (as an additional value we have to consider the historical interest which the 'heirs to antiquity' were bound to take in the scanty allusions of the classical authors for the sole reason that these authors were classical[64]), the theory of proportions achieved an

of visual experience but, above all, for its pervasive relativism. Distance can be conducive to beauty in that it subdues imperfections and irregularities; but the same is true of proximity in that it renders effective the refinements of the design, etc. (cf., by way of contrast, the absolutism of the Stoics [Aëtius, *Stoicorum veterum Fragmenta*, J. ab Armin, ed., Leipzig, II, 1903, p. 299 ff.]: 'the' most beautiful colour is dark blue, 'the' most beautiful shape is the sphere, etc.). On the whole, the pertinent passage of the *Optica* (which was taken over word for word, and not selectively, by a medieval writer like Vitellio) deserves the attention of the Orientalists if only because so purely aesthetic an approach to beauty seems to be foreign to other Arabic thinkers; see, for example, Ibn Chaldûn (Khaldoun), *Prolegomena* (French translation in *Notices et Extraits de la Bibliothèque Impériale*, Paris, 1862–5, XIX–XX), Vol. II, p. 413: '. . . and this [viz., the correct proportion, here used in a moral as well as aesthetic sense] is what is meant by the term beautiful *and good.*'

64. Vitruvius, so zealously exploited and interpreted by Renaissance writers, had not been unfamiliar to the Middle Ages (cf. Schlosser, op. cit., p. 33 [and now H. Koch, cited p. 8]); but it is precisely the specifications of the proportions which were generally neglected by the medieval writers. As a rule, they transmit, besides the division of the face into thirds, only the familiar statement about the inscribability of the human figure into a square and a circle (a statement which lent itself to cosmological interpretation), and no attempt was made to test Vitruvius' data empirically or even to amend the obvious corruption

unheard-of prestige in the Renaissance. The proportions of the human body were praised as a visual realization of musical harmony;[65] they were reduced to general arithmetical or geometrical principles (particularly the 'golden section', to which this period of Plato worship attached a quite extravagant importance);[66] they were connected with the various classical gods, so that they seemed to be invested with an antiquarian and historical, as well as with a mythological and astrological, significance.[67] And new attempts

in his text (see Notes 16 and 83, pp. 95 and 127); Ghiberti proposes to describe the circle around the figure not from the navel, but from the crotch; Cesare Cesariano, *M. Vitruvio Pollione, De Architettura Libri Decem*, Como, 1521, fols. XLIX and I, utilized the Vitruvian division of the face into 3 equal parts, each of which is 1/30 of the total length, for charting a 'calibrated grid' comprising the entire figure, etc.

65. Cf., e.g., Pomponius Gauricus, *De sculptura* (H. Brockhaus, ed., Vienna, 1886, p. 130 ff.). Furthest in this respect goes a work published at Venice in 1525, *Francisci Giorgii Veneti de harmonia mundi totius cantica tria*. That the writer (the same Francesco Giorgi who furnished the well-known report on S. Francesco della Vigna at Venice) infers from the possibility of inscribing the human figure in a circle – whose centre he, like Ghiberti, transfers to the crotch – a correspondence between microcosm and macrocosm is not unusual. But he also connects the height, width and depth relationships within the human body with the dimensions of Noah's ark (300:50:30) and very seriously equates particular proportions with the antique musical intervals, for instance:

Total length: length minus the head = 9:8 (*tonus*)
Length of torso: length of the legs = 4:3 (*diatessaron*)
Chest (from pit of throat to navel): abdomen = 2:1 (*diapason*), etc.

The writer owes his knowledge of Francesco Giorgi's book, which, though hardly ever quoted in art-historical literature, is not unimportant because of its possible connexion with Dürer's theory of proportions (cf. below, Note 92, p. 131), to what used to be the Bibliothek Warburg at Hamburg and is now the Warburg Institute of London University.

66. Cf. e.g., Luca Pacioli, *La divina proportione*, C. Winterberg, ed. (*Quellenschriften für Kunstgeschichte*, new ser., II), Vienna, 1889, p. 130 ff. Further: Mario Equicola, *Libro di natura d'amore*, here quoted from the Venice edition, 1531, fol. 78 r/v.

67. Giovanni Paolo Lomazzo, *Trattato dell' arte della pittura*, Milan, 1584 (reprinted Rome, 1844), Book IV, Ch. 3; Book I, Ch. 31.

were made – in connexion with a remark by Vitruvius – to identify human proportions with those of buildings and parts of buildings, in order to demonstrate both the architectonic 'symmetry' of the human body and the anthropomorphic vitality of architecture.[68]

This high evaluation of the theory of proportions was, however, not always matched by a readiness to perfect its methods. The more enthusiastic the Renaissance authors wax about the metaphysical significance of human proportions, the less disposed they seem, as a rule, to empirical study and verification. What they actually produced was generally little more than a recapitulation (at most, an emendation) of Vitruvius or, even more often, a reproduction of the nine-units system already known to Cennini. Only occasionally did they attempt to specify the measurements of the head by a new method[69] or, to keep up with the conquest of the third dimension, sought to supplement the statements about length and width with statements about depth.[70] One senses the dawn of a new era chiefly in that the theoreticians began to check the Vitruvian data by measuring classical statues – whereby they found them, at first, to be confirmed in all respects[71] but later arrived, occasionally, at divergent results;[72] and in that at least a few of them,

68. Thus, e.g., Filarete, op. cit.; further, L. B. Alberti, *De re aedificatoria*, VII, Ch. 13; after him, Giannozzo Manetti (ed. Muratori, *SS. rer. Ital., III*, Part II, p. 937); Lomazzo, op. cit., Book I, Ch. 30, etc. Such correspondences are particularly noteworthy when an attempt is made to illustrate them pictorially, as, for example, in the 'Codex Angelo da Cortina', now in the Stadtbibliothek at Budapest, or by Francesco di Giorgio Martini (treatise cited above, Note 30, p. 105), Plate Volume, Pl. I.

69. See Ghiberti, loc. cit., who, incidentally, repeats the Vitruvian canon in addition to his own; cf. also Luca Pacioli, loc. cit.

70. This applies to Pomponius Gauricus who – certainly under the influence of Leonardo da Vinci, noticeable also in other respects – gives, comparatively speaking, more detailed information than do the other writers.

71. Luca Pacioli, op. cit., pp. 135–6.

72. Cesare Cesariano, op. cit., fol. XLVIII.

often with reference to classical mythology, insisted upon a certain differentiation of the ideal canon.

The coexistence of the Vitruvian and the pseudo-Varronic traditions implied, *per se*, two different types, one comprising nine face-lengths, the other ten; and when these types were supplemented by an even shorter one, the theorists arrived at a triad which could be related, according to taste, with specific gods,[73] with the three styles of classical architecture,[74] or with the categories of nobility, beauty, and grace.[75] It is significant, however, that our expectation to see these types elaborated in detail is nearly always disappointed. When it comes to exact, individual measurements, the authors either fall silent, or, while recognizing a plurality of types, single out one which, at second glance, turns out to be identical with one of the old stand-bys – the canons of Vitruvius and Cennini.[76] And if the First Book of Lomazzo's *Trattato della pittura* stands out for both its great variety of types and for its exact specification of their measurements, it owes this distinction to the simple fact that Lomazzo, writing as late as 1584, had predecessors whom he could exploit in reckless fashion; the man of nine head-lengths (Ch. 9) is identical with Dürer's 'Type D', the one of eight head-lengths (Ch. 10) with Dürer's 'Type B', that of seven head-lengths (Ch. 11) with Dürer's 'Type A', the very slender man (Ch. 8) with Dürer's 'Type E', etc.

As far as solid knowledge and methodical procedure are concerned, only two artist-theoreticians of the Italian Renaissance took decisive steps toward developing the theory of proportions beyond medieval standards: Leone Battista

73. See Lomazzo, op. cit., IV, 3. His identification of the pagan gods with Christian characters was anticipated by Dürer.

74. Filarete, loc. cit.; cf. also Francesco Giorgi, op. cit., I, p. 229 ff., where a nine-head type is distinguished from a seven-head type.

75. Thus, Federigo Zuccari (cf. Schlosser, *Die Kunstliteratur*, Vienna, 1924, p. 345 f.).

76. Identical with the latter is, e.g., Filarete's 'Doric' man who, oddly enough, is slenderer than the 'Ionic' and the 'Corinthian'.

Alberti, the prophet of the 'new, grand style', in art, and Leonardo da Vinci, its inaugurator.[77]

Both agree in their determination to raise the theory of proportions to the level of an empirical science. Dissatisfied with the inadequate data of Vitruvius and their own Italian forerunners, they disregarded tradition in favour of an experience supported by the accurate observation of nature. Italians that they were, they did not attempt to replace the one, ideal type with a plurality of 'characteristic' ones. But they ceased to determine this ideal type on the basis of a harmonistic metaphysics or by accepting the data of sanctified authorities: they ventured to face nature herself and approached the living human body with compass and ruler, except that from a multitude of models they selected those which, in their own judgement and in the opinion of competent advisers, were deemed the most beautiful.[78] Their intention was to discover the ideal in an attempt to define the normal, and instead of determining the dimensions only roughly and only in so far as they were visible on the plane, they sought to approach the ideal of a purely scientific anthropometry by ascertaining them, with great exactitude and careful regard to the natural structure of the body, not only in height but also in width and depth.

Alberti and Leonardo, then, supplemented an artistic practice which had freed itself from medieval restrictions by a theory of proportions which accomplished more than to provide the artist with a planimetric schema of design – a theory which, based on empirical observation, was capable of defining the normal human figure in its organic articulation and in full three-dimensionality. These two great 'moderns' differed, however, in one important respect:

77. It is hoped that Bramante's studies on proportions, whose existence is attested to in literary references, will be discovered in the future.

78. Alberti, op. cit., p. 201. Leonardo (*Leonardo da Vinci, das Buch von der Malerei*, H. Ludwig, ed. [*Quellenschriften für Kunstgeschichte*, XV–XVII], Vienna, 1881, Articles 109 and 137) even admits the validity of general public opinion (cf. Plato, *Politicus*, 602b).

Alberti tried to attain the common goal by perfecting the method – Leonardo, by expanding and elaborating the material. With the open-mindedness that characterizes his approach even to the antique,[79] Alberti freed himself, as far as method is concerned, from every tradition. He devised – only loosely attaching his procedure to Vitruvius' statement that the foot is equal to one sixth of the total length of the body – a new, ingenious system of mensuration which he called 'Exempeda'; he divided the total length into *six pedes* (feet), sixty *unceolae* (inches), and six hundred *minuta* (smallest units)[80] – with the result that he could easily yet accurately obtain and tabulate the measurements taken from the living model (Text Fig. 6); the quantities could even be added and subtracted like decimal fractions – which indeed they are. The advantages of this new system are obvious. The traditional units – *teste* or *visi* – were too large for detailed mensuration.[81] To express the measurements in common fractions of the total length was cumbersome because it is impossible to determine how many times an unknown length is contained in a known one without prolonged experimentation (it took the *unica et infinita diligentia* of a Dürer to operate in this fashion without losing patience). And to apply commercial standards of measurement (such, for example, as the 'Florentine cubit' or the 'Roman *canna*') and their subdivisions would have been fruitless when the pur-

79. See also, e.g., Dagobert Frey, *Bramantestudien*, I, Vienna, 1915, p. 84.

80. Alberti, op. cit., p. 178 ff. The term 'Exempeda' is supposed to derive from the verb ἐξεμπεδόω ('to observe strictly'); according to others, it is intended to convey, in somewhat questionable Greek, the idea of a 'six-foot system'.

81. Alberti's system, on the other hand, was in many respects too intricate for practical use. In practice, most artists had recourse to the unit of a *testa* divided into halves or thirds; cf. the well-known Michelangelo drawing, Thode 532 (photogr. Braun 116). According to his own statement, Michelangelo's interests were, in fact, directed less toward the compilation of numerical measurements, than toward the observation of *atti e gesti*.

pose of the undertaking was to ascertain, not the absolute, but the relative dimensions of the object: the artist could benefit only by a canon which enabled him to represent his figure on any scale required.

The results obtained by Alberti himself are, it must be admitted, somewhat scanty; they consist of one single table of measurements which, however, Alberti claims to have verified by investigating a considerable number of different

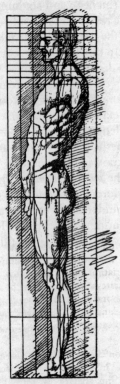

Figure 6. Follower of Leonardo da Vinci, figure proportioned according to L. B. Alberti's 'Exempeda'. Drawing in the *Codex Vallardi*. Photo Giraudon, no. 260; the subdivision of the upper section entered by the writer.

persons.[82] Leonardo, instead of refining the method of measurement, concentrated on enlarging the field of observation. When dealing with human – as opposed to equine – proportions, he mostly resorted, after the model of Vitruvius and in sharp contrast to all other Italian theorists,[83] to the method of common fractions without, however, entirely rejecting the 'Italo-Byzantine' division of the body into nine or ten face-lengths.[84] He could be satisfied with these relatively simple methods because he interpreted the prodigious amount of visual material which he collected (without, unfortunately, ever synthesizing it) from an entirely original point of view. Identifying the beautiful with the natural, he sought to ascertain, not so much the aesthetic excellence as the organic uniformity of the human form; and for him, whose scientific thinking was largely dominated by analogy,[85] the criterion for this organic uniformity consisted in the existence of 'correspondences' between as many as possible, though often completely disparate, parts of the body.[86] Thus, most of his statements are couched in the

82. Alberti, op. cit., p. 198 ff.

83. Whom he excerpted and emended (Richter, *The Literary Works of Leonardo da Vinci*, London, 1883, No. 307, Pl. XI). The fact that Lomazzo used the method of common fractions is based on his direct dependence upon Dürer (cf. above, p. 123).

84. In Leonardo's studies both types – one corresponding to the Vitruvian proportions, the other to the Cennini-Gauricus canon – coexist without differentiation so that it is often difficult or impossible to connect a particular statement with either the one or the other. [For Leonardo's far more elaborate system of measuring the proportions of the horse, see now E. Panofsky, *The Codex Huygens and Leonardo da Vinci's Art Theory* (Studies of the Warburg Institute, XIII), London, 1940, p. 51 ff.]

85. Cf. L. Olschki, *Geschichte der neusprachlichen wissenschaftlichen Literatur*, I. Heidelberg, 1919, p. 369 ff. I do not agree, however, with Olschki's interpretation of Leonardo on all points.

86. Cf. E. Panofsky, *Dürers Kunsttheorie*, Berlin, 1915, p. 105 ff. The method of 'determining analogies' was adopted by Pomponius Gauricus and, among others, Affricano Colombo, who appended to his small book on the planets (*Natura et inclinatione delle sette Pianeti*) a

form: 'da x a y è simile a lo spatio che è infra v e z' ('the distance xy equals the distance vz'). Above all, however, he extended the very aims of anthropometry in a novel direction: he embarked upon a systematic investigation of those mechanical and anatomical processes by which the objective dimensions of the quietly upright human body are altered from case to case, and thereby fused the theory of human proportions with a theory of human movement. He determined the thickening of the joints while flexing or the expansion and contraction of the muscles which attends the bending or stretching of the knee or the elbow, and ultimately managed to reduce all movements to a general principle which may be described as the principle of continuous and uniform circular motion.[87]

These two developments throw light on what is perhaps the most fundamental difference between the Renaissance and all previous periods of art. We have repeatedly seen that there were three circumstances which could compel the artist to make a distinction between the 'technical' proportions and the 'objective': the influence of organic movement, the influence of perspective foreshortening, and the regard for the visual impression of the beholder. These three factors of variation have one thing in common: they all presuppose the artistic recognition of subjectivity. Organic movement introduces into the calculus of artistic composition the subjective will and the subjective emotions of the thing represented; foreshortening, the subjective visual experience of

theory of proportions for painters and sculptors (completely based on Vitruvius in every other respect). His fusing of astrological doctrines with the theory of proportions is a characteristic attempt at reinterpreting Leonardo's scientific naturalism in the spirit of cosmological mysticism.

87. *Trattato della pittura*, Article 267 ff. Alberti had already observed (op. cit., p. 203) that the breadth and thickness of the arm change according to its movement; but he had not as yet attempted to determine the extent of these changes numerically. [For Leonardo's theory of circular movement, see now Panofsky, *The Codex Huygens*, pp. 23 ff., 122 ff., Figs. 7–13.]

the artist; and those 'eurhythmic' adjustments which alter that which is right in favour of that which seems right, the subjective visual experience of a potential beholder. And it is the Renaissance which, for the first time, not only affirms but formally legitimizes and rationalizes these three forms of subjectivity.

In Egyptian art only the objective had counted because the represented beings did not move from their own volition and consciousness, but seemed, by virtue of mechanical laws, to be eternally arrested in this or that position; because no foreshortening took place; and because no concessions were made to the visual experience of the beholder.[88] In the Middle Ages, art espoused, as it were, the cause of the plane against that of the subject as well as that of the object, and produced that style in which, though 'actual' – as opposed to 'potential' – movement took place, the figures seemed to act under the influence of a higher power rather than of their own free will; and in which, though the bodies turn and twist in various ways, no real impression of depth is achieved or intended. Only in classical antiquity did the three subjective factors of organic movement, perspective foreshortening and optical adjustment attain recognition; but – and this is the fundamental difference – such recognition was, so to speak, unofficial. Polyclitan anthropometry was not paralleled by an equally developed theory of movement nor by an equally developed theory of perspective: whatever foreshortening is encountered in classical art does not result from the interpretation of the visual image as a central projection constructible by strict geometrical methods; and the adjustments intended to rectify the view for the beholder were, so far as we know, handled only 'by rule of thumb'. It was, therefore, a fundamental innovation when the Renaissance supplemented anthropometry with

88. Setting aside all stylistic considerations, we must bear in mind that the most important Egyptian works of art were not created for the purpose of being seen; they were placed in dark, inaccessible tombs, removed from every view.

both a physiological (and psychological) theory of movement and a mathematically exact theory of perspective.[89]

Those who like to interpret historical facts symbolically may recognize in this the spirit of a specifically 'modern' conception of the world which permits the subject to assert itself against the object as something independent and equal; whereas classical antiquity did not as yet permit the explicit formulation of this contrast; and whereas the Middle Ages believed the subject as well as the object to be submerged in a higher unity.

The actual transition from the Middle Ages to the Renaissance (and, in a sense, beyond it) can be observed, as under laboratory conditions, in the development of the first German theorist of human proportions: Albrecht Dürer. Heir to the Northern, Gothic tradition, he started out with a planimetrical surface scheme (at the beginning not even incorporating the Vitruvian data) which, like Villard's '*pourtraicture*', purported to determine posture, movement, contour and proportions at the same time (Plate 26).[90] Under

89. In the Renaissance even the 'eurhythmic' alterations to which the measurements had to be subjected in works placed above eye level (or, for example, on vaulted surfaces) were determined by means of exact geometrical construction. See Leonardo's directions for painting objects on curved walls (Richter, op. cit., Pl. XXXI; *Trattato*, Article 130), or Dürer's directions for the scaling of letters which, though placed on different levels, would appear to be of equal size (*Underweysung der Messung* . . ., 1525, fol. K. 10); Dürer's method, transferred from wall inscriptions to mural paintings, is repeated in Barbaro, op. cit., p. 23.

90. It is this structural affinity rather than the fortuitous correspondence observed by Mortet (cf. Note 56, p. 115) which constitutes an intrinsic relationship between Dürer and the Middle Ages, especially Villard de Honnecourt. H. Wölfflin (in *Monatshefte für Kunstwissenschaft*, VIII, 1915, p. 254) would therefore seem to overstate the case when he says that Mortet had correctly recognized the connexion between Dürer's early studies in human proportion and Gothic tradition. It may be mentioned here that Dr Edmund Schilling has succeeded in discovering circular arcs, traced with the compass, in the Sebastian drawing L.190 which this writer had claimed as belonging to the series of constructed drawings beginning with L.74/75 (our Plate 26).

the influence of Leonardo and Alberti, however, he shifted
his aims towards a purely anthropometric science which he
believed to have an educational rather than practical value:
'In the rigid postures in which they are drawn up on the
foregoing pages,' he says of his numerous, elaborate parad-
igms, 'the figures are of no use whatever.'[91] In his dis-
ciplined and unrewarding pursuit of knowledge for its own
sake, Dürer employed the classical and Leonardesque method
of common fractions (Text Fig. 7) in the First and Second
Book, and Alberti's 'Exempeda' (whose smallest unit, $\frac{1}{600}$,
he split into three further subdivisions)[92] in the Third. But

91. 'Dann die Bilder döchten so gestrackt, wie sie vorn beschrieben
sind, nichts zu brauchen.' Cf. Panofsky, *Dürers Kunsttheorie*, p. 81 ff.,
especially p. 89 ff. and 111 ff.

92. It is a moot question as to how Dürer became familiar with Al-
berti's 'Exempeda', since the *De Statua*, in which it is described, was
not published until many years after Dürer's death. Conceivably
Dürer's source can be identified with the *Harmonia mundi totius* by
Francesco Giorgi (see Note 65, p. 121); this work contains (fol. C.1) a
circumstantial description of Alberti's method, which – apart from one
terminological misunderstanding – is fairly accurate and amounts to a
direct quotation: 'Attendendum est ad mensuras, quibus nonnulli
microcosmographi metiuntur ipsum humanum corpus. Dividunt enim
id per sex pedes . . . et mensuram unius ex iis pedibus hexipedam [!]
vocant. Et hanc partiuntur in gradus decem, unde ex sex hexipedis
gradus sexaginta resultant, gradum vero quemlibet in decem . . .
minuta.' 'Attention must be paid to the measurements which certain
microcosmographers apply to the human body itself. They divide it
into six feet . . . and the measure of one of these feet they call *exempeda*
[!]. This measure they divide into ten parts [*gradus*, called *unceolae* by
Alberti]; so that six feet total sixty parts, and each part into ten smallest
units [*minuta*, the authentic Albertian term].' The author himself, how-
ever, prefers a division into 300 rather than 600 *minuta*, in order to pre-
serve the aforementioned (Note 65, p. 121) correspondences between
the human body and Noah's ark. The publication date of Francesco
Giorgi's work, 1525, would agree with our hypothesis, since it can be
proved (cf. Panofsky, *Dürers Kunsttheorie*, p. 119) that Dürer first be-
came acquainted with the 'Exempeda' between 1523 and 1528.
[Agrippa of Nettesheim may have drawn from the same source, since
he refers to the 'Exempeda' system in the printed edition of his *De
occulta philosophia* (published in 1531), II, 27, but not in the original
version of 1509.]

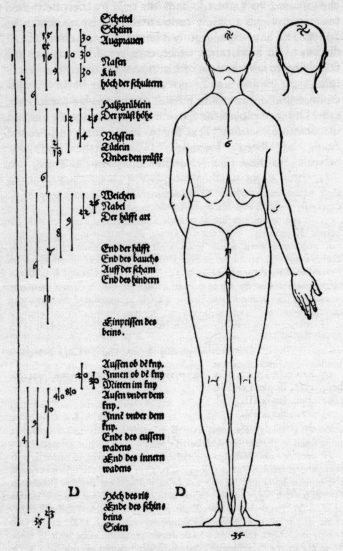

Figure 7. Albrecht Dürer, 'Man D'. From the first book of *Vier Bücher von menschlicher Proportion*, Nuremberg, 1528.

he surpassed both great Italians not only by the variety and precision of his measurements, but also by a genuinely critical self-limitation. Firmly renouncing the ambition to discover one ideal canon of beauty, he undertook the infinitely more laborious task of setting up various 'characteristic' types which – each in its own way – should 'avoid crude ugliness'. He accumulated no fewer than twenty-six sets of proportions, plus an example of the infant's body and the detailed measurements of the head, the foot and the hand.[93] Not satisfied with even this, he indicated ways and means of further varying these many types so as to capture even the abnormal and grotesque by strictly geometrical methods (Text Fig. 8).[94]

Dürer, too, attempted to supplement his theory of mensuration with a theory of movement (which, however, turned out to be rather awkward and mechanical[95] because of his lack of anatomical and physiological knowledge) and with a theory of perspective.[96] Since he, like the great Italian painter-theoreticist, Piero della Francesca, wanted to see perspective applied to human figures as well as to inanimate objects, he attempted to facilitate this very complicated process by reducing the irrational surfaces of the human body to shapes definable by simple planes,[97] and it is extra-

93. Albrecht Dürer, *Vier Bücher von menschlicher Proportion*, Nuremberg, 1528, Books I and II.

94. ibid., Book III.

95. ibid., Book IV.

96. Albrecht Dürer, *Underweysung der Messung mit dem Zirckel und Richtscheyt*, Nuremberg, 1525, fol. P.L.v. ff.

97. Dürer, *Vier Bücher . . .*, Book IV, and numerous drawings. I am referring to the famous 'cube system' which, according to Lomazzo, goes back to Foppa, and which was later taken up and developed by Holbein, Altdorfer, Luca Cambiaso, Erhard Schön, and others (cf. Meder, op. cit., p. 624, Figs. on pp. 319, 619, 623). This system is related to Dürer's drawings of heads the surfaces of which are reduced to polygons (illustrated in Meder, op. cit., p. 622), a device which the present writer has tried to trace back to Italian sources (*Kunstchronik*, new ser., XXVI, 1915, col. 514 ff.) and to which Meder (p. 564, Fig. 267) has produced a more conclusive analogy.

ordinarily informative to compare these schemes, elaborated in the twenties, with the constructions of *c.* 1500 (Plate 26). Instead of interfering with the final representation, the Later Dürer only prepares it; instead of defining contours by circular arcs, he inscribes plastic units into stereometrical solids; to a mathematical schematization of linear design he opposes a mathematical clarification of plastic concepts (Plate 27).[98]

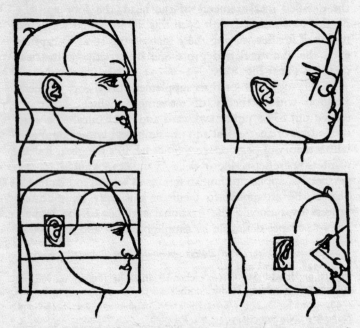

Figure 8. Albrecht Dürer, four caricatured profiles. From the third book of *Vier Bücher von menschlicher Proportion*, Nuremberg, 1528.

98. In another way, likewise no longer planimetric, the figure in motion is schematized in a series of drawings, ascribed to Erhard Schön, an example of which is reproduced in Text Fig. 9 (reproductions also in Fr. W. Ghillany, *Index rarissimorum aliquot librorum, quos habet bibliotheca publica Noribergensis*, 1846, p. 15). For the method followed in these drawings, cf. the illustration in Leonardo's *Trattato*, Article 173.

V

Dürer's *Vier Bücher von menschlicher Proportion* marks a climax which the theory of proportions had never reached before nor was to reach ever after. It also marks, however, the beginning of its decline. Dürer himself succumbed, to a degree, to the temptation of pursuing the study of human proportions as an end in itself: by their very exactitude and

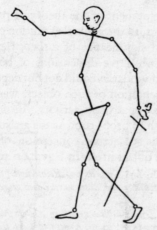

Figure 9. Erhard Schön (?), schematization of human movement (tracing). Nuremberg, Stadtbibliothek.

complexity his investigations went more and more beyond the bounds of artistic usefulness, and finally lost almost all connexion with artistic practice. In his own work, the effect of this overdeveloped anthropometric technique is less noticeable than that of his first, imperfect endeavours. And if we remember that the smallest unit of his metrical system, the so-called 'particle' (*Trümlein*), was equal to less than a millimetre, the chasm between theory and practice becomes obvious.

What follows Dürer's efforts in the theory of human proportions as a branch of the theory of art is, therefore, on the one hand a series of such insignificant workshop productions, all more or less dependent on his *opus maius*, as the booklets by Lautensack,[99] Beham,[1] Schön,[2] van der Heyden,[3] or Bergmüller,[4] and, on the other, such aridly dogmatic works as those of a Schadow[5] or a Zeising.[6] But while his methods did not serve, as he had hoped, the cause of art, they proved invaluable for the development of such new sciences as anthropology, criminology and – most surprisingly – biology.[7]

This final development of the theory of proportions corresponds, however, to the general evolution of art itself. The artistic value and significance of a theory exclusively concerned with the objective dimensions of bodies contained within definable boundaries could not but depend on whether or not the representation of such objects was recognized as the essential goal of artistic activity. Its importance was bound to diminish in proportion as the artistic genius began to emphasize the subjective conception of the object in preference to the object itself. In Egyptian art, the theory of

99. H. Lautensack, *Des Circkels und Richtscheyts, auch der Perspectiva und Proportion der Menschen und Rosse kurtze doch gründliche Underweisung*, Nuremberg, 1564.

1. H. S. Beham, *Dies Büchlein zeyget an ... ein Mass oder Proporcion des Ross*, Nuremberg, 1528; idem, *Kunst und Lere Büchlein ...*, Frankfurt, 1546 (and frequently thereafter); cf. also his engravings, pp. 219–21.

2. E. Schön, *Underweysung der Proportion und Stellung der Possen*, Nuremberg, 1542 (facsimile edition, L. Baer, ed., Frankfurt, 1920).

3. J. van der Heyden, *Reissbüchlein ...*, Strassburg, 1634.

4. J. G. Bergmüller, *Anthropometria oder Statur des Menschen*, Augsburg, 1723.

5. G. Schadow, *Polyclet oder von den Massen der Menschen*, Berlin, 1834 (11th ed., Berlin, 1909).

6. A. Zeising, *Neue Lehre von den Proportionen des Körpers*, Leipzig, 1854; idem, *Aesthetische Forschungen*, Frankfurt, 1855.

7. I am referring to the very serious revival of Dürer's doctrine of 'geometrical variation' (*Vier Bücher ...*, Book III) in D'Arcy W. Thompson's famous book *On Growth and Form*, first published in 1917.

proportions meant almost everything because the subject meant almost nothing; it was doomed to sink into insignificance as soon as this relation was reversed. The victory of the subjective principle was prepared, we recall, by the art of the fifteenth century, which affirmed the autonomous mobility of the things represented and the autonomous visual experience of the artist as well as the beholder. When, after the 'revival of classical antiquity' had spent its momentum, these first concessions to the subjective principle came to be exploited to the full, the role of the theory of human proportions as a branch of art theory was finished. The styles that may be grouped under the heading of 'pictorial' subjectivism – the styles most eloquently represented by seventeenth-century Dutch painting and nineteenth-century Impressionism – could do nothing with a theory of human proportions, because for them solid objects in general, and the human figure in particular, meant little in comparison with the light and air diffused in unlimited space.[8] The styles that may be grouped under the heading of 'non-pictorial' subjectivism – pre-Baroque Mannerism and modern 'Expressionism' – could do nothing with a theory of human proportions, because for them the solid objects in general, and the human figure in particular, meant something only in so far as they could be arbitrarily shortened and lengthened, twisted, and, finally, disintegrated.[9]

8. To Northern art this applies at an even earlier date (fifteenth and sixteenth centuries), except for such artists as Dürer and his followers who fell under the spell of classical tendencies.

9. Cf. Michelangelo's statement referred to in Note 81, p. 125. Even in the theoretical literature on art which, as such, necessarily gravitates toward 'objectivistic' classicism, a waning of the interest in a scientific theory of proportions can be observed in certain places and at certain times. Vincenzo Danti, the epigone of Michelangelo, planned a work (published only in small excerpts) which, despite its title *Delle perfette proportioni*, does not proceed mathematically but approaches the subject from an anatomical, mimic and pathognomic point of view (see J. von Schlosser, *Die Kunstliteratur*, pp. 343 ff., 359, 396); and the Netherlander Carel van Mander treated the problem of proportions with extraordinary indifference (see Schlosser, ibid.). [Cf. also E.

In 'modern' times, then, the theory of human proportions, abandoned by the artists and the theorists of art, was left to the scientists – except for circles fundamentally opposed to the progressive development which tended toward sub-jectivity. It is no accident that the mature Goethe, having abandoned the Romanticism of his youth in favour of an essentially classicistic conception of art, devoted a warm and active interest to what had been the favourite discipline of Leonardo and Dürer: 'To work away at a canon of mascu-line and feminine proportions,' he writes to J. H. Meyer,

to seek the variations out of which character arises, to examine more closely the anatomical structure, and to seek the beautiful forms that mean exterior perfection – to such difficult researches I wish you to contribute your share just as I, for my part, have made some preliminary investigations.[10]

Panofsky, *Idea* (Studien der Bibliothek Warburg, V), Leipzig and Berlin, 1924, p. 41 ff.; in the Italian translation, Florence, 1952, p. 57 ff.] All the more surprising is the fact that Rembrandt, who certainly had no special interest in the theory of proportions, on one occasion drew a Vitruvius man-in-a-square; but he 'disguised' him so success-fully that he has not been recognized as such: as an Oriental, sketched from the model and dressed in turban and long cloak, whose posture is casual rather than rigid, the head turned slightly to the side. Were it not for the square and the crosslines dividing the torso, the drawing (C. Hofstede de Groot, *Die Handzeichnungen Rembrandts*, Haarlem, 1906, No. 631) would be accepted as a costume study from life, and the outspread arms would be interpreted as an expressive gesture.

10. Goethe, Letter to Meyer of 13 March 1791 (Weimar edition, IV, 9, p. 248).

3
Abbot Suger of St-Denis

Rarely – in fact, all but never – has a great patron of the arts
been stirred to write a retrospective account of his intentions
and accomplishments. Men of action, from Caesars to
country doctors, have recorded the deeds and experiences
they felt would not attain deserved permanence save by
grace of the written word. Men of expression, too, from
writers and poets to painters and sculptors (once artistry had
been promoted to Art by the Renaissance), have resorted to
autobiography and self-interpretation whenever they feared
that their works alone, being but isolated and crystallized
products of a continuous process of creation, might not
convey a unified and living message to posterity. Not so
with the patron, the man whose prestige and initiative sum-
mon other men's work into being: the prince of the Church,
the secular ruler, the aristocrat and the plutocrat. From his
point of view the work of art should render praises unto the
patron, but not the patron unto the work of art. The
Hadrians and Maximilians, the Leos and Juliuses, the Jean
de Berrys and Lorenzo de' Medicis decided what they
wanted, selected the artists, took a hand in devising the
programme, approved or criticized its execution and paid –
or did not pay – the bills. But they left it to their court
officials or secretaries to draw up the inventories, and to
their historiographers, poets and humanists to write the des-
criptions, eulogies and explanations.

A special concatenation of circumstances and a unique
blend of personal qualities were needed to bring into exist-

ence the documents produced by Suger, Abbot of St-Denis, and preserved by time's mercy.

I

As the head and reorganizer of an abbey that in political significance and territorial wealth surpassed most bishoprics, as the Regent of France during the Second Crusade, and as the 'loyal adviser and friend' of two French kings at a time when the Crown began to reassert its power after a long period of great weakness, Suger (born 1081 and Abbot of St-Denis from 1122 until his death in 1151) is an outstanding figure in the history of France; not without reason has he been called the father of the French monarchy that was to culminate in the state of Louis XIV. Combining the shrewdness of a great businessman with a natural sense of equity and a personal rectitude (*fidelitas*) recognized even by those who did not really like him, conciliatory and averse to violence yet never infirm of purpose and not lacking physical courage, restlessly active yet a past master in the art of biding his time, a genius for detail yet capable of seeing things in perspective, he placed these contradictory gifts at the service of two ambitions: he wanted to strengthen the power of the Crown of France, and he wanted to aggrandize the Abbey of St-Denis.

In Suger these ambitions did not conflict with each other. On the contrary, they appeared to him as aspects of but one ideal, which he believed to correspond both to natural law and to the Will Divine. For he was convinced of three basic truths. First, a king, and most particularly the king of France, was a 'vicar of God', 'bearing God's image in his person and bringing it to life'; but this fact, far from implying that the king could do no wrong, entailed the postulate that the king must do no wrong ('it disgraces a king to transgress the law, for the king and the law – *rex et lex* – are receptacles of the same supreme power of government'). Second, any king of France, but quite especially Suger's beloved master, Louis

le Gros, who at his coronation in 1108 had divested himself
of the secular sword and had been girded with the sword
spiritual 'for defence of the Church and the poor', had both
the right and the sacred duty to subdue all forces conducive
to internal strife and obstructive to his central authority.
Third, this central authority and, therefore, the unity of the
nation were symbolized, even vested, in the Abbey of St-
Denis which harboured the relics of the 'Apostle of all Gaul',
the 'special and, after God, unique protector of the realm'.

Founded by King Dagobert in honour of Saint Denis and
his legendary Companions, Sts Rusticus and Eleutherius
(usually referred to by Suger as 'the Holy Martyrs' or 'our
Patron Saints'), St-Denis had been the 'royal' abbey for
many centuries. 'As though by natural right' it housed the
tombs of the French kings; Charles the Bald and Hugh
Capet, the founder of the ruling dynasty, had been its titular
abbots; and many princes of the blood received their early
education there (it was indeed in the school of St-Denis-de-
l'Estrée that Suger, as a boy, had formed his lifelong friend-
ship with the future Louis le Gros). In 1127 St Bernard
summed up the situation fairly correctly when he wrote:

This place had been distinguished and of royal dignity from
ancient times; it used to serve for the legal business of the Court
and for the soldiery of the king; without hesitation or deceit
there were rendered unto Caesar the things which are his, but
there were not delivered with equal fidelity to God the things
which are God's.

In this much-quoted letter, written in the sixth year of
Suger's abbacy, the Abbot of Clairvaux congratulates his
worldlier *confrère* on having successfully 'reformed' the
Abbey of St-Denis. But this 'reform', far from diminishing
the Abbey's political importance, invested it with an inde-
pendence, prestige and prosperity that permitted Suger to
tighten and to formalize its traditional ties with the Crown.
Reform or no reform, he never ceased to promote the inter-
ests of St-Denis and the Royal House of France with the

same naïve, and in his case not entirely unjustified, conviction of their identity with those of the nation and with the Will of God as a modern oil or steel magnate may promote legislation favourable to his company and to his bank as something beneficial to the welfare of his country and to the progress of mankind.[1] For Suger the friends of the Crown were and remained the 'partisans of God and Saint Denis' just as an enemy of St-Denis was and remained a 'man with no regard for either the king of the Franks or the King of the Universe'.

Constitutionally peace-loving, Suger tried to achieve his ends, wherever possible, by negotiation and financial settlement rather than by military force. From the inception of his career he had incessantly worked for an improvement of the relations between the Crown of France and the Holy See, which had been worse than strained under Louis le Gros' father and predecessor, Philip I. Suger was entrusted with special missions to Rome long before his elevation to the abbacy; it was on one of these missions that he received the news of his election. Under his skilful management the relations between the Crown and the Curia developed into so firm an alliance that it not only strengthened the internal position of the king but also neutralized his most dangerous external enemy, the German Emperor Henry V.

No diplomacy could prevent a series of armed conflicts with Louis' other great foe, the proud and gifted Henry I Beauclerc of England. A son of William the Conqueror, Henry very naturally refused to renounce his continental heritage, the Duchy of Normandy, while Louis, just as naturally, tried to transfer it to his less powerful and more reliable vassals, the Counts of Flanders. Yet Suger (who had a genuine admiration for Henry's military and administrative genius) miraculously managed to acquire and to retain his

1. [This sentence was written nearly ten years before a well-known industrialist, on the verge of his transformation into statesman, declared: 'What is good for General Motors is good for the United States.']

confidence and private friendship. Time and again he acted as an intermediary between him and Louis le Gros; and it is in this connexion that Suger's special protégé and devoted biographer, the monk Willelmus of St-Denis (relegated to the Priory of St-Denis-en-Vaux as soon as his protector had died) produced one of those happy formulae that are at times granted to simple-minded affection rather than to critical acumen: 'Has not Henry, the mighty King of England,' he writes, 'prided himself on this man's friendship and enjoyed the intercourse with him? Has he not chosen him as his mediator with Louis, King of France, and as a tie of peace?'

Mediator et pacis vinculum: these four words comprise about all that can be said about Suger's aims as a statesman, with respect to foreign as well as to interior policy. Thibaut IV (the Great) of Blois, a nephew of Henry I of England, was generally on the side of his uncle. But with him, too, Suger remained on excellent terms and finally succeeded in bringing about a lasting peace between him and the King of France, now Louis VII who had succeeded his father in 1137; Thibaut's son, Henry, was to become one of the younger Louis' most loyal supporters. When Louis VII, chivalrous and temperamental, had fallen out with his Chancellor, Algrin, it was Suger who effected a reconciliation. When Geoffrey of Anjou and Normandy, the second husband of Henry Beauclerc's only daughter, threatened war, it was Suger who warded it off. When Louis VII had good reasons to wish a divorce from his wife, the beautiful Eleanor of Aquitaine, it was Suger who prevented the worst as long as he lived, so that the politically disastrous rupture did not become a fact until 1152.

It is no accident that the two great victories of Suger's public life were bloodless ones. One was the suppression of a *coup d'état* attempted by the brother of Louis VII, Robert de Dreux, whom Suger, then Regent and a man of sixty-eight, 'put down in the name of righteousness and with the confidence of a lion'. The other and still greater victory was the frustration of an invasion attempted by Emperor Henry

V of Germany. Feeling himself sufficiently strong after the Concordat of Worms, he had prepared a powerful attack but was forced to retreat in the face of a 'France whose forces had become united'. For once, all the king's vassals, even the greatest and most recalcitrant of them, had laid aside their quarrels and grievances and followed the 'call of France' (*ajuracio Franciae*): a triumph, not only of Suger's general policy but also of his special office. While the hosts were assembling, the relics of Saint Denis and his Companions were laid out on the main altar of the Abbey, later to be restored to the crypt 'on the shoulders of the king himself'. The monks said offices day and night. And Louis le Gros accepted from the hands of Suger, and 'invited all France to follow it', the banner of St-Denis so as to proclaim the king of France a vassal of the Abbey, one of whose possessions, Le Vexin, he held in fief. And it was not long after Louis' death that this banner came to be identified with that famous 'Oriflamme' that was to remain the visible symbol of national unity for almost three centuries.

In only one contingency did Suger advise and even insist on the use of force against his countrymen: when 'rebels' appeared to violate what Louis le Gros had promised to protect, the rights of the Church and of the poor. Suger could look with reverence upon Henry Beauclerc, and with wistful respect upon Thibaut of Blois who opposed the king on almost equal terms; but he was unremitting in his hatred and contempt for such 'serpents' and 'wild beasts' as Thomas de Marle, Bouchart de Montmorency, Milon de Bray, Matthieu de Beaumont or Hugues du Puiset (many of them members of the minor nobility), who had established themselves as local or regional tyrants, attacked their loyal neighbours, ravaged the towns, oppressed the peasants and laid their hands on ecclesiastical property – even on the possessions of St-Denis. Against these Suger recommended, and helped to enforce, the strongest possible measures, favouring the oppressed not only for reasons of justice and humanity (though he was, by instinct, a just and humane man) but also because

he was intelligent enough to know that a bankrupt merchant could not pay taxes and that a farmer or winegrower subject to constant pillage and extortion was likely to abandon his fields or vineyards. When Louis VII came home from the Holy Land Suger was able to turn over to him a country as peaceful and unified as it had seldom been before; and, still more miraculously, a well-filled treasury. 'From then on,' writes Willelmus, 'the people and the prince called him the Father of the Fatherland'; and (with a special reference to the loss of Aquitaine resulting from the divorce of Louis VII): 'No sooner had he been taken from our midst than the sceptre of the realm suffered great damage owing to his absence.'

II

What Suger could realize only in part within the macrocosm of the kingdom, he could realize in full within the microcosm of his Abbey. Even if we deduct a little from the high-minded condemnation of St Bernard who likened the unreformed St-Denis to a 'workshop of Vulcan' and a 'synagogue of Satan', and if we somewhat discount the bitter invectives of poor, disgruntled Abelard who speaks of 'intolerable obscenities' and calls Suger's predecessor, Adam, 'a man as much the more corrupt of habits and renowned for infamy as he was the others' superior by his prelacy', even then we cannot fail to see that the conditions at St-Denis previous to Suger were far from satisfactory. Suger himself tactfully refrains from any personal indictment of Adam, his 'spiritual father and foster parent'. But he tells us of gaping fissures in the walls, of damaged columns and of towers 'threatening ruin'; of lamps and other furnishings falling to pieces for want of repair; of valuable ivories 'mouldering away under the chests of the treasury'; of altar vessels 'lost as pawns': of unfulfilled obligations toward princely benefactors; of tithes handed over to laymen; of outlying possessions either not brought under cultivation at all or de-

serted by the tenants on account of oppression from nearby squires and barons; and, worst of all, of constant trouble with the 'bailiffs' (*advocati*) who held the hereditary right to certain revenues from the Abbey's domains in return for protection against outside enemies (*advocationes*), but were often unable or unwilling to fulfil this office and even more often abused it by arbitrary taxation, conscription and corvée.

Long before Suger became the head of St-Denis he had a firsthand experience of these unhappy conditions. Having served for about two years as Abbot's Deputy (*praepositus*) at Berneval-le-Grand in Normandy, where he had occasion to become familiar with and to be greatly impressed by the administrative innovations of Henry Beauclerc, he was transferred, in the same capacity, and at the age of twenty-eight, to one of the Abbey's most cherished possessions, Toury-en-Beauce, not far from Chartres. But he found it avoided by pilgrims and merchants and almost empty of tenants, owing to persecutions on the part of his *bête noire*, Hugues du Puiset: 'Those who had remained could hardly live under the burden of so nefarious an oppression.' After enlisting both the moral support of the Bishops of Chartres and Orléans and the manual aid of the local priests and parishioners, he asked protection from the king himself and fought, with considerable bravery and varying success, until the castle of Le Puiset succumbed to the last of three sieges within two years and was destroyed, or at least put out of commission, in 1112. The wicked Hugues managed to hold on to his possession for another ten or fifteen years, but seems to have left his castle in charge of a Provost and ultimately disappeared into the Holy Land. Suger, however, began to restore the domain of Toury 'from sterility to fecundity', and no sooner had he been elected abbot than he stabilized the situation for good. He built sturdy, 'defensible' houses, fortified the whole place with palisades, a solid fort and a new tower above the entrance gate; arrested, 'when he happened to be in the neighbourhood with an armed force',

Hugues' Provost, who had begun 'to take revenge for past misfortunes'; and settled the question of the *advocatio* in thoroughly characteristic fashion. The *advocatio*, it turned out, had descended by inheritance to a young girl, the granddaughter of one Adam de Pithiviers, who could not do much good but very much harm in case she were to marry the wrong person. So Suger arranged to 'give the maiden together with the *advocatio*' to a nice young man of his own entourage, put up one hundred pounds to be divided between the newlyweds and the apparently not very prosperous parents, and everybody was happy: the young lady had a dowry and a husband; the young gentleman had a wife and a modest but steady income; the parents had a share of Suger's hundred pounds; 'the unrest in the district was allayed'; and the Abbey's annual revenue from Toury rose from twenty pounds to eighty.

This story of one single domain is characteristic of Suger's whole method of administration. Where force was necessary he applied it with energy and no regard for personal danger; he tells of several other cases in which he had to resort to arms 'in the early days of his abbacy'. But it is more than professional hypocrisy – though an admixture of this element cannot be overlooked – when he professes regret on this account: had it been within his power, he would have solved all problems in much the same way as he solved that of Adam de Pithiviers' granddaughter.

Apart from obtaining numerous royal donations and privileges (the most important of which were the extension of the Abbey's local jurisdiction and the concession of the big annual fair known as the 'Foire du Lendit') and from securing private benefactions of all kinds, Suger was a great hand at discovering forgotten claims to lands and feudal rights. 'In the docile age of my youth,' he says, 'I used to thumb the documents of our possessions in the ambry and to consult the charts of our immunities in view of the dishonesty of many calumniators.' He did not hesitate to push such claims for the sake of the Holy Martyrs, but he seems to have done

this, on the whole, 'without chicanery' (*non aliquo malo ingenio*), the only possible exception being the eviction of the nuns from the convent of Argenteuil. This eviction was demanded, not only on legal but also on moral grounds (which does cast some little doubt upon the validity of the former), and Suger has even been suspected of having been influenced by the fact that Abelard's Heloise was Prioress of Argenteuil. Certain it is, however, that the claims of St-Denis were upheld by a synod on which was present so upright a defender of Abelard's rights as Geoffroy de Lèves, Bishop of Chartres; and from what we know of Suger it would seem doubtful whether he even thought of the old scandal in connexion with the case.

In all other known instances Suger appears to have acted in perfect good faith. New property was acquired and rented at fair prices. Bothersome but legitimate liabilities were abolished by paying off the holders of the titles even if they happened to be Jews. Undesirable *advocati* were given a chance to renounce their privileges in return for a compensation either agreed upon directly or fixed by canonical procedure. And as soon as physical and legal security had been established Suger embarked upon a programme of reconstruction and rehabilitation which, as in Toury, proved advantageous both to the welfare of the tenantry and the finances of the Abbey. Dilapidated buildings and implements were replaced and new ones provided. Measures were taken against reckless deforestation. New tenants were settled in many places so as to transform into cornfields and vineyards what had been waste lands. The obligations of the tenantry were conscientiously revised with careful distinction between rightful 'consuetude' and arbitrary 'exaction', and with due regard for individual needs and capacities. And all this was done under the personal supervision of Suger who, with all his obligations as a 'prince of the Church and the realm', moved about his domains as the whirlwind, laying out plans for new settlements, indicating the most suitable places for fields and vineyards, looking after the smallest detail and

seizing upon every opportunity. Of the possession of Essonnes, for instance, not much had been left, after long depredations by the Counts of Corbeil, except a ruined little chapel known as Notre-Dame-des-Champs, where 'sheep and goats came to feed upon the very altar overgrown with vegetation'. One fine day Suger was notified that candles had been observed to be burning in the deserted shrine and that sick people had been cured there in miraculous fashion. Seeing his chance at once, he sent down his Prior Hervée – 'a man of great saintliness and admirable simplicity though not too erudite' – with twelve monks, restored the chapel, established claustral buildings, planted vineyards, provided ploughs, wine presses, altar vessels, vestments, and even a little library; and within a few years the place had developed into the medieval equivalent of a flourishing and self-sufficient sanitarium.

III

In thus enlarging and improving the outlying domains of the Abbey, Suger created the basis for a thorough reorganization of the convent itself.

In 1127, we remember, St-Denis was 'reformed', and this 'reform' elicited St Bernard's famous letter of congratulation, already mentioned twice. This letter is, however, more than an expression of pious satisfaction. Marking the end of a whispering – or rather clamouring – campaign apparently launched by St Bernard himself, it seals an armistice and offers peace terms. In depicting the state of affairs at St-Denis in sinister colours and describing the indignation of the 'saintly', St Bernard makes it perfectly clear that Suger alone had been the object of this indignation:

It was at your errors, not at those of your monks, that the zeal of the saintly aimed its criticism. It was by your excesses, not by theirs, that they were incensed. It was against you, not against the Abbey, that arose the murmurs of your brothers. You alone were the object of their indictments. You would mend your ways,

and nothing would remain that might be open to calumny. In fine, if you were to change, all the tumult would subside, all the clamour would be silenced. This was the one and only thing that moved us: that, if you were to continue, that pomp and circumstance of yours might appear a little too insolent. ... Finally, however, you have satisfied your critics and even added what we can justly praise. For what shall rightly be commended in human affairs if this (although in truth a work of God) is not deemed worthy of the highest praise and admiration, this simultaneous and so sudden change of so many men? Much joy shall be in heaven over one sinner's conversion – what about that of a whole congregation?

Thus all seems well with Suger, who – a pun scarcely pardonable even in a saint – has learned to 'suck' (*sugere*) the breasts of Divine Wisdom instead of the lips of flatterers. But after so many amenities St Bernard strongly intimates that the continuance of his good will depends upon Suger's conduct in the future, and finally he comes to the point; he wishes the elimination of Etienne de Garlande, Seneschal of Louis le Gros, who, combining a high position in the Church with an even greater influence at Court, was the most formidable barrier between the Abbot of Clairvaux and the Crown.

We do not know what Suger – St Bernard's senior by nine years – replied to this amazing document; but we learn from the events that he understood it. By the end of the very same year, 1127, Etienne de Garlande fell from grace. Though he returned to favour afterwards he never returned to power. And on 10 May 1128, 'the Abbot of Clairvaux found himself, for the first time, in direct and official relation with the King of France': Suger and St Bernard had come to terms. Realizing how much they could hurt each other as enemies – one the adviser of the Crown and the greatest political power in France, the other the mentor of the Holy See and the greatest spiritual force in Europe – they decided to be friends.

From now on nothing but praise of Suger is heard from St Bernard (though he retained a certain tendency to make

Suger responsible for the objectionable conduct of others and on one occasion somewhat maliciously asked him, the 'rich abbot', to lend assistance to a 'poor one'). They addressed each other as '*vestra Sublimitas*', '*vestra Magnitudo*' or even '*Sanctitas vestra*'. Shortly before his death, Suger expressed the wish to see Bernard's 'angelic face' and was comforted by an edifying letter and a precious handkerchief; and, above all, they carefully refrained from interfering with each other's interests. Suger observed the strictest neutrality when St Bernard persecuted his heretics or appointed bishops and archbishops almost at will, and he did nothing to prevent the Second Crusade of which he was foresighted enough to disapprove. St Bernard, on the other hand, abstained from further fulminations against St-Denis and never revised his optimistic interpretation of Suger's conversion and reform, no matter what they amounted to in reality.

No doubt Suger was as God-fearing a man as any other faithful churchman of his century and exhibited the proper emotions on the proper occasions, 'flooding the pavement with tears' before the tomb of the Holy Martyrs (not too exceptional at a time when kings sank weeping to their knees in front of sacred relics and melted into tears at official funerals), and showing himself 'devoutly festive, festively devout' on the joyous feasts of Christmas and Easter. But hardly did he ever undergo a conversion comparable to that of the German cleric Mascelinus, whom St Bernard enticed from the service of the Archbishop of Mainz into the monastery of Clairvaux, or of the Saint's own brother Guy, whom he wrested from a beloved wife and two young children. No doubt Suger abolished all sorts of irregularities in the Abbey. But he most certainly did not transform it into a place where 'no secular person has access to the House of God', where 'the curious are not admitted to the sacred objects', where 'silence and a perpetual remoteness from all secular turmoil compel the mind to meditate on celestial things'.

In the first place, the reform of St-Denis resulted, not so

much from a sudden change of heart on the part of the brethren as from their skilful and considerate re-education. Where St Bernard speaks of the 'conversion of a whole congregation' Suger, characteristically, congratulates himself on having 'reinstated the purpose of the holy Order in peaceable fashion, without upheaval and disturbance of the brethren though they had not been accustomed to it'. In the second place, this reform, while doing away with flagrant waste and disorderliness, was far from achieving, or even aiming at, anything like St Bernard's austere ideal of monastic life. As has already been mentioned, St-Denis continued to render unto Caesar the things which are Caesar's, and this the more effectively the more secure had become its possessions, the sounder its finances, and the firmer the Abbot's grip on his community; and the life of the monks, while probably more strictly supervised than before, was made as pleasant as possible.

St Bernard conceived of monasticism as a life of blind obedience and utter self-denial with respect to personal comfort, food and sleep; he himself is said to have waked and fasted *ultra possibilitatem humanam*. Suger, on the other hand, was all for discipline and moderation, but thoroughly against subjection and asceticism. To the admiring amazement of his biographer he did not put on weight after his accession to power. But neither did he make a point of self-mortification. 'Declining to be conspicuous in one way or the other', he liked his food 'neither very exquisite nor very coarse'; his cell measured barely ten by fifteen feet, but his couch was 'neither too soft nor too hard' and was – a very charming touch – 'covered with pretty fabrics in daytime'. And what he did not demand of himself he demanded even less of his monks. He held that the relationship between prelates and subordinates was prefigured by that between the priests of the Old Law and the Ark of the Covenant; as it had been the duty of those priests to protect their Ark with animals' skins lest it be damaged by wind and rain, so, he thought, was it the duty of an abbot to provide for the

physical well-being of his monks 'lest they break down on the road'. Thus the chilly choir stalls of copper and marble – a real hardship in winter – were replaced by comfortable wooden ones. The diet of the monks was constantly improved (with a special injunction that the poor be given their proper share); and it was with obvious enthusiasm that Suger revived the discontinued observances in memory of Charles the Bald which entailed, in honour of 'so great an Emperor and so intimate and cordial a friend of the blessed Denis', an exceptionally good dinner every month. Where St Bernard made a cult of silence Suger was what a French scholar terms a 'causeur infatigable'. 'Very human and genial' (*humanus satis et jocundus*), he loved to keep his monks together until midnight, telling of memorable events which he had 'either seen or heard of' (and he had seen and heard of a great deal), narrating the deeds of whatever French king or prince was named to him, or reciting long passages of Horace from memory.

The reformed St-Denis as realized by Suger thus differed very considerably from the reformed St-Denis as imagined by St Bernard; and in one essential respect there was not only a difference but an irreconcilable contrast between the one and the other. Nothing could be further from Suger's mind than to keep secular persons out of the House of God: he wished to accommodate as great a crowd as possible and wanted only to handle it without disturbances – therefore he needed a larger church. Nothing could seem less justified to him than not to admit the curious to the sacred objects: he wished to display his relics as 'nobly' and 'conspicuously' as he could and wanted only to avoid jostling and rioting – therefore he transferred the relics from the crypt and the nave to that magnificent upper choir which was to become the unsurpassed model of the Gothic cathedral *chevet*. Nothing, he thought, would be a graver sin of omission than to withhold from the service of God and His saints what He had empowered nature to supply and man to perfect: vessels of gold or precious stone adorned with pearls and gems,

golden candelabra and altar panels, sculpture and stained glass, mosaic and enamel work, lustrous vestments and tapestries.

This was precisely what the *Exordium Magnum Ordinis Cisterciensis* had condemned and what St Bernard had thundered against in the *Apologia ad Willelmum Abbatem Sancti Theodorici*. No figural painting or sculpture, except for wooden crucifixes, was tolerated; gems, pearls, gold and silk were forbidden; the vestments had to be of linen or fustian, the candlesticks and censers of iron; only the chalices were permitted to be of silver or silver-gilt. Suger, however, was frankly in love with splendour and beauty in every conceivable form; it might be said that his response to ecclesiastical ceremonial was largely aesthetic. For him the benediction of the holy water is a wonderful dance, with countless dignitaries of the Church, 'decorous in white vestments, splendidly arrayed in pontifical mitres and precious orphreys embellished by circular ornaments', walking 'round and round the vessel' as a 'chorus celestial rather than terrestrial'. The simultaneous performance of the first twenty masses in the new *chevet* is a 'symphony angelic rather than human'. Thus, if the spiritual pre-eminence of St-Denis was Suger's conviction, its material embellishment was his passion: the Holy Martyrs, whose 'sacred ashes' could be carried only by the king and took precedence over all other relics however much revered, had to have the most beautiful church in France.

From the earliest years of his abbacy Suger had begun to raise funds for the reconstruction and redecoration of the basilica, and when he died he left it 'renewed from its very foundations' and filled with treasures second only – perhaps even superior – to those in Hagia Sophia. In arranging his processions, translations, foundation ceremonies and consecrations Suger foreshadowed the showmanship of the modern movie producer or promoter of world's fairs, and in acquiring pearls and precious stones, rare vases, stained glass, enamels and textiles he anticipated the unselfish rapacity of the modern museum director; he even appointed the first known ancestors of our curators and restorers.

In short, by making concessions to the zeal of St Bernard in matters of morals and major ecclesiastical policy, Suger gained freedom and peace in all other respects. Unmolested by the Abbot of Clairvaux, he made his Church the most resplendent in the Western world and raised pomp and circumstance to the level of a fine art. If his St-Denis had ceased to be a 'synagogue of Satan' it certainly became, more than it had ever been, a 'workshop of Vulcan'.

IV

After 1127, then, Suger had St Bernard no longer at his heels; but he had him very much on his mind, and this is one of the several reasons why he became that great exception to the rule, the patron who turned *littérateur*.

There can be no doubt that the memorials reprinted in this volume are in part pointedly apologetic and that this apology is largely directed against Cîteaux and Clairvaux. Time and again Suger interrupts his enthusiastic descriptions of gleaming gold and precious jewels to counter the attacks of an imaginary opponent who is in fact not imaginary at all but identical with the man who has written:

But we who, for the sake of Christ, have deemed as dung whatever shines with beauty, enchants the ear, delights through fragrance, flatters the taste, pleases the touch – whose devotion, I ask, do we intend to incite by means of these very things?

Where St Bernard, in the words of 'pagan Persius', indignantly exclaims: 'What has gold to do in the sanctuary?' Suger requests that all the gorgeous vestments and altar vessels acquired under his administration be laid out in the church on his anniversary ('for we are convinced that it is useful and becoming not to hide but to proclaim Divine benefactions'). He deeply regrets that his Great Cross, one of the most sumptuous objects ever contrived by man, still lacks its full complement of gems and pearls: and he is keenly disappointed that he was forced to encase the new tomb of the Holy Martyrs with mere copper-gilt instead of

with solid gold ('for we, most miserable men, ... should deem it worth our effort to cover the most sacred ashes of those whose venerable spirits – radiant as the sun – attend upon Almighty God with the most precious materials we possibly can').

At the end of the description of the main altar – to the frontal of which he had added three other panels, 'so that the whole altar would appear golden all the way round' – Suger goes over to the offensive:

If golden pouring vessels, golden vials, little golden mortars used to serve, by the word of God or the command of the Prophet, to collect the blood of goats or calves or the red heifer: how much more must golden vessels, precious stones, and whatever is most valued among all created things, be laid out, with continual reverence and full devotion, for the reception of the blood of Christ! ... If, by a new creation, our substance were reformed from that of the holy Cherubim and Seraphim, it would still offer an insufficient and unworthy service for so ineffable a victim. ... The detractors also object that a saintly mind, a pure heart, a faithful intention, ought to suffice for this sacred function; and we, too, explicitly and especially affirm that it is these that principally matter. But we profess that we must do homage also through the outward ornaments of sacred vessels. ... For it behoves us most becomingly to serve our Saviour in all things in a universal way – Him Who has not refused to provide for us in all things in a universal way and without any exception.

Remarkable in utterances like these is Suger's use of passages from Scripture as evidence against the Cistercians. In Hebrews St Paul had likened the blood of Christ to that of sacrificial animals mentioned in the Old Testament (but solely in order to illustrate the superiority of spiritual over merely magical sanctification): Suger concludes from this comparison that Christian chalices should be more gorgeous than Jewish vials and pouring vessels. Pseudo-Andrew had apostrophized the Cross of Golgotha as being adorned with the members of Christ 'even as with pearls': Suger infers from this poetic apostrophe that a liturgical crucifix should

gleam with a profusion of real pearls. And when he finishes the description of his new *chevet* with a magnificent quotation from Ephesians containing the clause: 'in Whom all the building groweth unto one holy temple in the Lord,' he qualifies the word 'building' by the parenthesis 'whether spiritual or material', thereby twisting St Paul's metaphor into a justification of superresplendent architecture.

This does not mean that Suger deliberately 'falsified' the Bible and the Apocrypha. Like all medieval writers he quoted from memory and failed to make a sharp distinction between the text and his personal interpretation; so that his very quotations – and this is the reward for verifying them – reveal to us his own philosophy.

To speak of Suger's philosophy may seem surprising. As one of those who, to quote his own phrase, 'are men of action by virtue of their prelacies' (and whose relation to the 'contemplative' life is merely one of benevolent patronage), Suger had no ambitions as a thinker. Fond of the classics and the chroniclers, a statesman, a soldier and a jurisconsult, an expert in all that which Leone Battista Alberti was to sum up under the heading of *La Cura della Famiglia*, and apparently not without interest in science, he was a proto-humanist rather than an early scholastic. Nowhere does he evince the slightest interest in the great theological and epistemological controversies of his time, such as the dispute between the realists and the nominalists, the bitter argument about the nature of the Trinity, or that great issue of the day, the case of faith *v.* reason; and his relations with the protagonist of this intellectual drama, Peter Abelard, were, characteristically, of a strictly official and entirely impersonal nature.

Abelard was a genius, but a genius of that paranoiac sort that repels affection by overbearance, invites real persecution by constantly suspecting imaginary conspiracies, and, feeling oppressed by any kind of moral indebtedness, tends to convert gratitude into resentment. After the cruel events that had ruined his life he had found refuge at St-Denis during the gay and inefficient administration of Abbot Adam. Soon

Abelard indulged in criticism which, warranted or not, seldom endears a newcomer to an established community, and finally he 'facetiously' announced a discovery that, from the point of view of St-Denis, amounted to *lèse-majesté*: he had chanced upon a passage in Bede according to which the titular Saint of the Abbey was not the same person as the famous Dionysius the Areopagite mentioned in the Acts of the Apostles and held to have been the first bishop of Athens, but was identical with the more recent and far less famous Dionysius of Corinth. Abelard was accused as a traitor to the Crown, was thrown into prison, managed to escape, and sought shelter in the territory of Thibaut of Blois. This was the state of affairs when Suger became Adam's successor, and presently the problem was solved: after some calculated hesitation Suger consented to drop the whole matter and permitted Abelard to live in peace wherever he pleased, under the sole condition that he would not enter another monastery – this sole condition being imposed, according to Abelard, because 'the Abbey did not want to forfeit the glory that it used to derive from myself', but much more probably because Suger, considering Abelard a good riddance, was nevertheless reluctant to see an ex-monk of St-Denis subjected to the authority of another and therefore, in his estimation, inferior abbot. He did not object when Abelard, some two or three years later, became a (very unhappy) abbot himself; he took no part in St Bernard's savage and carefully prepared attack that led to Abelard's condemnation by the Synod of Sens in 1140; and no one knows whether or not Suger even opened one of those books in which the Abbot of Clairvaux had detected sheer paganism flavoured with the combined heresies of Arius, Nestorius and Pelagius.

What Suger did read, however, were the writings ascribed to the very man whose semi-legendary personality had caused the rift between Abelard and St-Denis. That Dionysius the Areopagite, of whom nothing is known except that he 'clave unto St Paul and believed', had been identified, not

only with the actual Saint Denis, Apostle of the Gauls, but also with a most important theological writer – to us a nameless Syrian of *c.* 500 – whose works had thus become no less revered a patrimony of the Abbey than were the banner of Le Vexin and the relics of the Holy Martyrs. A manuscript of the Greek texts, obtained by Louis the Pious from the Byzantine Emperor Michael the Stammerer, had been immediately deposited at St-Denis; after an earlier, not quite successful attempt these texts had been brilliantly translated and commented upon by John the Scot, the honoured guest of Charles the Bald; and it was in these translations and commentaries that Suger discovered – somewhat ironically in view of Abelard's fate – not only the most potent weapon against St Bernard but also a philosophical justification of his whole attitude toward art and life.

Fusing the doctrines of Plotinus and, more specifically, Proclus with the creeds and beliefs of Christianity, Dionysius the Pseudo-Areopagite – whose 'negative theology', defining the Superessential One as eternal darkness and eternal silence, and thus identifying ultimate knowledge with ultimate ignorance, can concern us here no more than it concerned Suger – combined the Neo-Platonic conviction of the fundamental oneness and luminous aliveness of the world with the Christian dogmas of the triune God, original sin and redemption. According to the Pseudo-Areopagite, the universe is created, animated and unified by the perpetual self-realization of what Plotinus had called 'the One', what the Bible had called 'the Lord', and what he calls 'the superessential Light' or even 'the invisible Sun' – with God the Father designated as 'the Father of the lights' (*Pater luminum*), and Christ (in an allusion to John 3 : 19 and 8 : 12) as the 'first radiance' *(φωτοδοσία, claritas)* which 'has revealed the Father to the world' ('Patrem clarificavit mundo'). There is a formidable distance from the highest, purely intelligible sphere of existence to the lowest, almost purely material one (almost, because sheer matter without form cannot even be

said to exist); but there is no insurmountable chasm between the two. There is a hierarchy but no dichotomy. For even the lowliest of created things partakes somehow of the essence of God – humanly speaking, of the qualities of truth, goodness and beauty. Therefore the process by which the emanations of the Light Divine flow down until they are nearly drowned in matter and broken up into what looks like a meaningless welter of coarse material bodies can always be reversed into a rise from pollution and multiplicity to purity and oneness; and therefore man, *anima immortalis corpore utens*, need not be ashamed to depend upon his sensory perception and sense-controlled imagination. Instead of turning his back on the physical world, he can hope to transcend it by absorbing it.

Our mind, says the Pseudo-Areopagite at the very beginning of his major work, the *De Caelesti Hierarchia* (and consequently John the Scot at the very beginning of his commentary), can rise to that which is not material only under the 'manual guidance' of that which is (*materiali manuductione*). Even to the prophets the Deity and the celestial virtues could appear only in some visible form. But this is possible because all visible things are 'material lights' that mirror the 'intelligible' ones and, ultimately, the *vera lux* of the Godhead Itself:

Every creature, visible or invisible, is a light brought into being by the Father of the lights. . . . This stone or that piece of wood is a light to me. . . . For I perceive that it is good and beautiful; that it exists according to its proper rules of proportion; that it differs in kind and species from other kinds and species; that it is defined by its number, by virtue of which it is 'one' thing; that it does not transgress its order; that it seeks its place according to its specific gravity. As I perceive such and similar things in this stone they become lights to me, that is to say, they enlighten me (*me illuminant*). For I begin to think whence the stone is invested with such properties . . .; and soon, under the guidance of reason, I am led through all things to that cause of all things which endows them with place and order, with number, species and kind,

1. Roger van der Weyden, *The Vision of the Three Magi* (detail). Berlin, Kaiser Friedrich Museum.

2. *Christ resurrecting the Youth of Nain*. Munich, Staatsbibliothek. *c.*1000.

3. Francesco Maffei,
Judith. Faenza,
Pinacoteca.

4. *Head of St John.*
Hamburg, Museum für
Kunst und Gewerbe.
*c.*1500.

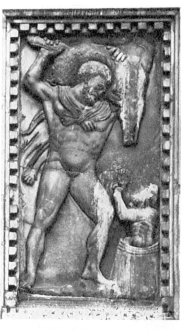

5. *Hercules Carrying the Erymanthean Boar.* Venice, St Mark's. Third century (?).

6. *Allegory of Salvation.* Venice, St Mark's. Thirteenth century.

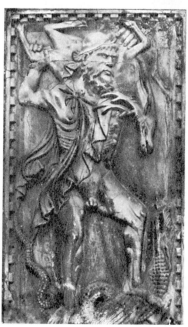

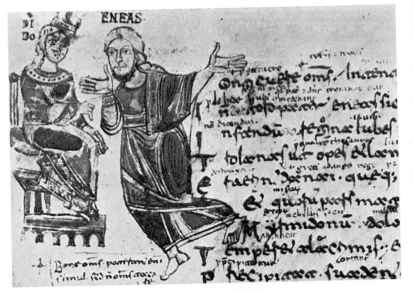

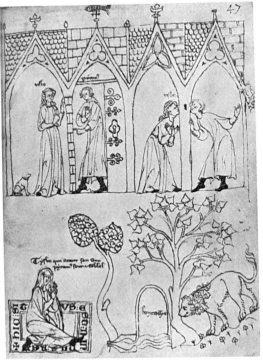

7. *Aeneas and Dido.*
Naples, Biblioteca
Nazionale. Tenth
century.

8. *Story of Pyramus and
Thisbe*. Paris,
Bibliothèque Nationale.
Dated 1289.

9. *St John the Evangelist*.
Rome, Vatican Library.
c.1000.

10. *Atlas and Nimrod*.
Rome, Vatican Library.
c.1100.

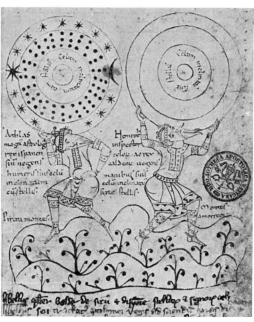

11. *The Pagan Gods*. Munich, Staatsbibliothek. *c*.1100.

12. *Saturn* from the Chronograph of 354 (Renaissance copy).
Rome, Vatican Library.

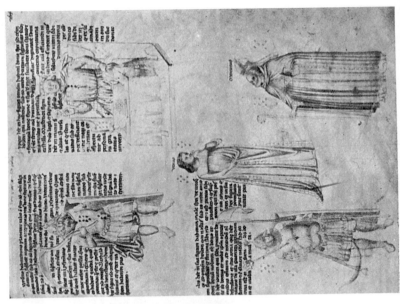

13. *Saturn, Jupiter, Janus, and Neptune.* Monte Cassino. Dated 1023.

14. *Saturn, Jupiter, Venus, Mars, and Mercury.* Munich, Staatsbibliothek. Fourteenth century.

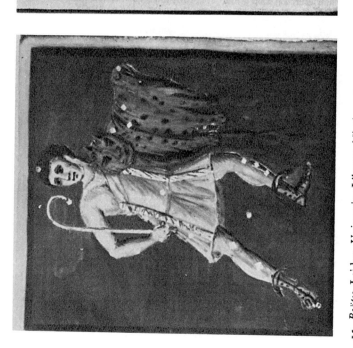

IPSAM HELICEN SEQUITUR SENIOR IACULOQ. MINATU...

SIUEILLE ARTOPHYLAX SEUBACCHIO MUNERECESSUS

CARUS EREPTAM SENSABIT SIDEREUITAM

Ipsam helicen sequitur senior iaculoq. minatur
Siue ille artophylax: seu bacchio munere cessus
Carus ereptam pensabitr sidere uitam

15. *Boötes*. Leiden, University Library. Ninth century.

16. *Abduction of Europa*. Lyon, Bibliothèque de la Ville.
Fourteenth century.

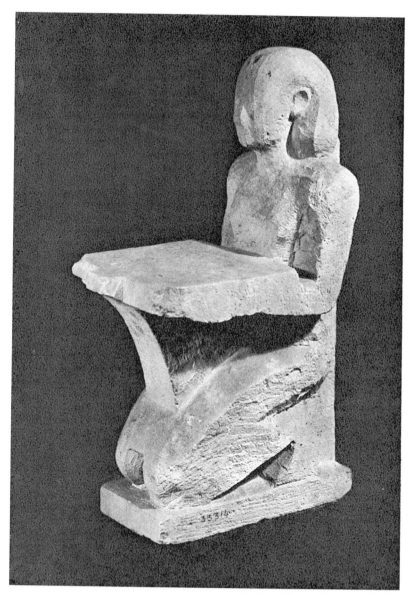

17. Unfinished Egyptian statue. Cairo Museum.

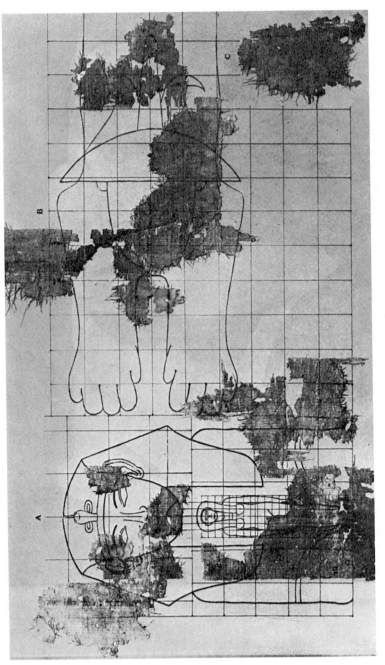

18. Egyptian sculptor's working drawing (papyrus). Berlin, Neues Museum.

19. *Madonna.* Hamburg, Staats- und Universitätsbibliothek. Early thirteenth century.

20. *Head of Christ.* Hamburg, Staats- und Universitätsbibliothek. Early thirteenth century.

21. *Head of St Florian*
(mural). Salzburg,
Nonnberg Convent.
Twelfth century.

22. *St Noëmisia* (mural).
Anagni, Cathedral.
Twelfth century.

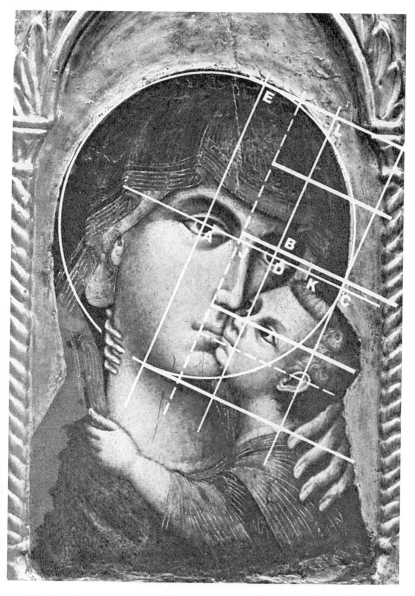

23. Meo da Siena (?), *Madonna*. Florence, S.M. Maggiore.
Fourteenth century.

24. Villard de Honnecourt, *Constructed Head*. Paris, Bibliothèque Nationale.

25. *Head of Christ* (stained-glass window). Rheims, Cathedral. *c.*1235.

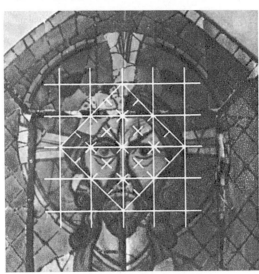

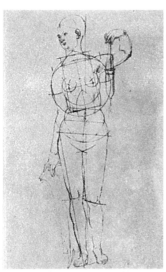

26. Albrecht Dürer, *Planimetrical Construction of Female Figure* (drawing). Berlin, Kupferstichkabinett. *c.*1500.

27. Albrecht Dürer, *Stereometrical Construction of Male Figure*. Formerly Dresden, Sächsische Landesbibliothek. *c.*1523.

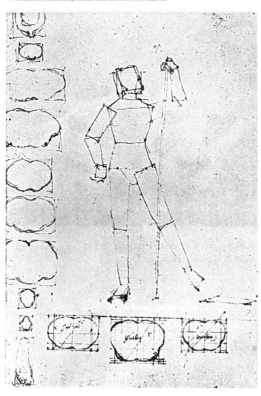

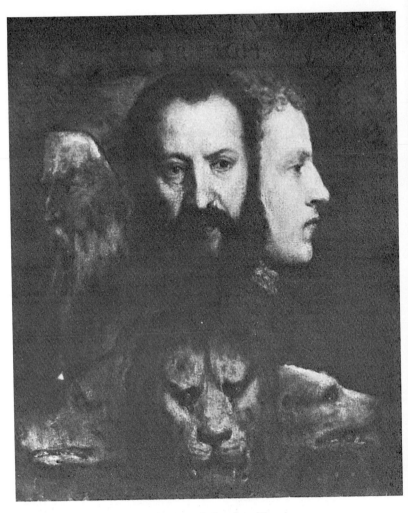

28. Titian, *Allegory of Prudence*. Formerly London, Francis Howard Collection, now London, National Gallery.

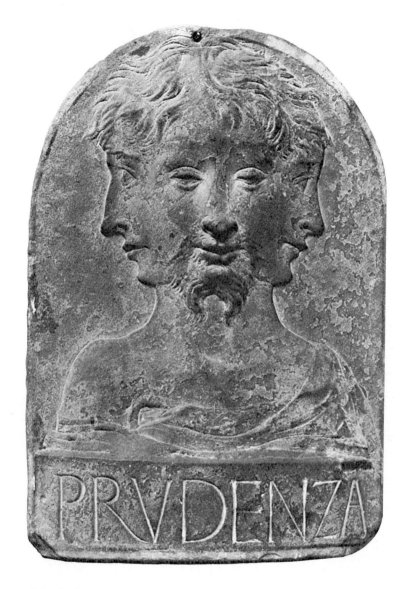

29. School of Rossellino, *Prudence*. London, Victoria and Albert Museum.

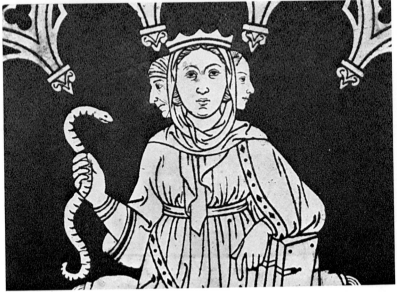

30. *Allegory of Prudence*. Rome, Biblioteca Casanatense. Early fifteenth century.

31. *Prudence* (niello). Siena, Cathedral. Late fourteenth century.

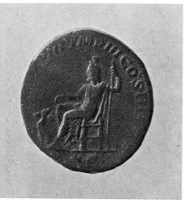

32. *The Three-headed Companion of Serapis.* Graeco-Egyptian statuette after L. Begerus, *Lucernae . . . iconicae,* Berlin, 1702.

33. *The Three-headed Companion of Serapis.* Graeco-Egyptian statuette after B. de Montfaucon, *L'Antiquité expliquée,* Paris, 1722 ff.

34. *Serapis.* Coin of Caracalla.

35. *Apollo*. Rome, Vatican Library. *c.*1420.

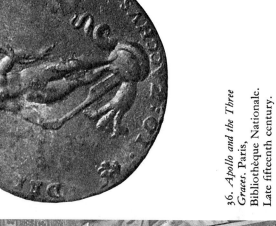

36. *Apollo and the Three Graces.* Paris, Bibliothèque Nationale. Late fifteenth century.

37. Giovanni Zacchi, *Fortune.* Medal of the Doge Andrea Gritti. Dated 1536.

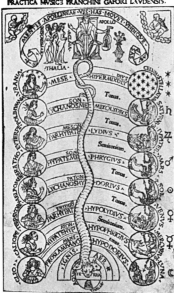

38. *Allegory of Music.*
Frontispiece of
Franchinus Gaforius,
Practica musicae, Milan,
1496.

39. Hans Holbein the
Younger, *Allegory of
Time.* Frontispiece of
J. Eck, *De primatu
Petri,* Paris, 1521.

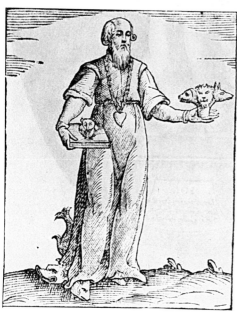

40. *Serapis*. Engraving from Vincenzo Cartari, *Imagini dei Dei degli Antichi*, Padua, 1603.

41. *Allegory of Good Counsel*. Woodcut from Cesare Ripa, *Iconologia*, Venice, 1643, s.v. 'Consiglio'.

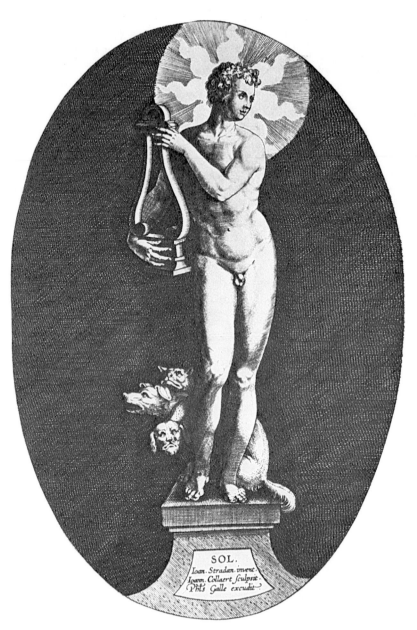

42. Jan Collaert after Giovanni Stradano, *Sol-Apollo*
(engraving).

43. Artus Quellinus the Elder, *Allegory of Good Counsel*.
Amsterdam, Paleis (after J. van Campen, *Afbeelding van't
Stad-Huys van Amsterdam*, 1664–8).

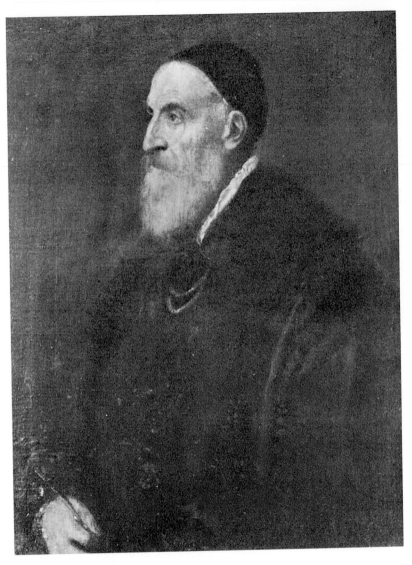

44. Titian, *Self-Portrait*. Madrid, Prado.

45. Titian (and helpers), *Mater Misericordiae* (detail). Florence,
Palazzo Pitti.

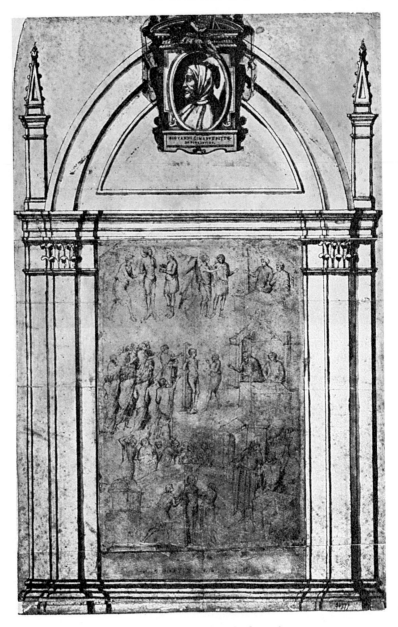

46. Drawing formerly ascribed to Cimabue, in frame by
Giorgio Vasari (recto). Paris, Ecole des Beaux-Arts.

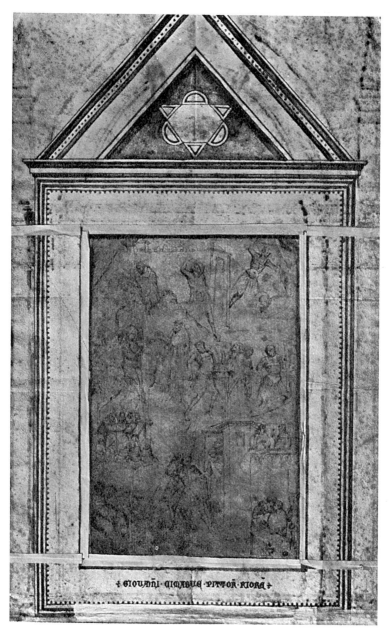

‡ GIOVÃÑI · CIMÃBUE · PITTOR · FIORÑ ‡

47. Drawing formerly ascribed to Cimabue, in frame by
Giorgio Vasari (verso). Paris, Ecole des Beaux-Arts.

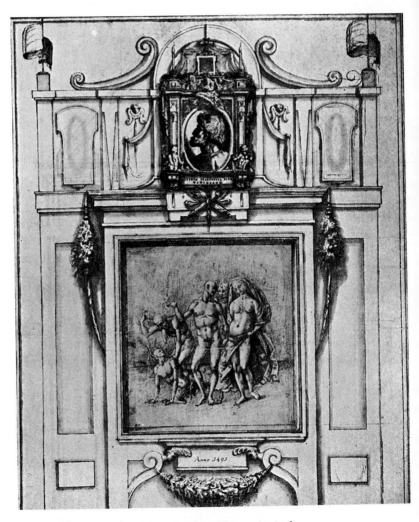

48. Drawing formerly ascribed to Vittore Carpaccio, in frame
by Giorgio Vasari. London, British Museum.

with goodness and beauty and essence, and with all other grants and gifts.

Thus the whole material universe becomes a big 'light' composed of countless small ones as of so many lanterns ('... universalis hujus mundi fabrica maximum lumen fit, ex multis partibus veluti ex lucernis compactum'); every perceptible thing, man-made or natural, becomes a symbol of that which is not perceptible, a stepping-stone on the road to Heaven; the human mind, abandoning itself to the 'harmony and radiance' (*bene compactio et claritas*) which is the criterion of terrestrial beauty, finds itself 'guided upward' to the transcendent cause of this 'harmony and radiance' which is God.

This ascent from the material to the immaterial world is what the Pseudo-Areopagite and John the Scot describe – in contrast to the customary theological use of this term – as the 'anagogical approach' (*anagogicus mos*, literally translated: 'the upward-leading method'); and this is what Suger professed as a theologian, proclaimed as a poet, and practised as a patron of the arts and an arranger of liturgical spectacles. A window showing subjects of an allegorical rather than typological character (e.g. The Prophets Carrying Grain to a Mill Turned by St Paul, or The Ark of the Covenant Surmounted by the Cross) 'urges us on from the material to the immaterial'. The twelve columns supporting the high vaults of the new *chevet* 'represent the number of the Twelve Apostles' while the columns in the ambulatory, likewise twelve in number, 'signify the [minor] Prophets'. And the consecration ceremony of the new narthex was carefully planned to symbolize the idea of the Trinity: there was 'one glorious procession of three men' (one archbishop and two bishops) that performed three distinct motions, leaving the building by a single door, passing in front of the three principal portals and, 'thirdly', re-entering the church by another single door.

These instances may be interpreted as normal medieval

symbolism without specifically 'Dionysian' connotations. But the deservedly famous passage in which Suger relates his experience in contemplating the precious stones that glowed on the main altar and its ornaments, the 'Cross of St Eloy' and the '*Escrin de Charlemagne*', is full of direct reminiscences:

When – out of my delight in the beauty of the house of God – the loveliness of the many-coloured stones has called me away from external cares, and worthy meditation has induced me to reflect, transferring that which is material to that which is immaterial, on the diversity of the sacred virtues: then it seems to me that I see myself dwelling, as it were, in some strange region of the universe which neither exists entirely in the slime of the earth nor entirely in the purity of Heaven; and that, by the grace of God, I can be transported from this inferior to that higher world in an anagogical manner.

Here Suger gives a vivid picture of that trancelike state which can be induced by gazing upon such shining objects as crystal balls or precious stones. But he describes this state, not as a psychological but as a religious experience, and his description is principally in the words of John the Scot. The term *anagogicus mos*, explained as a transition from the 'inferior' to the 'higher' world, is as literal a quotation as is the phrase *de materialibus ad immaterialia transferendo*; and the 'diversity of the sacred virtues', which reveals itself in the divers properties of the gems, recalls both the 'celestial virtues' appearing to the Prophets 'in some visible form' and the spiritual 'illumination' to be derived from any physical object.

Yet even this splendid piece of prose is nothing as compared to the orgy of Neo-Platonic light metaphysics to which Suger abandons himself in some of his poetry. He was intensely fond of inscribing everything accomplished under his administration, from the parts of the building itself to the stained-glass windows, altars and vases, with what he calls *versiculi*: hexameters or elegiac couplets not always very classical in meter but full of original, at times very witty, conceits

and on occasion verging upon the sublime. And when his aspirations were the highest he had recourse not only to the still Neo-Platonic language of the *tituli* of Early Christian mosaics but also to the phraseology of John the Scot:

> *Pars nova posterior dum jungitur anteriori,*
> *Aula micat medio clarificata suo.*
> *Claret enim claris quod clare concopulatur,*
> *Et quod perfundit lux nova, claret opus*
> *Nobile. . . .*

Once the new rear part is joined to the part in front,
The church shines with its middle part brightened.
For bright is that which is brightly coupled with the bright,
And bright is the noble edifice which is pervaded by the new
 light.

Literally interpreted, this inscription, commemorating the consecration of the new *chevet* and describing its effect upon the rest of the church once the rebuilding of its 'middle part' would be completed, seems to paraphrase a purely 'aesthetic' experience: the new, transparent choir, which had replaced the opaque Carolingian apse, would be matched by an equally 'bright' nave, and the whole building would be pervaded by a light more brilliant than before. But the words are deliberately chosen so as to be intelligible on two different levels of meaning. The formula *lux nova* makes perfect sense with reference to the improvement of the actual lighting conditions brought about by the 'new' architecture; but at the same time it recalls the light of the New Testament as opposed to the darkness or blindness of the Jewish Law. And the insistent play upon the words *clarere, clarus, clarificare*, which almost hypnotizes the mind into the search for a significance hidden beneath their purely perceptual implications, reveals itself as metaphysically meaningful when we remember that John the Scot, in a remarkable discussion of the principles he proposed to follow in his translation, had explicitly decided for *claritas* as the most adequate rendering of the numerous Greek expressions with

which the Pseudo-Areopagite denotes the radiance or splendour emanating from the 'Father of the lights'.

In another poem Suger explains the doors of the central west portal which, shining with gilded bronze reliefs, exhibited the 'Passion' and the 'Resurrection or Ascension' of Christ. In reality these verses amount to a condensed statement of the whole theory of 'anagogical' illumination:

> *Portarum quisquis attollere quaeris honorem,*
> *Aurum nec sumptus, operis mirare laborem.*
> *Nobile claret opus, sed opus quod nobile claret*
> *Clarificet mentes, ut eant per lumina vera*
> *Ad verum lumen, ubi Christus janua vera.*
> *Quale sit intus in his determinat aurea porta:*
> *Mens hebes ad verum per materialia surgit,*
> *Et demersa prius had visa luce resurgit.*

Whoever thou art, if thou seekest to extol the glory of these doors,
Marvel not at the gold and the expense but at the craftsmanship of the work.
Bright is the noble work; but, being nobly bright, the work
Should brighten the minds so that they may travel, through the true lights,
To the True Light where Christ is the true door.
In what manner it be inherent in this world the golden door defines:
The dull mind rises to truth, through that which is material
And, in seeing this light, is resurrected from its former submersion.

This poem states explicitly what the other merely implies: the physical 'brightness' of the work of art will 'brighten' the minds of the beholders by a spiritual illumination. Incapable of attaining to truth without the aid of that which is material, the soul will be guided by the 'true', though merely perceptible, 'lights' (*lumina vera*) of the resplendent reliefs of the 'True Light' (*verum lumen*) which is Christ; and it will thus be 'raised', or rather 'resurrected' (*surgit, resurgit*), from terrestrial bondage even as Christ is seen rising

in the '*Resurrectio vel Ascensio*' depicted on the doors. Suger would not have ventured to designate reliefs as *lumina* had he not been familiar with those passages which demonstrate that every created thing 'is a light to me'; his 'Mens hebes ad verum per materialia surgit' is nothing but a metrical condensation of John the Scot's '. . . impossibile est nostro animo ad immaterialem ascendere caelestium hierarchiarum et imitationem et contemplationem nisi ea, quae secundum ipsum est, materiali manuductione utatur' ('. . . it is impossible for our mind to rise to the imitation and contemplation of the celestial hierarchies unless it relies upon that material guidance which is commensurate to it'). And it is from phrases such as: 'Materialia lumina, sive quae naturaliter in caelestibus spatiis ordinata sunt, sive quae in terris humano artificio efficiuntur, imagines sunt intelligibilium luminum, super omnia ipsius verae lucis' ('The material lights, both those which are disposed by nature in the spaces of the heavens and those which are produced on earth by human artifice, are images of the intelligible lights, and above all of the True Light Itself') that the lines; '. . . ut eant per lumina vera/Ad verum lumen . . .' are derived.

One can imagine the blissful enthusiasm with which Suger must have absorbed these Neo-Platonic doctrines. In accepting what he took for the *ipse dixits* of Saint Denis, he not only did homage to the patron saint of his abbey but also found the most authoritative confirmation of his own innate beliefs and propensities. Saint Denis himself seemed to sanction Suger's conviction (which found its practical expression in his role as *mediator et pacis vinculum*) that 'the admirable power of one unique and supreme reason equalizes the disparity between things human and Divine': and that 'what seems mutually to conflict by inferiority of origin and contrariety of nature is conjoined by the single, delightful concordance of one superior, well-tempered harmony.' Saint Denis himself seemed to justify Suger's partiality to images and his insatiable passion for everything lustrously beautiful, for gold and enamel, for crystal and mosaic, for pearls and

precious stones of all descriptions, for the sardonyx in which 'the sard's red hue, by varying its property, so keenly vies with the blackness of the onyx that one property seems to be bent on trespassing upon the other,' and for stained glass designed 'by the exquisite hands of many masters from different regions'.

St Bernard's contemporary eulogists assure us – and his modern biographers seem to agree – that he was simply blind to the visible world and its beauty. He is said to have spent a whole year in the noviciate of Cîteaux without noticing whether the ceiling of the dormitory was flat or vaulted and whether the chapel received its light from one window or from three; and we are told that he rode a whole day on the shores of the Lake of Geneva without casting a single glance upon the scenery. However, it was not a blind or insensitive man who wrote the *Apologia ad Willelmum*:

And further, in the cloisters, under the eyes of the brethren engaged in reading, what business has there that ridiculous monstrosity, that amazing misshapen shapeliness and shapely misshapenness? Those unclean monkeys? Those fierce lions? Those monstrous centaurs? Those semihuman beings? Those spotted tigers? Those fighting warriors? Those huntsmen blowing their horns? Here you behold several bodies beneath one head; there again several heads upon one body. Here you see a quadruped with the tail of a serpent; there a fish with the head of a quadruped. There an animal suggests a horse in front and half a goat behind; here a horned beast exhibits the rear part of a horse. In fine, on all sides there appears so rich and so amazing a variety of forms that it is more delightful to read the marbles than the manuscripts, and to spend the whole day in admiring these things, piece by piece, rather than in meditating on the Law Divine.

A modern art historian would thank God on his knees for the ability to write so minute, so graphic, so truly evocatory a description of a decorative ensemble in the 'Cluniac manner'; the one phrase *deformis formositas ac formosa deformitas* tells us more about the spirit of Romanesque sculpture than many pages of stylistic analysis. But in addition the whole

passage reveals, especially in its remarkable conclusion, that St Bernard disapproved of art, not because he did not feel its charms but because he felt them too keenly not to consider them dangerous. He banished art, like Plato (only that Plato did it 'regretfully'), because it belonged on the wrong side of a world that he could see only as an unending revolt of the temporal against the eternal, of human reason against faith, of the senses against the spirit. Suger had the good fortune to discover, in the very words of the thrice blessed Saint Denis, a Christian philosophy that permitted him to greet material beauty as a vehicle of spiritual beatitude instead of forcing him to flee from it as though from a temptation; and to conceive of the moral as well as the physical universe, not as a monochrome in black and white but as a harmony of many colours.

v

It was not only against Cistercian puritanism that Suger had to defend himself in his writings. Some of the opposition, it seems, came from the ranks of his own monks.

In the first place, there were the fastidious who objected to Suger's taste or, if 'taste' be defined as a sense of beauty tempered by reticence, lack of taste. Both as a writer and as a patron of the arts he aimed at gorgeousness rather than unobtrusive refinement. As his ear delighted in a kind of medieval euphuism, involved though not always grammatical, bristling with word-play, quotation, metaphor and allusion, and thundering with oratory (the almost untranslatable first chapter of the *De Consecratione* is like an organ prelude filling the room with magnificent sound before the appearance of a discernible theme), so did his eye demand what his more sophisticated friends apparently considered ostentatious and flamboyant. One hears the echo of a faint and futile protest when Suger refers to the mosaic incongruously combined with the sculpture of an already proto-Gothic portal as having been installed there 'on his orders and contrary to modern

custom'. When he exhorts the admirer of his door reliefs 'not to marvel at the gold and the expense but at the craftsmanship of the work' he seems to make a good-natured allusion to those who kept reminding him that, according to Ovid, the perfection of 'form' should be valued more highly than precious material. Suger aims at the same critics – and here quite clearly in a spirit of friendly irony – when he admits that the new golden back of the main altar was indeed somewhat lavish (chiefly, he claims, because it had been executed by foreigners) but hastens to add that its reliefs – just as the frontal of the new 'Autel des Reliques' – were admirable for their workmanship as well as for their costliness; so that 'certain people' might be able to apply their favourite quotation: '*Materiam superabat opus.*'

In the second place, there was the more serious dissatisfaction of those who objected to Suger's enterprises in the name of sacred traditions. The Carolingian church of St-Denis was held, until quite recently, to have been built by the original founder of the Abbey, King Dagobert; according to legend it had been consecrated by Christ in person; and modern scholarship has confirmed the tradition that the old structure was never touched until Suger's accession to power. But when Suger wrote his report 'On What Was Done under His Administration' he had torn down the old apse and the old west front (including the porch protecting the tomb of Pepin the Short), had constructed a brand-new narthex and a brand-new *chevet*, and had just started operations that would eliminate the last remaining part of the ancient basilica, the nave. It was as if a President of the United States were to have had the White House rebuilt by Frank Lloyd Wright.

In justifying this destructively creative enterprise – which was to set the course of Western architecture for more than a century – Suger untiringly stresses four points. First, whatever had been done had been done upon due deliberation with the brethren 'whose hearts burned for Jesus while He talked with them by the way', and many of them had even

explicitly requested it. Second, the work had manifestly found grace in the eyes of God and the Holy Martyrs who had miraculously disclosed the presence of suitable building materials where nothing of the kind had been believed to exist, who had protected unfinished vaults from a terrible storm, and had promoted the work in many other ways so that the *chevet* could be constructed in the incredibly brief – and symbolically significant – space of three years and three months. Third, care had been taken to save as much as possible of the sacred old stones 'as though they were relics'. Fourth, the rebuilding of the church was an indisputable necessity because of its dilapidated condition and, more important, because of its relative smallness which, coupled with an insufficient number of exits, had led to riotous and dangerous disorders on feast days; Suger, free from 'any desire for empty glory' and entirely uninfluenced by 'the reward of human praise and transitory compensation', would never have 'presumed to set his hand to such a work, nor even to think of it, had not so great, so necessary, so useful and honourable an occasion demanded it'.

All these assertions are entirely correct – so far as they go. No doubt Suger discussed his plans with those of the brethren whom he found interested and cooperative, and he was careful to have his decisions formally approved by the general chapter. But a lack of unanimity becomes at times apparent even from his own narrative (as when he tells us how, after the completion of the narthex and *chevet*, 'some people' had persuaded him to finish the towers before rebuilding the nave, but how 'Divine inspiration' had urged him to reverse the process); and the formal approval of the general chapter seems to have been obtained *ex post facto* rather than beforehand (as when the construction and consecration of the new narthex, and the laying of the foundations for the new *chevet*, were solemnly placed on record in an '*Ordinatio*' enacted afterwards).

No doubt the operations proceeded with unusual speed and smoothness. But to what extent the discovery of stones

and timber in unexpected places and the survival of the 'isolated and newly made arches tottering in mid-air' required the personal intercession of the Holy Martyrs in addition to Suger's own ingenuity and to the skill of his workmen is a matter of surmise.

No doubt Suger rebuilt the basilica a part at a time and thereby saved the 'sacred stones' at least provisionally, as it were. But the fact remains that in the end nothing was left of them except the remodelled substructures of the *chevet*; his very eulogists praised him for having remade the church 'from top to bottom'.

No doubt the old building was worn with age and no longer able to accommodate without grave inconvenience the crowds attracted by the Fair and the relics. But one cannot help feeling that Suger is a little overemphatic in depicting these tribulations, all the more so because the fearsome stories of the pious women who could reach the altar only 'by walking upon the heads of the men as though upon a pavement', or had to be carried into the cloisters 'in a half-dead condition', are told alternately to prove the need of a new narthex and the need of a new *chevet*. One thing is certain: the main incentive to Suger's artistic activity – and to his writing about it – must be sought within himself.

VI

There is no denying, in spite (or, rather, because) of his persistent protestations to the contrary, that Suger was animated by a passionate will to self-perpetuation. To put it less academically: he was enormously vain. He requested the honour of an anniversary – not without a wistful admonition to future Cellarers not to be angry because of the additional expense for food and drink but to remember that it was he, Suger, who had increased the budget of their department – and thereby placed himself on the same footing as King Dagobert, Charles the Bald and Louis le Gros, the only persons previously thus honoured. He frankly thanked God for

having reserved the task of rebuilding the church to 'his lifetime and labours'(or, as he puts it in another place, to 'so small a man who was the successor to the nobility of such great kings and abbots'). At least thirteen of the *versiculi* with which he covered every available space on walls and liturgical objects mention his name; and numerous donor's portraits of him were strategically disposed on the main axis of the basilica: two in the principal entrance (one in the tympanum, the other on the doors), a third one at the foot of the Great Cross that commanded the opening arch of the new upper choir and could be seen from almost every point in the church, and one or two more in the windows adorning the central chapel of the ambulatory. When we read of Suger's huge, gold-lettered inscription above the west portals ('O may it not be obscured!'), when we observe him constantly preoccupied with the memory of future generations and alarmed by the thought of 'Oblivion, the jealous rival of Truth', when we hear him speak of himself as the 'leader' (*dux*) under whose guidance the church had been enlarged and ennobled, we feel as though we listened to some of Jacob Burckhardt's evidence for 'the modern form of glory', and not to the words of an abbot of the twelfth century.

Yet there is a fundamental difference between the Renaissance man's thirst for fame and Suger's colossal but, in a sense, profoundly humble vanity. The great man of the Renaissance asserted his personality centripetally, so to speak: he swallowed up the world that surrounded him until his whole environment had been absorbed by his own self. Suger asserted his personality centrifugally: he projected his ego into the world that surrounded him until his whole self had been absorbed by his environment.

To understand this psychological phenomenon, we have to remember two things about Suger that again place him in diametrical contrast to the highborn convert, St Bernard. First, Suger entered the monastery, not as a novice devoting himself to monastic life of his own free will, or at least with

the comprehension of a relatively mature intelligence, but as an oblate dedicated to Saint Denis when a boy of nine or ten. Second, Suger, the schoolmate of young noblemen and princes of the blood, was born – no one knows where – of very poor and very lowly parents.

Many a boy would have developed into a shy or bitter person under such circumstances. The future abbot's extraordinary vitality resorted to what is known as overcompensation. Instead of either yearningly clinging to or drastically breaking away from his natural relatives, Suger kept them at a friendly distance and, later on, made them participate, in a small way, in the life of the Abbey.[2] Instead of either concealing or resenting his humble birth, Suger almost gloried in it – though only to glory all the more in his adoption by St-Denis. 'For who am I, or what is my father's house?' he exclaims with young David. And his literary works as well as his official documents fairly bristle with such phrases as: 'I, insufficient with regard to family as well as knowledge'; or: 'I, who succeeded to the administration of this church against the prospects of merit, character and family'; or (in the words of Hannah, mother of Samuel): 'I, the beggar, whom the strong hand of the Lord has lifted up from the dunghill.' But the strong hand of the Lord had operated through the Abbey of St-Denis. In taking him away from his natural parents, He had given to Suger another 'mother' – an expression persistently recurring in

2. The names of Suger's father, Helinandus, and of one brother and sister-in-law, Radulphus and Emmelina, figure in the obituary of the Abbey. Another brother, Peter, accompanied Suger to Germany in 1125. One of his nephews, Gerard, paid to the Abbey an annual amount of fifteen shillings, five shillings as rent and ten for reasons unknown. Another nephew, John, died on a mission to Pope Eugenius III, who wrote a very cordial letter of condolence to Suger. A third one, Simon, witnessed an Ordinance of his uncle in 1148 and became embroiled with the latter's successor, Odon de Deuil (who was a protégé of St Bernard and looked with disfavour upon everyone close to Suger). None of these instances seems to involve illegitimate favouritism.

his writings – who had made him what he was. It was the Abbey of St-Denis which had 'cherished and exalted him'; which had 'most tenderly fostered him from mother's milk to old age'; which 'with maternal affection had suckled him as a child, had held him upright as a stumbling youth, had mightily strengthened him as a mature man and had solemnly set him among the princes of the Church and the realm.'

Thus Suger, conceiving of himself as the adopted child of St-Denis, came to divert to the Abbey the whole amount of energy, acumen and ambition nature had bestowed upon him. Completely fusing his personal aspirations with the interests of the 'mother church,' he may be said to have gratified his ego by renouncing his identity: he expanded himself until he had become identical with the Abbey. In spreading his inscriptions and portraits all over the church, he took possession of it but at the same time divested himself, to some extent, of his existence as a private individual. When Peter the Venerable, Abbot of Cluny, saw Suger's narrow little cell he is said to have exclaimed, with a sigh: 'This man puts all of us to shame; he builds, not for himself, as we do, but only for God.' But for Suger there was no difference between the one and the other. He did not need much private space and luxury because the space and luxury of the basilica was no less his than was the modest comfort of his cell; the Abbey Church belonged to him because he belonged to the Abbey Church.

Nor did this process of self-affirmation through self-effacement stop at the borders of St-Denis. To Suger, St-Denis meant France, and so he developed a violent and almost mystical nationalism as apparently anachronistic as was his vaingloriousness. He whom all contemporary writers praise as a man of letters at home in all subjects, one who could write boldly, brilliantly and 'almost as fast as he could speak', never felt moved to make use of this gift except in honour of the Abbey of which he was the head, and of the two French kings whom he had served – according to his

eulogists, had ruled. And in the *Life of Louis le Gros* we find sentiments that foreshadow the specific form of patriotism best characterized by the French word *chauvinisme*. According to Suger, the English are 'destined by moral and natural law to be subjected to the French, and not contrariwise'; and what he thought of the Germans, whom he loved to describe as 'gnashing their teeth with Teutonic fury', appears from the following:

Let us boldly cross their border lest they, withdrawing, bear with impunity what they have arrogantly presumed against France, the mistress of the earth. Let them feel the reward of their affront, not in our land but in theirs which, often conquered, is subject to the Franks by the royal right of the Franks.

In Suger's case this urge to grow by metempsychosis, if one may say so, was further sharpened by an apparently irrelevant circumstance which he himself does not mention at all (perhaps he had even ceased to be conscious of it) but which appeared noteworthy to all his admirers: he was uncommonly small of stature. 'He had been allotted a short and spare body,' says Willelmus, and goes on to marvel how such a 'weak little frame' (*imbecille corpusculum*) could stand the strain of so 'vigorous and lively a mind'. And an anonymous encomiast writes:

I am amazed at the huge spirit in such a body,
And how so many and so great good qualities have room in
a small vessel.
But by this one man nature wanted to prove
That virtue can be hidden under any kind of skin.

An exceptionally small physique seems to be insignificant in the eyes of history; and yet it has been an essential factor in determining the character of many a well-remembered historical figure. More effectively than any other handicap can it be turned into an asset if the victim of this handicap is able to outbalance his physical inferiority by what is perhaps most graphically described as 'pluck', and if he can break down

the psychological barrier separating him from the group of average-sized men with whom he lives by a more-than-average aptitude and willingness to identify his own self-interest with theirs. It is this combination of pluck and will-to-fellowship (often coupled with a naïve, innocuous vanity) that places such 'great little men' as Napoleon, Mozart, Lucas van Leyden, Erasmus of Rotterdam or General Montgomery in a class by themselves and endows them with a special charm or fascination. The evidence seems to show that Suger had some of this peculiar charm and that his tiny stature was as much of an incentive to his great ambitions and accomplishments as was his lowly origin. A Canon Regular of St-Victor, bearing the curious name of Simon Chièvre-d'Or (Simon Capra Aurea), showed remarkable insight into the character of his dead friend when he included in his obituary the following couplet:

> *Corpore, gente brevis, gemina brevitate coactus,*
> *In brevitate sua noluit esse brevis.*

Small of body and family, constrained by twofold smallness,
He refused, in his smallness, to be a small man.

It is amusing and, at times, almost a little pathetic to note how far Suger's unselfish selfishness would go where the prestige and splendour of St-Denis were concerned. How he put on a shrewd little show to prove to one and all the authenticity of certain relics given by Charles the Bald. How he induced 'by his example' the royal, princely and episcopal visitors of the Abbey to donate the stones of their very rings for the adornment of a new altar frontal (apparently divesting himself of his own ring in their presence and thereby forcing them to do likewise). How members of those ill-advised orders that had no use for pearls and gems except to convert them into money for alms offered him theirs for sale, and how he, thanking God for the 'merry miracle', gave them four hundred pounds for the lot 'though they were worth much more'. How he would corner travellers from

the East until they assured him that the treasures of St-Denis surpassed those of Constantinople; how he tried to gloss over his disappointment if a more obtuse or less obliging visitor failed to give him such satisfaction; and how he finally consoles himself with a quotation from St Paul: 'Let every man abound in his own sense,' which he takes to mean (or pretends to take to mean): 'Let every man believe himself to be rich.'

As a 'beggar lifted up from the dunghill' Suger was naturally not free from that arch-weakness of the parvenu, snobbery. He wallows in the names and titles of all the kings, princes, popes, and high ecclesiastics who had visited the Abbey and shown him their personal esteem and affection. He looks with a certain condescension upon the mere counts and nobles, not to mention the 'ordinary troops of knights and soldiers', who flocked to the Great Consecration of 11 June 1144; and it is not without boastfulness that he twice enumerates the nineteen bishops and archbishops whom he had brought together on this glorious day: had only one more been able to attend, each of the twenty new altars would have been consecrated by a different dignitary – while, as it was, the Bishop of Meaux had to officiate at two. But again it is impossible to draw a sharp line between personal and what may be called institutional self-satisfaction. When speaking of himself, Suger makes no distinction, even in one and the same sentence, between 'I' and 'we'; at times he uses the 'we' much as a sovereign would, but more often than not he does it in the spirit of a genuinely 'pluralistic' feeling: 'we, the community of St-Denis'. While taking enormous pride in the little private presents he occasionally received from royalty, he never failed to offer them afterwards to the Holy Martyrs; and his abbatial dignity did not prevent him from personally supervising the purchase of food for grand occasions or from rummaging in chests and cupboards in order to recover long-forgotten *objets-'art* that might be re-used.

For all his airs, Suger had never lost touch with the 'com-

mon man' whom he had come to know so well in the long
years at Berneval and Toury, and whose immortal ways of
thought and speech he occasionally sketches with a few
masterly strokes. We almost hear the ox drivers at the quarry
near Pontoise as they grumble about 'having nothing to do'
and 'the labourers standing around and losing time' when
part of the help had run away in a violent rainstorm. We
almost see the sheepish yet supercilious grin of the woodmen
in the *Forêt de Rambouillet* when the great Abbot had asked
them what they considered a stupid question. Some excep-
tionally long beams were needed for the roofing of the new
west part and could nowhere be found in the nearer vicinity;

But on a certain night, when I had returned from celebrating
Matins, I began to think in bed that I myself should go through
all the forests in these parts. ... Quickly disposing of other
duties and hurrying up in the early morning, we hastened with
our carpenters, and with the measurements of the beams, to the
forest called Iveline. When we traversed our possession in the
Valley of Chevreuse we summoned ... the keepers of our own
forests as well as those who knew about the other woods, and
questioned them under oath whether we could find there, no
matter with how much trouble, any timbers of that measure. At
this they smiled, or rather would have laughed at us if they had
dared; they wondered whether we were quite ignorant of the
fact that nothing of the kind could be found in the entire region.
... But we ... began, with the courage of our faith as it were, to
search through the woods; and toward the first hour we had
found one timber adequate to the measure. Why say more? By
the ninth hour or sooner we had, through the thickets, the depths
of the forests and the dense, thorny tangles, marked down twelve
timbers (for so many were necessary) ...

There is something engaging, even touching, about this
picture of the little man, nearer sixty than fifty, how he can-
not sleep after midnight service, still worrying about his
beams; how he is struck with the idea that he ought to look
after things himself; how he dashes off in the early morning,
at the head of his carpenters and with the measurements in

his pocket; how he scrambles through the wilderness 'with the courage of his faith' – and ultimately gets precisely what he wants. However, setting aside all 'human interest', this small incident gives perhaps the final answer to our initial question: Why was it that Suger, in contrast to so many other patrons of the arts, felt compelled to commit his exploits to writing?

As we have seen, one of his motives was a desire for self-justification, possibly sharpened by the fact that he, unlike popes, princes and cardinals of later centuries, still felt a kind of democratic responsibility to his chapter and order. A second motive was, unquestionably, his personal and, as we have termed it, institutional vanity. But both these impulses, strong though they were, might not have become articulate had it not been for Suger's well-founded conviction that his had been a role quite different from that of one who, to quote the *Oxford Dictionary's* definition of a 'patron', 'countenances or protects or deigns to employ a person, cause or art'.

A man who takes his carpenters into the woods in quest of beams and personally picks the right trees, a man who sees to it that his new *chevet* is properly aligned with the old nave by means of 'geometrical and arithmetical instruments', is still more closely akin to the ecclesiastical amateur architect of the earlier Middle Ages – and, by the way, to the non-ecclesiastical gentleman architect of colonial America – than to the great patrons of the High Gothic and Renaissance periods who would appoint an architect-in-chief, pass judgement on his plans and leave all technical details to him. Devoting himself to his artistic enterprises 'both with mind and body', Suger may be said to record them, not so much in the capacity of one who 'countenances or protects or deigns to employ' as in the capacity of one who supervises or directs or conducts. To what extent he was responsible or co-responsible for the very design of his structures is for others to decide. But it would seem that very little was done without at least his active participation. That he selected and in-

vited the individual craftsmen, that he ordered a mosaic for a place where apparently nobody wanted it, and that he devised the iconography of his windows, crucifixes and altar panels is attested by his own words; but also an idea such as the transformation of a Roman porphyry vase into an eagle suggests a whim of the abbot rather than the invention of a professional goldsmith.

Did Suger realize that his concentration of artists 'from all parts of the kingdom' inaugurated in the theretofore relatively barren Ile-de-France that great selective synthesis of all French regional styles which we call Gothic? Did he suspect that the rose window in his west façade – so far as we know the first appearance of this motif in this place – was one of the great innovations in architectural history, destined to challenge the inventiveness of countless masters up to Bernard de Soissons and Hugues Libergier? Did he know, or sense, that his unreflecting enthusiasm for the Pseudo-Areopagite's and John the Scot's light metaphysics placed him in the van of an intellectual movement that was to result in the proto-scientific theories of Robert Grosseteste and Roger Bacon, on the one hand, and in a Christian Platonism ranging from William of Auvergne, Henry of Ghent and Ulric of Strassburg to Marsilio Ficino and Pico della Mirandola, on the other? These questions, too, will have to be left unanswered. Certain it is, however, that Suger was acutely conscious of the stylistic difference that existed between his own, 'modern' structures (*opus novum* or even *modernum*) and the old Carolingian basilica (*opus antiquum*). So long as parts of the old building were still in existence he clearly perceived the problem of harmonizing (*adaptare et coaequare*) the 'modern' work with the 'ancient'. And he was fully aware of the new style's distinctive aesthetic qualities. He felt, and makes us feel, its spaciousness when he speaks of his new *chevet* as being 'ennobled by the beauty of length and width'; its soaring verticalism when he describes the central nave of this *chevet* as being 'suddenly (*repente*) raised aloft' by the supporting columns; its luminous transparency

when he depicts his church as 'pervaded by the wonderful and uninterrupted light of most radiant windows'.

It has been said that Suger was harder to visualize as an individual than were the great cardinals of the seventeenth century of whom he was the historical ancestor. Yet it would seem that he steps out of the pages of history as a figure surprisingly alive and surprisingly French: a fierce patriot and a good householder; a little rhetorical and much enamoured of grandeur, yet thoroughly matter-of-fact in practical affairs and temperate in his personal habits; hard-working and companionable, full of good nature and *bon sens*, vain, witty, and irrepressibly vivacious.

In a century unusually productive of saints and heroes Suger excelled by being human; and he died the death of a good man after a life well spent. In the fall of 1150 he fell ill of a malarial fever and was past hope before Christmas. In the effusive and somewhat theatrical way of his period he asked to be led into the convent and weepingly implored the monks to be forgiven for everything in which he might have failed the community. But he also prayed to God to be spared until the end of the festive season 'lest the joy of the brethren be converted into sorrow on his account'. This request, too, was granted. Suger died on 13 January 1151, the octave of Epiphany that ends the Christmas holidays. 'He did not tremble in the sight of the end,' says Willelmus, 'because he had consummated his life before his death; nor was he loath to die because he had enjoyed to live. He departed willingly because he knew that better things were in store for him after his passing, and he did not hold that a good man should leave like one who is ejected, who is thrown out against his will.'

4

Titian's *Allegory of Prudence*: A Postscript

Exactly thirty years ago my late friend Fritz Saxl and myself, then young *Privatdozenten* at the University of Hamburg, received a letter accompanied by two photographs; one showed a little-known metal cut by Holbein (Plate 39), the other a recently published painting by Titian, then owned by the late Mr Francis Howard of London (Plate 28).[1] The letter came from Campbell Dodgson, Keeper of the Print Room in the British Museum and the foremost authority on graphic art in Germany. He had observed that the two compositions had their most characteristic and intriguing features in common and asked us whether we might be able to throw some light on their iconographic significance.

Much flattered and pleased, we answered as best we could; and Campbell Dodgson, with the impulsive generosity which was the very essence of his nature, replied that, instead of using our exposition for his own purposes, he had translated it into English and proposed to offer it to the *Burlington Magazine* for publication. Here it appeared in 1926,[2] and four years later a German version, revised and

1. D. von Hadeln, 'Some Little-Known Works by Titian', *Burlington Magazine*, XLV, 1924, p. 179 f. The measurements of the picture (on canvas) are 76·2 cm. by 68·6 cm. For several other bibliographical references I am indebted to Dr L. D. Ettlinger of the Warburg Institute at London. Quite recently the picture was sold at Christie's to Mr Leggatt, and it is now in the National Gallery.

2. E. Panofsky and F. Saxl, 'A Late-Antique Religious Symbol in Works by Holbein and Titian', *Burlington Magazine*, XLIX, 1926, p. 177 ff.

somewhat expanded, was included in my book on Hercules at the Crossroads and Other Classical Subjects in Post-medieval Art.[3] However, since I seem to have missed some crucial points even then, I may be forgiven for acting upon the advice of Goethe's Mephistopheles: 'Du musst es drei Mal sagen.'

I

The authenticity of Mr Howard's picture (which can be traced to the collection of Joseph Antoine Crozat, the patron and friend of Watteau) cannot be – and, so far as I know, has never been – questioned. Shining with the magnificence of Titian's *ultima maniera*, it must be counted among his latest works and may be dated, on purely stylistic grounds, between 1560 and 1570, probably less than ten years before the master's death.[4] Seen in the context of Titian's *oeuvre* in its entirety, however, it is not only exceptional but unique. It is the only work of his that may be called 'emblematic' rather than merely 'allegorical': a philosophical maxim illustrated by a visual image rather than a visual image invested with philosophical connotations.

When confronted with Titian's Allegories – the so-called *Education of Cupid* in the Galleria Borghese, the so-called *Allegory of the Marquis d'Avalos* in the Louvre, the *Feast of Venus* and the *Bacchanal of the Andrians* in the Prado, the

3. E. Panofsky, *Hercules am Scheidewege und andere antike Bildstoffe in der neueren Kunst*. For later references, see H. Tietze, *Tizian, Leben und Werk*, Vienna, 1936, p. 293, Pl. 249 (also in English, 1937); *Catalogue, Exhibition of Works by Holbein and Other Masters of the Sixteenth and Seventeenth Centuries*, London Royal Academy, 1950–51, No. 209; J. Seznec, *The Survival of the Pagan Gods*, New York, 1953, p. 119 ff., Fig. 40.

4. I agree with the date proposed by Tietze, loc. cit., rather than with the dating in the 1540s proposed in the London *Catalogue* of 1950–51. The later date, probable for purely stylistic reasons, can be confirmed by the features of the old man (which are, as will be seen, Titian's own) as well as by the fact that the probable iconographic source of the picture, Pierio Valeriano's *Hieroglyphica*, was not published until 1556.

Apotheosis of Ariadne in the National Gallery at London, and, above all, the *Sacred and Profane Love* – we are invited but not forced to look for an abstract and general significance behind the concrete and particular spectacle that enchants our eyes and can be understood as representing an event or situation rendered for its own sake. It is, in fact, only quite recently that the *Feast of Venus*, the *Bacchanal of the Andrians* and the *Apotheosis of Ariadne* have revealed their Neo-Platonic content:[5] conversely, there are those who interpret the *Sacred and Profane Love* as a straightforward, non-allegorical illustration inspired by a specific incident in Francesco Colonna's *Hypnerotomachia Polyphili*.[6]

In the Howard picture the conceptual significance of the perceptible data is so obtrusive that it simply does not seem to make sense until we have discovered its ulterior meaning. It has all the characteristics of the 'emblem' which, as defined by one who ought to know,[7] partakes of the nature of the symbol (only that it is particular rather than universal), the puzzle (only that it is not quite so difficult), the apophthegm (only that it is visual rather than verbal), and the proverb (only that it is erudite rather than commonplace). The painting is, therefore, the only work of Titian's – who

5. E. Wind, *Bellini's Feast of the Gods*, Cambridge, Mass., 1948, p. 56 ff.

6. W. Friedlaender, 'La Tintura delle Rose (Sacred and Profane Love)', *Art Bulletin*, XX, 1938, p. 320 f.; cf., however, R. Freyhan, 'The Evolution of the Caritas Figure', *Journal of the Warburg and Courtauld Institutes*, XI, 1948, p. 68 ff., particularly p. 85 f.

7. See Claudius Minos' introduction to Andrea Alciati's *Emblemata*, first published in the Lyons edition of 1571; in the Lyons edition of 1600, p. 13 ff. A nice, brief definition of emblems – here called *'devises'* – is given by the Maréchal de Tavanes, the well-known general and admiral of Francis I (*Mémoires de M. Gaspard de Saulx, Maréchal de Tavanes*, Château de Lagny, 1653, p. 63): 'Today the devices are distinct from coats-of-arms in that they are composed of body, soul and spirit: the body is the picture, the spirit the invention, the soul the motto' ('en ce temps les devises sont séparées des armoiries, composées de corps, d'âme et d'esprit: le corps est la peinture, l'esprit l'invention, l'âme est le mot').

usually limited lettering to his own name or that of the sitter in a portrait – to carry a genuine 'motto' or 'titulus':[8] EX PRAETERITO/ PRAESENS PRVDENTER AGIT/ NI FVTVRĀ ACTIONĒ DETVRPET. 'From the [experience of the] past, the present acts prudently, lest it spoil future action.'[9]

II

The elements of this inscription are so arranged as to facilitate the interpretation of the parts as well as the whole: the words *praeterito*, *praesens* and *futurā* serve as labels, so to speak, for the three human faces in the upper zone, viz., the profile of a very old man turned to the left, the full-face portrait of a middle-aged man in the centre, and the profile of a beardless youth turned to the right: whereas the clause *praesens prudenter agit* gives the impression of summarizing the total content after the fashion of a 'headline'. We are given to understand, then, that the three faces, in addition to typifying three stages of human life (youth, maturity and old age), are meant to symbolize the three modes or forms of time in general; past, present, and future. And we are further asked to connect these three modes or forms of time with the idea of prudence or, more specifically, with the three psychological faculties in the combined exercise of which this virtue consists: memory, which remembers, and learns from, the past: intelligence, which judges of, and acts in, the present: and foresight, which anticipates, and provides for or against, the future.

8. The inscription in the allegorical portrait of Philip II and his son Ferdinand in the Prado (MAIORA TIBI) is not a 'motto' or 'titulus' but an integral part of the picture itself. Inscribed on a scroll offered by an angel, it plays a role comparable to that of the Angel Gabriel's AVE MARIA in renderings of the Annunciation.

9. In my and Saxl's previous publications the abbreviation signs above the A in FVTVRA and the E in ACTIONE, which were invisible in the photographs then at our disposal, are omitted. This omission was rectified in the London *Catalogue* of 1950–51; but here the clearly legible NI before FVTVRA has been rendered as NE. The sense is not affected by any of these corrections.

This coordination of the three modes or forms of time with the faculties of memory, intelligence and foresight, and the latter's subordination to the concept of prudence, represent a classical tradition which preserved its vitality even when Christian theology had elevated prudence to the status of a cardinal virtue. 'Prudence,' we read in Petrus Bechorius' *Repertorium morale*, one of the most popular late-medieval encyclopedias, 'consists of the memory of the past, the ordering of the present, the contemplation of the future' ('in praeteritorum recordatione, in praesentium ordinatione, in futurorum meditatione'), and the origin of this rhymed formula – quoted from a treatise traditionally ascribed to Seneca, though actually composed by a Spanish bishop of the sixth century A.D.[10] – can be traced back to the pseudo-Platonic dictum according to which 'wise counsel' (συμβουλια), takes into consideration the past, which furnishes precedents, the present, which poses the problem on hand, and the future, which harbours the consequences.[11]

Medieval and Renaissance art found many ways to express this tripartition of prudence in a visual image. Prudence is shown holding a disc the three sectors of which bear the inscription 'Tempus praeteritum', 'Tempus praesens' and 'Tempus futurum',[12] or a brazier from which burst forth

10. Berchorius (see this page, and Note 31, p. 193) refers to Seneca's *Liber de moribus*; but the formula occurs in a treatise entitled *Formula vitae honestae* or *De quattuor virtutibus cardinalibus*, likewise ascribed to Seneca and usually printed together with the *Liber de moribus* (cf. *Opera Senecae*, Joh. Gymnicus, ed., Cologne, 1529, fol. II v.). The real author of the former is certainly Bishop Martin of Bracara.

11. Diogenes Laertius, *De vitis, dogmatibus et apophthegmatibus clarorum philosophorum*, III, 71. For the re-emergence of the original connexion of the three modes of time with *Consilium* rather than *Prudentia* in Cesare Ripa's *Iconologia*, see below, p. 199.

12. See the miniature published by J. von Schlosser, 'Giustos Fresken in Padua und die Vorläufer der Stanza della Segnatura', *Jahrbuch der kunsthistorischen Sammlungen des Allerhöchsten Kaiserhauses*, XVII, 1896, p. 11 ff., Pl. X.

three flames analogously labelled.[13] She is represented enthroned beneath a canopy inscribed 'Praeterita recolo, praesentia ordino, futura praevideo' while looking at her reflection in a triple mirror.[14] She is impersonated by a cleric who handles three books displaying appropriate admonitions (Plate 30).[15] Or, finally, she is depicted – after the fashion of those Trinities which, being of a pagan origin, were frowned upon by the Church but never lost their popularity[16] – as a three-headed figure exhibiting, in addition to a middle-aged face seen in front view which symbolizes the present, a young and an old face turned to profile which symbolize, respectively, the future and the past. This three-headed Prudence appears, for example, in a Quattrocento relief in the Victoria and Albert Museum at London now ascribed to the school of Rossellino (Plate 29),[17] and – the significance of the tricephalous image here further clarified by the traditional attribute of wisdom, the serpent (Matthew 10; 16) – in one of the niellos in the late fourteenth-century pavement of Siena Cathedral (Plate 31).[18]

13. See Ambrogio Lorenzetti's fresco in the Palazzo Pubblico at Siena.

14. See a Brussels tapestry of about 1525, published in H. Göbel, *Wandteppiche*, Leipzig, 1923–34, I, 2 (Netherlands), Pl. 87.

15. Rome, Biblioteca Casanatense, Cod. 1404, fols. 10 and 34.

16. For the problem of this iconographic type, see, in addition to the literature referred to in my and Saxl's previous publications: G. J. Hoogewerff, 'Vultus Trifrons, Emblema Diabolico, Imagine improba della SS. Trinità', *Rendiconti della Pontifica Accademia Romana di Archeologia*, XIX, 1942-3, p. 205 ff.; R. Pettazzoni, 'The Pagan Origins of the Three-headed Representation of the Christian Trinity', *Journal of the Warburg and Courtauld Institutes*, IX, 1946, p. 135 ff.; and W. Kirfel, *Die dreiköpfige Gottheit*, Bonn, 1948 (cf. also the review by A. A. Barb, *Oriental Art*, III, 1951, p. 125 f.).

17. See now *Victoria and Albert Museum, Catalogue of Italian Sculpture*, E. Maclagan and M. H. Longhurst, eds., London, 1932, p. 40, Pl. 30d.

18. See *Annales Archéologiques*, XVI, 1856, p. 132. Among other examples we may mention a figure on the Baptistry at Bergamo (A. Venturi, *Storia del arte italiana*, IV, Fig. 510); the title page of Gregorius Reisch, *Margarita Philosophica*, Strassburg, 1504(illustrated in Schlosser, op. cit., p. 49); a miniature in MS. 87, fol. 3 of the University Library

III

The 'anthropomorphic' portion of Titian's picture can thus be derived from texts and images transmitted to the sixteenth century by a continuous and purely Western tradition. To understand the three animal heads, however, we must go back to the dark and remote sphere of the Egyptian or pseudo-Egyptian mystery religions – a sphere which had vanished from sight in the Christian Middle Ages, dimly emerged above the horizon with the beginning of Renaissance humanism toward the middle of the fourteenth century, and became the object of passionate interest after the discovery of Horapollo's *Hieroglyphica* in 1419.[19]

One of the greatest gods of Hellenistic Egypt was Serapis, whose statue – traditionally ascribed to Bryaxis, famous for his contribution to the decoration of the Mausoleum – was admired in the god's chief sanctuary, the Serapeion at Alexandria. Known to us through numerous descriptions and replicas (Plate 34),[20] it showed Serapis enthroned in Jovian majesty, sceptre in hand and his attribute, the *modius* (corn measure), on his head. His most distinctive feature, how-

at Innsbruck (*Beschreibendes Verzeichnis der illuminierten Handschriften in Oesterreich*, I [*Die illuminierten Handschriften in Tirol*, H. J. Hermann, ed.], Leipzig, 1905, p. 146, Pl. X); and, as a curious anachronism, a painting by the Hamburg Baroque painter Joachim Luhn (Hamburg, Museum för Hamburgische Geschichte), for which see H. Röver, *Otto Wagenfeldt und Joachim Luhn*, Diss., Hamburg, 1926. In some instances, such as a relief on the Campanile at Florence (Venturi, loc. cit., Fig. 550), Raphael's fresco in the Stanza della Segnatura and Rubens' 'modello' of a Triumphal Chariot in the Antwerp Museum (*P. P. Rubens* [Klassiker der Kunst, V, 4th ed., Stuttgart and Berlin] p. 412), the number of heads is reduced to two, indicating only the past and the future.

19. See now Seznec, loc. cit., p. 99 ff., with further literature.

20. See A. Roscher, *Ausführliches Lexikon der griechischen und römischen Mythologie*, s.v. *Sarapis, Hades*, and *Kerberos*; Pauly-Wissowa, *Realencyclopaedie der klassischen Altertumswissenschaft*, s.v. *Sarapis*; Thieme-Becker, *Allgemeines Künstlerlexikon*, s.v. *Bryaxis*.

ever, was his companion: a tricephalous monster, encircled by a serpent, which bore on its shoulders the heads of a dog, a wolf and a lion – in short, the same three animal heads that confront the beholder in Titian's Allegory.

The original significance of this strange creature – which so intensely appealed to popular imagination that it was separately duplicated in terracotta statuettes bought by the faithful as pious souvenirs (Plates 32, 33) – poses a question which even a Greek of the fourth century A.D. no longer dared to answer: in his *Romance of Alexander*, Pseudo-Callisthenes speaks only of a 'polymorphous animal the essence of which no one can explain'.[21] But since Serapis, however much his powers were extended later, seems to have begun his career as a god of the nether world (he was actually referred to as 'Pluto' or 'Jupiter Stygius'),[22] it is quite possible that his three-headed companion was no more than an Egyptian version of Pluto's Cerberus, with two of the latter's three dog's heads replaced by those of indigenous, death-dealing divinities, the wolf's head of Upnaut and the lion's head of Sakhmet; Plutarch may be essentially right in simply identifying the Serapis monster as 'Cerberus'.[23] The serpent, however, seems to be the original incarnation of Serapis himself.[24]

While we must thus admit that we do not know what Serapis' extraordinary pet meant to the Hellenistic East, we do know what it meant to the Latin and Latinized West. That monument of late-antique polymathy and exegetic refinement, the *Saturnalia* by Macrobius (active as a high Roman official from 399 to 422 A.D.),[25] contains, among innumerable

21. Cf. R. Reitzenstein, *Das iranische Erlösungsmysterium*, Bonn, 1921, p. 190.

22. See Roscher and Pauly-Wissowa, s.v. *Sarapis*.

23. Plutarch, *De Iside et Osiride*, 78.

24. See Reitzenstein, op. cit.; cf. H. Junker, 'Uber iranische Quellen der hellenistischen Aion-Vorstellung', *Vorträge der Bibliothek Warburg*, 1921-2, p. 125 ff.

25. For Macrobius, see E. R. Curtius, *Europäische Literatur und lateinisches Mittelalter*, Berne, 1928, *passim*, especially p. 442 ff.

other items of antiquarian and critical interest, not only a description but also an elaborate interpretation of the famous statue in the Serapeion, and in it we read the following:

They [the Egyptians] added to the statue [of Serapis] the image of a three-headed animal the central, and largest, head of which bears the likeness of a lion; on the right there rises the head of a dog trying to please with a friendly expression, while the left part of the neck terminates in the head of a rapacious wolf; and a serpent connects these animal forms with its coils (*easque formas animalium draco conectit volumine suo*), its head turned back towards the right hand of the god, who pacifies the monster. The lion's head thus denotes the present, the condition of which, between the past and the future, is strong and fervent by virtue of present action; the past is designated by the wolf's head because the memory of things that belong to the past is devoured and carried away; and the image of the dog, trying to please, signifies the outcome of the future, of which hope, though uncertain, always gives us a pleasing picture.[26]

Macrobius, then, interpreted the companion of Serapis as a symbol of Time – a thesis corroborating his basic conviction that the major pagan gods in general, and Serapis himself in particular, were solar divinities under different names: 'Serapis and the sun have one indivisible nature.'[27] The pre-Copernican mind was naturally inclined to conceive of time as governed, even engendered, by the perpetual and uniform

26. Macrobius, *Saturnalia*, I, 20, 13 ff.: 'uel dum simulacro signum tricipitis animantis adiungunt, quod exprimit medio eodemque maximo capite leonis effigiem; dextra parte caput canis exoritur mansueta specie blandientis, pars uero laeua ceruicis rapacis lupi capite finitur, easque formas animalium draco conectit uolumine suo capite redeunte ad dei dexteram, qua compescitur monstrum, ergo leonis capite monstratur praesens tempus, quia condicio eius inter praeteritum futurumque actu praesenti ualida feruensque est. sed et praeteritum tempus lupi capite signatur, quod memoria rerum transactarum rapitur et aufertur. item canis blandientis effigies futuri temporis designat euentum, de quo nobis spes, licet incerta, blanditur.'

27. Macrobius, loc. cit.: 'Ex his apparet Sarapis et solid unam et indiuiduam esse naturam.'

motion of the sun: and the presence of a serpent – which, supposedly tending to devour its own tail, was a traditional symbol of time and/or a period recurring in time[28] – seemed to lend further support to Macrobius' interpretation. On the strength of his exegesis posterity took it for granted that the three animal heads of the Alexandrian monster expressed the same idea as do the human heads of different age which we encountered in such Western representations of Prudence as that in the Rossellinesque relief in the Victoria and Albert Museum or in the Siena pavement: the tripartition of time into past, present and future, the provinces of memory, intelligence and foresight. From a Macrobian point of view the zoomorphic triad was thus equivalent to the anthropomorphic one, and we can easily foresee the possibility of either replacing or combining the one with the other – all the more so as Time and Prudence were linked, in iconographic tradition, by the common denominator of the serpent. This is indeed what happened in the Renaissance: but it was by a long and tortuous road that the Serapis monster wandered from Hellenistic Alexandria to Titian's Venice.

IV

For more than nine hundred years the fascinating creature lay imprisoned in the Macrobius manuscripts. It was, significantly, by Petrarch – the man who more than any other

28. For the serpent as a symbol of time or a recurring period of time, see, for example, Horapollo, *Hieroglyphica* (now accessible in an English translation by G. Boas, *The Hieroglyphics of Horapollo*, New York, 1950), I, 2; Servius, *Ad Vergilii Aeneadem*, V, 85; Martianus Capella, *De nuptiis Mercurii et Philologiae*, I, 70. Cf. F. Cumont, *Textes et monuments figurés relatifs aux mystères de Mithra*, Brussels, 1896, I, p. 79. The snake biting its tail is thus mentioned, and in part illustrated, as an attribute of Saturn, the god of time, in the mythographers from the *Mythographus III* and Petrarch (*Africa*, III, 147 f.) down to Vincenzo Cartari, *Imagini dei Dei degli Antichi* (first published in 1556; in the edition of 1571, p. 41) and G. P. Lomazzo, *Trattato della pittura* (first published in 1584), VII, 6 (in the reprint of 1844, Vol. III, p. 36).

may be held responsible for what we call the Renaissance – that it was rediscovered and set free. In the Third Canto of his *Africa* (composed in 1338) he describes the sculptured representations of the great pagan gods that adorned the palace of King Syphax of Numidia, the friend – and, later, enemy – of Scipio Africanus. In these 'ecphrases' the poet turns mythographer, as it were, drawing from medieval as well as classical sources; but his beautiful hexameters, free from all 'moralizations' and vitalizing an agglomeration of single characteristics and attributes into coherent living images, stand between the texts of the *Mythographus III* and Berchorius like a precocious piece of Renaissance poetry between two specimens of medieval prose. And it was in these hexameters that the three-headed animal described by Macrobius re-entered upon the stage of Western literature and imagery:

> Next to the god a huge, strange monster sits,
> Its triple-throated face turned up to him
> In friendly manner. On the right it looks
> A dog and on the left, a grasping wolf;
> Midway a lion. And a curling snake
> Conjoins these heads: they mean the fleeting times.[29]

The god, however, with whom these verses associate Macrobius' *triceps animans* is no longer Serapis. Petrarch could succumb to the charm of a fantastic beast composed of four ferocious entities, yet good-natured and submissive, fraught with metaphysical significance yet thoroughly alive and acting as a character in its own right rather than serving as a mere attribute; but he had no use for its outlandish mas-

29. Petrarch, *Africa*, III, 156 ff.:

> *Proximus imberbi specie crinitus Apollo ...*
> *At iuxta monstrum ignotum immensumque trifauci*
> *Assidet ore sibi placidum blandumque tuenti.*
> *Dextra canem, sed laeva lupum fert atra rapacem,*
> *Parte leo media est, simul haec serpente reflexo*
> *Iunguntur capita et fugientia tempora signant.*

ter. Tirelessly proclaiming the supremacy of his Roman ancestors over the Greeks, not to mention the barbarians, he replaced the Egyptian Serapis with the classical Apollo – a substitution doubly justifiable in that, *teste Macrobio*, the nature of Serapis is no less solar than Apollo's, and in that the latter, too, dominated the three modes or forms of time supposedly expressed by the three animal heads: he was not only a sun god but also the leader of the Muses and the protector of seers and poets, who, thanks to him, 'know all that is, that will be, and that was'.[30]

It is thus in connexion with the image of Apollo rather than Serapis that our monster was revived in subsequent literary descriptions and, through them, in book illuminations and prints. But, owing to a linguistic ambiguity in both the original source and its chief intermediaries, that is to say, Macrobius and Petrarch, we can observe a curious development. Both describe the three animal heads as 'connected' or 'conjoined' by a curling serpent (Macrobius: *easque formas ... draco conectit volumine suo*: Petrarch: *serpente reflexo/ Iunguntur capita*). In a mind still familiar with the actual aspect of Serapis and his companion these phrases would automatically conjure up the image of a three-headed quadruped – the original Cerberus – wearing the serpent as a kind of necklace (Plates 32, 33). To the medieval reader, however, they could just as well suggest three heads growing out of a serpent's body, in other words, a three-headed reptile. In order to avoid this ambiguity (and, as so often happens when flipping a coin, putting his money on 'tails' when 'heads' would have been right), the first mythographer to incorporate Petrarch's description decided for the reptilian body. 'At his [Apollo's] feet,' writes Petrus Berchorius (and, after him, the anonymous author of the *Libellus de imaginibus deorum*),

30. Homer, *Iliad*, I, 70, with reference to Calchas: ὅς ἤδη τά τ᾽ ἐόντα, τά τ᾽ ἐσσόμενα πρό τ᾽ ἐόντα.... ἦν διὰ μαντοσύνην, τὴν οἱ πόρε Φοῖβος Ἀπολλών. For a transference of these lines from the seer and the poet to the physician, see p. 197.

there was depicted a horrifying monster the body of which was like that of a serpent (*corpus serpentinum*); and it had three heads, to wit, that of a dog, a wolf and a lion, which, though separated from each other, converged in one single body having only one snake tail.[31]

In this reptilian form – stranger even than the four-legged original and, by sheer coincidence, transforming it into the ancient image of what may be called the 'time serpent'[32] – our monster appears wherever fifteenth-century artists were called upon to produce an image of Apollo meeting the general standards of the period yet satisfactory to an intellectual upper class. It greets us on the pages of the *Ovide moralisé* in prose[33] and the *Libellus de imaginibus deorum* (Plate 35);[34]

31. The Berchorius text (*Repertorium morale*, Book XV) was separately printed under the name of Thomas Valeys (Thomas Wallensis) in a book entitled *Metamorphosis Ovidiana moraliter . . . explanata*, Paris, 1511 (1515 edition, fol. VI), and the description of Apollo reads as follows: 'Sub pedibus eius depictum erat monstrum pictum quoddam terrificum, cuius corpus erat serpentinum, triaque capita habebat, caninum, lupinum et leoninum. Que, quamvis inter se essent diversa, in corpus tamen unum cohibebant, et unam solam caudam serpentinam habebant.' The allegorical explanation of the monster is taken from Macrobius.

32. See Note 28, p. 190.

33. While the complete Latin Berchorius text was not illustrated, its French translations (printed in 1484 by Colard Mansion at Bruges, and in 1493 by A. Vérard at Paris, under the title *Ovide métamorphose moralisée*) were often accompanied by pictures. The Apollo is found in a manuscript of about 1480, Copenhagen, Royal Library, MS. Thott 399, fol. 7 v. The French text (fol. 9 ff. in the Bruges edition, fol. 6 v. in the Paris edition) does not differ materially from the Latin.

34. The text of the *Libellus de imaginibus deorum* (see now Seznec, op. cit., pp. 170–79) differs from the Berchorius text especially in that the allegorical explanation is deleted. It is transmitted through an illustrated manuscript in the Vatican Library, Cod. Reg. lat. 1290. See H. Liebeschütz, *Fulgentius Metaforalis; Ein Beitrag zur Geschichte der antiken Mythologie im Mittelalter* (*Studien der Bibliothek Warburg*, IV, Leipzig-Berlin, 1926), p. 118. Our Plate 35 (Liebeschütz, Fig. 26) represents Cod. Reg. lat. 1290, fol. 1 v.

in Christine de Pisan's *Epître d'Othéa*,[35] in the *Chroniques du Hainaut*:[36] in commentaries on the *Echecs amoureux* (Plate 36);[37] and, finally, in Franchino Gafurio's *Practica Musicae* of 1497 (Plate 38),[38] where the *corpus serpentinum* extends, throughout the eight celestial spheres, from the feet of Apollo down to the silent earth.

It took the 'reintegration of classical form with classical subject matter', achieved in the course of the Cinquecento, to break the spell of this persistent tradition. Not until the second half of the sixteenth century could Giovanni Stradano, evidently under the direct impression of some genuine late-antique specimen, restore to our monster its authentic canine body[39] and at the same time reinvest its master – here playing the role of Sol in a series of Planets – with his true Apollonian beauty (Plate 42). It should be noted, however, that this Apollonian sun-god was patterned after Michelangelo's *Risen Christ* in Sta Maria sopra Minerva. At a time when artists, as Dürer expressed it, had learned to fashion the image of Christ, 'the most beautiful of all men', in the likeness of Apollo, the image of Apollo could also be fashioned in the likeness of Christ: in the judgement of his contemporaries and followers, Michelangelo and the Antique had become equivalent.[40]

35. Brussels, Bibliothèque Royale, MS. 9392, fol. 12 v.

36. Brussels, Bibliothèque Royale, MS. 9242, fol. 174 v.

37. Paris, Bibliothèque Nationale, MS. fr. 143, fol. 39.

38. See now Seznec, loc. cit., p. 140 f., and A. Warburg, *Gesammelte Schriften*, Berlin and Leipzig, 1932, I, p. 412 ff.

39. Conversely, the illustrator of the Copenhagen *Ovide moralisé* manuscript, fol. 21 v., provided, apparently by sheer inadvertence, Pluto's authentic Cerberus with the three different animal heads rightfully belonging only to the Serapis monster. Isidore of Seville, *Origines*, XI, 3, 33, on the other hand, transferred Macrobius' allegorical interpretation of the Serapis monster to Pluto's completely canine Cerberus, who, according to him, signifies 'tres aetates, per quas mors hominem devorat, id est, infantiam, iuventutem et senectutem.'

40. See below, p. 338.

V

The year 1419, we recall, saw the discovery of Horapollo's *Hieroglyphica*, and this discovery not only gave rise to an enormous enthusiasm for everything Egyptian or would-be Egyptian but also produced – or, at least, immeasurably promoted – that 'emblematic' spirit which is so characteristic of the sixteenth and seventeenth centuries. A set of symbols surrounded with the halo of remote antiquity and constituting an ideographic vocabulary independent of linguistic differences, expansible *ad libitum* and intelligible only to an international elite, could not but capture the imagination of the humanists, their patrons and their artist friends. It was under the influence of Horapollo's *Hieroglyphica* that there came into being those countless emblem books, ushered in by Andrea Alciati's *Emblemata* of 1531, whose very purpose it was to complicate the simple and to obscure the obvious where medieval pictorialization had tried to simplify the complex and to clarify the difficult.[41]

This simultaneous rise of Egyptomania and emblematism resulted in what may be called the iconographic emancipation of the Serapis monster. While the passion for things Egyptian led to the dissolution of its recent and slightly illegitimate alliance with Apollo, the search for new 'emblems' – supposed to avoid historical or mythological personages – prevented its reattachment to its rightful master, Serapis. So far as I know, it is only in the illustrations of Vincenzo Cartari's *Imagini dei Dei degli Antichi* (first printed in 1571) that the monster, here still in its reptilian form, occurs as an adjunct of Serapis in Renaissance art (Plate 40).[42] In all other

41. For a nice characterization of emblematic illustrations, see W. S. Heckscher, 'Renaissance Emblems: Observations Suggested by Some Emblem-Books in the Princeton University Library', *The Princeton University Library Chronicle*, XV, 1954, p. 55.

42. For Cartari's *Imagini dei Dei degli Antichi*, see Seznec, op. cit., p. 25 ff. Our Plate 40 represents the engraving in the Padua edition of 1603, p. 69.

representations produced from the end of the fifteenth century up to the end of the seventeenth it appears as an ideograph or hieroglyph in its own right – until the eighteenth century filed it away, if one may say so, as a curious though occasionally misunderstood archaeological specimen (Plates 32, 33).[43]

In the *Hypnerotomachia Polyphili* of 1499, already mentioned, it serves as a banner or standard so as to lend a rather gratuitous 'Egyptian' touch to the Triumph of Cupid.[44] In Holbein's metal cut of 1521, likewise referred to above, a giant hand holds it aloft above a beautiful landscape (Plate 39) so as to convey the idea that past, present and future are, quite literally, 'in the hand of God'.[45] Giovanni Zacchi's medal in honour of the Doge Andrea Gritti, dated 1536, symbolizes that natural or cosmic time which controls the revolution of a universe apparently dominated by Fortune but in reality, as we learn from the motto (DEI OPTIMI MAXIMI OPE), controlled by the Creator of all things (Plate

43. See, for example, L. Begerus, *Lucernae veterum sepulchralis iconicae*, Berlin, 1702, II, Pl. 7 (our Plate 32) or A. Banier, *Erläuterung der Götterlehre*, German translation by J. A. Schlegel, II, 1756, p. 184. It is noteworthy that so great an authority as B. de Montfaucon, *L'Antiquité expliquée*, Paris, 1722 ff., Suppl., II, p. 165, Pl. XLVIII (our Plate 33), while correctly classifying the monument, had entirely forgotten the Macrobius text and, misled by the anthropomorphic appearance of the lion and the simian appearance of the wolf, misidentifies the heads: 'Il n'est pas rare de voir Serapis avec Cerbere . . . on en [of heads] voit aussi trois ici. Mais une d'homme, une de chien, une de singe.'

44. Francesco Colonna, *Hypnerotomachia Polyphili*, Venice, 1499, fols. y 1 and y 2; the text says only that a nymph participating in the Triumph of Cupid carried, with great reverence and obdurate superstition, 'the gilded effigy of Serapis worshipped by the Egyptians' and describes the animal heads and the snake without any further explanation. A copy after the woodcut on fol. y 1, apparently unconnected with the text, is found in a manuscript in the Ambrosian Library at Milan, Cod. Ambros. C 20 inf., fol. 32.

45. Holbein's metal cut was used as a frontispiece for Johann Eck, *De primatu Petri libri tres*, Paris, 1521.

37).[46] In emblematic and 'iconological' literature, finally, it became what it still is in Titian's Allegory: an erudite symbol of Prudence.

Pierio Valeriano's *Hieroglyphica* of 1556 – a treatise based on Horapollo's but augmented by innumerable accretions ancient and modern – mentions the Serapis monster twice: first, under the heading 'Sol', where the Macrobius passage is quoted *in extenso* and the sun god is depicted as, if one may say so, an ultra-Egyptian character, bearing the three animal heads upon the shoulders of his own nude body;[47] and, second, under the heading 'Prudentia'. Here Pierio explains that prudence 'not only investigates the present but also reflects about the past and the future, examining it as in a mirror, in imitation of the physician who, as Hippocrates says, "knows all that is, that was and that will be"'; and these three modes or forms of time, he adds, are *hieroglyphice* expressed by a 'triple-head' (*tricipitium*) combining the head of a dog with those of a wolf and a lion.[48]

Some thirty or forty years later this 'triple-head' – now, as should be noted, a group of heads entirely divorced from any body, serpentine, canine or human – was firmly established as an independent symbol, a symbol that lent itself to a poetic (or affective) as well as to a rationalistic (or moral) interpretation, according to whether the element stressed was 'time' or 'prudence'.

In the mind of Giordano Bruno, always preoccupied with the metaphysical and emotional implications of spatial and temporal infinity, the 'three-headed figure conjured up from Egyptian antiquity' grew into a terrifying apparition, its individual components looming up successively and recurrently so as to picture time as an unending sequence of futile repentance, real suffering, and imaginary hopes. In his *Eroici Furori* of 1585 (Second Book, First Chapter) the reasonable

46. See G. Habich, *Die Medaillen der italienischen Renaissance*, Stuttgart, 1922, Pl. LXXV, 5.

47. Pierio Valeriano, *Hieroglyphica*, Frankfurt edition of 1678, p. 384.

48. ibid., p. 192.

philosopher, Cesarino, and the 'enraptured lover', Maricondo, discuss the cyclical nature of time. Cesarino explains that, as winter is followed by summer every year, so long historical periods of decline and misery – such as the present – will give way to spiritual and intellectual rebirth. To this Maricondo replies that, while he accepts an ordered succession of phases in human life as well as in nature and history, he cannot share the other's optimistic view of this succession: the present, he feels, is always even worse than the past, and both are made endurable only by the hope for a future which, by definition, is never there. This, he goes on to say, was well expressed by the Egyptian figure where 'upon one bust [!] they placed three heads, one of a wolf looking backward, the second of a lion seen in front view, and the third of a dog looking forward', which tends to show that the past afflicts the mind by memories, that the present tortures it, even more severely, in actuality and that the future promises, but does not bring, improvement. He concludes with a *sonetto codato* ('tailed sonnet') which, in a crescendo of despair, piles metaphor upon metaphor in order to describe the state of a soul for which the three 'modes of time' mean nothing but as many forms of either suffering or disappointment:

> A wolf, a lion and a dog appear
> At dawn, at midday, and at dusky eve:
> That which I spent, retain, and may acquire,
> That which I had, now have, or may still have.
> For what I did, and do, and have to do
> In times that were, or are, or are to come
> I feel remorse, and grief, and yet assurance
> In loss, in suffering, and in suspense.
> Experience past, fruit present, distant hope
> Have threatened me, afflict me, and assuage
> The mind with what is bitter, sour, and sweet.
> The age which I have lived, live, and shall live
> Sets me atremble, shakes, and braces me
> In absence, presence, nullibicity.

Sufficiently, too much, enough
Has me the 'then', the 'now', and the 'anon'
Harassed by fear, by torture, and by hope.[49]

The other, less poetic but more encouraging aspect of the
tricipitium is represented by that *summa* of iconography
which, drawing from classical and medieval as well as con-
temporary sources, has rightly been called 'the key of seven-
teenth- and eighteenth-century allegory'[50] and was exploited
by artists and poets as illustrious as Bernini, Poussin, Ver-
meer, and Milton: Cesare Ripa's *Iconologia*, first published in
1593, reprinted many times thereafter and translated into
four languages. Aware of the fact that the idea of prudence
as a combination of memory, intelligence and foresight had
originated in the pseudo-Platonic definition of 'wise coun-
sel' (συμβουλία),[51] the very learned Ripa includes Pierio

49. Giordano Bruno, *Opere italiane*, G. Gentile, ed., Bari, II, 1908,
p. 401 ff.:

> Un alan, un leon, un can appare
> All'auror, al dì chiaro, al vespr' oscuro.
> Quel che spesi, ritegno, e mi procuro,
> Per quanto mi si diè, si dà, puo dare.
>
> Per quel che feci, faccio ed ho da fare,
> Al passato, al presente ed al futuro
> Mi pento, mi tormento, m'assicuro,
> Nel perso, nel soffrir, nell'aspettare.
>
> Con l'agro, con l'amaro, con il dolce
> L'esperienza, i frutti, la speranza
> Mi minacciò, m'affligono, mi molce.
> L'età che vissi, che vivo, ch'avanza,
> Mi fa tremante, mi scuote, mi folce,
> In absenza, presenza e lontananza.
>
> Assai, troppo, a bastanza
> Quel di gia, quel di ora, quel d'appresso
> M'hanno in timor, martir e spene messo.

50. For Cesare Ripa, cf. especially E. Mâle, 'La Clef des allegories
peintes et sculptées au 17ᵉ et au 18ᵉ siècles', *Revue des Deux Mondes*,
7th series, XXXIX, 1927, pp. 106 ff., 375 ff.; E. Mandowsky, *Unter-
suchungen zur Iconologie des Cesare Ripa*, Diss., Hamburg, 1934.

51. Cf. above, Note 11, p. 185.

Valeriano's 'triple-head' among the many attributes of *Buono Consiglio*, 'Good Counsel' (Plate 41).

'Good Counsel' is an old man (because 'old age is most useful in deliberations'); in his right hand he holds a book on which an owl is perched (both long-accepted attributes of wisdom); he treads on a bear (symbol of anger) and a dolphin (symbol of haste); and around his neck he wears a heart suspended from a chain (because, 'in the hieroglyphic language of the Egyptians', good counsel comes from the heart).[52] In his left hand, finally, he carries 'three heads, a dog's facing right, a wolf's facing left and a lion's in the middle, all attached to one neck'. This triad signifies, says Ripa, the 'principal forms of time, past, present and future'; it is, therefore, 'according to Pierio Valeriano', a *simbolo della Prudenza*; and prudence is not only, 'according to St Bernard', a precondition of good counsel but also, 'according to Aristotle', the basis of a wise and happy life: 'good counsel requires, in addition to wisdom as represented by the owl upon the book, prudence as represented by the aforementioned three heads.'[53]

With Pierio Valeriano, then, the 'Serapis monster *en buste*', as we may call it for short, became a modern, 'hieroglyphic' substitute for all the earlier portrayals of 'tripartite Prudence'. And when the citizens of Amsterdam erected their 'Stad-Huys', that most magnificent of all Town Halls which today proudly discharges the duties of a royal palace, the great sculptor Artus Quellinus decorated the Council Chamber with an enchanting frieze wherein all the attributes of Ripa's *Buono Consiglio*, including the 'triple-head', appear as an array of independent motifs, emancipated from the human figure but dynamically connected with each other by the unifying rhythm of an admirable acanthus *rinceau* and the activities of sportive *putti* (Plate 43). The wolf's head of the

52. This seems to refer to Horapollo, *Hieroglyphica*, II, 4: 'A man's heart hung from his gullet means the mouth of a good man.'

53. '. . . al consiglio, oltre la sapienza figurata con la civetta sopra il libro, e necessaria la prudenza figurata con le tre teste sopradette.'

tricipitium, now growing out of a luxuriant acanthus plant, barks in answer to the question of a dignified sphinx, the only detail not anticipated by Ripa but fitting in with the 'Egyptian' spirit of the ensemble.[54] *Putti* bridle the dolphin, hold the bear by his nose ring while threatening him with clubs, and display the heart on its chain. Only the owl remains aloof and alone with his book and his dignity, a humourous image of theoretical 'wisdom' as opposed to practical 'prudence'.

VI

After this long digression the antecendents of Titian's Allegory are fairly clear. Like Giordano Bruno, he would seem to have owed his acquaintance with the Egyptian *tricipitium* to Pierio Valeriano, whose *Hieroglyphica* was published, as will be recalled, in 1556; but unlike Giordano Bruno, he adhered to Pierio's rational and moralistic interpretation of the symbol.

From an iconographic point of view, the Howard picture is no more than the old-fashioned image of Prudence in the guise of three human heads of different ages (Plates 29, 31), superimposed upon the modern image of Prudence in the guise of the 'Serapis monster *en buste*'. But this very superimposition – never resorted to by any other artist – presents a problem. What could have caused the greatest of all painters to combine two heterogeneous motifs apparently saying the same thing, and thus to complicate complication by what seems to amount, not only to a concession to the fashionable fad of Egypt-inspired emblematics but also to a relapse into

54. Jacob van Campen, *Afbeelding van't Stad-Huys van Amsterdam*, 1664–8, Pl. Q. The printed explanation conforms to Ripa's in all points except for the fact that the chained heart is no longer interpreted as a reference to the fact that wise counsel comes out of a good heart but in the same way as are the bridled animals standing for anger and haste: 'het Haert moet gekeetent syn' ('the heart [viz., subjective feeling] must be chained').

scholasticism and, even worse, to redundancy? In other words, what was the purpose of Titian's picture?

Its discoverer, puzzled by this very question, suggested that it may have served as a *timpano*, that is to say, a decorated cover protecting another painting.[55] But it is difficult to imagine what this other painting might have looked like. It could not have represented a religious theme because the subject of the Howard picture is secular. It could not have represented a mythological theme because the message of the Howard picture is in the nature of a moralistic maxim. And it could not have been a portrait because the Howard picture – or, to be more precise, its dominant section – is in itself a series of portraits.

This very fact, however, may answer our question. There can be no doubt (although I myself failed to realize it until fairly recently) that the hawk-eyed profile of the old man personifying the past is that of Titian himself. It is the face seen in the unforgettable self-portrait in the Prado (Plate 44), which dates from precisely the same period as does the Howard picture, that is to say, the later sixties, when Titian was more than ninety, or, if the modern sceptics should be right, at least close to eighty.[56] This was the period when the old master and patriarch felt that the time had come to make provision for his clan. And it is not too hazardous to suppose that his *Allegory of Prudence* – a subject most appropriate for such a purpose – was to commemorate the legal and financial measures taken on this occasion; were it permissible to indulge in romantic speculation, we might even imagine that it was intended to conceal a little cupboard recessed into the wall (*repositiglio*) wherein important documents and other valuables were kept.

With an insistence painful to the sensitive, the aged Titian

55. Von Hadeln, op. cit.

56. On the inconclusive discussion about Titian's birth date, see Hetzer's judicious article in Thieme-Becker, op. cit., XXXIV, p. 158 ff., and (in defence of the earlier date) F. J. Mather, Jr., 'When Was Titian Born?' *Art Bulletin*, XX, 1938, p. 13 ff.

collected money from all sides, and finally, in 1569, he persuaded the Venetian authorities to transfer his *senseria* – the broker's patent which had been awarded to him more than fifty years before and carried an annual stipend of one hundred ducats as well as sizeable tax exemptions – to his devoted son Orazio, who – in sharp contrast to his wretched elder brother, Pomponio – had been his father's loyal helper throughout his life and was to follow him even in death. Orazio Vecelli, then about forty-five years old, was thus formally declared 'successor' in 1569, the 'present' to Titian's 'past'. This in itself would lead to the conjecture that it is his face which appears – 'stronger and more fervent', as Macrobius had said of the present in relation to both past and future, more real in its vigorous colour and emphatic modelling, as the great painter interpreted this phrase – in the centre of the Howard picture: and visual confirmation of this conjecture is found in the *Mater Misericordiae* in the Palazzo Pitti at Florence, one of the latest products of Titian's workshop, where the same personage, older by some five years but bearing unmistakably identical features, appears next to the master himself (Plate 45).[57]

If Titian's own face stands for the past and that of his son Orazio for the present, we would expect that the third,

57. For the *Mater Misericordiae* in the Palazzo Pitti, see E. Tietze-Conrat, 'Titian's Workshop in His Late Years', *Art Bulletin*, XXVIII, 1946, p. 76 ff., Fig. 8. Mrs Tietze, considering the painting (commissioned in 1573) as an authentic work executed with the help of assistants, correctly recognized Titian himself in the old man in the foreground but was inclined to identify the black-bearded, middle-aged man next to him with his brother Francesco rather than with his son Orazio. Since, however, Francesco had died in 1560 (after having retired from painting in 1527 and operated a wood business at Cadore during the rest of his life), since we do not know how he looked, and since the face of the personage in question is manifestly identical with the central head in the Howard picture, there seems to be no valid reason for the assumption that the 'second-in-command' in the *Mater Misericordiae* is a deceased brother of the *paterfamilias* rather than his living son and heir. This fact was generously admitted by Mrs Tietze *in litteris*.

youthful face which signifies the future belongs to a grandson. Titian, unfortunately, had no living grandson at the time. But he had taken into his house, and carefully instructed in his art, a distant relative 'whom he particularly loved':[58] Marco Vecelli, born in 1545 and thus in his early twenties when the *Allegory of Prudence* can be presumed to have been painted. It is, I think, none other than this 'adopted' grandson (his portrait, too, possibly recurring in the *Mater Misericordiae*)[59] whose handsome profile completes the three generations of Vecellis. Be that as it may, the countenance of the youth, like that of the old man, has less corporeality than the virile face in the centre. The future, like the past, is not as 'real' as the present. But it is blurred by an excess of light rather than obscured by shadow.

True, Titian's picture – combining the three animal heads recently linked to the idea of prudence with the portraits of himself, his heir apparent and his heir presumptive – is what the modern beholder is apt to dismiss as an 'abstruse allegory'. But this does not prevent it from being a moving human document; the proudly resigned abdication of a great king who, another Hezekiah, had been bidden 'to set his house in order' and was then told by the Lord: 'I will add unto thy days.' And it is doubtful whether this human document would have fully revealed to us the beauty and appropriateness of its diction had we not had the patience to

58. See C. Ridolfi, *Le maraviglie dell'arte*, Venice, 1648 (D. von Hadeln, ed., Berlin, 1914–24, II, p. 145).

59. I am referring to the young man in armour, kneeling directly behind Orazio Vecelli. His features are fairly similar to the youthful face in the Howard picture except for the fact that it is embellished by a moustache (which, however, Marco Vecelli could easily have grown between *c.* 1569 and 1574); neither would the armour necessarily preclude an identification with Marco because iconographic tradition required the presence of military men as well as civilians in groups representing a cross section of the Christian community (cf. also the so-called 'All Saints pictures' and representations of the Brotherhood of the Rosary). Yet I am not quite so confident in identifying the third member of the family group in the *Mater Misericordiae* with Marco Vecelli as I am in identifying the second with Orazio.

decode its obscure vocabulary. In a work of art, 'form' cannot be divorced from 'content': the distribution of colour and lines, light and shade, volumes and planes, however delightful as a visual spectacle, must also be understood as carrying a more-than-visual meaning.

5

The First Page of Giorgio Vasari's 'Libro'

A Study on the Gothic Style in the Judgement
of the Italian Renaissance. With an Excursus on
Two Façade Designs by Domenico Beccafumi

I

In the Bibliothèque de l'École des Beaux-Arts in Paris there
is a sketch leaf in pen and ink, showing numerous small
figures and scenes on both sides of the page, which is – or
was when this essay was originally published – catalogued as
'Cimabue' (Plates 46, 47).[1] The hagiographical content of
the sketches has thus far defied identification,[2] and it is
equally difficult to place them stylistically.

What strikes the beholder is, quite apart from the delicate
and facile technique, a pronouncedly classicizing character
which immediately recalls compositions of the fourth and
fifth centuries A.D. The frequency of parallel movements, the

1. Accession No. 34777; paper without watermark. Dimensions of
the sketch leaf: *c.* 19·6 cm. × 28 cm.; of the frame, *c.* 34 × 53·5 cm.
The frame is slightly cropped, and the strips which hold it together
have been renewed. The drawing comes from the collection of W.
Young Ottley, who discussed it in his *Italian School of Design*, London,
1823, p. 7, No. 5, where the recto – without the frame – is reproduced.
Since then it does not seem to have attracted attention.

2. Even the distinguished librarian of the Société des Bollandistes,
Hippolyte Delehaye, who was kind enough to examine the drawing
and to show it to other experts, has not arrived at a convincing con-
clusion. For want of a better interpretation, we may still consider the
possibility of identifying the hero of the scenes on the recto with St
Potitus (*Acta Sanctorum*, Jan. 1, p. 753 ff., particularly p. 762). [It was
this youthful martyr with whom no less a man than Leone Battista
Alberti began – and closed – a series of 'Lives of the Saints' (cf. G. A.
Guarino, 'Leon Battista Alberti's "Vita S. Potiti"', *Renaissance News*,
VIII, 1955, p. 86 ff.).]

presence of such purely late-antique architectural motifs as the classical amphitheatre in the lower zone of the recto illustrated in Plate 46 – contrasting, however, with the unmistakably Gothic tabernacle in the second zone – the modelling and proportions of the nudes, the *contrapposto* movements of the soldiers, and the shape of the weapons – all this brings to mind such works as the wall paintings, preserved to us in copy, of St Paul's Without the Walls[3] and particularly, the Joshua Roll.

All these classicizing motifs, however, have been transformed in a spirit which, in a general way, may be characterized as 'early Trecento'. Morphologically speaking, our drawing reflects a style less ponderous and monumental than that of Giotto, yet less ethereal and lyrical than that of Duccio – a style most compatible with that of the 'Roman School', which, through Pietro Cavallini, extended its influence to Naples, Assisi and Tuscany. We need only to compare the drapery and the foot of a man shrinking back in fear (Plate 47, upper centre), the squatting postures of encamped soldiers (same Plate, lower left), or the groups of magistrates in the amphitheatre scenes (Plate 46) with analogous motifs in, say, the Cavallinesque paintings in Santa Maria di Donnaregina or the much-debated frescoes of the Velluti Chapel in Sta Croce[4] to become aware of this stylistic transformation.

How are we to account for this unusual union of late-antique and early-Trecento elements? It would be easiest to

3. J. Garber, *Die Wirkung der frühchristlichen Germäldezyklen der alten Peters- und Paulsbasiliken in Rom*, Berlin, 1918. Cf. especially the Jacob lifting the stone in Garber, Fig. 9, and the Joseph in Garber, Fig. 12, with the torturer in our Plate 46, upper left; or the man in the short skirt in Garber, Fig. 15, with the saint's companion in our Plate 46, upper centre.

4. For the latter, see A. Venturi, *Storia dell'Arte Italiana*, V, p. 217 ff.; R. van Marle, *Development of the Italian Schools of Painting*, The Hague, 1923–36, I, p. 476 ff. Van Marle ascribes the *Combat with the Dragon* to the School of Cimabue, the *Miracle of Monte Gargano*, on the other hand, to an unknown painter trained by both Cimabue and Giotto.

attribute the Paris sketch leaf – considered either as a substantially faithful rendering of an Early Christian picture cycle, or as a series of original designs harking back to late-antique models[5] – if not to Cimabue himself, at least to one of his contemporaries. In fact, we know that the direct reassimilation of Early Christian prototypes, setting in at the turn of the thirteenth century, was no less important for the formation of the Trecento style .than was the 'Byzantine wave' that surged over the West about a century earlier for the birth of the *maniera greca* in Italy and the Gothic style in the North.

However, the assumption of a direct copy after paintings of the fourth or fifth centuries would presuppose the existence of Early Christian martyr cycles which, as far as we know, cannot be substantiated. The assumption of an original project would not account for either the incoherence of the whole or for the anomaly of the Gothic tabernacle. And both assumptions are at variance with the fact that the manual execution of the Paris sketches – as opposed to morphology – does not agree with a date as early as about 1300. These sketches are conceivable only between such contour drawings as are found, for example, in the Milan *Historia Troiana* (Bibl. Ambrosiana, Cod. H. 86, sup.) and the fully developed, 'illusionistic' *Handzeichnungen* of the Pisanello-Ghiberti period: in other words, they must be ascribed, not to Cimabue or any other artist active around 1300 who personally participated in the 'Early Christian renaissance' of this time, but to an artist active around 1400, who copied a cycle of paintings produced about a century before. That this cycle will ever be identified can hardly be expected: but we may say that the interpretation of the Paris sketches as later copies after such a cycle is most consistent with their compositional and technical characteristics.

5. This view was personally expressed by Professors W. Köhler and H. Beenken, and it was the latter who called my attention to the frescoes in the Velluti Chapel.

The First Page of Giorgio Vasari's 'Libro'

So interpreted, the sketch leaf loses some of the stylistic interest which it would have had as an original document of early Trecento art. It gains, however, in importance from an historical point of view. It was shortly before 1400 that Filippo Villani wrote those famous sentences in praise of Cimabue (who until then was merely 'famous') as the inaugurator of a new phase in the general evolution of art:

Johannes, whose cognomen was Cimabue, by his art and genius first restored verisimilitude to an antiquated art, childishly deviating from verisimilitude by the ignorance of the painters and, as it were, dissolute and wayward.[6]

If we are right in dating the Paris sketches in Villani's generation, they can be understood as a pictorial parallel to the conception of history set down in these sentences; as evidence that the idea of an 'artistic rebirth' originating with Cimabue was not a 'purely literary construction' but was based upon an immediate artistic experience; or was, at least, accompanied by such an immediate experience. If an artist active around 1400 tried to copy a series of paintings produced, if not by Cimabue himself, at least by one of Cimabue's contemporaries, this very fact would seem to show that not only the ideologically minded humanists but also the intuitively perceptive artists began to recognize the basis of their own activities in the achievement of the early Trecento, and that they approached the works of this

6. Filippo Villani, *De origine civitatis Florentiae et eiusdem famosis civibus*: 'Primus Johannis, cui cognomento Cimabue nomen fuit, antiquatam picturam et a nature similitudine pictorum inscicia pueriliter discrepantem cepit ad nature similitudinem quasi lasciuam et vagantem longius arte et ingenio reuocare.' See J. von Schlosser, 'Lorenzo Ghibertis Denkwürdigkeiten; Prolegomena zu einer künftigen Ausgabe', *Jahrbuch der K. K. Zentralkommission*, IV, 1910, especially pp. 127 ff., 163 ff.; further, E. Benkard, *Das literarische Porträt des Giovanni Cimabue*, Munich, 1917, p. 42 ff. There is a convenient extract of Schlosser's article in his *Präludien*, Berlin, 1927, p. 248 ff.

period with a specifically 'artistic' interest.[7] The next great step was Masaccio's reversion to Giotto.

II

Thus the traditional attribution of the Paris sketches does, after all, contain a grain of truth; but the name of Cimabue would hardly have been connected with them without some definite evidence. This evidence is provided by the mount or frame. Decorated in pen and bistre, it consists of four pieces of stout yellowish paper put together in such a way that both sides of the sheet are visible: and on this frame Cimabue's authorship is attested not once but twice; on the verso by a handwritten inscription GIOVANÑI CIMABVE PITTOR̄ FIORȄ, and on the recto by a pasted-on woodcut portrait,[8] in the cartouche of which the same words (without abbreviations) can be read.

The art historian does not need to be told that this woodcut has been pulled from one of the blocks that were made for the second edition of Giorgio Vasari's *Lives of the Most Famous Painters, Sculptors and Architects*. He will immediately suspect that the 'Cimabue' drawing comes from Vasari's own collection, and that it was he, in accordance with a habit of which we have repeated evidence, who provided it with its hand-drawn frame.[9] This suspicion can be confirmed. First, the portrait print – the addition of which must have been planned from the outset since the design of the frame leaves space for it – was by no means cut out of a

7. The Albertina drawing reproduced in J. Meder, *Die Handzeichnung*, Vienna, 1919, Fig. 266, and formerly attributed to Ambrogio Lorenzetti, is probably a parallel case. Like our sketch leaf, it would seem to date from shortly before 1400 and to render an earlier model. Cf. also the well-known early Quattrocento copies after Giotto's lost *Navicella*.

8. Also reproduced in Karl Frey, *Le Vite ... di M. Giorgio Vasari*, Munich, I, 1, 1911, p. 388 (hereafter referred to as 'Frey').

9. This was already recognized by Ottley, who, however, does not reproduce the frames.

printed copy of the *Lives*; as indicated by its blank verso, it is a proof impression such as Vasari used in many comparable cases (cf. the frame, reproduced in Plate 48, enclosing an Umbro-Florentine drawing which Vasari attributed to 'Vittore Scarpaccia' because it may have reminded him of the 'animated and foreshortened nudes' in Carpaccio's *Martyrdom of the Ten Thousand*).[10] Second, we know from Vasari himself that he possessed a sketch leaf which he considered as a work by Cimabue and, therefore, placed at the very beginning of his famous album (*Libro*)[11] of drawings, now dispersed – a sketch leaf which exhibited 'many small representations of miniature-like execution':

There remains for me to say of Cimabue that in the beginning of our book, where I have put together drawings from the own hand of all those who have made drawings from his time to ours, there are to be seen certain small things made by his hand in the way of miniature, wherein, although today perchance they appear rather rude than otherwise, it is seen how much excellence was given by his work to draughtsmanship.[12]

We can even determine the years during which Vasari –

10. *Vasari Society*, Series II, Part VIII, No. 1. In this case the fact that a proof was used is all the more evident as the cartouche differs from that employed in the printed edition (Vol. II, p. 517; Vasari had only five cartouches for his portrait cuts, each of which was used repeatedly). It may be mentioned that Vasari considered the pennants which decorate the frame of his 'Carpaccio' drawing as a motif peculiar to this painter (see, e.g., his famous Ursula cycle) and worthy of particular praise.

11. For Vasari's collection of drawings, see Jenö Lányi, 'Der Entwurf zur Fonte Gaia in Siena', *Zeitschrift für bildende Kunst*, LXI, 1927/8, p. 265 ff. [and, more recently, O. Kurz's essay cited above, p. 10].

12. *Frey*, p. 403: 'Restami a dire di Cimabue, che nel principio d'un nostro libro, doue ho messo insieme disegni di propria mano di tutti coloro, che da lui in qua hanno disegnato, si vede di sua mano alcune cose piccole fatte a modo di minio, nelle quali, come ch'hoggi forse paino anzi goffe che altrimenti, si vede, quanto per sua opera acquistasse di bontà il disegno.' [The English rendering of passages from Vasari conforms, with some changes, to the translation of Gaston Du C. de Vere, published by the Medici Society, London, 1912–15.] Our sketch leaf is also mentioned in the *Life of Gaddo Gaddi*; see G. Vasari,

whose phrase *fatte a modo di minio* ('made in the way of miniature') expresses an admirable feeling for the antecedents of the postmedieval drawing style – saw and acquired his 'Cimabue' leaf. It must have entered his collection between 1550 and 1568: for it seems that Cimabue the draughtsman came to Vasari's attention only after the first edition of the *Lives* had been completed. In the Giunti edition of 1568 he not only announces his precious possession in the *Life of Cimabue* but also begins the concluding sentence of the general Preface with the words:

But it is now time to come to the Life of Giovanni Cimabue, and even as he gave the first beginning to the new method of drawing and painting, so it is just and expedient that he should give it to the Lives. ...

In the Torentino edition of 1550, however, no mention is made of the drawing, and the Preface speaks only of 'the new method of painting. . . .'[13]

The decoration of the frame poses a problem no less arresting than does the drawing itself. Like the other en-

Le Vite . . ., G. Milanesi, ed., Florence, 1878–1906 (hereafter quoted as '*Vasari*'), I, p. 350: 'E nel nostro libro detto di sopra è una carta di mano di Gaddo, fatta a uso di minio come quella di Cimabue, nella quale si vede, quanto valesse nel disegno' ('And in our aforesaid book there is a drawing by the hand of Gaddo, made after the fashion of a miniature like that of Cimabue, wherein one sees how proficient he was in draughtsmanship'). The terms *a uso di minio* and *a modo di minio* do not, of course, imply that the drawings were executed in colours and on parchment. In the *Life of Giotto* (*Vasari*, I, p. 385) Vasari explicitly says of the miniature painter Franco Bolognese (whom Dante made famous): '. . . lavorò assai cose eccellentemente in quella maniera . . ., come si può vedere nel detto libro, dove ho di sua mano disegni di pitture e di minio. . . .' Here an explicit distinction is made between drawings *di pitture* and *di minio*, which can mean only drawings made in preparation of paintings and of book illuminations.

13. *Frey*, p. 217. The Giunti edition of 1568 has: 'Ma tempo e di uenire hoggi mai a la uita di Giouanni Cimabue, il quale, si come dette principio al nuouo modo di disegnare e di dipignere, cosi è giusto e conueniente che e'lo dia ancora alle uite.' The Torrentino edition of 1550 has only: '. . . si come dette principio all nuouo modo del dipig-

framements prepared by Vasari for his *Libro*, it simulates architecture: but, unlike these, it simulates structures of a pronouncedly Gothicizing style. The frame on the verso resembles an encrusted tabernacle the triangular gable of which is decorated with tracery; that on the recto imitates a magnificent portal with bossed capitals, pinnacles decorated with crockets, and a pointed arch for which the woodcut portrait, invested with a quasi-sculptural appearance by *bistre* wash, serves as a somewhat incongruous keystone. Even the inscription on the verso tries to reproduce the character of early Trecento script with almost palaeographic fidelity: such details as the initial and terminal crosses, the points separating the words, the ligatures, and the abbreviation signs are copied so carefully that a friend experienced in such matters believed the inscription to be a work of the nineteenth century until he was convinced by the *Lives* that Vasari's epigraphical knowledge was extensive enough to permit his performance.[14]

That Vasari was able to design a Gothicizing architecture and a Gothicizing inscription is not surprising: what is surprising is that he had the wish to do so – he, whose famous philippic against the Gothic style (Introduction I, 3) heaps

nere . . .' The passage in the *Life of Niccolo and Giovanni Pisani*, where *disegno* is discussed with respect to Cimabue (*Frey*, p. 643), also belongs in the period after 1550, since the *Life* of the Pisani does not appear in the first edition at all. Since the first edition thus makes no mention of Cimabue as a draughtsman, we must abandon the view that he owes his place of honour at the beginning of the *Lives* to Vasari's conviction that *disegno* is the 'common father' of the three visual arts and that, therefore, the *Lives* had to open with the biography of one who had 'transformed the art of drawing into something specifically Italian' (E. Benkard, op. cit., p. 73). Important though Vasari's *disegno* theory is (cf. below, p. 252 f.), the idea of opening the series of 'modern' artists with Cimabue did not require a systematic foundation since his position as the Father of the Florentine Renaissance was firmly established by the historiographers.

14. The imitator gives himself away, however, by omitting the 'e' in 'pittore' and by placing an abbreviation sign over 'Giovanni' even though both 'n's are written out.

every abuse on the 'monstrous and barbarous' *maniera tedesca* and who considers the pointed arch, the *girare le volte con quarti acuti*, as the most contemptible absurdity of this 'abomination of architecture'.

'We come at last to another sort of work,' he says, after discussing the classical orders,

called German, which both in ornament and in proportion is very different from both the ancient and the modern. Nor is it adopted now by the best architects but is avoided by them as monstrous and barbarous, and lacking everything that can be called order. Nay it should rather be called confusion and disorder. In their buildings, which are so numerous that they sickened the world, doorways are ornamented with columns which are slender and twisted like a screw, and cannot have the strength to sustain a weight, however light it may be. Also on all the façades, wherever else there is enrichment, they build a malediction of little niches one above the other, with no end of pinnacles and points and leaves, so that, not to speak of the whole erection seeming insecure, it appears impossible that the parts should not topple over at any moment. Indeed, they have more the appearance of being made of paper than of stone or marble. In these works they made endless projections and breaks and corbellings and flourishes that throw their works all out of proportion; and often, with one thing being put above another, they reach such a height that the top of a door touches the roof. This manner was the invention of the Goths, for, after they had ruined the ancient buildings, and killed the architects in the wars, those who were left constructed the buildings in this style. They turned the arches with pointed segments, and filled all Italy with these abominations of buildings, so in order not to have any more of them their style has been totally abandoned. May God protect every country from such ideas and style of buildings! They are such deformities in comparison with the beauty of our buildings that they are not worthy that I should talk more about them, and therefore let us pass on to speak of the vaults.[15]

How can we explain that the very man who wrote these words designed our 'Gothic' frames?

15. *Frey*, p. 70: 'Ecci un altra specie di lavori che si chaimano Tedeschi, i quali sono di ornamenti e di proporzioni molto differenti

III

For the Northern countries, above all for Germany, there was no real 'Gothic problem' until well into the eighteenth century. The theorists of architecture, dependent on Italian models and largely Vitruvian in outlook, tended to reject, with haughty disdain, what François Blondel calls 'that monstrous, intolerable style which in the days of our fathers was commonly practised under the name of "Gothic"'[16] and, for this very reason, could see no real problem in their attitude toward this 'monstrosity'. The practitioners, on the other hand, having at first appropriated the decorative accessories of the new Italian style rather than its essential

da gli antichi et da' moderni. Ne hoggi s'usano per gli eccellenti, ma son fuggiti da loro come mostruosi e barbari, dimenticando ogni lor cosa di ordine, che più tosto confusione o disordine si può chiamare: auendo fatto nelle lor fabriche, che son tante ch'hanno ammorbato il mondo, le porte ornate di colonne sottili et attorte a uso di vite, le quali non possono auer forza a reggere il peso di che leggerezza si sia. Et cosi per tutte le facce et altri loro ornamenti faceuano una maledizione di tabernacolini, l'un sopra l'altro, con tante piramidi et punte et foglie, che non ch'elle possano stare, pare impossible, ch'elle si possino reggere; et hanno più il modo da parer fatte di carta che di pietre o di marmi. Et in queste opere faceuano tanti risalti, rotture, mensoline et viticci, che sproporzionauano quelle opere che faceuano, et spesso con mettere cosa sopra cosa andauano in tanta altezza, che la fine d'una porta toccaua loro il tetto. Questa maniera fu trouata da i Gothi, che per hauer ruinate le fabriche antiche, et morti gli architetti per le guerre, fecero dopo coloro che rimasero le fabriche di questa maniera, le quali girarono le volte con quarti acuti et riempierono tutta Italia di questa maledizione di fabriche, che per non hauerne a far più, s'e dismesso ogni modo loro. Iddio scampi ogni paese da venir tal pensiero et ordinio di lauori, che per essere eglino talmente difformi alla bellezza delle fabriche nostre, meritano, che non se ne fauelli più che questo; et pero passiamo a dire delle volte.'

For another strong passage, see below, Note 89, p. 248. Cf., moreover, Schlosser, *Kunstliteratur*, p. 171 ff. (discussing the affinity between Vasari's and Giovanni Battista Gelli's judgement of the Gothic style as well as Vasari's influence upon the later writers).

16. François Blondel, *Cours d'Architecture*, Paris, 1675, Préface.

structural principles and its new feeling for space, were still too intimately linked to the medieval past to become aware of a fundamental antimony between the Gothic style and the Renaissance; even Blondel, apparently so hostile to the Gothic in all its manifestations, limits his strictures in fact to the 'barbarous' ornament while considering the buildings themselves as 'essentially conforming to the rules of art, so that beneath the monstrous chaos of their decoration a beautiful symmetry may be perceived'.[17] The supposedly 'posthumous' Gothic of a Christoph Wamser and all the other Jesuit Gothicists represents, not so much a conscious revival of a style irrevocably dead as a conscious adherence to a style still living[18] – except that this conscious adherence entailed, at so late a date, a certain isolation from the *maniera moderna* adopted by their more progressive contemporaries and thereby forced their style into a kind of purism and archaism.

Where the necessity of restorations or additions (whether in the interior or on the exterior) led to a direct encounter between the old and the new, the Northern masters either 'continued to apply the old style with perfect unconcern without thinking of either stylistic dependence or opposition' (Tietze), as in the additions to the north tower on the façade of the Collegiate Church of Neuberg; or else they worked, with equal unconcern, according to the new style, as in the numerous cases where Baroque domes or spires were placed upon Gothic towers, or where Baroque altars or

17. ibid., V, 5, 16. It is to this passage that the aged Goethe refers in an attempt to justify *ex post facto* the 'amphigoric' essay in which he had praised the Gothic style in his youth (*Über Kunst und Altertum*, Weimar edition, Vol. IV, Part 2, 1823). Even the famous lines of Molière's *Gloire de Val-de-Grâce* (quoted, e.g., in Michel, *Histoire de l'art*, VI, 2, p. 649) are essentially directed only against the Gothic type of decoration:

> Ce fade goût des *ornements gothiques,*
> Ces monstres odieux des siècles ignorants,
> Que de la barbarie ont produit les torrents . . .

18. Cf. J. Braun, *Die belgischen Jesuitenkirchen*, supplementary volume to *Stimmen aus Maria Laach*, XCV, 1907, particularly p. 3 ff.

galleries were set into Gothic interiors. In the former case, there is no consciousness of a fundamental difference in style at all; in the latter, this difference in style is resolved with the same assurance and inevitability with which in earlier centuries the High Gothic nave of Paderborn Cathedral had been attached to the Early Romanesque transept, or the Late Gothic choir of St Sebald's at Nuremberg to the Early Gothic nave. Even where a disparity of styles was realized, this realization did not call, as a rule, for a decision on general, theoretical principles. The individual problems were solved from case to case, whether the stylistic dichotomy was smoothed out or, on the contrary, exploited as a stimulant.

When, in the first decades of the eighteenth century, this unreflecting acceptance of the Gothic style began to disappear (not without persisting, in many instances, up to our day), the 'Gothic question' did not at once grow into a question of principle but was solved by a masterly, subjective synthesis of the conflicting elements. In a penetrating investigation of Viennese eighteenth-century Gothic – valid, *mutatis mutandis*, for the total province of German art[19] – Hans Tietze has shown how, down through the reign of Joseph II, the Baroque

so freely and effectively combined the elements of medieval architecture with contemporary ones that a new art form came into being. . . . Gothicizing elements were consciously developed so as to produce a modern impression; there was no preoccupation with historical fidelity; rather the architects sought to surpass what looks like their prototypes. . . . The intention was to fashion Gothic – or, more precisely – medieval elements into a

19. In *Kunstgeschichtliches Jahrbuch der K. K. Zentralkommission*, III, 1909, p. 162 ff. (hereafter cited as '*Tietze*'); *idem*, 'Das Fortleben der Gotik durch die Neuzeit', *Mitteilungen der kunsthistorischen Zentralkommission*, 3rd series, XIII, 1914, p. 197 ff. The important article by A. Neumeyer on the Gothic revival in German art of the late eighteenth century (in *Repertorium für Kunstwissenschaft*, XLIX, 1928, p. 75 ff.) came to the writer's attention only after completion of this article. [For more recent literature, see above, p. 9–10.]

new, unprecedented creation the artistic spirit of which was indubitably modern.

The rebuilding of the Deutschordenskirche at Vienna, the dome of the Convent Church at Kladrub, and, in Germany, F. J. M. Neumann's superb west towers of Mainz Cathedral (Plate 49, 1767–74) are monumental evidence of this architectural attitude which, though already distinctly retrospective, was still inclined to, and capable of, an unhistorical blending of the old with the new – an attitude soon to develop into a broadminded universalism which placed the Gothic on almost the same level with the Chinese or the Arabic. In 1721 Bernhard Fischer von Erlach published his *Plan of a Historical Architecture*. Here, it is true, no Gothic buildings are illustrated;[20] but the Preface offers to the architect a choice, as it were, between various 'styles' much as a painter such as Christian Dietrich excelled in imitating various 'great masters'. Fischer explains this variety by national peculiarities and at the end even arrives at a moderate appreciation of the Gothic style:

The designers will see here that the tastes of nations differ no less in architecture than in the manner of dress or preparation of foods, and by comparing one with the other, they will be able to choose judiciously. Finally, they will be able to perceive that custom may permit a certain *bizarrerie* in the art of building, such as Gothic tracery and rib-vaults with pointed arches. . . . [21]

At approximately the same time there began in England those two movements – in part carried on or promoted by

20. Some medieval castles, such as the one at Meissen, occur only in the context of landscape prospects.

21. B. Fischer von Erlach, *Entwurff einer historischen Architektur*, Preface: 'Les dessinateurs y verront que les goûts des nations ne diffèrent pas moins dans l'architecture que dans la manière de s'habiller ou d'aprêter les viandes, et en les comparant les unes aux autres, ils pouront en faire un choix judicieux. Enfin ils reconnoitront qu'à la vérité l'usage peut authoriser certaines bisarreries dans l'art de bâtir, comme sont les ornements à jour du Gothique, les voûtes d'ogives en tiers point.' I quote from the Leipzig edition of 1742.

the same people – which aimed, on the one hand, at a reform of gardening in the spirit of 'natural', landscape-like scenery and, on the other, at a deliberate revival of the Gothic style of architecture. It is no accident that these two movements were so closely connected in time and place and that, before serious, monumental architecture was permitted to express itself in 'Gothic' forms, the 'Gothic' style was chiefly considered for the pavilions, tea houses, resting places and 'hermitages' of the newly 'landscaped' parks. Ever since the theory of art had begun to consider the difference between antique, medieval and modern architecture, the Gothic was looked upon not only as a 'ruleless' but also as a specifically 'naturalistic' style: as a mode of architecture originating from the imitation of living trees (that is to say, from the technique ascribed by classical theorists to the primeval forebears of civilized man), whereas the classical system began with the tectonic joining of squared timber (see the 'Report on the Remains of Ancient Rome', originally attributed to Raphael but now mostly ascribed to Bramante or Baldassare Peruzzi).[22]

Small wonder that the taste for this 'primitive' kind of architecture grew in conjunction with the preference for a garden style which replaced the basin with the 'lake', the canal with the 'brook', the *parterre* with the 'meadow', the avenue intended for the carriages and horses of many visitors with the winding footpath often designated as a 'philosopher's walk', and the stereometric discipline of trimmed *bosquets* with the untrammelled growth of picturesque trees. What a man like Lenôtre had expressly rejected – 'that beautiful gardens should look like forests'[23] – was now aspired to with half-serious, half-playful self-deception. This sentimental accentuation of 'naturalness' created an inner affinity between the 'English gardens' and the innumerable 'Gothic' chapels, castles and hermitages with which they began to be flooded and which, according to the theory of

22. On this report, see Schlosser, *Kunstliteratur*, pp. 175 and 177 ff.
23. J. Guiffrey, *André le Nostre*, Paris, 1913, p. 123.

origin just mentioned, tended to be constructed from un-squared branches or roots of trees (Plate 50).[24] A most illu-minating anticipation of this taste, today surviving only in the parks of watering places and in the gardens of suburban villas, is found in a fifteenth-century engraving belonging to the so-called Baldini-group, where the rustic character of the Hellespontine Sibyl is emphasized by a seat of rude branches and twigs (Plate 51).[25] It should be added that such 'Gothic' structures also often appear as artificial ruins, to demonstrate the triumph of time over human endeavour.[26]

24. From Paul Decker, *Gothic Architecture*, London, 1759, which is, significantly, exclusively devoted to garden architectures. It should be noted that this small publication, as well as its parallel, *Chinese Archi-tecture*, is by no means a partial translation from Paul Decker, *Fürst-licher Baumeister oder Architectura Civilis*, Augsburg, 1711–18 (as even Schlosser, *Kunstliteratur*, pp. 572 and 588, assumes). The author of the latter work is an elder Paul Decker, a pupil of Schlüter, and it contains nothing similar. The notice 'Printed for the author' permits us to con-clude that the author of *Gothic Architecture* was still alive in 1759, whereas the elder Paul Decker died in 1713.

25. Published in *International Chalcographic Society*, 1886, III, No. 8. In the Sibyllinian Texts (conveniently reprinted in E. Mâle, *L'Art religieux de la fin du Moyen-Age en France*, Paris, 1922, p. 258 ff.) the Sibylla Hellespontica is described as: 'In agro Troiano nata ... veste *rurali induta*', and her prophecy reads: 'De excelsis coelorum habita-culo prospexit Deus humiles suos.' She was thus looked upon as a child of nature and, therefore, presumed to live on about the same level of civilization as the primitives who built their dwellings of unsquared branches (cf. the illustrations to Filarete's treatise on architecture, re-produced in M. Lazzaroni and A. Muñoz, *Filarete*, Rome, 1908, Pl. I, Figs. 3 and 4). It appears, then, that a desire for either 'historical' or allegorical accuracy could produce something akin to the later *style rustique* (cf. E. Kris, in *Jahrbuch der kunsthistorischen Sammlungen in Wien*, I, 1926, p. 137 ff.). [For the classical theories of primeval civilization and their revival in the Renaissance, see now Panofsky, *Studies in Iconology* (cited above, p. 13), p. 44, Figs. 18, 21–3.]

26. H. Home (Lord Kames), *Elements of Criticism*, London, 1762, p. 173. The author prefers Gothic ruins to classical ones, because the former demonstrate the triumph of time over strength, the latter, the triumph of barbarism over taste – perhaps not so much from contempt for the Gothic as from the notion that Greek ruins suggest violent destruction by human hands, whereas Gothic ruins evoke the idea of

In the Northern countries, then, the first conscious 're-vival' of the Gothic style resulted, not so much from a preference for a particular form of architecture, as from a desire to evoke a particular mood. Those eighteenth-century structures do not pay homage to an objective style but are intended to operate as a subjective stimulant suggestive of natural freedom as opposed to the constraint of civilization, of the contemplative and the idyllic as opposed to hectic social activity and, finally, of the weird and the exotic. The charm they had for the sophisticated was somewhat analogous to that of an American trapper's meal which, according to Brillat-Savarin, equals, and under certain circumstances surpasses, that of an artfully composed Parisian repast. To becomes conscious of the fact that Gothic was not only a taste but also a style, that is to say, that it expressed an artistic ideal determined by autonomous and determinable principles, the Northern public had to be educated by two apparently – but only apparently – contradictory experiences: on the one hand, it had to be converted to a strictly classic-istic point of view from which the Gothic style as well as the Baroque could be seen 'at a distance' and, therefore, in per-spective (as Tietze justly observes, 'the severest classicist of the Vienna of Joseph II was also her strictest Gothicist'[27]);

natural decay; the point of the antithesis is the contrast between 'time' and 'barbarism' rather than between 'strength' and 'taste'. Be that as it may, Home's statement illustrates a new preoccupation with 'moods' rather than form. The Renaissance had been inclined to admire in the ruin, not so much the grandeur of the destructive forces as the beauty of the objects destroyed. 'From the ruins still visible in Rome we infer the divinity of those classical minds,' says the 'Report on Ancient Rome' (see Note 22, p. 219), and a drawing by Martin van Heemskerck is inscribed: 'Roma quanta fuit, ipse ruina docet', a phrase which brings to mind the well-known poem by Hildebert of Lavardin. For the Romantic taste for the Gothic and the ruin in England, cf., in addition to the literature cited by Tietze, L. Haferkorn, *Gotik und Ruine in der englischen Dichtung des 18. Jahrhunderts*, 1924 (Beiträge zur englischen Philologie, Vol. 4).

27. *Tietze*, p. 185.

on the other, it had to become susceptible – in certain cases, as in early German Romanticism, on a highly emotional basis – to the historical and national significance of medieval monuments of art. A serious reappreciation of the Gothic style presupposed the activities of men like Félibien and Montfaucon in France;[28] Willis, Bentham, Langley, and Walpole in England;[29] Christ, Herder and Goethe in Germany. Only a combination of Classicism and Romanticism could move the North to attempt an 'archaeological' appraisal and reconstruction of the Gothic style, and only this combination could give rise to the conviction, soon to crystallize into a destructive dogma, that any addition planned for an old church, 'if not made according to the

28. Schlosser, *Kunstliteratur*, p. 430, 442 and *Präludien*, p. 288. Local and regional historiographers (e.g., Dom U. Plancher in his *Histoire générale et particulière de Bourgogne*, Dijon, 1739–87) reveal, of course, a reverent interest in medieval monuments at a much earlier date than do the theorists of architecture. This is also true of Germany where the admirable H. Crumbach (*Primitiae Gentium sive Historia et Encomium SS. Trium Magorum*, Cologne, 1653-4, III, 3, 49, p. 799 ff.) enthusiastically extolled the beauty of the Cathedral and even published the medieval plans in order to make them available for future completion (!). However, the same Crumbach (brought to my attention by Miss Helen Rosenau) was thoroughly familiar with Vitruvius and the Italian theorists of architecture, and this very familiarity enabled him, by turning condemnation into praise, to interpret the Gothic style in quite surprisingly modern fashion: 'Utar hoc capite vocibus artis Architectonicae propriis e Vitruvio petitis, quas operi Gothico conabor accomodare. ... Operis totius et partium symmetria nullam certam regulam Ionici, Corinthiaci vel compositi moris, sed Gothicum magis institutum sequitur, unde, quicquid collibitum fuerat, faberrime sic expressit ars, ut cum naturis rerum certare videatur, habita tamen partium omnium peraequa proportione: neque enim in stylobatis, columnis et capitulis vel in totius structurae genere vetus Italorum architecturae ratio fertur; sed opus hac fere solidius, firmius et, cum res exigit, interdum ornatius apparet.' From the Italian theory of architecture, then, Crumbach adopts the by now familiar idea that the Gothic style follows only the rules of nature but claims that just this endows the Gothic structures with the values of totality, freedom, strength, and, 'where required', decorative exuberance.

29. Schlosser, *Kunstliteratur*, pp. 431, 444.

Gothic style of architecture, would not be able to blend properly with the old Gothic edifice';[30] and that it was an 'artistic sin' if, 'in repairing old monuments and buildings, the restorer were not to follow the style and method in which they were built' or if an 'altar in the Roman style were erected in a Gothic church'.[31]

IV

According to Tietze, it was the engraver Charles Nicolas Cochin, competent also as an art theorist, who – on the occasion of Michelange Slodtz's unrealized project for decorating the choir of St Germain d'Auxerre – first raised the 'problem of stylistic purity' with regard to the Gothic style.[32] But this is true, as it was probably intended to be, exclusively of the North. In Italy, the appearance of this problem, which in the transalpine countries could become acute only after a long process of dissolution and reconsolidation, was inevitable from the very beginning; for here the Renaissance movement itself had with one fell swoop established that distance between Gothic and contemporary art, of which, as we have seen, the North was virtually unaware up to the simultaneous rise of Classicism and Romanticism.

From the days of Filippo Villani, the Italians took it for granted that the great and beautiful art of antiquity, destroyed by hordes of savage conquerors and suppressed by the religious zeal of early Christianity, had given way, during

30. Report of the year 1783 regarding a 'Stöckel' for St Stephen's in Vienna, quoted by *Tietze*, p. 175.

31. J. G. Meusel, *Neue Miscellaneen*, Leipzig, 1795–1803, quoted by *Tietze*, ibid. It was at precisely the same time that there arose what the Grimm brothers characterized as an 'irritating purism' – a purism that differs from the earlier efforts of a Philipp Zesen much as does Meusel's from 'Jesuit Gothic'. For the connexion between 'Romantic' and 'historical' appreciation of the Middle Ages, see the fine observations by G. Swarzenski in the *Katalog der Ausstellung mittelalterlicher Glasmalereien im Städelschen Kunstinstitut*, Frankfurt, 1928, p. 1.

32. Quoted by *Tietze*, ibid. In contrast to the authors just mentioned, Cochin does not arrive at a positive decision.

the dark Middle Ages (*le tenebre*), to an art either barbaric and uncivilized (*maniera tedesca*) or ossified by an estrangement from nature (*maniera greca*); and that the present, having found its way back to both nature and classical models, had happily created an *antica e buona maniera moderna*.[33] Thus the Renaissance placed itself, from the outset, in an intensively perceived contrast to the Middle Ages in general and to the Gothic style in particular – a contrast recognized in theory as well as in practice. Small wonder that a period in which a man like Filarete wrote a whole tract on architecture in order to convert his North Italian patrons from the reprehensible architecture of the Middle Ages to the architecture of the Florentine 'Renaissance', and for which the designation *gotico* or *tedesco* signifies the harshest criticism imaginable,[34] either failed to observe the Gothic undercurrent prevailing in late Quattrocento and early 'Mannerist' art, or else – where, as in Pontormo, this undercurrent came to the surface in the shape of manifest borrowings – severely disapproved of it.[35]

33. In this respect cf. particularly Schlosser, *Präludien*, loc. cit.

34. Cf. Note 36, p. 225. For Vasari, see, for example, the Introduction, I, 3 (*Frey*, p. 69): 'Le quali cose non considerando con buon giudicio e non le imitando, hanno a'tempi nostri certi architetti plebei . . . fatto quasi a caso, senza seruar decoro, arte o ordine nessuno, tutte le cose loro mostruose e peggio che le Tedesche' ('In our own time certain vulgar architects, not considering these things judiciously and not imitating them [the splendid works of Michelangelo], have worked . . . almost as if by chance, without observing decorum, art or any order, all their things monstrous and worse than the Gothic ones'); or his criticism of Antonio da Sangallo's model for St Peter's (*Vasari*, V, p. 467), which, with its numerous small motifs, gives the impression that the architect 'imiti più la maniera ed opera Tedesca che l'antica e buona, ch'oggi osservano gli architetti migliori' ('imitated the style and manner of the Germans rather than the good manner of the ancients, which is now followed by the better architects'). Both passages are quoted in J. Burckhardt, *Geschichte der Renaissance in Italien*, 7th ed., Stuttgart, 1924, p. 31.

35. See W. Friedlaender, 'Der antiklassische Stil', *Repertorium für Kunstwissenschaft*, XLVI, 1925, p. 49. Further, F. Antal, 'Studien zur Gotik im Quattrocento', *Jahrbuch der preussischen Kunstsammlungen*,

However, precisely this opposition to the Middle Ages compelled and enabled the Renaissance really to 'confront' Gothic art, and thereby, even though through glasses tinted by hostility, to *see* it for the first time – to see it as an alien and contemptible, yet for this very reason truly characteristic, phenomenon which could not be taken too seriously. As paradoxical as it may sound: where the North, for want of distance, needed a long time to appreciate Gothic works as stimulants of a peculiar emotional experience, and an even longer time to understand them as manifestations of a great and serious style, the very enmity toward the Gothic established the basis for its recognition in Italy.

The comparison of pointed-arch vaulting with the intersecting of living trees, later repeated *ad nauseam* by the very partisans of the Gothic, goes back, as has been mentioned, as far as the author of the pseudo-Raphael report on Roman architecture.[36] And if we divest Vasari's remarks of their derogatory intention and phraseology, they emerge as a stylistic characterization, impossible in the Middle Ages and possible in the North only many centuries later, which, in a measure, is still valid today.[37] Vasari says: 'Often, with one thing being put above another, they reach such a height that the top of a door touches the roof.'[38] We speak of repetition

XLVI, 1925, p. 3 ff.; idem, 'Gedanken zur Entwicklung der Trecento- und Quattrocento-malerei in Siena und Florenz', *Jahrbuch für Kunstwissenschaft*, II, 1924-5, p. 207 ff.

36. Like all Renaissance theorists from Alberti to Paolo Frisi (Schlosser, *Kunstliteratur*, p. 434 and *passim*), the author of the report prefers, as a matter of course, the round (Roman) arch to the pointed and supports this view not only by aesthetic but also by statical reasons. He even maintains that the straight entablature (the weakness of which was frankly admitted by Vasari, Introduction I, 3, *Frey*, p. 63) surpasses the pointed arch in stability. Filarete (*Traktat über die Baukunst*, W. von Ottingen, ed., Vienna, 1890, p. 274) was sufficiently openminded to question the statical superiority of the round arch to the pointed and prefers the former for purely aesthetic reasons.

37. Cf. Schlosser, *Kunstliteratur*, p. 281, and *Präludien*, p. 281.

38. Quoted above, p. 214.

of form (rhyme as opposed to meter!) and verticalism. Vasari says:

Also on all the façades, wherever else there is enrichment, they build a malediction of little niches one above the other, with no end of pinnacles and points and leaves, so that, not to speak of the whole erection seeming insecure, it appears impossible that the parts should not topple over at any moment. . . . In these works they made endless projections and breaks and corbellings and flourishes that throw their works all out of proportion.[39]

We speak of the absorption of mass into structure and of the disappearance of the wall surface behind a screen of ornament. Vasari says:

For they did not observe that measure and proportion in the columns that the art required, or distinguish one Order from another, whether Doric, Corinthian, Ionic or Tuscan, but mixed them all together with a rule of their own that was no rule, making them very thick or very slender, as suited them best.[40]

We speak of the naturalistic, free handling of the decorative forms and of 'absolute' instead of 'relative' proportion.[41]

39. Quoted ibid.

40. *Vasari*, II, p. 98 (Preface to the Second Part): 'Perchè nelle colonne non osservarono quella misura e proporzione che richiedeva l'arte, ne distinsero ordine che fusse più Dorico, che Corinthio o Ionico o Toscano, ma a la mescolata con una loro regola senza regola faccendole grosse grosse o sottili sottili, come tornava lor meglio.' In describing the Sangallo model which he censured as being quasi-Gothic (*Vasari*, V, p. 467), Vasari instinctively – and characteristically – employs a very similar terminology: 'Pareva a Michelangelo ed a molti altri ancora . . . che il componimento d'Antonio venisse troppo sminuzzato dai risalti e dai membri, che sono piccoli, siccome anco sono le colonne, *archi sopra archi, e cornice sopra cornice*' ('It seemed to Michelangelo, as well as to many others . . . that Antonio's composition was too much cut up by wall strips and members that are too small, as are also the columns, the arches upon arches, and the cornices upon cornices').

41. C. Neumann, 'Die Wahl des Platzes für Michelangelos David in Florenz im Jahr 1504; Zur Geschichte des Masstabproblems', *Repertorium für Kunstwissenschaft*, XXXVIII, 1916, p. 1 ff.

Vasari says: 'Indeed they [the buildings] have more the appearance of being made of paper than of stone or marble.'[42] We speak of the dematerialization of the stone.

Thus the Italian Renaissance – in a first, great retrospective view which dared to divide the development of Western art into three great periods – defined for itself a *locus standi* from which it could look back at the art of classical antiquity (alien in time but related in style) as well as at the art of the Middle Ages (related in time but alien in style): each of these two could be measured, as it were, by and against the other. Unjust though this method of evaluation may appear to us, it meant that, from then on, periods of civilization and art could be understood as individualities and totalities.[43]

This change in attitude had an important practical consequence. With the recognition of a fundamental difference between the Gothic past and the modern present, the naïveté with which the Middle Ages could juxtapose or fuse the old and the new – a naïveté which, as we have seen, the North preserved into the eighteenth century – was gone forever. And since, on the other hand, the Renaissance, reviving classical art theory as well as classical art itself, had adopted that fundamental axiom according to which beauty is almost synonymous with what the ancients called ἁρμονία or *concinnitas*, every instance in which a 'modern' architect had to cope with a medieval structure requiring completion, extension or restoration posed a question of principle. The Gothic style was undesirable; but no less undesirable was a violation

42. 'Et hanno [the buildings] più il modo da parer fatte di carta che di pietre o di marmi' (quoted above, p. 214).

43. It has frequently been stated, and will be discussed in detail elsewhere, that this individualization and totalization, made possible only by an awareness of historical distance, distinguishes the attitude of the Italian Renaissance toward classical antiquity from that of the Middle Ages. But the attitude of the Italian Renaissance toward the Middle Ages presupposes, in spite of its essentially negative character, a similar awareness of distance; in the sixteenth and seventeenth centuries the North looked upon the Gothic style with the same naïveté as it had upon the antique in the twelfth, thirteenth and fourteenth.

of what Alberti, the very founder of the theory of art, called *convenienza* or *conformità*:

First of all, one must see to it that all the parts are in harmony with each other; and they are in harmony if they correspond, so as to form one beauty, in regard to size, function, kind, colour and other similar qualities.[44]

It would be absurd if Milo the athlete were to be represented with frail hips or Ganymede with the limbs of a porter, and 'if the hands of Helen or Iphigeneia were aged and knotty'.

What if, instead of a Helen, we had before us a Gothic saint? In this case, would it not be just as absurd if her hands were those of a Greek Venus? Or, speaking in terms of practical and acute problems, would it not be a sin against art and nature to close two rows of Gothic piers with a 'modern', i.e., classicizing, vault? Most experts answered this question, even in theory, with a resounding 'yes', and called it an *esorbitanza* if 'an Italian hat were to be set upon a German costume'.[45]

Thus the Italians, when coming to terms with Gothic monuments, could not escape from a basic decision where the Northerners could go ahead without misgivings. Consciously rejecting the *maniera tedesca* in favour of the *maniera moderna* but committed to the principle of *conformità*, they had to face the 'problem of stylistic unity' as early as the fifteenth century. And we can understand that, paradoxical as it sounds, the very estrangement from the Middle Ages could cause a Renaissance architect to build in a Gothic style

44. *L. B. Albertis kleinere kunsttheoretische Schriften*, H. Janitschek, ed., Vienna, 1877, p. 111: 'Conviensi imprima dare opera che tutti i membri bene convengano. Converranno, quando et di grandezza et d'offitio et di spetie et di colore et d'altre simili cose corresponderanno ad una bellezza.'

45. Report of Terribilia on the vaulting of San Petronio, G. Gaye, *Carteggio inedito d'artisti*, Florence, 1839–40, III, p. 492, quoted below, Note 78, p. 241. Other statements of a similar nature are quoted below, p. 236 f.

more 'pure' than F. J. M. Neumann and Johann von Hohenberg were to employ three hundred years later.

Setting aside the possibility of completely and – in contrast to the Northern practice – intentionally disregarding the extant structure (as is the case with the majority of Florentine and Roman façade projects), the problem of *conformità* could be solved in one of only three ways. First, the given structure could be remodelled according to the principles of the *maniera moderna* (or, even more effectively, encased in a contemporary sheath); second, the work could be continued in a consciously Gothicizing style; third, there could be a compromise between these two alternatives.

The first of these methods, not always applicable but most congenial to the temper of the times, was introduced by Alberti in his *Tempio Malatestiano* (S. Francesco) at Rimini and applied by Vasari himself when he redecorated the refectory of a Neapolitan monastery;[46] it was explicitly recommended by Sebastiano Serlio for the modernization of medieval palaces;[47] and it was followed, on a grand scale, in

46. *Vasari*, VII, 674 (quoted in Burckhardt, loc. cit.). At first Vasari did not want to accept the commission, given to him in 1544, because the refectory was built in the old-fashioned style of architecture 'with vaults in pointed arches, low and poorly lighted' ('e con le volte a quarti acuti e basse e cieche di lumi'). Then, however, he discovered that he could have 'all the vaults of the refectory remade in stucco, so as to remove all the old-fashioned and clumsy appearance of those arches by means of rich coffers in the modern manner' ('a fare tutte le volte di esso refettorio lavorate di stucchi per levar via con ricchi partimenti di maniera moderna tutta quella vecchiaia e goffezza di sesti'); the ease with which the tufa could be carved permitted him 'to cut square, oval and octagonal coffers into the tufa and also to reinforce and repair it by means of nails' ('tagliando, di fare sfondati di quadri, ovati e ottanguli, ringrossando con chiodi e rimmettendo de' medesimi tufi') and thus to reduce all those arches 'a buona proporzione'.

47. S. Serlio, *Tutte l'opere d'architettura . . .*, Venice, 1619, VII, pp. 156–7, 170–1 (referred to in Schlosser, *Kunstliteratur*, p. 364; cf. also below, p. 268 and Plate 61). Serlio characteristically addresses himself to proprietors who would like to modernize their Gothic palaces in order not to seem inferior to their progressive neighbours ('che vanno

three world-famous remodelling jobs: Bramante's Santa Casa at Loreto ('which was Gothic but became a beautiful and graceful work when that wise architect applied to it a fine decoration'[48]), Andrea Palladio's Basilica at Vicenza, and Boromini's St John in the Lateran.

The second method – submission to *conformità* – was proposed by Francesco di Giorgio Martini and Bramante in their designs and reports for the crossing tower (*Tiburio*) of Milan Cathedral, for which they demanded, as a matter of course, that 'the decoration, the lantern and the ornamental details be made so as to harmonize with the style of the whole structure and the rest of the church';[49] after some vacillation,[50] it was in fact erected in a Gothic style which in comparison with the dome of the Abbey Church of Kladrub in

pur fabbricando con buono ordine, osservando almeno la simetria') but cannot or will not spend the money for an entirely new structure. An instance of such a reconstruction, particularly interesting because of the artist in question, is discussed in the Excursus, p. 266 ff.

48. Letter of Andrea Palladio, in Gaye, op. cit., III, p. 397: 'qual era pur Tedescho, ma con lhaver quel prudente architeto agiontovi boni ornamenti rende l'opera bella et gratiosa.'

49. Francesco di Giorgio Martini's report of 27 June 1490 (G. Milanesi, *Documenti per la Storia dell'arte senese*, Siena, 1854–6, II, p. 429, mentioned, e.g., by Burckhardt, loc. cit.): 'di fare li ornamenti, lanterna et fiorimenti *conformi a l'ordine de lo hedificio et resto de la Chiesa*.' Bramante's report (there is little reason to doubt this authorship) goes even further in stressing the principle of *conformità*. The place and basic shape of the crossing tower being determined by the extant structure, the former should be built square, so as not to 'deviate' from the original project, and the details should even be patterned after the old architectural drawings preserved in the archives of the Cathedral: 'Quanto a li ornamenti come sone scale, corridoi, finestre, mascherie, pilari e lanterne, quello che e facto sopra la sagrestia, bona parte ne da intendere, e meglio se intende anchora per alcuni disegni che ne la fabrica se trouano facti in quello tempo, che questo Domo fu edificato' (reprinted, e.g., in H. von Geymüller, *Die ursprünglichen Entwürfe für St Peter in Rom*, Paris, 1875, p. 117 ff.). For Leonardo's 'Gothic' plans for the *Tiburio*, see L. H. Heydenreich, *Die Sakralbaustudien Lionardo da Vincis* (Diss. Hamburg), 1929, p. 25 ff and 38 ff.

50. Burckhardt, op. cit., p. 33.

Bohemia or Neumann's lantern tower at Mainz appears almost archaeologically correct (Plate 52). The same policy was advised by the majority of the artists who between 1521 and 1582 assayed the problem of the façade of San Petronio in Bologna;[51] and, later on, by that unknown Baroque architect who proposed to extend the principle of *conformità* from the individual structure to the entire site by adding a huge Gothic palace to the buildings in front of Siena Cathedral.[52]

The third solution – compromise – is exemplified, as early as *c.* 1455, by Alberti's façade for S. Maria Novella. A compromise was also envisaged in Vignola's much-criticized plans for San Petronio (Plate 55)[53] and in an extremely interesting model submitted by Gherardo Silvani in 1636 when, for the second time, a competition was held for a façade of Florence Cathedral (Plate 56). In conscious imitation of the Campanile (which is flush with the Cathedral façade) this model shows an ordinary Baroque composition enriched by octagonal Gothic turrets and interspersed with such Gothic details as encrusted pilasters alongside the fluted ones, an encrustation motif on the pediment, and a parapet composed of hexafoils in the upper story; its artistic intention – deliberate adjustment of the new to the old – was explicitly stressed by Baldinucci:

Silvani, then, produced his model, composing it of two orders; and at the corners he proposed to build two round turrets looking like campaniles, not only as a terminal feature of the Gothic

51. For this and the following, see A. Springer's famous study 'Der gotische Schneider von Bologna' (*Bilder aus der neueren Kunstgeschichte*, Bonn, 1867, p. 147 ff.). Cf. also Ludwig Weber, 'Baugeschichte von S. Petronio in Bologna', in *Beiträge zur Kunstgeschichte*, new. ser., XXIX, 1904, p. 31 ff., especially p. 44 ff.; H. Willich, *Giacomo Barozzi da Vignola*, Strassburg, 1906, p. 23 ff.; G. Dehio, *Untersuchungen über das gleichseitige Dreieck als Norm gotischer Bauproportionen*, Stuttgart, 1894. [See now the monograph by Zucchini, cited above, p. 10.]

52. See Kurt Cassirer, 'Zu Borominis Umbau der Lateransbasilika', *Jahrbuch der preussischen Kunstsammlungen*, XLII, 1921, p. 55 ff., Figs. 5-7.

53. Willich, op. cit., Pl. I and p. 26.

system with which the church is encrusted but also in order to avoid a sudden departure from the old style.[54]

Such a compromise solution, or even the continuation of an extant structure in Gothic forms, does not, however, amount to an aesthetic endorsement of the Gothic style. In choosing the 'Gothic' alternative, the architects merely deferred to the *conformità* postulate; and, wherever possible, they decided in favour of the *maniera moderna*. Against the one compromise plan of Gherardo Silvani there are eight others in which not the slightest concession is made to the Gothic character of either the Cathedral or the Campanile (seven of these submitted in 1587). Of all the Gothicizing projects thus far discussed, only that for the crossing tower of Milan Cathedral was actually carried out; whereas the somewhat analogous problem of placing a lantern upon the Gothic dome of Florence Cathedral (Plate 53) was solved in a diametrically opposed sense. In its stereometric and structural principle this lantern – begun by Brunelleschi in 1446 – is fundamentally closer to the Gothic spirit than the capricious *Tiburio* of Milan, where the octagonal prisms, set one into the other, are essentially no less un-Gothic than the inverted flying buttresses which hang like garlands. In Brunelleschi's lantern, the Corinthian pilasters serve as a classical cloak for what is really a Gothic compound pier, and that modern symbol of strength, the spiral volute (which here appears for the first time) is really a Gothic flying buttress in disguise.[55]

54. F. Baldinucci, *Notizie de' Professori del Disegno*, 1681 (in the edition of 1767, XIV, p. 114): 'fece adunque il Silvani il suo modello, componendolo di due ordini; e nell'estremità de'lati intese di fare due tondi pilastri a foggia di campanili, non solo per termine dell'ordine gottico, con che e incrostata la chiesa, ma eziandio per non discostarsi di subito dal vecchio.'

55. In both these cases we have a clear distinction between antithetical principles: in the Milan *Tiburio*, modern syntax and Gothic vocabulary; in Brunelleschi's lantern, Gothic syntax and modern vocabulary. In Mainz and Kladrub, on the other hand, we have a fusion of both these elements.

That the Milan *Tiburio* was built as planned while Brunelleschi's lantern hides its Gothic essence beneath a modern – that is, classical-inspired – appearance is not an accident. The *conformità* principle could enforce the actual execution of a Gothicizing project only where it was supported by a real, if by no means purely aesthetic, preference for the Gothic style. And this preference, it seems, existed only in the northern part of Italy, separated from the rest by the Apennines. Here the break between the modern and the medieval styles of architecture was less abrupt than in Tuscany, let alone in Rome, where hardly any Romanesque churches and only a single Gothic one were built in the entire Middle Ages; it is significant that the 'outer triforium' remained a favourite motif of North-Italian Renaissance architecture (cf., e.g., the Certosa di Pavia, S. Maria delle Grazie at Milan, Cristoforo Rocchi's model of 1486 for the Cathedral at Pavia, or even the pilgrimage church, S. Maria della Croce near Crema, not executed until around 1500, whose outer triforium consists of genuinely Gothic trefoil arches). When Cesariano used a Commentary on Vitruvius[56] as a springboard for discussing the very Gothic problem of triangulation *v.* quadrangulation, he lent involuntary expression to an attitude too Italian not to participate in the general revival of classical antiquity yet too Northern to renounce the old medieval methods of architecture altogether. In this artistic borderland there could arise a genuine 'Gothic faction', and its opposition to the 'modernists' could erupt in an embittered discussion of principle the like of which was as impossible in Germany and France as it was in Rome and Florence.

It is illuminating, however, that this discussion of principle – characteristically reaching its highest pitch at the point nearest to what may be called 'Italy proper' – was rooted not so much in a diversity of artistic taste as in cultural, social and political antagonisms. The famous dispute over the

56. Cf. Schlosser, *Kunstliteratur*, p. 220, 225; Dehio, op. cit.

façade of San Petronio[57] involved not only the excellence of the Gothic style of architecture as compared to the modern but also the merits of the native master as compared to the 'foreigner'[58] (Bologna always considered Florence and Rome as 'hostile powers' and found it easier to honour Dürer than Michelangelo or Raphael[59]); and it involved, moreover, the preservation of a democratic conception of art and life based on the medieval guild system and therefore symbolized, as it were, by the Gothic style, as opposed to the ambitions of a rising aristocracy and of a class of artists unknown in the Middle Ages. Closely allied with the new aristocracy, these 'virtuosi' thought of themselves as educated gentlemen and representatives of a free profession rather than craftsmen and guild members, and their style was considered not only as 'modernistic' but also as an art of the 'upper classes'. It is no accident that it was the Conte Giovanni Pepoli who urged Palladio to submit his classicizing projects for the façade of San Petronio[60] and 'resolutely

57. See the bibliographical references in Note 51, p. 231.

58. That Giacomo Ranuzzi, a local architect and vigorous opponent of Vignola, is responsible for the non-Gothic plan reproduced by Weber, Pl. I, has been doubted by Willich (op. cit., p. 29). It gives the impression of having been produced by an amateur.

59. It is no accident that the same Malvasia who called Raphael a *boccalaio Urbinate* praises Dürer as the 'maestro di tutti' and goes so far as to maintain that all the 'great ones' (sc., the Florentines and the Romans) would be beggars were they to return to Dürer what they had borrowed from him (quoted by A. Weixlgärtner, 'Alberto Duro', *Festscgrift für Julius Schlosser*, Zurich, Leipzig and Vienna, 1926, p. 185). In an unpublished but highly instructive 'Plan of Study' for the young members of the Academy of Bologna, Rome ranks below Parma and Venice as a place worth visiting; Florence is omitted altogether; and Dürer is credited with having first restored 'nobility to draperies' (*la nobiltà di piegatura*) and overcome the 'dryness of the ancients' (*la seccaggine, ch'hebbero gli Antichi*, here, naturally, the medieval). See Bologna, Biblioteca Universitaria, Cod. 245: *Punti per regolare l'esercitio studioso della gioventù nell'accademia Clementina delle tre arti, pittura, scultura, architettura.*

60. Gaye, op. cit., III, p. 316. [It should be noted that in Serlio's stage designs the 'tragic scene', destined for plays which, up to the

defended the plans'[61] of an architect who, from the beginning, had addressed himself only to those who 'understood something of architecture as a profession' ('intelligenti della professione d'architettura')[62] and whose very classicism might actually be interpreted as a form of protest against the native art of his North Italian homeland.

Thus even in North Italy a conscious preference for the Gothic style remained restricted to a middle class swayed by local patriotism and political prejudice (much as the sympathetic interest accorded to the Flemish 'primitives' by the semi-Protestant circles around Occhino and Valdes and, later on, by Counter-Reformation authors such as Giovanni Andrea Gilio, was founded on religious rather than aesthetic convictions[63]). These provincial reactionaries did not claim greater beauty for the *maniera tedesca*; they defended their position either with technical and financial considerations, or with the reverence due to forebears, or – particularly illuminating from our point of view – with the principle of *conformità*. Against Peruzzi's plans, although they included

advent of the 'bourgeois tragedy' in the eighteenth century, involved only royalty and princes, exclusively consists of Renaissance buildings (*Libro primo* [= *quinto*] *d'architettura*, Venice, 1551, fol. 29 v., our Plate 57), whereas the 'comic scene', destined for plays about ordinary folk (ibid., fol. 28 v., our Plate 58), shows a mélange of Renaissance and Gothic structures.]

61. Gaye, op. cit., III, p. 396.

62. ibid., p. 317.

63. For Gilio's contention that the art of the 'Primitives' is more 'reverent' than that of the moderns, cf. Schlosser, *Kunstliteratur*, p. 380, and the remark – characteristically attributed to Vittoria Colonna – that Netherlandish painting is more 'devout' than Italian (Francisco de Hollanda, quoted in Schlosser, *Kunstliteratur*, p. 248). The appreciation of Northern painting by the collectors and connoisseurs (especially of the fifteenth century) is another story, though both points of view may coincide in certain cases; Professor Warburg calls my attention to a letter of Alessandra Macinghi-Strozzi in which she refuses to sell a Flemish *Holy Face* on canvas because it is 'una figura divota e bella' (*Lettere ai Figliuoli*, G. Papini, ed., 1914, p. 58).

even a 'Gothic' one,[64] the local architect, Ercole Secca-
danari, raised the objection 'that they do not harmonize
with the form of this structure' ('che non ano *conformità* con
la forma deso edificio').[65] The projects of Palladio were re-
jected on the grounds that 'it seemed impossible to reconcile
this classical project with the Gothic, since there was such a
difference between the one and the other' ('parea cosa im-
possibile accomodar sul todesco questo vecchio essendo
tanto discrepanti uno del altro'),[66] and that his gables 'do not
at all agree with the doors' ('non hanno conformità alcuna
con esse porte').[67] And when Vignola tried to solve the
problem by the compromise plan already mentioned (Plate
55), it was objected, first, that he had failed to follow the
intentions of the Founder (*la volontà del primo fondatore*) in
certain respects; and, second, that he had placed round
columns on angular bases and a Doric entablature on
medieval capitals.[68]

To the 'foreign' architects, of course, any proposal of
peaceful coexistence with the Gothic style was deeply re-
pugnant. With what feelings Giulio Romano may have
drawn his 'Gothic' façade we do not know; but it is hardly
to be doubted that Peruzzi's sympathy belonged to his two
classical plans rather than to his single 'Gothic' one. And
Vignola and Palladio, when provoked, expressed themselves
with all the clarity we could desire. To the reproach that he
had turned tall windows into circular 'oculus' windows and
vice versa Vignola replies:

64. Museo di San Petronio, No. 1; the two 'modern' plans, Nos. 2
and 3. Vasari (IV, p. 597) speaks of only one Gothic and one 'modern'
plan.
65. Gaye, op. cit., II, p. 153.
66. ibid., III, p. 396.
67. ibid., III, p. 398.
68. ibid., II, p. 359 f. The text reads: 'Ch'io pongo architrave,
freggio e cornice doriche sopra li moderni'; for the usage of *moderno*
for 'medieval' as opposed to 'classical' (already obsolete at the time),
cf. Schlosser, *Kunstliteratur*, p. 113.

If one attempts to put the whole system of the façade in proportion as is required by good architecture, they [the windows] are not correctly placed because the oculus windows ... break into the first story of the façade. ... Similarly the window above the large entrance door of the nave cuts into the second story of the church and even into its gable. ... I believe that, if that Founder were alive, one could make him, without too much trouble, see and admit the errors which he has committed owing to his period, and not through any fault of his own; for in that age good architecture had not yet come to light as is the case with our own era.[69]

Palladio, it is true, made all sorts of well-considered concessions to the feelings of the Bolognese; but he could not help revealing his true opinion from the outset. To a preliminary inquiry from Pepoli's cousin he replied, orally, that all the drawings on hand were worthless; the best, relatively speaking, was still the 'Gothic' project of Terribilia (Plate 54), who had been architect-in-chief from 1568. On the whole, Palladio thought it would be far better, even from a financial point of view, to continue the work in a totally different – that is to say, un-Gothic – style and to either tear down or remodel everything extant including the lower zone of the wall (*imbasamento*).[70] When he was given to understand that he should not make too radical demands and must be satisfied with sensible improvements,[71] he

69. Gaye, op. cit., II, p. 360: 'che a voler metter in proportione tutto l'ordine della facciata, come ricerca la buona architettura, non sono al luoco suo, percioche gli occhi ... rompeno il primo ordine della facciata [namely, when the façade is articulated, in classical fashion, into three horizontal storeys!] ...; similmente la finestra sopra la porta grande nella nave del mazzo scavenzza il secondo ordine et più scavezza el frontespicio della chiesa ... io credo, s'esso fondatore fosse in vita, con manco fatica se li farebbe conoscer et confessar li errori che per causa del tempo l'a commesso, e non di lui, percio che in quel tempo non era ancora la buona architettura in luce come alli nostri secoli.' It is significant that Vignola tries to stress the horizontal even in equalizing the height of the gables.

70. ibid., III, p. 316.

71. ibid., III, p. 319.

composed a report which is a masterpiece of diplomacy: he has inspected the building and finds the drawings of the two local architects, Terribilia and 'Teodaldi' (Domenico Tibaldi), quite good, considering that they, too, had had to cope with the Gothic *imbasamento*, which, after all, exists and, in point of fact, deserves to be preserved because it had been expensive to build and because it displayed 'certain features most beautiful by the standards of its period' ('bellissimi avertimenti, come pero comportavana quei Tempi, nelli quali egli fu edifficato'). In view of these circumstances, Palladio goes on to say, both plans are praiseworthy and, 'since the style had to be Gothic, could not be different from what they are' ('che per essere opera todesca, non si poteva far altrimenti'). There are, he adds in a spirit of indulgent superiority, quite a few Gothic buildings in existence: St Mark's at Venice (which was referred to as 'Gothic' as late as the eighteenth century), the Church of the Frari, the *Duomo* at Milan, the Certosa di Pavia, the Santo at Padua, the Cathedrals of Orvieto, Siena and Florence, the Ducal Palace, the *Salone* at Padua ('said to be the largest interior in all Europe, and yet it is an *opera todesca*'), and the Palazzo Communale at Vicenza. In short, under the circumstances Palladio himself could have done no better and would recommend only greater economy with regard to the carved ornaments (*intagli*) and pinnacles (*piramidi*). After this, however, he comes to the point: even in the *imbasamento* some changes should be made by shuffling the elements around a little bit ('mover qualque parte di quello luoco a luoco'), and a really perfect solution was possible only if one could go ahead regardless of either the *imbasamento* or anything else. Then – and only then – would he himself be prepared to make a drawing; but it would be quite expensive.[72]

In the end, Palladio consented to cooperate with Terribilia and to preserve the lower structure as it was, hoping, of course, that it would finally be changed in several respects;[73] he even sent a drawing and, shortly after, two others of a

72. ibid., III, p. 322 ff. 73. ibid., III, p. 332 ff.

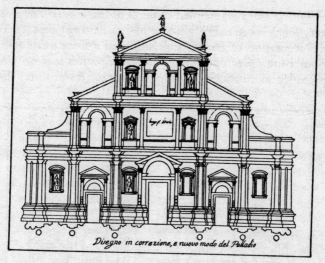

Figure 10. Andrea Palladio, first project for the façade of San Petronio (contour print). Bologna, Museo di S. Petronio.

more daring character (Text Figs. 10 and 11).[74] He was, however, to pay dearly for this conciliatory attitude. No sooner had his plan begun to be put into operation than there was raised, together with all kinds of other objections, that furious protest, already mentioned, against a combination of the *tedesco* with the *vecchio*.[75] And in Palladio's indignant reply, in which he constantly refers to Vitruvius and classical antiquity, he finally gives vent to his long-repressed rage against the Gothic and its practitioners (while inadvertently

74. Reproduced in O. Bertotti Scamozzi, *Les bâtimens et les desseins de André Palladio*, Vicenza, 1776-83, IV, Pl. 18–20. The fourth drawing, which shows the ground floor completely unchanged but combined with upper storeys remodelled in a Palladian style, should not be ascribed to Palladio himself; rather it is one of the compromise proposals of which Palladio approved in an effort to be conciliatory. This would explain the inscription: 'Io, Andrea Palladio, laudo il presente disegno.'

75. Gaye, op. cit., III, p. 395.

admitting that his intended changes of the *imbasamento* were very much more radical than he had made them appear). To the accusation of having superimposed a Corinthian and a Composite order upon the Gothic, he replies that his plan provided so thorough a redecoration of the lower storey that

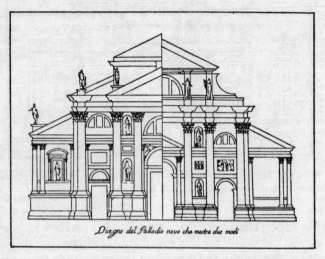

Figure 11. Andrea Palladio, two other projects for the façade of San Petronio (contour print). Bologna, Museo di S. Petronio.

it could no longer be called 'Gothic' at all – certainly no more than the Casa Santa at Loreto after having been 'encased with good ornaments'. As far as the composition as a whole is concerned, however, the critics showed, according to Palladio, a deplorable lack of understanding for architecture:

I do not know in what German author they [viz., the critics] have ever read a definition of architecture which [in reality] is nothing but a symmetry of the members within a body, each being so well proportioned and so concordant with the others and vice versa that by their harmony they give the impression of majesty and decorum; the Gothic style, however, should be

called confusion and not architecture, and that is the kind which those experts must have learned, not the good one.[76]

After this declaration of war there was still much discussion back and forth, but no more positive action,[77] and a provisional cease-fire in this battle of the façade[78] is marked

76. ibid., III, p. 396 ff.: 'ne so in che autori tedeschi habino mai veduto descrita larchitetura, qual non e altro che una proportione de membri in un corpo, cussi ben l'uno con gli altri e gli altri con l'uno simetriati et corispondenti, che armonicamente rendino maesta et decoro. Ma la maniera tedesca si può chiamare confusione et non architetura et quelle dee haver questi valenthuomoni imparata, et non la buona.'

77. For the plan submitted by Girolamo Rainaldi in 1626, see Weber, op. cit., p. 43. Not mentioned by Weber is the very historizing plan by Mauro Tesi of the eighteenth century (Museo di San Petronio, No. 27), a parallel to Vidoni's project for the façade of the Duomo at Milan (reproduced by Tietze in *Mitteilungen der kunsthist. Zentr.-Komm.*, 1914, p. 262). On the whole, Palladio's failure spelled the defeat of the Modernists; see the anonymous drawing of *c.* 1580 (Weber, Pl. IV) and all the plans of the nineteenth century (Museo di San Petronio, Nos. 22–4, 39–43, 47), for which see Weber, p. 60. In the end, nothing was accomplished at all.

78. At the beginning of the eighties, as the dispute over the façade subsided, there began the equally famous, and in a certain sense analogous, battle over the vaulting of the unfinished nave. In 1586 the idea of 'certain people', to place a frieze and architrave upon the Gothic pillars, was unanimously rejected (as 'non conveniente a questa opera todescha'), and pointed-arch cross vaults were considered as the only possible solution, 'poi che non si crede, che questi Todeschi in simil tempi di buona maniera habbino fatte volte daltra forma' (Gaye, op. cit., III, pp. 477 ff. and 482 f.). Accordingly, Terribilia closed one bay in 1587–9; but since he followed classical rather than Gothic principles of proportion, his vault was – with some justification – criticized by the Gothicists as 'too low'. The spokesman for this Gothic faction was the tailor Carlo Carazzi, called Il Cremona, who is treated as a comic figure by Springer and Schlosser (*Kunstliteratur*, p. 360); cf., however, for his vindication, Weber, op. cit., p. 47 ff., with reprint of Carazzi's petitions on p. 76 ff. By referring to all possible authorities, especially to Cesariano's theory of triangulation, Carazzi demanded higher vaults, and finally succeeded. Two facts are noteworthy: first, that special emphasis is placed on Carazzi's success in winning over many members of the aristocracy ('multi *gentilhomini* principali della città', Gaye, III,

by a most interesting 'final report', submitted on 25 September 1582, by the Milanese architect Pellegrino de' Pellegrini. A model of clarity, this final report begins by dividing the existing plans into three groups ('some try to follow, as best they can, the Gothic order according to which the work was begun, others intend to change this order in favour of classical architecture, and some of these represent a com-

p. 485); second, that both parties were in complete agreement on one point: that a church begun in the Gothic style ought to be finished in the Gothic style. 'Se adunque l'arte ad imitatione della natura deve condure l'opere sue a fine,' says Carlo Carazzi, 'la chiesa di San Petronio si deve continuare et finire sopra li principii ed fondamenti, sopra li quali e comminciata' ('As surely as art must accomplish its work in imitation of nature [that is to say, avoid a mixture of different genera], as surely must we continue and finish the Church of San Petronio on the principles and maxims on which it was begun'); that is to say, according to the 'ordine chiamata da ciascuno ordine thedesco'. In this, at least, he had the full support of Terribilia (Gaye, III, p. 492), who writes: 'Questa volta dovea essere d'ordine Tedesco et di arte composito, per non partorire l'esorbitanza di ponere un capello Italiano sopra un habito Tedesco' ('This vault must be built in the Gothic style in order not to produce the monstrosity of placing an Italian hat upon a German costume'). The only difference is that Carazzi, in a just feeling for Gothic proportions, believed that triangulation did provide a strict rule of construction; whereas, according to Terribilia, the Gothic style shared with the other styles only the 'regole naturali' (which dictate straight lines for supporting members, windows, towers, and foundations), but completely lacked any 'regole trovate dal'uso e dal'arte'. With respect to the 'rules of nature', then, even a Gothic structure must follow the prescripts of Vitruvius; with regard to the particular 'alterationi', however, it should be arranged according to the best examples of the Gothic style, or else 'dal propio edifficio, che si dovrà continuare o emendare'. In one passage – the passage in which he speaks of the *chiese tedesche ben fatte* – Terribilia even admits at least one definite rule of proportion (Gaye, op. cit., III, p. 493): 'perchè si vede in tutte le chiese tedesche *ben fatte*, ed ancor delle antiche, le quali hanno più d'una andata, che sempre dove termina l'altezza del una delle andate più basse, ivi comincia la imposta della volta più alta' ('one observes in all well-built German churches as also in ancient [Italian] ones which have more than one aisle, that the vaults of the higher [central] aisle are sprung from the level marked by the total height of the lower [side] aisles').

bination of that barbarous postclassical architecture with the classical order');[79] and it ends with a strong statement in favour of 'stylistic purity'. In principle, Pellegrino would welcome the complete remodelling of the church 'in the classical style' (*a forma di architettura antica*), which is the only one to combine beauty and decorum with strength. If, however, the Bolognese find it impossible to bid good-bye to the Gothic, then

I should much prefer to observe the rules of this [Gothic] architecture (which, after all, are more reasonable than some people think), and not to mix one order with the other as has been done by some.[80]

V

In some of the observations just quoted and, characteristically, even in those which are by no means favourable to the Gothic style, we perceive a curious undertone which should not be permitted to be lost in the din of this noisy debate. The same Terribilia who denies to Gothic architecture any fixed aesthetic 'rule' speaks of 'well-made Gothic churches' (*chiese tedesche ben fatte*) and thereby admits the existence of praiseworthy structures within what he considers an objectionable style. Pellegrino de' Pellegrini, preferring a com-

79. Gaye, op. cit., III, p. 446: 'Parte atendano a seguire più che hano saputo l'ordine Todesco, con il quale e incaminato l'opera, et altri quasi intendano a mutar detto ordine et seguire quello dell'architettura antica, et parte de'detti disegni sono uno composito di detta architettura moderna barbara con il detto ordine antico.' It is obvious that Pellegrini's 'catalogue' of the plans on hand corresponds to the three types of possible solutions defined above, p. 229 f. He emphasizes, moreover, that good architects who actually understood the 'ragione di essa fabricha Tedesca', when employing this style, were particularly careful 'to avoid confusion'.

80. ibid.: 'A me piaceria osservare più li precetti di essa architettura che pur sono più raggionevoli de quello che altri pensa, senza compore uno ordine con l'altro, come altri fano.'

plete remodelling *all'antica* to any other solution and characterizing Gothic architecture as 'barbarous', yet expresses the judicious opinion that, 'after all, the rules of Gothic architecture are more reasonable than some people think'. Andrea Palladio, who does not hesitate to pronounce all medieval architecture a *confusione*, discovers in the existing *imbasamento* 'certain admirable ideas, as far as the period of construction permitted'. And even Vignola, embittered as he was, declares, we recall, that the many errors committed by the old Gothic master of San Petronio (and which the latter would have unhesitatingly admitted in 1547) were 'the fault of the period and not of himself, since in those days good architecture was not as yet known, as is the case in our time'.

Remarks like these – and this is why I have devoted some time to the dispute about the façade of San Petronio – announce, in spite of all dogmatic antagonism against the Gothic, the emergence of what we may call a historical point of view – historical in the sense that the phenomena are not only connected in time but also evaluated according to '*their* time'. And this leads us back, at long last, to Giorgio Vasari.

Vasari, too, was a representative, in fact, a pioneer, of a historical way of thinking – a way of thinking which in itself must be judged 'historically'. We should fail to do justice to the nature and meaning of Vasari's procedure were we to equate it, without reservations, with what we, men of the twentieth century, mean by 'historical method';[81] but we should be equally wrong were we, again from the point of view of the twentieth century, to persist in emphasizing only his historical inadequacy, or even to deny his historical intention.[82]

81. This is the opinion of U. Scoti-Bertinelli, *Giorgio Vasari Scrittore*, Pisa, 1905, p. 134.

82. This was asserted, against Scoti-Bertinelli, by L. Venturi, *Il gusto dei primitivi*, Bologna, 1926, p. 118 ff. Recently R. Krautheimer, 'Die Anfänge der Kunstgeschichtsschreibung in Italien', *Repertorium*

The First Page of Giorgio Vasari's 'Libro'

It is characteristic of Vasari's conception of history, shared by his contemporaries and 'fellow travellers', that it was dominated by two essentially heterogeneous principles which were to be separated only in the course of a long and laborious development (a process, incidentally, which can be observed in all spheres of intellectual endeavour). On the one hand, a need was felt for an exposition of the phenomena as to their tangible connexion in time and place; on the other, a need was felt for an interpretation of the phenomena as to their value and significance. Today we have gone beyond the separation of these two principles (a separation accomplished only in the eighteenth and nineteenth centuries) and fondly believe that the 'art-historical' and the 'art-theoretical' approach represent two points of view dissimilar as to method but necessarily interrelated and interdependent as to their ultimate goal. We distinguish an 'art history' limited to the understanding of the relations which connect the individual creations, from an 'art theory' concerning itself, in critical or phenomenological manner, with the general problems posed and solved by them. And just because we are conscious of this distinction we are able to envisage a synthesis which may ultimately succeed in interpreting the historical process with due regard to 'artistic problems' and, conversely, to appraise the 'artistic problems' from a historical point of view.

The Vasarian conception, on the other hand, amounts – considered from our point of view – to a conflation of two antithetical principles not as yet recognized as antithetical: it combines a pragmatism that tries to explain every individual phenomenon as the effect of a cause and to view the whole process of history as a succession of phenomena, each of them 'motivated' by a preceding one, with a dogmatism that believes in an absolute or perfect 'rule of art' (*perfetta*

für Kunstwissenschaft, L, 1929, p. 49 ff., has discussed Vasari's place in the development of art history; but his valuable article appeared too late to be considered here.

regola dell'arte)[83] and considers every individual phenomenon as a more or less successful attempt to comply with this rule. As a result of this conflation, Vasari's historical construction was bound to be a teleology. He was forced to interpret the whole succession of individual performances as a succession of attempts to approach, more and more closely, that *perfetta regola dell'arte*, which means that he was forced to bestow praise and blame on each individual performance according to the degree of *perfezione* achieved by it.

We cannot expect such a conception of art history, when applied to 'periods' and 'styles', to resolve the contrast between 'good' and 'bad' into a mere difference in kind; to abandon the sharp split between 'medieval' and 'Renaissance' art in favour of a modern concept of difference within the framework of continuity; and to understand every individual phenomenon on the basis of its own premises instead of measuring it by the absolute standard of a *perfetta regola*. Yet the Vasarian interpretation of history was necessary to call into being – though in somewhat roundabout fashion – what we are wont to call the concept of historical justice because the unperceived duality of motives which precluded a clear distinction between a historical and a theoretical method of approach was found to result in an open contradiction. If, on the one hand, the value of every artistic performance was measured by the standard of the *perfetta regola*, while, on the other, the ultimate achievement of this 'perfection' was held to presuppose a continuous succession of individual performances each of which represented a step on a predetermined road, it became inevitable to appraise each of these steps as a more or less significant 'improvement' (*miglioramento*).[84] In other words, the *general level of*

83. *Vasari*, II, p. 95: '. . . non si può se non dirne bene e darle un po' più gloria, che, *se si avesse a giudicare con la perfetta regola dell'arte*, non hanno meritato l'opere stesse' ('. . . we must speak well of them and give them a little more glory than the works themselves have merited, *were we to judge them by the perfect standard of art*').

84. Cf., instead of countless others, the passage quoted in Note 27, p. 262.

achievement at any given time (for example, in Vasari's opinion, the absolute zero marked by the Middle Ages) *had to be recognized as a second standard* of valuation according to which the individual work of art, however far from 'perfection', appeared as, relatively speaking, meritorious. The standard of the '*perfetta regola*' came, inevitably, to be supplemented by the standard of the '*natura di quei tempi*': it had to be recognized that a given historical condition imposed insurmountable limitations upon each artist and that, therefore, a positive value had to be attributed to his work from the historical point of view even if it had to be condemned from the standpoint of aesthetic dogma.

Thus we can understand what seemed surprising at first glance: that the most radical opponents of the Gothic style were the first to perceive the necessity of recognizing relative values in what appeared to have no absolute value at all; and that the very same hostility which, as we have seen, produced the first stylistic characterization of medieval art produced its first historical evaluation. But we can also understand that the first historical evaluation of the Gothic style tended to be clothed in the form of an apology: an apology for the poor artist who could produce nothing better in his time, and an apology for the poor historian who must be prepared to consider, indeed to recognize, such imperfect buildings, statues and paintings.

Even Vasari, whose antagonism to the Gothic could not have been stronger, bestows warm praise upon a whole series of high- and late-medieval monuments of art and architecture.[85] He has, therefore, been accused of an 'astonishing inconsistency' which could be explained only by his local patriotism;[86] but he is inconsistent only in so far as the very foundations of his art-historical thinking, when con-

85. *Frey*, p. 486: '. . . fece Arnolfo il disegno et il modello del non mai abbastanza lodato tempio di Santa Maria del Fiore. . . .' Cf. also, for instance, *Frey*, p. 199, on S. M. in sul Monte, or *Frey*, p. 196, on SS. Apostoli and its relation to Brunelleschi.

86. *Frey*, p. 71, Note 48.

sidered from our own point of view, are contradictory. When he approves of certain Gothic buildings while disapproving of Gothic architecture in general, he is no more inconsistent than when he declares of many earlier painters or sculptors that their works – although 'we moderns cannot call them beautiful any longer' – were 'remarkable for their time' and had contributed this or that to the revival of the arts.[87] The point is that his estimates, when they do not refer to the great productions of his own age, are relative and absolute at the same time; and where he exceptionally acknowledges an earlier work, to wit, the dome and lantern of Florence Cathedral, as 'unsurpassed', he is careful to stress that he is dealing with a special case: 'we must, however, not deduce the excellence of the whole from the goodness and perfection of one single detail.'[88] Only from our point of view, but not from that of the sixteenth century, is it a contradiction when the same author who in one passage praises Arnolfo di Cambio's model of the Cathedral as something which (according to the standard of the period) cannot 'be praised too highly', elsewhere accuses the same Arnolfo, as well as his younger contemporary, Giotto, of all that confusion of style and corruption of proportion in which (according to the *perfetta regola dell'arte*) the nature of the Gothic consists. This confusion and corruption could be dispelled only after the 'gran Filippo Brunelleschi' had rediscovered the classical measurements and orders.[89] And even Brunelleschi cannot,

87. See, for example, the passage on Cimabue's draughtsmanship (quoted p. 211) or the passages on the improvement of architecture by Arnolfo di Cambio (quoted in Notes 25 and 27, pp. 261 and 262).

88. Quoted in Note 90, p. 249.

89. *Vasari*, II, 103: 'Perchè prima con lo studio e con la diligenza del gran Filippo Brunelleschi l'architettura ritrovò le misure e le proporzioni degli antichi, cosi nelle colonne tonde, come ne' pilastri quadri e nelle cantonate rustiche e pulite, e allora si distinse ordine per ordine, e fecesi vedere la differenza che era tra loro' ('Wherefore, with the study and the diligence of the great Filippo Brunelleschi, architecture first recovered the measures and proportions of the ancients, in the round columns and the square piers as well as in the corner facings both rusticated and smooth; and then one order was distin-

according to Vasari, claim the quality of *perfezione*, since art has risen to a still higher degree of excellence after him.[90]

Vasari – and this is the most important point – acknowledged this peculiar kind of relativity himself. In the Preface to the Second Part, for example, we read:

guished from another, and the difference between them became evident'). In his own *Life* (*Vasari*, II, p. 328) he states that before his time architecture had completely gone astray and that the people had spent much money unwisely, 'facendo fabbriche senza ordine, con mal modo, contriste disegno, con stranissime invenzioni, con disgraziatissima grazia, e con peggior ornamento' ('making buildings without order, with bad method, with sorry design, with most strange inventions, with most ungraceful grace, and with even worse ornament'). Later on, praising Brunelleschi once more for his rediscovery of the antique orders, Vasari adds that Brunelleschi's achievement was all the greater because 'ne' tempi suoi era la maniera Tedesca in venerazione per tutta Italia e dagli artefici vecchi exercitata' ('in his times the German manner was held in veneration throughout all Italy and practiced by the old craftsmen'). In the first edition of the *Lives*, the list of such abominations still includes Florence Cathedral and Sta Croce (*Vasari*, II, p. 383); in the second edition, these buildings were transferred to the newly inserted *Life of Arnolfo di Cambio* (cf. below, p. 261) and, therefore, stricken from the black-list.

90. *Vasari*, II, p. 105: 'Nondimeno elle si possono sicuramente chiamar belle e buone. Non le chiamo già perfette, perchè veduto poi meglio in quest'arte, mi pare poter ragionevolmente affermare, che la mancava qualcosa. E sebbene e'v'è qualche parte miracolosa, e della quale ne' tempi nostri per ancora non si è fatto meglio, ne per avventura si fara in quei che verranno, come verbigrazia la lanterna della cupola di S. Maria del Fiore, e per grandezza essa cupola ...: pur si parla universalmente in genere, e non si debbe dalla perfezione e bont d'una cosa sola argumentare l'eccellenza del tutto.' ('None the less, they [the works of the Brunelleschi generation] can be safely called beautiful and good. I do not as yet call them perfect, because later there was seen something better in that art, and it appears to me that I can reasonably affirm that there was something wanting in them. And although there are in them some parts so miraculous that nothing better has been done in our times, nor will be, peradventure, in times to come, such as, for example, the lantern of the cupola of S. Maria del Fiore, and, in point of size, the cupola itself ...: yet we are speaking generically and universally, and we must not infer the excellence of the whole from the goodness and perfection of one single thing.')

Therefore those masters who lived at that time, and were put by me in the First Part of the book, deserve to be praised and to be held in the credit which their works deserve, if only one considers – as is also true of the works of the architects and painters of those times – that they had no help from the times before them, and had to find the way by themselves; and a beginning, however small, is ever worthy of no small praise.[91]

And, perhaps even more clearly:

Nor would I have anyone believe that I am so dull and so poor in judgement that I do not know that the works of Giotto, of Andrea Pisano, of Nino, and of all the others, whom I have put together in the First Part by reason of their similarity of manner, if compared with those of the men who laboured after them, do not deserve extraordinary or even mediocre praise; or that I did not see this when I praised them. But whosoever considers the character of those times, the dearth of craftsmen, and the difficulty of finding good assistance, will hold them not merely beautiful, as I have called them, but miraculous. . . .[92]

At the end of his own *Life*, finally, we find some sentences which, in view of the very place in which they occur, must be considered as a conclusive statement of conviction:

91. *Vasari*, II, p. 100: 'Laonde que' maestri che furono in questo tempo, e da me sono stati messi nella prima parte, meriteranno quella lode, e d'esser tenuti in quel conto che meritano le cose fatte da loro, purchè si consideri, come anche quelle degli architetti e de' pittori de que' tempi, che non ebbono innanzi ajuto ed ebbono a trovare la via da per loro; e il principio, ancora che piccolo, e degno sempre di lode non piccola.'

92. *Vasari*, II, p. 102: 'Ne voglio che alcuno creda che io sia si grosso, ne di si poco giudicio, che io non conosca, che le cose di Giotto e di Andrea Pisano e Nino e degli altri tutti che per la similitudine delle maniere ho messi insieme nella prima parte, se elle si compareranno a quelle di color, che dopo loro hanno operato, non merieranno lode straordinaria ne anche mediocre. Ne è che io non abbia cio veduto, quando io gli ho laudati. Ma chi considerarà la qualità di que' tempi, la carestia deglia artefici, la difficultà de' buoni ajuti, le terrà non belle, come ho detto io, ma miracolose.' Regarding the expression 'miracolose', cf., e.g., the passage quoted in Note 90, p. 249.

To those to whom it might appear that I have overpraised any craftsmen, whether old or modern, and who, comparing the old with those of the present age, might laugh at them, I know not what else to answer save that my intention has always been to praise not absolutely but, as the saying is, relatively (*non semplicemente ma, come s'usa dire, secondo chè*), having regard to place, time, and other similar circumstances; and in truth, although Giotto, for example, was much extolled in his day, I know not what would have been said of him, as of other old masters, if he had lived in the time of Buonarotti; whereas the men of this age, which is at the topmost height of perfection, would not be in the position that they are if those others had not first been such as they were before us.[93]

It took some time for this apologetic recognition to develop into the positive postulate of historical justice.[94] Yet

93. *Vasari*, VII, p. 726: 'A coloro, ai quali paresse che io avessi alcuni o vecchi o moderni troppo lodato e che, facendo comparazione da essi vecchi a quelli di questa età, se ne ridessero, non so che altro mi rispondere; se non che intendo avere sempre lodato, non semplicemente, ma, come s'usa dire, secondo chè, e avuto rispetto ai luoghi, tempi ed altre somiglianti circostanze. E nel vero, come che Giotto fusse, poniamo caso, ne' suoi tempi lodatissimo: non so quello, che di lui e d'altri antichi si fusse detto, se fussi stato al tempo del Buonarroto – oltre che gli uomini di questo secolo, il quale è nel colmo della perfezione, non sarebbono nel grado che sono, se quelli non fussero prima stati tali e quel, che furono, innanzi a noi' (quoted in L. Venturi, op. cit., p. 118).

94. The postulate of historical justice is explicitly formulated in Giovanni Cinelli's Introduction to Francesco Bocchi's *Le Bellezze della Città di Firenze*, Florence, 1677, p. 4: 'Onde per il fine stesso della Legge, cioè di dare "*ius suum unicuique*", siccome non istimerò bene le cose ordinarie doversi in estremo lodare, cosi io non potrò anche sentir biasimare il disegno di Cimabue benchè lontano dal vero, ma devesi egli molto nondimeno commendare per esser stato il rinuovatore della pittura' ('Thus, in view of the very *raison d'être* of the law, to give *ius suum unicuique*, I do not think it right to bestow extreme praise upon ordinary things; but by the same token I cannot listen to people who criticize the design of Cimabue although it is far from correct; one must, nevertheless, commend him very much for having been the reformer of painting'). That this demand for justice was focused on

Vasari's clear differentiation between 'beautiful' and 'miraculous', and his insistent plea for the historical *secondo chè* – the term, needless to say, is borrowed from the scholastic distinction between *simpliciter* or *per se* and *secundum quid*, the 'statement in the absolute' and the 'statement in relation to something' – enable us to see that his Gothic frame is somewhat less paradoxical than it seemed at first sight. To understand it completely, however, we must go a little farther. It is, after all, a considerable step from the reluctant acceptance of Gothic antiquities to the spontaneous production of a work in the Gothic manner, and even the principle of *conformità* is not sufficient to explain our little monument.

In constructing the Milan *Tiburio* the artists were confronted with the problem of preserving stylistic unity while adding a new tower to a given nave, that is to say, of harmonizing two elements, one old, the other new, but homogeneous as to medium. Vasari posed to himself the problem of producing stylistic unity by adding a new frame to a given drawing, that is to say, of harmonizing two elements, one old, the other new, but heterogeneous as to medium. In the case of the *Tiburio*, the problem was, as we learn from the sources, exclusively a matter of formal correspondence; the style of the new *Tiburio* was intended to be as 'Gothic' as that of the old nave. Cimabue's art, however, was, according to Vasari himself, not Gothic but 'Byzantine' ('although he [Cimabue] imitated these Greeks, he added much perfection to the art'[95]); and that Vasari was not primarily concerned with stylistic *conformità* is evident from the very fact that he did not shrink from decorating the arch of his medievalizing portal with one of his own woodcuts, set in a cartouche as modern as he could make it.

the person of Cimabue was, of course, dictated by the same considerations which prompted Vasari to design a 'historical' frame for what he believed to be a Cimabue drawing.

95. *Frey*, p. 392: '... se bene imitò quei greci, aggiunse molta perfezione all'arte. ...'

The idea that a drawing by Cimabue belongs in a medieval frame is, therefore, fundamentally different from the idea that a Gothic church should receive a Gothic tower; it does not imply the postulate of optical uniformity within a given work of art but the postulate of spiritual uniformity within a given period – a uniformity which transcends not only the diversity of the media (figural representation and architectural decoration) but also the diversity of styles ('Gothic' and 'Byzantine'). This postulate – historical rather than aesthetic – was in fact the ruling principle of Vasari's *Lives*, where architecture, sculpture and painting are shown to develop *pari passu* and, for the first time, reduced to a common denominator. It was Vasari who first[96] asserted that these arts were daughters of one father, the 'art of design', *commune padre delle tre arti nostre, architettura, scultura et pittura*,[97] whereby he not only invested the notion of 'design' with an ontological halo (to which his successors, such as Federico Zuccari and the spokesmen of many academies, were to add a metaphysical one)[98] but also established what we are apt to take for granted: the inner unity of what we call the visual arts or, even more concisely, the Fine Arts.

Vasari accepts, of course, a certain hierarchy within this triad. For him, as for most of his forerunners and contemporaries, the non-imitative art of architecture takes preced-

96. The idea that sculpture and painting, in spite of these differences, are 'sister arts' and should try to compose their family quarrel goes as far back as Alberti and was championed by Benedetto Varchi (the addressee of the letter quoted in Note 99, p. 254) as well as by Vasari himself. But no one before Vasari had stressed – and, to an extent, accounted for – the inherent unity of the three 'visual arts' or treated them in one book.

97. *Frey*, p. 103 ff. The whole passage on *disegno* (*Frey*, pp. 103–7) is not as yet included in the first edition of 1550 and was inserted (according to Frey at the instigation and with the assistance of Vincenzo Borghini) into the Introduction to the second edition of 1568. However, Vasari characterizes design as the 'father' of the three arts as early as 1546 (Letter to Benedetto Varchi, quoted in Note 99, p. 254).

98. Cf. E. Panofsky, *Idea* (Studien der Bibliothek Warburg, V), Leipzig and Berlin, 1924, pp. 47 ff., 104.

ence over the representational arts; and as a painter he felt obliged to decide the old dispute between sculpture and painting in favour of the latter.[99] But he never wavered in his conviction that all the Fine Arts are based on the same creative principle and, therefore, subject to a parallel development. True to the spirit of his Introduction – where architecture, sculpture and painting are, for the first time, treated in one dissertation – he constantly speaks of them as *queste tre arti*, devotes equal attention to their respective representatives, and never tires of stressing the uniformity of their historical fate. Vasari's 'Gothic' frame would become completely comprehensible if we were able to show that the figural style of a Cimabue drawing and the architectural style affected by its frame occupy the same *locus* within Vasari's conception of history.

As is well known, this conception of history is based upon a theory of evolution according to which the historical 'progress' of art and culture passes through three predetermined – and, therefore, typical[1] – phases (*età*): a first, primitive stage in which the three arts are in their infancy[2]

99. G. Bottari and S. Ticozzi, *Raccolta di lettere sulla pittura, scultura ed architettura*, Milan, 1822–5, p. 53 (architecture superior to painting and sculpture), and p. 57: 'E perchè il disegno è padre di ognuna di queste arti ed essendo il dipingere e disegnare più nostro che loro'; German translation in E. Guhl, *Künstlerbriefe*, 2nd ed., Berlin, 1880, I, p. 289 ff.

1. *Vasari*, II, p. 96: '. . . giudico che sia una proprietà ed una particolare natura di queste Arti, le quali da uno umile principio vadano a poco a poco migliorando, e finalmente pervengano al colmo della perfezione. E questo me lo fa credere il vedere essere intervenuto quasi questo medesimo in altra facultà; che per essere fra tutte le Arti liberali un certo chè di parentado, è non piccolo argumente che e'sia vero' ('. . . I judge that it is the peculiar and particular nature of these arts to go on improving little by little from a humble beginning, and finally to arrive at the height of perfection; and of this I am persuaded by seeing that almost the same thing came to pass in other faculties, which is no small argument in favour of its truth, seeing that there is a kind of kinship between all the liberal arts').

2. *Vasari*, II, p. 103: 'Ora poi che noi abbiamo levate da balia, per un modo di dir così fatto, queste tre Arti, e cavatele dalla fanciullezza, ne viene la seconda età, dove si vedrà infinitamente migliorata ogni

and exist, as it were, only as a 'rough sketch' (*abozzo*);[3] a second, transitional stage, comparable to adolescence, in which considerable advances have been made, but which cannot as yet attain to absolute perfection;[4] and, finally, a stage of full maturity in which art 'has climbed so high that one is inclined to fear a recession rather than to hope for further advancement'.[5]

It had been a favourite idea of the classical historiographers – an idea, by the way, which survived throughout the Middle Ages in numerous variations – that the evolution of a state or nation corresponds to the ages of man.[6] In order

cosa' ('And now that we have weaned these three arts, to use such a fashion of speaking, and brought them up beyond the state of infancy, there comes their second age, wherein there will be seen infinite improvements in everything').

3. *Vasari*, II, p. 102.

4. *Vasari*, II, p. 95.

5. *Vasari*, II, p. 96.

6. Cf. Schlosser, *Kunstliteratur*, p. 277 ff. A systematic investigation of the various forms in which the historical periods were compared with the ages of man is all the more necessary as the dissertation of J. A. Kleinsorge, *Beiträge zur Geschichte der Lehre vom Parallelismus der Individual-und Gesamtentwicklung*, Jena, 1900, is fairly inadequate. The classical historians apply this comparison (already taken for granted by Critolaus) to the Roman state; the Christian authors (in so far as they speak for themselves instead of, like Lactantius, referring to the Roman writers with polemical intent), apply it to the world as a whole, to 'Christianity' (thus, for example, the Saxon 'World Chronicle', *Mon. Ger. Dtsch. Chroniken*, II, p. 115) or to the Church. Thus, Opicinus de Canistris [see now R. Salomon, *Opicinus de Canistris, Weltbild und Bekenntnisse eines Avignonesischen Klerikers des 14. Jahrhunderts*, London, 1936, pp. 185 ff., 221 ff.] maintains that two hundred popes had ruled from St Peter to the first Jubilee Year, the first fifty constituting the *pueritia* of the Church; the second fifty, the *iuventus*; the third fifty, the *senectus*; and the last fifty, the *senium*. The division of the human life into quarters, generally preferred because of its correspondence with the seasons of the year, the elements, and the humours (see F. Boll, 'Die Lebensalter', *Jahrbücher für das klassische Altertum*, XVI, 1913, p. 89 ff.), can be carried out only by either subdividing middle age into *adolescentia* and *maturitas* or *iuventus*, or else by subdividing old age into *senectus* and *senium*.

to arrive at his system of periodization, Vasari had only to replace the concept of the state or nation by the concept of intellectual and, particularly, artistic culture: and even in this respect the Roman historians offered a starting point.[7] We can actually name the author to whom Vasari seems to be most deeply indebted: L. Annaeus Florus, whose *Epitome rerum Romanarum* was published in an Italian translation in 1546. Florus periodizes Roman history in the following way:

If one were to consider the Roman people as something like a human being and to survey their entire lifetime, how they began, how they grew up, how they attained, as it were, to the flower of maturity, and how they subsequently, in a manner of speaking, grew old, one may discover therein four stages or phases. Their first age was under the kings, lasting about two hundred and fifty years, when they fought with their neighbours about their own mother; this would be their childhood. The next age extends, for another two hundred and fifty years, from the Consulate of Brutus and Collatinus to that of Appius Claudius and Quintus Flavius, during which they conquered Italy; this was the period most intensely alive with men and arms, wherefore it may be called their adolescence. Then follow the two hundred years up to Augustus during which they subjected the whole world; this is the youth of the Empire and, as it were, its vigorous maturity. From Augustus up to our own day a little less than two hundred years have passed. During this time [the Roman people] aged and boiled away, so to speak, because of the Emperors' lack of energy – unless they put forth their strength under the leadership of Trajan, so that the old age of the Empire, against all hopes, revives as though it had regained its youth.[8]

7. Velleius Paterculus, for example, observes at the conclusion of the first part of his *Historia Romana* (I, 17), where he comments about the brevity of every state of efflorescence: 'Hoc idem evenisse grammaticis, plastis, pictoribus, sculptoribus quisquis temporum institerit notis, reperiet, eminentiam cuiusque operis artissimis temporum claustris circundatam' ('Whoever pays attention to the distinctive features of periods will find that the same is true of philologists, sculptors, painters and carvers, that is to say, that in every kind of endeavour great achievement is confined to extremely narrow limits of time').

8. *Epitome rerum Romanarum*, Preface; cf. Schlosser, *Kunstliteratur*, p. 277: 'Siquis ergo populum Romanum quasi hominem consideret

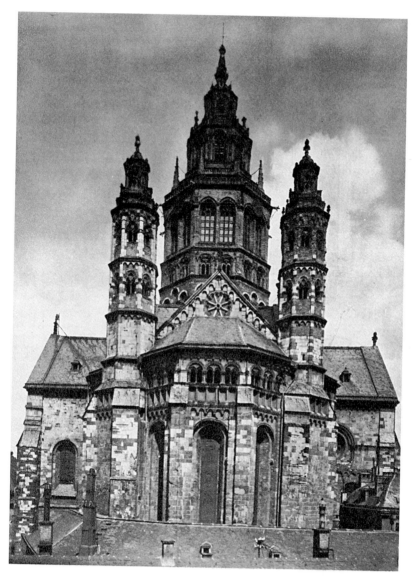

49. Mainz Cathedral seen from the west.

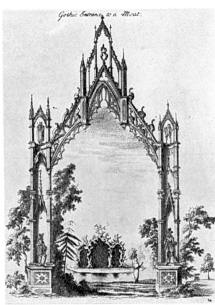

Gothic Entrance to a Moat.

50. Paul Decker,
Entrance to a Moat. From
Gothic Architecture,
London, 1759.

51. *The Hellespontine
Sibyl* (Florentine
engraving). Fifteenth
century.

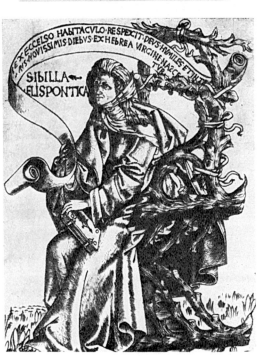

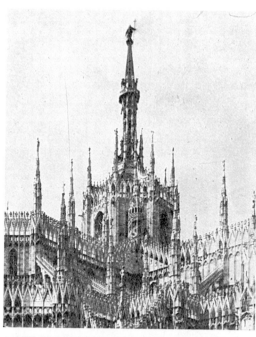

52. Milan Cathedral, Crossing Tower.

53. Copy of Brunelleschi's model of the lantern of Florence Cathedral. Florence, Museo di S.M. del Fiore.

54. Francesco Terribilia, project for the façade of San
Petronio. Bologna, Museo di S. Petronio.

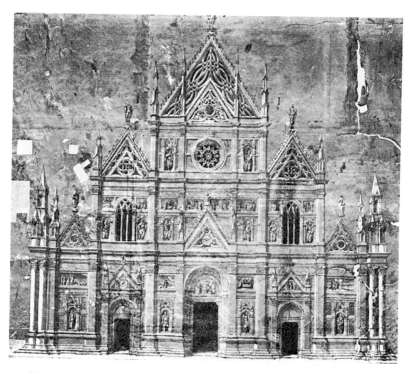

55. Giacomo Barozzi da Vignola, project for the façade of
San Petronio. Bologna, Museo di S. Petronio.

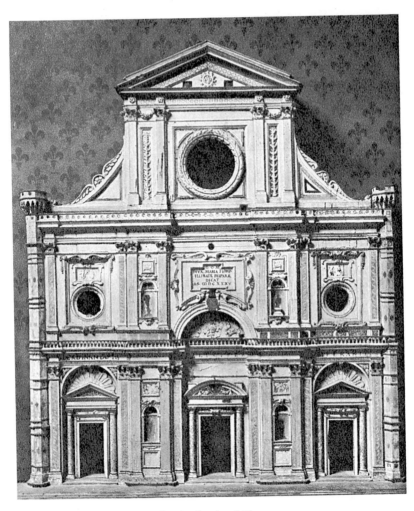

56. Gherardo Silvani, model for the façade of Florence
Cathedral. Florence, Museo di S.M. del Fiore.

57. Sebastiano Serlio, *Tragic Scene*. Woodcut from *Libro
primo . . . d'architettura*, Venice, 1551.

58. Sebastiano Serlio, *Comic Scene*. Woodcut from *Libro
primo . . . d'architettura*, Venice, 1551.

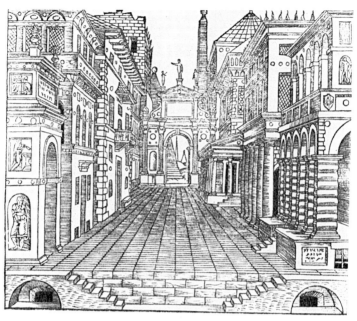

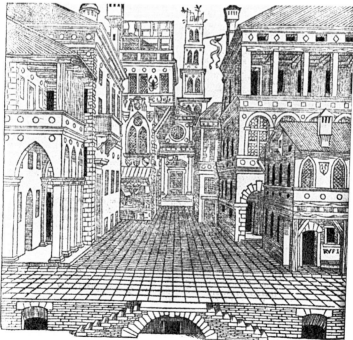

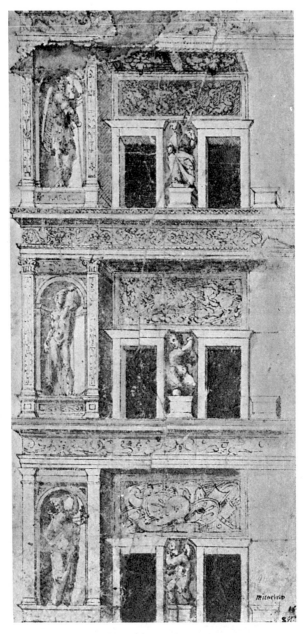

59. Domenico Beccafumi, project for the remodelling of the 'Casa dei Borghesi'. London, British Museum.

50. 'Casa dei Borghesi', Siena.

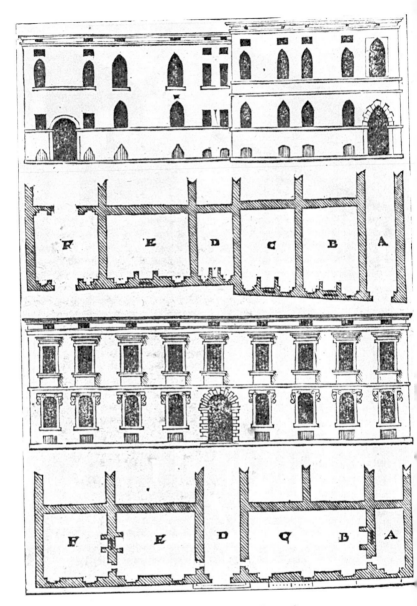

61. Sebastiano Serlio, suggestion for the remodelling of
Gothic palaces. Woodcut from *Tutte l'opere d'architettura*,
Venice, 1619.

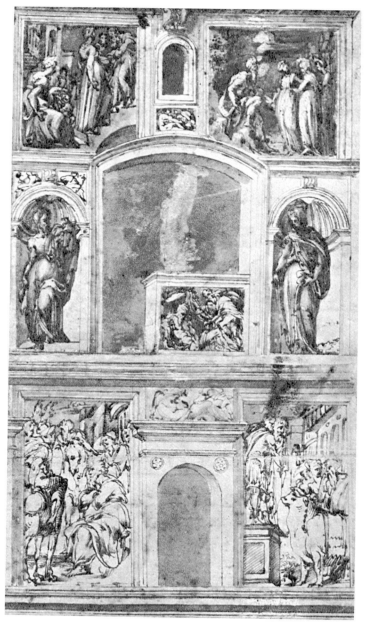

62. Domenico Beccafumi, project for the decoration of a
façade. Windsor, Royal Library.

63. The Casino of Pius IV, Rome.

64. The Uffizi, Florence.

65. Albrecht Dürer, *Rape of Europa and other Sketches* (drawing). Vienna, Albertina.

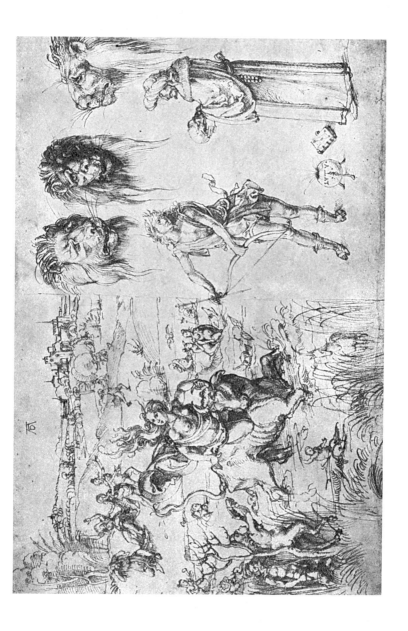

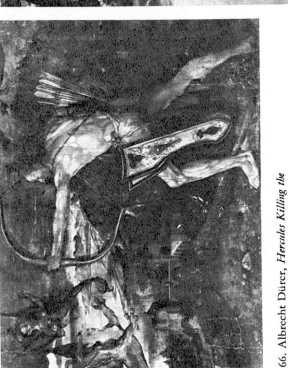

66. Albrecht Dürer, *Hercules Killing the Stymphalian Birds*. Munich, Alte Pinakothek. Dated 1500.

67. Antonio Pollaiuolo, *Hercules Killing Nessus* (detail). Courtesy of the Yale University Art Gallery.

68. Albrecht Dürer, *Rape of the Sabine Women* (drawing). Bayonne, Musée Bonnat. Dated 1495.

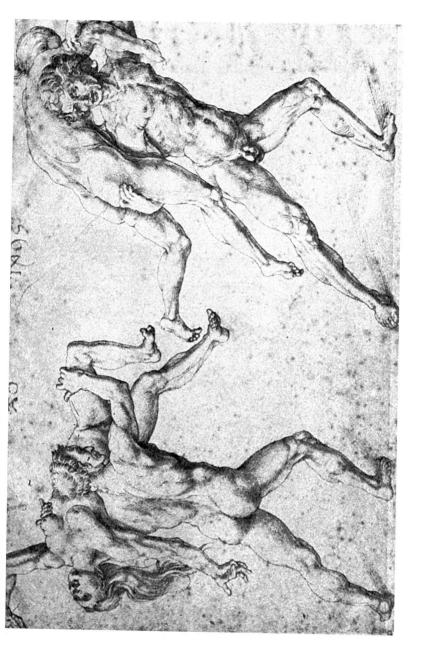

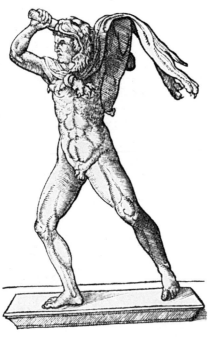

69. *Hercules.* Woodcut
from Petrus Apianus,
*Inscriptiones
sacrosanctae vetustatis,*
Ingolstadt, 1534.

70. *Hercules.* Woodcut
from Petrus Apianus,
*Inscriptiones sacrosanctae
vetustatis,* 1534.

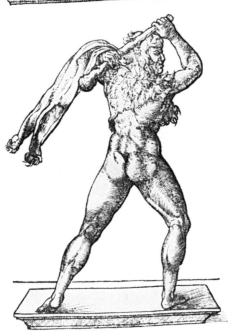

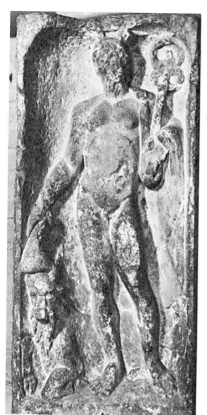 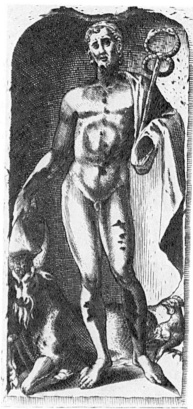

71. *Roman Mercury*. Augsburg, Maximilian-Museum.

72. *Roman Mercury*. Engraving after Plate 71, from M. Welser, *Rerum Augustanarum libri VIII*, Augsburg, 1594.

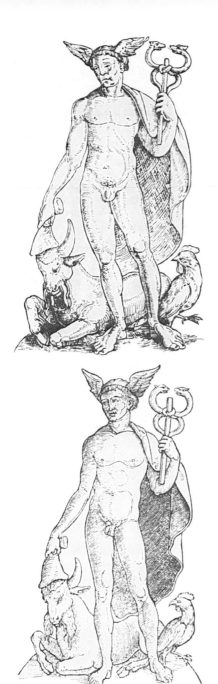

73. *Roman Mercury.*
Woodcut after Plate 71,
from Conrad Peutinger,
Inscriptiones . . .,
Mayence, 1520.

74. *Roman Mercury.*
Woodcut after Plate 71,
from Petrus Apianus,
*Inscriptiones sacrosanctae
vetustatis*, Ingolstadt,
1534.

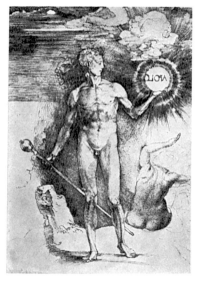

75. Albrecht Dürer,
Aesculapius or
Apollo Medicus
(drawing). Berlin,
Kupferstichkabinett.

76. Albrecht Dürer,
Sol-Apollo and Diana
(drawing). London,
British Museum.

77. *The Apollo Belvedere.*
Drawing in *Codex
Escurialensis.*

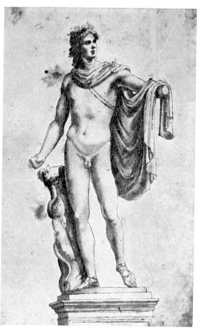

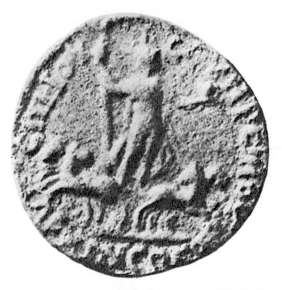

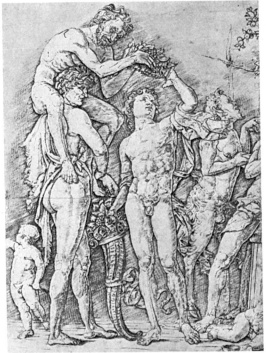

78. *Helios Pantokrator.*
Coin of Aizenis in
Phrygia.

79. Andrea Mantegna,
Bacchanal with the Vat
(detail of engraving).

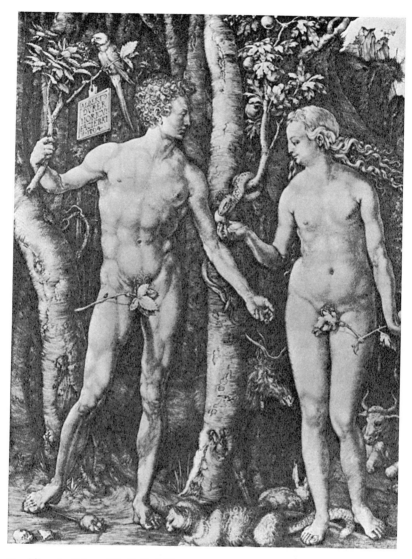

80. Albrecht Dürer, *The Fall of Man* (engraving). Dated 1504.

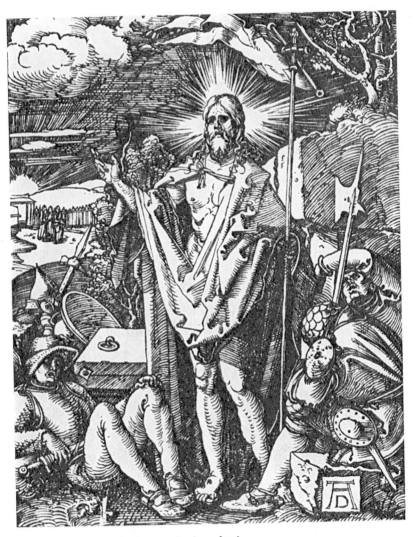

81. Albrecht Dürer, *The Resurrection* (woodcut).

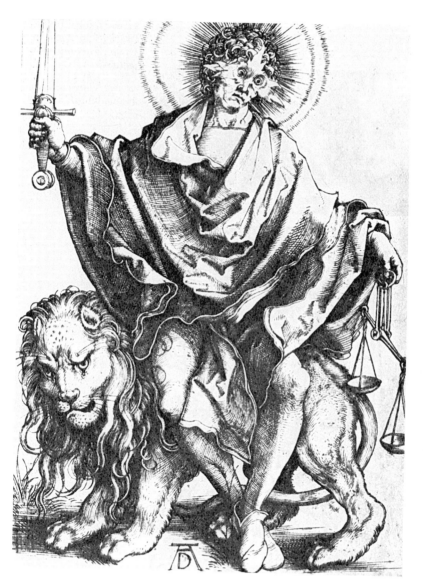

82. Albrecht Dürer, *Sol Iustitiae* (engraving).

83. *Sol.* Capital from the Palace of the Doges in Venice. Early fifteenth century.

84. *Sol.* Woodcut from the Frankfurt Calendar of 1547.

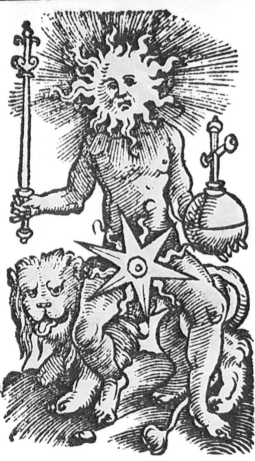

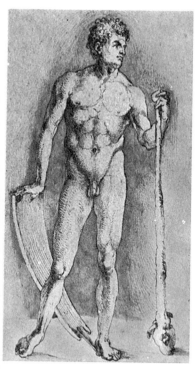

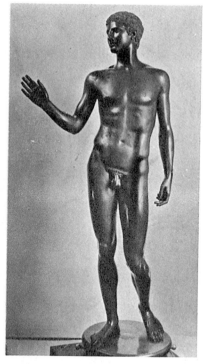

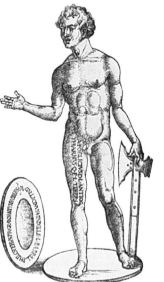

85. Albrecht Dürer,
Nude Warrior (drawing).
Bayonne, Musée Bonnat.

86. *Athlete from the
Helenenberg.* Vienna,
Kunsthistorisches
Museum.

87. *Athlete from the
Helenberg.* Woodcut after
Plate 86, from Petrus
Apianus, *Inscriptiones
sacrosanctae vetustatis.*

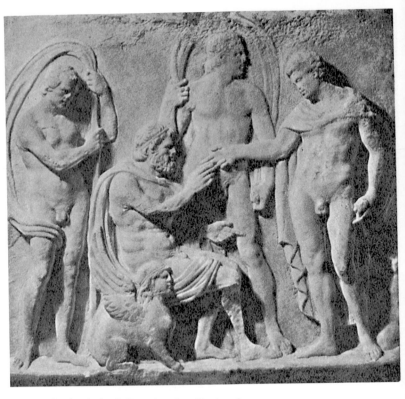

88. Pseudo-classical relief produced at Venice about 1525–30.
Vienna, Kunsthistorisches Museum.

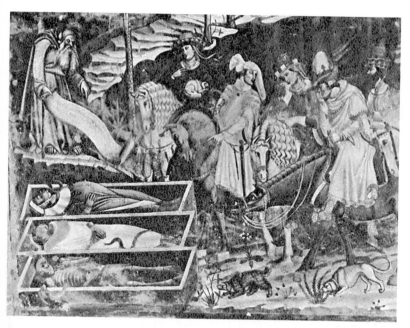

89. Francesco Traini, *The Legend of the Three Quick and the Three Dead* (detail of mural). Pisa, Camposanto.

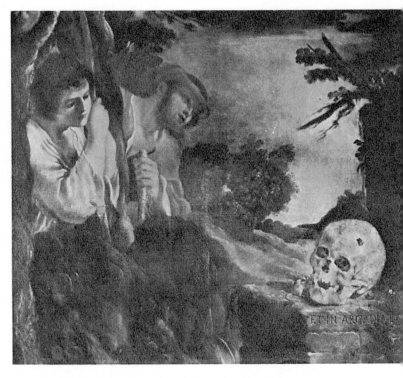

90. Giovanni Francesco Guercino, '*Et in Arcadia ego*'. Rome,
Galleria Corsini.

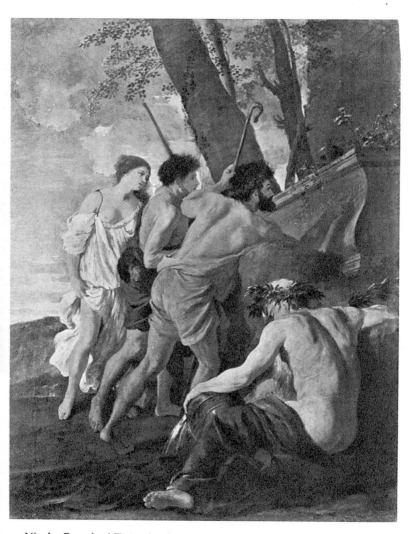

91. Nicolas Poussin, '*Et in Arcadia ego*'. Chatsworth, Devon-
shire Collection. Reproduced by permission of the trustees of
the Chatsworth Settlement.

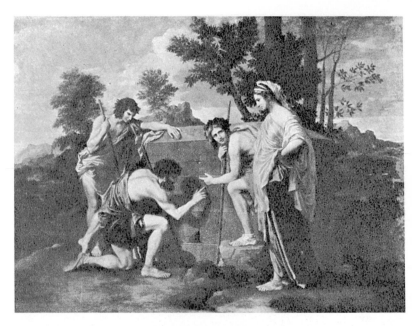

92. Nicolas Poussin, '*Et in Arcadia ego*'. Paris, Louvre.

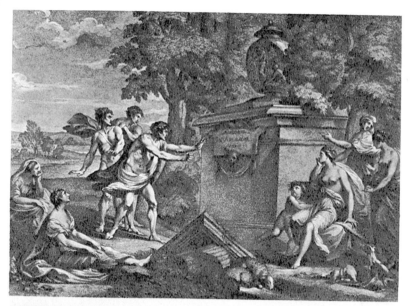

93. Giovanni Battista Cipriani, '*Death even in Arcady*'
(engraving).

94. Georg Wilhelm Kolbe, '*I too, was in Arcady*' (engraving).

95. Honoré Fragonard, *The Tomb* (drawing). Vienna, Albertina.

However, when comparing Vasari's views with those of
Florus (and other Roman historians from Sallustius down
to Lactantius),[9] we are struck by one crucial difference.
Where Florus and Sallustius very logically permit the *ro-
busta maturitas* of manhood to pass over into the decrepitude
of old age, and where Lactantius even sees this old age fol-
lowed by second childhood and, finally, death, Vasari carries
the parallel between the historical process and the ages of
man only to the 'perfection' of maturity: of Florus' four
stages of life (*infantia, adolescentia, maturitas, senectus*), he
recognizes only the three ascending ones.

Such an evasion of the bitter consequences of the com-
parison with the ages of man can also be observed in other
writers: but, where it occurs, it can always be accounted for
by special motives. When, for example, Tertullian and St
Augustine refrain from extending the biological parallel be-
yond the stage of maturity, Tertullian does so because he
considers the 'Paracletan' period as everlasting perfection;
and St Augustine, because he cannot admit that the de-

totamque eius aetatem percenseat, ut coeperit, utque adoleverit, ut
quasi ad quendam iuventae florem pervenerit, ut postea velut con-
senuerit, quattuor gradus processusque eius inveniet. Prima aetas sub
regibus fuit, prope ducentos quinquaginta per annos, quibus circum
ipsam matrem suam cum finitimis luctatus est. Haec erit eius infantia.
Sequens a Bruto Collatinoque consulibus in Appium Claudium Quin-
tum Flavium consules ducentos quinquaginta annos patet: quibus
Italiam subegit. Hoc fuit tempus viris armisque incitatissimum: ideo
quis adolescentiam dixerit. Dehinc ad Caesarem Augustum ducenti
anni, quibus totum orbem pacavit. Haec iam ipsa iuventa imperii et
quaedam quasi robusta maturitas. A Caesare Augusto in saeculum
nostrum haud multo minus anni ducenti: quibus inertia Caesarum
quasi consenuit atque decoxit, nisi quod sub Traiano principe movet
lacertos et praeter spem omnium senectus imperii, quasi reddita
iuventute, revirescit.'

9. *Div. Inst.*, VII, 15, 14 ff. (*Corp. Script. Eccles. Lat.*, IX, 1890, p.
633). Lactantius refers for his periodization to Seneca (to whom
Florus may also be indebted); but there is no doubt that he is most
strongly influenced by Sallustius, according to whom the decline of
the Roman Empire dates from the final subjugation of Carthage. This

velopment of the City of God can ever lead to old age or even death.[10]

On what grounds, then, did Vasari deny – or, at least, ignore – a decline demanded by nature? The answer is that his historical thinking, too, was bound to a dogma, though not to a theological one. It was bound to the humanist's unshakeable conviction that classical civilization had been destroyed by physical violence and bigoted suppression but, nearly a thousand years later, had been 'reborn' in the spontaneous revival of the *età moderna*. For Vasari and his contemporaries it was clearly impossible to reconcile this conviction with the notion of natural ageing and dying – just as it was impossible for them to admit the idea of a cyclical alternation between great periods of rise and fall (an idea that was to dawn in almost visionary fashion, in the mind of Giordano Bruno,[11] and was to crystallize into a formulated theory in Giovambattista Vico's famous doctrine of *corsi* and *ricorsi*[12]). Had classical civilization in general and classical art in particular met their end not by catastrophe but by their own old age, it would have been as absurd

theory evidently accounts for the fact that Lactantius, while placing – with Seneca – the 'beginning of maturity' at the end of the Punic Wars, yet claims that the *prima senectus* took its inception from this same event. He is, of course, not interested in the question of periodization as such; he is concerned only with proving that the pagan historians themselves had recognized the inevitable decline of the Roman Empire. Cf. the fine article by F. Klingner, 'Ueber die Einleitung der Historien Sallusts', *Hermes*, LXIII, 1928, p. 165 ff.

10. Cf. Kleinsorge, op. cit., pp. 5, 9.

11. It is characteristic of Bruno that his conception of a cyclical movement in history – far from claiming the status of an objective, 'historical law' – remains within a mythical and intensely emotional sphere. Deeply rooted in his personal pessimism, it is linked to dark Egyptian symbols (*Eroici Furori*, II, 1, cf. above, p. 161 f.) and gloomy 'hermetic' prophecies (ibid., II, 3, and *Spaccio della Bestia trionfante* [*Opere italiane*, G. Gentile, ed.], III, p. 180 ff.).

12. Cf., in particular, B. Croce, *La Filosofia di Giovambattista Vico*, Bari, 1911, p. 123 ff. (English translation by F. G. Collingwood, New York, 1913, Ch. 11) and M. Longo, *G. B. Vico*, Turin, 1921, p. 169 ff.

to bewail their destruction as to exult in their resurrection.

Thus we witness the remarkable spectacle that the theological dogma of the Church Fathers and the humanistic dogma of the Renaissance historiographers led to analogous results; in both cases the comparison of historical periods with the ages of man could be maintained only under the condition that the parallelism stop at the stage of maturity. Thereby Vasari could subordinate the idea of biological growth and decay to the idea of a spiritual 'progress' which can be furthered by external factors (for instance, by the natural surroundings, or by the rediscovery of Roman antiquities)[13] but is essentially contingent upon the 'nature of the arts' themselves.[14] This optimism, no longer founded on religion, has, however, something disquietingly brittle about it. As we can learn from Vasari's remark, quoted above, to the effect that the development had reached a point at which 'one fears a recession rather than hopes for further advancement', Vasari had a tragic premonition of impending decline. And behind his famous panegyric on Michelangelo – where he says that Michelangelo's paintings, if it were possible to compare them with the most famous Greek or Roman ones, would prove no less superior to them than were his sculptures[15] – there lurks the question: what, after the achievement of this *divino*, can be expected of other, lesser artists? It may not have been unwelcome to Vasari – the typical representative of a period which, though outwardly self-confident, was deeply insecure and often close to despair – that he was not compelled to answer this question. He who shifts the responsibility for the decline of classical civilization to migrations and iconoclasm is spared the necessity of diagnosing the disease of his own age as a congenital one.

Whatever his motives, in reducing the four stages of growth and decay to an ascending movement in three stages, Vasari was able to incorporate the idea of a quasi-biological

13. Schlosser, *Kunstliteratur*, p. 283.
14. Quoted in Note 1, p. 254. 15. *Vasari*, IV, p. 13 ff.

development, presumably valid for all historical processes, into that theory of catastrophe which explained one specific event – viz., the cultural decline of the 'dark ages' – by the destructiveness of barbarian tribes and the Christian antagonism to pictures. According to this compromise formula, the ascent in three 'stages' (*età*) has taken place twice in the history of European art: first, in classical antiquity; second, at the beginning of the Trecento, in the 'modern' era. In antiquity (where no names of architects were at Vasari's disposal) the first *età* is represented only by the sculptors Canachus and Calamis and the 'monochromatic' painters; the second, by the sculptor Myron and the 'four-colour painters' Zeuxis, Polygnotus and Timanthes: the third, finally, by Polyclitus, 'the other sculptors of the golden age', and the greater painter Apelles.[16] In modern times, however, where every medium could be exemplified by individual names, the first *età* begins with Cimabue, the Pisani, Giotto, and Arnolfo di Cambio;[17] the second, with Jacopo della Quercia, Donatello, Masaccio, and Brunelleschi; the third – distinguished by the appearance of the 'universal artist' who excels in all the three 'arts based on design' – is ushered in by Leonardo da Vinci, to reach its acme in Raphael and, above all, in Michelangelo.

This bold and beautiful structure, however, was not free from fissures marking precisely those places in which the theory of autonomous, natural growth and decay comes into conflict with the theory of external catastrophe. One of these fissures appears where Vasari concedes that the decline of classical art was contingent upon internal conditions obtaining even before the advent of the barbarians;[18] the other, where he realizes that the sudden reversal of the downward

16. The arrangement in Schlosser, *Kunstliteratur*, p. 283, is not entirely correct. According to Vasari, Polygnotus belongs to the second *età*.

17. Extremely noteworthy is the Introduction to the *Life of Niccolo and Giovanni Pisani* (*Frey*, p. 643; quoted in Benkard, op. cit., p. 68).

18. *Frey*, p. 170, line 23 ff.

trend, the post-medieval *rinascimento*, can be accounted for only by the unexpected appearance of particular individuals called into being, as it were, by an act of God. It is at this second juncture that we are confronted with Giovanni Cimabue who 'by God's will was born in the year 1240, in order to give the first light to the art of painting'.[19] He, 'it is true, still copied the Greeks'; but 'he perfected the art in many respects, because in great measure he freed it from its rude manner.'[20] And while it was left to Giotto 'to throw open the doors of truth for later generations',[21] and to Masaccio and Paolo Uccello to be the final liberators and true 'leaders to the highest peak',[22] Cimabue still must be honoured as the 'first cause which set in motion the revival of painting' ('la prima cagione della rinouazione dell'arte della pittura').[23]

At this same juncture, now, there stands – as an architect – Arnolfo di Cambio. As Vasari says of Cimabue that his style while still belonging to the *maniera greca*, yet deserves praise because he represents 'a great improvement in many things', so does he say – in nearly identical words – of Arnolfo di Cambio that he, while still far off from Brunelleschi, the real slayer of the Gothic dragon,[24] 'nevertheless deserves to be celebrated in loving reminiscence because, in so dark an age, he showed the way to perfection to those who came after him.'[25] This means that, in Vasari's view, Arnolfo di Cambio

19. *Frey*, p. 389.　　20. *Frey*, p. 392, quoted p. 252.

21. *Frey*, p. 401 f.

22. *Vasari*, II, p. 287. Even here, it should be noted, Vasari sees the three arts as a unity: Brunelleschi, Donatello, Ghiberti, Paolo Ucello and Masaccio, 'eccellentissimi ciascuno nel genero suo', have freed art from its crude and childish style.

23. *Frey*, p. 402.　　24. See Note 89, p. 248.

25. *Frey*, p. 492: 'Di questo Arnolfo hauemo scritta con quella breuità che si è potuta maggiore, la vita: perchè se bene l'opere sue non s'appressano a gran prezzo alla perfezzione delle cose d'hoggi, egli merita nondimeno essere con amoreuole memoria celebrato, hauendo egli fra tante tenebre mostrato a quelli che sono stati dopo se la via di caminare alla perfezzione' ('Of this Arnolfo we have written the Life, with the greatest brevity that has been possible, for the reason that, although his works do not approach by a great measure the

and Cimabue, each of them 'the voice of one crying in the wilderness', mark the same point in the progress of their respective professions, and in one passage he formulates this parallel between the no-longer-wholly-Gothic Arnolfo[26] and the no-longer-wholly-Byzantine Cimabue in what amounts to a mathematical equation: 'Arnolfo,' he says, 'furthered the development of the art of architecture as much as Cimabue advanced that of painting.'[27] In the end, we find him condensing this historical parallelism into a direct master-pupil relationship,[28] even into an actual collaboration at Florence Cathedral.[29]

For Vasari, then, Arnolfo is a building Cimabue, and Cimabue a painting Arnolfo; and this provides the final answer to our question. If Vasari intended to set his 'Cimabue' drawing in a 'stylistically correct' frame (and that he was particularly anxious to do this with a 'Cimabue' drawing is understandable in view of his exceptional respect for this 'renewer of art'), then he had to devise an 'Arnolfo frame' rather than a Gothic frame pure and simple.

The architecture thus contrived by Vasari, needless to say, is marked by unintentional anachronisms. The pointed arch

perfection of things today, he deserves, none the less, to be celebrated with loving memory, having shown amid so great darkness, to those who lived after him, the way to walk to perfection').

26. It is characteristic that Vasari (perhaps in order to set Arnolfo's art slightly above the 'real' Gothic style) cites as contemporary or even earlier a whole series of monuments which in reality post-date Arnolfo's lifetime. In placing them before Arnolfo, Vasari feels free to say that they 'are neither in a beautiful nor in a good manner but only vast and magnificent'. The Certosa di Pavia, for example, was begun in 1396, Milan Cathedral in 1386, San Petronio at Bologna in 1390. See *Frey*, p. 466 ff.

27. *Frey*, p. 484: 'Il quale Arnolfo, della cui virtù non manco hebbe miglioramento l'architettura, che da Cimabue la pittura hauuto s'hausse. . . .' For this equation – which, as has been mentioned, was perfectly clarified only in the second edition of the *Lives* and was ultimately extended so as to include the Pisani as sculptors and Andrea Tafi as a mosaicist – see Benkard, op. cit., p. 67 ff.

28. *Frey*, p. 484, line 4 ff. 29. *Frey*, p. 397, line 34 ff.

of the 'portal' – a motif which he must have designed with the greatest reluctance – is deprived of its actual apex by the pasted-on woodcut. The pinnacles, despite their crockets and finials, have assumed a very un-medieval appearance, a pyramid being placed upon a Tuscan pilaster and connected therewith by means of a slightly curved impost block. Instead of Gothic colonnettes we have pilasters foiled by a wall strip. The stringcourse, finally, moulded in orthodox classical fashion and vigorously broken out above the capitals, gives the impression of a 'modern' architrave rather than of a medieval *moulure*: Vasari could not bring himself to extend the foliate ornament of the capitals beyond the capitals themselves, conceiving of a capital as something exclusively belonging to the support, and not as something jointly owned by the support and the adjacent stringcourse. However, setting aside these anachronisms, what remains of 'Gothic' in Vasari's simulated portal – which, framing as it does the first page of his *Libro*, may be interpreted as a triumphal entrance to the *Tempio del disegno Fiorentino* – is borrowed from those buildings which Vasari himself attributed to Arnolfo di Cambio: from the Cathedral, the *Badia Fiorentina*, the Church of Sta Croce.

Thus Vasari's inconspicuous 'Gothic' frame bears witness, at a relatively early date, to the rise of a new attitude toward the heritage of the Middle Ages: it illustrates the possibility of interpreting medieval works of art, regardless of medium and *maniera*, as specimens of a 'period style'. When Vasari extended his imitative efforts to the very inscription, he was obviously not attracted by Gothic script from an aesthetic point of view (as had been the case with Lorenzo Ghiberti when he inscribed the 'Cassa di San Zanobi' with *lettere antiche*[30]), but felt that even the form of letters expresses the character and spirit of a given phase of history. Uninfluenced by private predilections, entirely unrelated to the practical

30. *Lorenzo Ghibertis Denkwürdigkeiten*, ed. J. Schlosser, Berlin, 1912, I, p. 48: 'Euui dentro uno epitaphyo *intaglato di lettere antiche* in honore del sancto.'

problems of completion or remodelling and thus completely different from the Gothicizing projects for the façade of San Petronio or the *Tiburio* of Milan Cathedral, Vasari's frame marks the beginning of a strictly art-historical approach which (in contrast to the study of political, legal or liturgical documents) is focused on the visual remains, and proceeds, to borrow Kant's phrase, in 'disinterested' manner. Some hundred years later, this new approach, concerned exclusively with the preservation, classification and interpretation of evidence, was to result in the astonishingly accurate survey drawings made in preparation of the remodelling of St John in the Lateran.[31] It was to bear fruit in the work of the great historians of the eighteenth and nineteenth centuries. And it was, ultimately, to give direction to our own activities.

Italy has never transcended a purely historical evaluation of the Gothic style – apart, perhaps, from that one memorable moment when conscious historical appreciation merged with unconscious preference in such artists as Boromini and Guarino Guarini. A 'Neo-Gothic' movement, generated by emotional impulses and aspiring to the production of a style

31. See Cassirer, op. cit. We must agree with F. Hempel (*Francesco Boromini*, Vienna, 1924, p. 112) in ascribing the drawings for the tabernacle of St John in the Lateran (Cassirer, Figs. 2–4) to Felice della Greca. On the other hand, he goes too far in asserting that the big drawing of the nave wall with its murals (Cassirer, Fig. 8 and Plate) was nothing but the customary 'survey drawing'. Cassirer correctly points out that a reproduction of the early fifteenth-century frescoes – a reproduction so accurate that it permits us to date them within a limit of ten or fifteen years – would have been quite unnecessary for the purpose of remodelling the architecture and can be explained only by a genuine interest in the subject. And although this interest, in so far as it was conscious, may well have been a merely 'historical' one, there is no doubt that artists such as Boromini and Guarini experienced an unconscious sympathy for the Gothic style. The Spiral tower of S. Ivo, the ceilings of the Palazzo Falconieri, and the dome of S. Lorenzo in Turin are not Gothic from a morphological point of view but very Gothic in feeling. In masters such as these, 'historical' interest and 'artistic' appreciation – equally balanced, as it were – operated separately according to the occasion.

sui juris, or Carl Friedrich Schinkel's heroic attempt at a creative synthesis between the Gothic and the antique[32] – such things were possible only in the North, which looked upon the *maniera barbara ovvero tedesca* as its true artistic heritage and the better part of its spiritual nature. Here, particularly in England and in the Germanic countries, we find a genuine 'Gothic Revival' – a revival, however, which tried to recapture the past, not, as the Renaissance had done, in a spirit of confident hope, but in a spirit of Romantic yearning.

32. Cf. August Grisebach, *Carl Friedrich Schinkel*, Leipzig, 1924, p. 134 ff.

Excursus

Two Façade Designs by Domenico Beccafumi
and the Problem of Mannerism in Architecture

I

Immediately after his return from Rome, where he is sup-
posed to have stayed some two years, Domenico Beccafumi,
called Meccherino, decorated the façade of a 'Casa dei
Borghesi' in Siena while Sodoma was engaged in a similar
task on the Palazzo Bardi: 'Below the roof, in a frieze in
chiaroscuro,' says Vasari,

he executed some little figures that were much extolled; and in
the spaces between the three ranges of travertine windows that
adorn the palace, he painted many ancient gods and other figures
in imitation of bronze, in chiaroscuro and in colour, which were
above average, although the work of Sodoma was more extolled.
Both these façades were executed in the year 1512.[33]

This account, repeated by several local writers and gener-
ally accepted by students of Beccafumi,[34] is essentially con-
firmed, though modified somewhat in one particular, by a
document: while Sodoma did decorate the Palazzo Bardi
during the period in question, he undertook this commission

33. *Vasari*, V, p. 635: 'Sotto il tetto fece in un fregio di chiaroscuro
alcune figurine molte lodate e nei spazi fra tre ordini di fenestre di
trevertino, che ha questo palagio; fece e di color di bronzo di chiaro-
scuro e colorite molte figure di Dii antichi ed altri, che furoni più che
ragionevoli, sebbene fu più lodata quella del Sodoma. E l'une e l'altra
di queste facciate fu condotta nell'anno 1512.'

34. See L. Dami, 'Domenico Beccafumi', *Bollettino d'Arte*, XIII,
1919, p. 9 ff. [M. Gibellino-Krascenninicowa, *Il Beccafumi*, Siena,
1933].

(on condition that he execute it within eight months) no earlier than 9 November 1513.[35] Thus, if we accept the premise that the two palaces were decorated simultaneously and, as it were, in competition, Beccafumi's frescoes should also be dated in 1513–14 rather than in 1512.

Like nearly all paintings of this type and period, the decoration of the 'Casa dei Borghesi' is completely destroyed. But the building itself, identified by the Borghese coat-of-arms, is still in existence (Plate 60);[36] and this, in conjunction with Vasari's account, enables us to connect Beccafumi's decoration with a drawing, preserved in the British Museum, which bears an old inscription ('Micarino') and can be safely accepted as a work of his (Plate 59). This drawing shows, as was not unusual, only half of the proposed arrangement; but what it does show exactly corresponds to the extant structure: a fairly narrow four-storey building (the three storeys shown in the drawing must be supplemented by a ground floor containing the entrance or entrances), having only four windows on each floor and distinguished by the fact that these windows rise directly from the principal mouldings and are shorter than the wall surface above them. The general proportions agree with those of the actual structure as well as can be expected of a *pensiero* which, as a rule, was not drawn to scale: 'It is not the custom of architects,' writes Vignola, 'to draw a small design to scale to such a degree that it can be transferred from small to large by means of a module; one normally makes them only in order to show the invention.'[37]

We are justified in applying this remark to our Becca-

35. G. Milanesi, *Documenti per la Storia dell'arte senese*, III, p. 69.

36. I express my sincere thanks to Professor A. Warburg and Dr Gertrude Bing for their friendly assistance in identifying the Palazzo and obtaining a photograph thereof.

37. Gaye, op. cit., II, p. 359 (Letter of Vignola to the officials of San Petronio): 'Non e consuetudine d'architetti dar un picol disegno talmente in proportione, che s'habbia a riportare de piccolo in grande per vigor de una piccola misura, ma solamente si usa far li disegni per mostrar l'inventione.'

fumi drawing because it represents, not only a plan for the pictorial decoration of the façade, but also a project for its architectural remodelling. The Borghese palace was originally a Gothic building, and it was 'modernized' in the sixteenth century, apparently in direct connexion with Beccafumi's activity. Only then can it have received its tall cornice (which goes beyond the upper margin of the London drawing), and only then were its Gothic windows, the pointed arches of which are still clearly discernible, brought 'up-to-date' by being provided with rectangular frames and lintels, and, as demanded by Serlio for such modernizations,[38] by being placed on axis (Plate 61). Originally, there was, to use Serlio's expression, *qualchè disparità* in that the windows of the two upper storeys were placed considerably nearer to the corners than those of the lower floor.

Not in every respect, however, did the owner of the palace comply with Beccafumi's suggestions as embodied in the London drawing. Had the painter had his way, the stringcourses would have been strengthened; the clear width of the windows would not have been enlarged; and, above all, the windows of the two upper storeys would have been moved inward instead of those of the lower floor being moved outward. In short, he would have wished to obtain a maximum of paintable surface; whereas the owner, as owners will, preferred a maximum of interior illumination and a minimum of costs.[39]

In spite of these comparatively minor discrepancies, the

38. See above, p. 229. In discussing Serlio's proposals for modernization, Schlosser, *Kunstliteratur*, p. 364, would seem to overemphasize the special conditions in France. As we can learn from the Casa dei Borghesi, the problem of remodelling Gothic palaces was a real one also in Italy.

39. The London drawing gives no clue as to Beccafumi's ideas for the remodelling of the ground floor. But we may assume that he would have planned to replace the four arched entrances by a single portal in the centre. In Florence and Rome a fairly consistent development from a multi-portal to a one-portal scheme can be observed at the time (see, in Florence, the Palaces Pazzi-Quaratesi, Guadagni, Strozzi, and

London drawing gives us a clear enough picture of what Beccafumi planned to do, and we cannot but admire his skill in veiling the reality of a still medieval façade with the semblance of a modern *quadratura*.

First of all, he reduced the dead wall above the windows by introducing simulated cornices consisting of a fasciated architrave and a decorated frieze so that the horizontal divisions, originally rather meagre, appear to be transformed into powerful classical entablatures. The vertical wall strips between the windows and the corners are articulated so as to lend support to this entablature: pairs of pilasters, changing from Doric to Ionic and Corinthian, are made to support the architrave, and each of these pairs, framing a niche, forms an aedicula which houses one of the 'figure di Dii antichi ed altri' mentioned in Vasari's description[40] – figures in which the impression of Michelangelo's and Sansovino's sculptures merges with that of Raphael's painted niche-statues in the *School of Athens*.[41]

Thus, the dead wall is concealed by an illusionary system of entablatures and supporting members. And the effect of

Bartolini-Salimbeni as opposed to Pitti, Riccardi, Rucellai; in Rome, the Palazzo Giraud-Torlonia and the Palazzo Farnese as opposed to the Cancelleria). Serlio, p. 171, considers the central placement of the portal as idiomatic: 'et mettere la porta nel mezzo, come è dovere.'

40. The iconography of the London drawing is not clear but would seem to be inspired by Virgil's *Aeneid* since the statue of an armoured youth in the topmost niche is inscribed MARCELLVS and closely corresponds to the latter's description in *Aen.* VI, 861:

> *Egregium forma iuvenem et fulgentibus armis,*
> *Sed frons laeta parum et deiecto lumina voltu.*

41. The statue in the second storey may be described as a synthesis of Michelangelo's *David* and the Apollo in Raphael's *School of Athens*. The seated figure between the windows in the upper storey, which presupposes the Isaiah of the Sistine ceiling, brings to mind Beccafumi's enthroned St Paul of 1515; the *putti* – partly reminiscent of Michelangelo's infant-caryatids, partly of the Michelangelesque Christ child in Raphael's Madonna di Foligno – are stylistically akin to the *putti* in Beccafumi's early works (cf., in addition to the enthroned St Paul, the somewhat earlier *Stigmatization of St Catherine of Siena*).

this simulated architecture (its ornament reminiscent, again, of Sansovino's tombs in S. M. del Popolo) is intensified by a clever use of perspective: the pilaster-flanked aediculae and the entablatures, seen from below in a foreshortening successively sharpened according to the distance from the eye, seem to project beyond the 'real' wall; to put it the other way, the 'real' wall seems to recede behind the simulated architecture. We thus believe – or are supposed to believe – that we are looking into three stage-sets superimposed upon each other and framed, as it were, by the entablatures and aediculae. As a result the frames of the windows no longer seems to project from the 'real' wall surface but from an imaginary backdrop decorated with martial emblems and scenes of equestrian combat; and the beholder is inclined to attribute the unfortunate lack of window sills to the effect of a worm's-eye perspective which makes them disappear behind the seemingly protruding cornices.

II

The same Beccafumi who thus reorganized the façade of the 'Casa dei Borghesi' has left us another façade design which, produced some fifteen years later, reveals a totally different concept of architecture (Plate 62). This second drawing, preserved in Windsor Castle,[42] is a plan for decorating a very modest house of only two storeys, the deceptive impression of a three-storeyed building being created only by the fact that an injudicious hand has pasted together two unrelated sheets. What looks like a ground floor has nothing to do with the other two storeys, and what seems to be the second storey is actually the ground floor, containing a shop.[43] The counter of this shop is decorated with a representation of the Drunkenness of Noah – perhaps because the shop belonged

42. Windsor, Royal Library, No. 5439. I thank Professor H. Kauffmann for calling my attention to this drawing.

43. See, e.g., the analogous shops in the Palaces Raffaello-Bramante, Bresciano, and dell'Aquila (Th. Hofmann, *Raffael in seiner Bedeutung als Architekt*, Zittau, 1909–11, III, Plates III, XIV).

to a wine merchant; the lateral sections of the wall are fashioned into niches which shelter the statues of prophets. In the second storey, located directly under the roof and, like the upper storeys of many large palaces, illuminated only by a small round-arched window, we see, on the left, the Presentation of Christ (the steps possibly suggested by Dürer's woodcut B.20); and, on the right, an enigmatical scene which might be interpreted as the Appearance of the Three Angels to Abraham were the approaching figures not females (perhaps the Visit of the Queen of Sheba and Her Handmaidens?).

There is an enormous difference between this drawing and the project for the 'Casa dei Borghesi'. The painted façade proposed for the 'Casa dei Borghesi' – its rhythmical organization reflecting the impression of buildings such as the Cancelleria or the Palazzo Giraud-Torlonia – conforms to the ideals of the High Renaissance or, to use Wölfflin's expression, the 'Classic' – as opposed to 'classical' – style, that is to say, its composition is dominated by four principles of articulation: (1) axial isonomy of the elements (no deviations from the vertical); (2) formal integrity of the elements (no interlocking of the stories, no overlapping); (3) proportional interrelation of the elements in the sense that in generically related members, such as window frames and niche pilasters, a similar relation obtains between height and width and that the whole is approximately determined by the formula $a : b = b : c$ (e.g., the width of the niches is to the width of the windows as the width of the windows is to the interval between them; the height of the window is to the height of the upper wall as the height of the upper wall is to the height of the entablature, etc.); (4) structural differentiation and consolidation of the elements in the sense that that which belongs together from a structural point of view is also united aesthetically. The whole façade is composed of several 'relief layers' which – clearly set apart from one another and clearly unified within themselves – express a difference of structural functions by a stratification in depth:

first layer, the self-contained structural system consisting of entablatures and corner aediculae; second layer, the statues between the windows; third layer, the window frames; fourth layer, the wall above the windows, apparently transformed into a backdrop surface.

An altogether different concept of architecture is proclaimed by the Windsor drawing. Here the niches of the ground floor have no axial relationship to the division of the upper storey; the arch of the shop cuts into the stringcourse, its archivolt overlapping the latter's mouldings; there is little evidence of fixed proportional relations (the artist intends to cover the surface with a rich and varied decoration rather than to organize it by rhythmical articulation), even less of what I have called a stratification in depth. No attempt has been made to contrast a self-contained structural system with an equally self-contained 'backdrop surface'; on the contrary, the substance of the wall, decorated rather than articulated, remains an $\dot{\alpha}\delta\iota\dot{\alpha}\phi o\rho o\nu$ (a 'thing undifferentiated') with respect to structure. Corroded, as it were, by all kinds of cavities and holes, and studded with all kinds of protrusions and consoles, the wall does not appear to be divided into separable layers, but ploughed up in its entirety.

The façade in the Windsor drawing, then, is evidently 'non-Classic'. But neither does it exhibit the characteristics which, according to Wölfflin's conclusive formulation, mark the Baroque style: colossality, massiveness, organic animation, and subordination of the parts to one dominant motif. We are forced to apply to architecture a concept which until now has tended to be reserved to the representational arts: Beccafumi's Windsor façade must be described as 'Mannerist architecture'. In point of fact, all the criteria which seems to distinguish it from the design for the 'Casa dei Borghesi' – the loosening of axial relationships, the interlacing of forms, the lack of proportionality, and, finally, the substitution of a homogeneous, unarticulated substance for a distinctly stratified structure – all these criteria are equally valid for the paintings of Pontormo, Rosso, Bronzino or

Jacopo del Conte, and, especially, for those of Beccafumi himself. And as Mannerism in the representational arts resulted (though by no means exclusively) from the re-activation of what has been called 'Quattrocento Gothic',[44] so did Mannerism in architecture result, to some extent, from the recrudescence of medieval tendencies within the framework of the 'Classic' style; it is significant that Beccafumi's Windsor project not only retains but even emphasizes the segmented arch, a real anathema by both classical and 'Classic' standards.

It is impossible here to define, much less to discuss, the whole problem of 'Mannerist architecture'.[45] Only one question is important for us, because it leads us back to our initial topic: the work and opinions of Giorgio Vasari. Must the historical view, current until about 1920, which assumes a continuous development of the 'Classic' Renaissance into the Baroque and considers everything 'Mannerist' as a side line or by-product – must this historical view be revised with respect to architecture in the same way as it had to be revised with respect to the representational arts? I doubt that this is necessary. On the contrary, it was perhaps an overconfident belief in a perfectly parallel and synchronous development of architecture, sculpture and painting which was the chief reason for the inaccurate appraisal of Mannerism in earlier art-historical writing. By and large, Central Italian, particularly Roman, architecture did rather continuously and consistently develop from the 'Classic' High Renaissance into the Early Baroque. If it was incorrect to presume the same of sculpture and painting (a presumption arising from the old habit of making architecture the 'measure of all things' in matters of stylistic development), we should commit an analogous error were we, in deference to the recent re-evaluation of Mannerism, to hastily reverse our ideas as to the evolution of architecture. In the representational arts of Central Italy, including Rome, the

44. See the articles by Friedlaender and Antal cited, Note 35, p. 224.
45. See the literature referred to above, p. 9 f.

Mannerist current had gathered so much momentum that it took the advent of fresh, North Italian forces and a deliberate revival of High Renaissance tendencies to ensure the victory of the Early Baroque. In the domain of architecture, however, we have, in the same Rome, an unbroken sequence which leads from Bramante, Raphael and Sangallo to Vignola, della Porta, the Lunghi, and Fontana, hence to Maderna, and hence to the great masters of High Baroque. This sequence still constitutes what may be called the mainstream of the development, and its importance is not diminished by the existence of Mannerist buildings. Mannerism, which is the rule in Central Italian painting, remains the exception in Central Italian architecture.

Seen in the context of the history of Renaissance art as a whole, this situation is not surprising. Central Italian architecture had, from the outset, resolutely broken with that Gothic the survival, or revival, of which is at least one of the conditions for the predominance of Mannerism. While Tuscan and Umbrian Quattrocento painting – there was no Roman Quattrocento painting to speak of – may be defined, quite roughly, as a Renaissance art on Gothic foundations, Tuscan and Umbrian Quattrocento architecture may be defined, equally roughly, as a Renaissance art on Romanesque foundations. The animated style of Botticelli, Filippino, Piero di Cosimo or Francesco di Giorgio which infuses the antique with Gothic sentiment – or, to put it the other way, infuses the Gothic style with classical vitality – is inherently different from an architecture so firmly anchored in Brunelleschi and Alberti that it could never be 'swept from its moorings' by the Mannerist wave.

Hence, two important facts become clear. First, we can understand that in Northern Italy, in Genoa and especially in the transalpine countries Renaissance architecture could never achieve a truly 'Classic' style; it was, if one may say so, Mannerist *ab ovo*. Almost its entire production consisted of 'Gothic bodies in modern clothing', and the exceptional road which led the great Elias Holl of Augsburg from the

Beckenhaus through the Zeughaus to the Town Hall represents neither a development from the German to the Italian, nor, as has also been maintained, a development from the alien to the national, but an auto-evolution of Mannerism to Early Baroque, which would not have been possible in Italy.[46] Second, we can understand that, where Mannerist architecture did invade the territories of Florence and Rome, the buildings in question were not designed by professional architects, but by such artists as were at home in the representational or decorative arts. Walter Friedlaender has clearly recognized that the style which revealed its climax in the Casino of Pius IV (Plate 63), and which he correctly derives from the Palazzo dell'Aquila, represents a 'reaction against the architectonic'.[47] We can now understand that it actually represented a rebellion of the non-architects: Raphael, the designer of the Palazzo dell'Aquila, was a painter, and so was Pirro Ligorio, the architect of the Casino of Pius IV (an architect, by the way, whose buildings show how little an interest in the Antique, even a definitely archaeological outlook, conflicts with a Mannerist style[48]). Giulio Mazzoni, the creator of the Palazzo Spada, was a painter and *stuccatore*. In Florence, the chief exponents of architectural Mannerism are the sculptor Bartolommeo Ammanati, the painter and stage-designer Bernardo Buontalenti, and, finally, the painter Giorgio Vasari.

Vasari indubitably imagined that as an architect he followed in the footsteps of Michelangelo. But in reality he was what Michelangelo had never been, a Mannerist.[49] Becca-

46. On Palladio's position, cf. above, p. 237 ff.

47. W. Friedlaender, *Das Casino Pius des Vierten*, Leipzig, 1912, p. 16.

48. Cf., in addition, B. Schweitzer, 'Zum Antikenstudium des Angelo Bronzino', *Mitteilungen des deutschen archäologischen Instituts, Römische Abteilung*, XXXIII, 1918, p. 45 ff.

49. For Michelangelo's place in the history of architecture, see K. Tolnay, 'Zu den späten architektonischen Projekten Michelangelos', *Jahrbuch der preussischen Kunstsammlungen*, LI, 1930, p. 1 ff. The present writer shares Tolnay's conviction that Michelangelo's architectural style cannot be classified under the headings of 'Renaissance',

fumi's Windsor drawing differs from his design for the 'Casa dei Borghesi' in precisely the same way as does Vasari's Uffizi (Plate 64) from the Palazzo Pandolfini or the Palazzo Vidoni. And it is almost ironic that Michelangelo's – and Vasari's – invectives against Antonio da Sangallo's model for St Peter's can be applied, with even greater justification, to Vasari's own architectural efforts (although they are, as he would have said, 'quite praiseworthy considering the nature of the period'): 'the composition . . . is too much cut up by projections and members that are too small, as are also the columns, the arches upon arches, and the cornices upon cornices.'[50]

'Baroque', or 'Mannerism', but must be considered as constituting a 'stylistic period by itself'. Only in the buildings of his Florentine period (1517–34) is it possible – in accord with the observations made by Walter Friedlaender with regard to the sculptures and drawings of these years – to observe a (none too essential) influence of the Mannerist current.

50. See Note 40, p. 226.

6

Albrecht Dürer and Classical Antiquity

With an Excursus on the Illustrations of
Apianus' *'Inscriptiones'* in Relation to Dürer

ALBRECHT DÜRER: In what honour and esteem this art was
held by the Greeks and Romans is sufficiently indicated in
the ancient books. Subsequently, though, it was completely
lost and hidden for more than a millennium; and only within
the past two hundred years has it been brought to light
again by the Italians.

The works produced by Albrecht Dürer at the turn of the
fifteenth century mark the beginning of the Renaissance style
in the North. At the end of an era more thoroughly estranged
from classical art than any other, a German artist rediscovered
it both for himself and his countrymen. That this complete
estrangement from the 'art of the Greeks and Romans'
should have preceded its rediscovery was, perhaps, a his-
torical necessity. Italian art could find its way back to the
Antique by way of affinity, as it were; the North could re-
capture it – if at all – only by way of antithesis. And to that
end all the threads that linked the art of the earlier Middle
Ages to that of the classical past had to be broken.

Dürer was the first Northern artist to feel this 'pathos of
distance'. His attitude towards classical art was neither that
of the heir nor that of the imitator but that of the *conquistador*.
For him antiquity was neither a garden where fruits and
flowers still bloomed, nor a field of ruins the stones and
columns of which could be re-used: it was a lost 'kingdom'
which had to be reconquered by a well-organized campaign.
And since he understood that Northern art could assimilate
the artistic values of antiquity only by a reform in principle,
he undertook this reform himself – in theory as well as in

practice. According to his own testimony, his theoretical works – a substitute for the lost 'books of the ancients' – were intended to enable 'the art of painting to attain, in time, to its pristine perfection'.[1] And when he endeavoured, almost three decades before the publication of his *Theory of Human Proportions*, to produce classical figures in classical movement, he did so, not in order to embellish his works with spoils accumulated here and there but with the intention (perhaps intuitively felt rather than consciously realized at the time) systematically to educate himself and his German fellow artists to a 'classical' attitude toward the expressive power and beauty inherent in the human body.

The idea of a golden age of art 'completely lost and hidden for more than a millennium'[2] but now to be revived, or, to use Dürer's expression, to 'regrow' (*Wiedererwachsung*),[3] had arisen in Italy;[4] and Italian too are the sources from which the Nuremberg master drew the knowledge and the experiences with the aid of which he hoped to accomplish his own Renaissance programme. Just as his theoretical interests were awakened by the casual communications of an Italian, and led him back, time and again, to the studies of Italian theorists,[5] so did he borrow from the 'nude images' (*nackete Bilder*) of the Italian painters, so highly praised by himself,[6] whatever he could assimilate of classical form and classical movement.

It would be unnecessary to stress this intermediary role of the Italian Renaissance were it not for the repeated attempts to explain Dürer's 'classical manner' (*antikische Art*) by direct contact with Greek and Roman statuary. Quite recently this view has been advocated, in a novel and captivating manner, by an author who goes even farther than all his

1. K. Lange and F. Fuhse, *Dürers schriftlicher Nachlass*, Halle, 1893, p. 207, line 7 ff.

2. ibid., p. 181, line 25. 3. E.g., ibid., p. 344, line 16.

4. Cf. the preceding section of this volume.

5. See E. Panofsky, *Dürers Kunsttheorie*, Berlin, 1915, *passim*; cf. also Section 2 of this volume.

6. Lange and Fuhse, op. cit., p. 254, line 17.

predecessors in his desire to emancipate the German artist from Italy. Not only is Dürer supposed to have been directly inspired by classical originals but we are asked to believe that these classical originals became accessible to him in Augsburg[7] rather than in Bologna, Padua or Venice.

It may seem comparatively unimportant whether the prototype of Dürer's Adam was an Italian drawing after the *Apollo Belvedere* or a provincial Roman relief, whether the posture of his bow-stringing Hercules can be traced back to a work by Pollaiuolo or to a classical statue. But there is a question of principle involved: we must ask ourselves, not so much whether these works by Dürer did come into being under the impression of classical originals as whether they could have come into being under the impression of classical originals – whether, in the light of the historical situation, it is at all possible to presume a direct influence of the Antique upon a German artist of the fifteenth century. And only in order to take a position on this question of principle, let us review the questions of fact.

I CLASSICAL PATHOS

The expressive power and the beauty of the human body – these were the two ideals which the Renaissance found realized in classical art. But just as the Italian Quattrocento was impressed and excited by the 'tragic unrest' of the Antique before it could appreciate and abandon itself to its 'classical calm',[8] so was the young Dürer enraptured by passionate scenes of death and abduction before he could gain access to the beauty of the *Apollo Belvedere*. The Death of Orpheus and the Abduction of Europa, the Labours of Hercules and a battle of raging sea monsters – this choice of

7. M. Hauttmann, 'Dürer und der Augsburger Antikenbesitz', *Jahrbuch der preussischen Kunstsammlungen*, XLII, 1921, p. 34 ff.

8. A. Warburg, 'Der Eintritt des antikisierenden Idealstils in die Malerei der Frührenaissance'; see now A. Warburg, *Gesammelte Schriften*, Leipzig and Berlin, 1932, I, p. 175 f.

subjects clearly indicates what Dürer first understood to be the *antikische Art*; even in Apollo, he saw at this stage, not so much an image of triumphant repose as an image of tense exertion: he represented him not in the eurhythmic pose of the great sun god but in a struggling movement suggested by a famous classical statue which represents little Cupid trying to string the bow of Hercules.[9]

All these works are based upon Italian models, either known or inferable with certainty. That the *Death of Orpheus* (drawing L.159), a composition the central motif of which Warburg was able to trace back to the time of Pericles,[10] derives from a Mantegnesque prototype transmitted through a North Italian engraving and probably inspired by a poetic source such as Politian's *Orfeo* was demonstrated long ago.[11] That the 'Cupid-Apollo' just mentioned (drawing L.456, our Plate 65) was copied, not from the classical original but from a Quattrocento paraphrase of this original, is evident from such non-classical characteristics as the precious angularity of the posture, the mannered flexure of the fingers, the fluttering lappets and ribbons of the drapery, the all-too-elegant boots.[12] And that the *Abduction of Europa*

9. F. Wickhoff, 'Dürers antikische Art', *Mitteilungen des Instituts für österreichische Geschichtsforschung*, I, p. 413 ff.

10. A. Warburg, 'Dürer und die italienische Antike'; see now op. cit., II, p. 443 ff. Cf. also J. Meder, 'Neue Beiträge zur Dürer-Forschung', *Jahrbuch der kunsthistorischen Sammlungen des Allerhöchsten Kaiserhauses*, XXX, 1911, p. 183 ff., particularly p. 211 ff. The ancestry of the motif can be traced back as far as the third millennium; see, e.g., the small Victory Relief of Mentuhotep in Cairo.

11. See the references in M. Thausing, *Albrecht Dürer*, Leipzig, 2nd ed., 1884, p. 226 (English translation, F. A. Eaton, ed., London, 1882, Vol. I, p. 221). The recent tendency is to connect Dürer's drawing not directly with the engraving that has come down to us but with a presumably superior prototype of this print (see Meder, op. cit., p. 213).

12. W. Weisbach, *Der junge Dürer*, Leipzig, 1906, p. 47 f.; further, Meder, op. cit., p. 214, and Hauttmann, op. cit., p. 34. A brief discussion of the iconography may be in order. Facing the Apollo there stands a bearded man, dressed in oriental garb and holding a skull, with a book and a cauldron at his feet. The inscription on this cauldron,

represented on the same sheet derives from an Italian paint-
ing or drawing is even more obvious.

To begin with, Dürer's representation corresponds in all
essential features with those admirable stanzas in Politian's
Giostra which have been quoted and analysed in the first
section of this volume.[13] Except for the satyrs and creatures
of the sea – which were common throughout the Renais-
sance and as personifications of *lito* and *mare* hardly require
explanation – Politian's verses contain all the characteristics
of Dürer's representation: the chorus of lamenting maidens,
the drapery that 'billows and flutters backward'; the 'atten-
tive' bull who turns back his head;[14] and, above all, the

LVTV.S, was expanded by Bickhoff (op. cit., p. 417) into '*lutum
sacrum*', 'holy vapour', and both the cauldron and the bearded Oriental
were, therefore, thought to be connected with the oracles of Apollo
where vapours play a considerable role. The word *lutum* ('mud, loam,
clay, putty'), however, can never mean 'vapour'. The correct reading
is *lutum sapientiae*, and this is a technical term of alchemy, designating
a special putty with which the apparatus were sealed (see E. O. von
Lippmann, *Die Entstehung und Ausbreitung der Alchemie*, Berlin, 1919,
p. 43); the matter which gives birth to Goethe's Homunculus is still
'in einen Kolben *verlutiert*'. The scene thus represents an alchemical
operation, which so well agrees with the fantastic costume, the book,
the boiling cauldron and the death's-head that Ephrussi (*Albert Dürer
et ses dessins*, Paris, 1887, p. 121) could hit upon the correct interpreta-
tion without having decoded the LVTV.S. The only question is whether
the Apollo, so closely related to the alchemist from a compositional
point of view, is also associated with him iconographically. This is not
certain but by no means impossible. Apollo-Sol, the sun, represents
for the alchemist the precious metal which he wants to produce: 'Die
Sonne selbst, sie ist ein lautres Gold' ('The sun itself, it is pure gold').
Thus the Apollo figure may be interpreted either as a symbol of the
gold sought by the operator or, more concretely, as a statue under the
auspices of which the operation takes place. Rabelais, for example,
ridicules the secret sciences in his superb description of a temple of
magic adorned with images of all the planetary gods, among them a
statue of 'Phoebus' made of the 'purest' gold (*Gargantua and Panta-
gruel*, V, 42).

13. See above, p. 80–81.

14. In other nearly contemporaneous representations (e.g., in the
engraving B.4 by the 'Master I.B. with the Bird', or in the wood-cuts

posture and movement of the heroine. The bearing of this apprehensively crouching Europa can hardly be more clearly described than in the words of Politian: calling back to her 'sweet companions', she clings to the back of the bull with one hand while with the other she grasps his horn, and 'she pulls up her bare feet as if she were afraid that the sea might wet them'.[15]

Thus the Europa drawing is linked to Italy by a literary association. But we must also presume a representational source of Italian origin: how thoroughly Northern the result would have been had Dürer worked only from a textual description is shown by his *Large Fortune* (engraving B.77) which, as regards subject matter, is also derived from a poem

in Francesco Colonna's *Hypnerotomachia*, Venice, 1499, fols. K IV or K V v.) the bull looks straight ahead and the posture of Europa is totally different.

15. Politian's description is, of course, dependent on Ovid; but it is impossible to derive Dürer's representation from Ovid directly. In the first place, Politian's version is not only based on the *locus classicus* (*Met.*, II, 870 ff., already quoted by Wickhoff, op. cit., p. 418 f.) but compiled from several scattered passages. Thus, the 'drapery that flutters backward' comes from *Met.*, I, 528; and the drawing up of the feet from *Fast.*, V, 611 f., where it is, moreover, portrayed as a repeated, transitory action ('saepe puellares subducit ab aequore plantas') while Politian describes it, as it were, as a fixed pose. In the second place, Dürer's drawing agrees with Politian's text also in motifs not found in Ovid and in part supplied from other sources: the lament of the companions and – if *nota* means 'he looks around' – the 'attentiveness' of the bull. In the third place, Europa's right hand should grasp the horn and her left should rest on the bull's back, whereas the opposite is true of Dürer's drawing. This can be explained by the fact that Politian speaks only of 'l'una' and 'l'altera mano'. Politian's text, incidentally, sufficiently explains the peculiar posture of Dürer's Europa which Wickhoff proposed to derive from a 'Nike Tauroktonos'. Hauttmann's conjecture that a sculpture, then preserved in Augsburg, which represented a 'taurus qui vehebat nudam puellam tensis bracchiis auxilium implorantem', may have served as Dürer's model is, of course, untenable because precisely the motif of the girl's arms 'extended in supplication' is absent from Dürer's composition.

by Politian[16] but is startlingly un-Italianate in appearance. In the Europa drawing, however, the influence of Quattrocento art is manifest in the visual aspects as well: the *putti* trumpeting on long horns,[17] the *amoretti* with their little globular heads,[18] the woeful companions tearing their hair and throwing up their arms with cries of horror[19] – all these are typical Italian motifs; and the little figures in the background (whose hyperbolic gestures of fear recur, by the way, in the 'Amymone' engraving)[20] are unmistakably patterned after those scantily dressed and nimble-footed 'nymphs' who were almost indispensable in would-be classical representations of the Quattrocento.[21]

16. K. Giehlow, 'Poliziano und Dürer', *Mitteilungen der Gesellschaft für vervielfältigende Künste*, XXV, 1902, p. 25 ff.

17. Cf., for instance, Bellini's so-called *Allegory of Providence* in the Venice Academy. The *putti* in Dürer's drawing, later developed in the engravings B.66 and B.67, would also seem to derive from the Venetian school; compare, for example, the genius with the globe in B.66 with the little flautist in Bellini's *Allegory of Fortune*, also preserved in the Venice Academy. E. Tietze-Conrat ('Dürer-Studien', *Zeitschrift für bildende Kunst*, LI, 1916, p. 263 ff.), trying to trace the engravings B.66 and B.67 back to a classical relief type but judiciously evaluating the historical situation, correctly postulates an 'intermediate link between them and the classical original'.

18. Cf. H. Wölfflin, *Die Kunst Albrecht Dürers*, 2nd ed., 1908, Munich, p. 170.

19. Cf., for instance, the second figure from the left in Mantegna's engraving, *The Entombment*, B.3.

20. E. Tietze-Conrat's (op. cit.) interpretation of the subject as 'Achelous and Perimele' (Ovid, *Met.*, VIII, 592 ff.) is at variance with the fact that the father who appears on the shore shows no trace of that *feritas paterna* which pitilessly condemns a ravished daughter to death. On the contrary, he hastens to the shore (cf. the running lansquenet in the woodcut B.131) in order to rescue the victim, or at least, since he arrives too late, to lament her. The fact that Ovid explicitly describes Achelous as taking on the form of a bull (IX, 80 ff.) and that one of his horns was transformed into a cornucopia would in itself have precluded their misinterpretation as 'antlers'.

21. Warburg, 'Botticellis Geburt der Venus . . .,' op. cit., I, *passim*, especially pp. 21 f. and 45 ff., where the extraordinary importance of

In the *Abduction of Europa* as in the *Death of Orpheus*, then, Dürer had gained access to the Antique by retracing what may be called a double detour: an Italian poet – perhaps Politian in both cases – had translated Ovid's descriptions into the linguistic and emotional vernacular of his time,[22] and an Italian painter had visualized the two events by setting in motion the whole apparatus of Quattrocento *mise-en-scene*:

the *ninfa* is illustrated by many literary examples. The word was regularly used wherever a classicizing paraphrase for 'maiden' or 'beloved' was desired.

22. It is only natural that artists interested in mythological subject matter often relied on contemporary authors writing in the vernacular. Politian's influence is evident, e.g., in Botticelli's *Birth of Venus*, Raphael's *Galatea* and the North Italian representations of Orpheus (see A. Springer, *Raffael und Michelangelo*, 2nd. ed., Leipzig, 1883, II, p. 57 ff.; Warburg, op. cit., I, pp. 33 ff., II, 446 ff.). It is also unnecessary to derive the many little sea creatures in Dürer's Europa drawing (if they must be accounted for by literary parallels at all) from Lucian and Moschus. Instead of other examples, we may quote the delightful description of an imaginary classical relief in the *Hypnerotomachia*, fol. D II v.: '... offeriuase ... caelatura, piena concinnamente di aquatice monstriculi. Nell' aqua simulata & negli moderati plemmyruli semihomini & foemine, cum spirate code pisciculatie. Sopra quelle appresso il dorso acconciamente sedeano, alcune di esse nude amplexabonde gli monstri cum mutuo innexo. Tali Tibicinarii, altri cum phantastici instrumenti. Alcuni tracti nelle extranee Bige sedenti dagli perpeti Delphini, dil frigido fiore di nenupharo incoronati. ... Alcuni cum multiplici uasi di fructi copiosi, & cum stipate copie. Altri cum fasciculi di achori & di fiori di barba Silvana mutuamente se percoteuano. ...' (abbreviations expanded and punctuation modernized). As far as Colonna's charming Maccaronian idiom can be understood and translated, this reads about as follows: 'There offered itself to the eyes ... a relief harmoniously filled with little aquatic monsters. In the simulated water and in the gentle surf [were seen] half-men and half-women with coiling fish tails. On these, attached to their backs, they daintily sat, some of the nude females hugging the monsters in a mutual embrace. Some played flutes, others fantastic instruments. Still others, sitting in strange chariots, were drawn by agile dolphins, crowned with the cool blossom of the water lily. ... Some held vases of many shapes, filled with plentiful fruit, and brimming cornucopias. Others fought one another with sprays of iris or *barba silvana* flowers. ...'

satyrs, Nereids, cupids, fleeing nymphs, billowing draperies and flowing tresses.[23] It was only after this twofold transformation that Dürer was able to appropriate the classical material. Only the landscape elements – trees and grasses, hills and buildings – are independent of Italian prototypes; and the way in which the space is filled, from beginning to end, with *tätig kleinen Dingen* is thoroughly Northern,[24] in

23. Cf. in this respect, Warburg, 'Botticellis Geburt der Venus', *passim*. Professor Carl Robert (Halle) kindly informed me that only Maenads were represented with flowing hair in classical antiquity, and even this only during a limited period. In the Italian Early Renaissance this highly specialized motif was so generally and enthusiastically adopted that it became, in a sense, the hallmark of the *maniera antica*; even in relatively accurate copies after classical works windblown hair and fluttering tresses were gratuitously added by Renaissance copyists (cf., e.g., the drawing in Chantilly discussed by Warburg, op. cit., p. 19 f.), or the well-known engraving *Ariadne and Bacchus* (*Catalogue of the Early Italian Engravings in the British Museum*, Text Vol., p. 44, Fig. A.V.10), where the figure in the right-hand corner should be compared with the corresponding figure in a relief in Berlin (reproduced in R. Kekulé von Stradonitz, *Beschreibung der antiken Skulpturen*, Berlin, 1891, No. 850). This curious idiosyncrasy, observed and emphasized by Warburg, distinguishes the Early Renaissance both from classical and contemporary Northern art. Classical art, as we have seen, loved to express physical movement but reinforced its effect by the addition of flowing hair only in the exceptional case of Maenads. Late Gothic art, on the other hand, so much delighted in the animated play of lines *qua* lines that it bestowed 'windblown' hair even upon such figures as show no trace of physical movement; see, for example, Schongauer's reposeful *Wise Virgins* (B.77, 78, 81, 84) or the equally tranquil *Wildendame* by the Master of the Playing Cards. The Italian Quattrocento, however, generalized a motif restricted to a special subject in classical antiquity but, on the other hand, restricted its use to figures represented in actual physical movement: the Late Gothic predilection for linear movement was given full scope, but only where it could contribute to the classical aspiration for organic, corporeal movement. By compressing the individual strands of hair into a compact mass, the High Renaissance, exemplified by Raphael's *Galatea*, quite logically translated the 'flowing-hair motif' from a linear into a plastic mode of expression.

24. So, too, Meder, op. cit., p. 215, as well as Weisbach, op. cit., pp. 36, 63 f.; cf. also below p. 314 ff.

spite of the fact that many of those 'busy little things' are classical satyrs, she-Pans and Tritons.

In 1500, six years after the *Death of Orpheus* and the *Abduction of Europa*, Dürer produced his only painting to treat a mythological subject (Plate 66). It represents Hercules Killing the Stymphalian Birds and may be considered as the final statement of Dürer's initial response to classical antiquity: it meant to him, at this time, heroic nudity, vigorous modelling expressive of anatomical structure, powerful movement, animal passion. In a general way, Dürer was guided by one of Pollaiuolo's Hercules pictures, particularly the *Killing of Nessus* in the Jarves Collection at New Haven (Plate 67).[25] But, curious though it seems, the style of this Italian prototype is more severely limited by Quattrocento conventions and mannerisms than that of its German 'derivative'. In Dürer's painting elegant slenderness gives way to powerful sturdiness; an agitated but indecisive posture (midway between a lunge and a run) to a forceful and unequivocal assault position, arms tense, one leg energetically put forward, the other firmly planted against the ground. Pollaiuolo's figure, it seems, provided only an outline which Dürer filled with plastic volume and functional energy, and it was a happy thought of Professor Max Hauttmann to seek the sources of this nobler and, if one may say so, more classical conception of the human body in the Antique itself. It was, however, not a classical original but the Italian translation of such an original the influence of which enabled Dürer to 'better the instruction'. And, remarkable coincidence, it was Pollaiuolo himself who played the role of intermediary.

In 1495 Dürer had made a partial copy of a drawing by Pollaiuolo, now lost but originally forming part of a series several members of which are still extant, which represented the Rape of the Sabine Women. Dürer's drawing (L.347, our Plate 68) shows two brawny men – or, rather, except for differences in the positions of the arms and head, one and

25. See Weisbach, ibid., p. 48 ff., with reproduction.

the same man rendered in front and rear view – each carry-
ing a woman on his shoulder. This Pollaiuolo figure is based
upon a type extremely popular in classical sculpture: more
intensely agitated, elaborated according to the standards of
the first *pictore anatomista* and – characteristically – trans-
planted from the sphere of agonistic pathos to that of the
erotic, Pollaiuolo's enamoured Roman repeats, in two
views, a *Hercules Carrying the Erymanthean Boar* well known
to us from many classical reliefs[26] and statues.[27] It is through
Pollaiuolo's translation,[28] and not by direct contact with a
Roman original which is supposed to have been, but never
was, in Augsburg (Plates 69, 70),[29] that Dürer had become

26. See C. Robert, *Die antiken Sarkophagreliefs*, III, 1, Berlin, 1897,
Pl. XXVIII ff., especially Pl. XXXI.

27. See, e.g., Clarac, *Musée de Sculpture comparée*, No. 2009.

28. Another painting formerly ascribed to Pollaiuolo and based
upon a classical statue, the *David* in the National Gallery of
Washington (Warburg, 'Dürer und die italienische Antike', op. cit.,
II, p. 449), is now assigned to Andrea Castagno (see Warburg, ibid.,
p. 625).

29. Hauttmann, op. cit., p. 38 ff., believes that the Hercules statue
reproduced – in front and rear view – in Petrus Apianus, *Inscriptiones
sacrosanctae vetustatis. . . . Petrus Apianus Mathematicus Ingolstadiensis et
Bartholomaeus Amantius Poeta DED.*, Ingolstadt, 1534, pp. 170, 171,
was owned by the Fuggers of Augsburg, although he admits that the
description of the Fugger Collection by Beatus Rhenanus (1531) makes
no mention of any Hercules statue, and that the legend of the Apianus
woodcuts can very well mean (in fact, does mean) only that one of the
Fuggers, Raimund, had made the object available for reproduction
from his collection of drawings. However, in order to have a classical
Hercules ready for Dürer's inspection at Augsburg in 1500, Hauttmann
proposes to identify the statue reproduced by Apianus with an *imago
marmorea* originally belonging to Peutinger. Mentioned by him, in
1514, as 'being in his house' and 'recently brought from Rome', it
might have passed, according to Hauttmann, into the Fuggers' pos-
session between 1531 and 1534. This hypothesis is hardly acceptable.
First, if the statue reproduced by Apianus had been owned by the
Fuggers at the time of publication, why should he have failed to say so
in unequivocal manner? Second, even if we admit the possibility of a
change in ownership – not altogether probable during Peutinger's
lifetime – how can we believe that a statue referred to as *nuper allata* in

acquainted with this classical type. As he employed the nude seen from the back present in the drawing of 1495 for his engraving '*Der Hercules*' of *c.* 1500/1501 (B.73), so did he use it – reversed – for the Hercules in the painting of 1500;[30] and this twofold and nearly contemporary reconversion would seem to indicate that Dürer knew the original mythological significance of the figure. In certain respects the painting even agrees with the drawing more closely than does the engraving. Note, for example, the position of the legs and such significant details as the foreshortening of the right foot and the physiognomical characteristics of the face: the marked depression above the strong, aquiline nose; the rounded, protruding forehead; and the raised eyebrows which give an impression of tenseness and strain.

In a woodcut designed, though probably not executed, by Dürer about the same time – one of the woodcut illustrations for the *Libri amorum* by Conrad Celtes, published in 1502 – we can observe an analogous use of the other figure in the drawing of 1495, the nude seen from the front. This woodcut (Text Fig. 12) represents Apollo in Pursuit of Daphne and is based, in a general way, upon a miniature ascribed by Liberale da Verona.[31] But Dürer improved upon this Italian

1514 had been in his possession as early as 1500? Third, the work reproduced by Apianus appears under the heading of 'Italian antiquities'. The inference is that the *Peutinger Hercules*, mentioned in 1514, is not identical with the statue reproduced by Apianus, and that a '*Fugger Hercules*' never existed.

30. The lansquenet in the engraving B.88, too, has been correctly derived from the drawing L.347 (*Ausstellung von Albrecht Dürers Kupferstichen, Kunsthalle zu Hamburg*, 21 May 1921, G. Pauli, ed., p. 7). In both these cases the figure appears, of course, in reverse. That the same is true of the painted Hercules, where the reversal did not result from the mechanics of the printing process, can be accounted for by the necessity of placing the bow in the archer's left hand.

31. MS. in Wolfenbüttel, reproduced by Paolo d'Ancona, 'Di alcuni codici miniati' (*Arte, X*, 1907, p. 25 ff., p. 31) and referred to by Hauttmann, op. cit., p. 38. The Apollo in the Parnassus woodcut which appears in Celtes' *Melopoiae* and *Guntherus Ligurinus* (both pub-

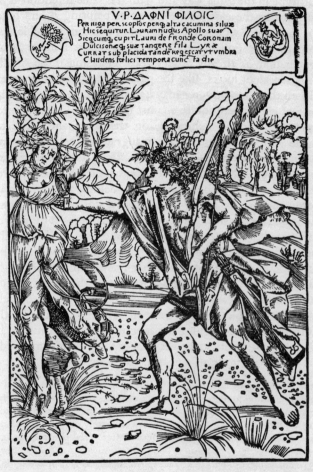

Figure 12. Albrecht Dürer (workshop), *Apollo and Daphne*. Woodcut from Conrad Celtes, *Quatuor Libri Amorum*, Nuremberg, 1502.

lished in 1507) is, by the way, based on a related prototype; see a miniature in the same manuscript, reproduced by Paolo d'Ancona, p. 30.

prototype in the same way and with the same intention as he had done in the case of the Hercules painting;[32] and here, too, the model which made this improvement possible was the copy after Pollaiuolo's *Rape of the Sabine Women*. Small wonder that, as already observed by Thausing,[33] the Apollo in the woodcut looks 'like the painted Hercules in reverse'.

In all these cases Dürer may be said to have espoused the cause of classical antiquity against that of the Quattrocento. His Italian models exhibited, on the one hand, delicate, gracile figures, delimited by calligraphical contours and moving with nervous animation, which thoroughly conformed to the taste of the Quattrocento; on the other, figures which by their solid build, plastic modelling and ponderous energy approached the style of classical statuary. Dürer perceived and emphasized these classical qualities – in the case of the Hercules to the extent of playing off Pollaiuolo the classicist against Pollaiuolo the proto-Mannerist. But this must not blind us to the fact that the classical style which Dürer was able thus to oppose to that of the Quattrocento had been made accessible to him by the Quattrocento itself. If it was possible for the German artist to retranslate the idiom of the Italians into the language of the Antique, he owed this possibility to the very Italians whom he 'emended'. The Quattrocento itself taught Dürer how to surpass it.[34]

32. 'The tripping movement of Dürer's model [viz., the Apollo in the Wolfenbüttel miniature], where the slender, angular figure touches the ground with only the ball of his right foot, has been changed to a forceful, lunging position, the right foot set firmly on the ground and the left, its span exposed to view, drawn after' (Hauttmann, op. cit., p. 38).

33. Thausing, op. cit., p. 279 (English translation, I, p. 272).

34. It is astonishing how narrowly Hauttmann has missed the point. He correctly observes that both the Celtes woodcut and the Hercules painting presuppose the influence of classical statuary in addition to that of their direct Italian prototypes; and he correctly presumes that Dürer had at his disposal a drawing reflecting a classical Hercules Carrying off the Erymanthean Boar in 'front and rear view'. But he has overlooked one thing, to wit, that this very drawing has actually come down to us: it is the drawing L.347 which renders such a Hercules

II CLASSICAL BEAUTY

The Hercules painting of 1500 represents Dürer's climactic effort in his quest of heroic pathos; but the same year, 1500, also marks the beginning of his attempt to recapture the other aspect of that 'double herme'[35] under the guise of which antiquity was worshipped by the Renaissance: the Apollonian. We know that it was the Venetian Jacopo de' Barbari who made Dürer aware of the 'problem of beauty' by showing him some studies in human proportions, and to whose engravings he looked for support at the beginning of his own theoretical studies. Starting with no knowledge of Vitruvius and proceeding by an essentially Gothic, geometrical method, Dürer first limited himself to female figures, utilizing Barbari's classicizing nudes as patterns; only a little later did he extend his efforts to the proportions and pose of the 'perfect male'.

These masculine figures mark a further step in Dürer's approach to classical antiquity: their proportions are based upon the Vitruvian canon, probably brought to his attention by one of his humanist friends and, for a while, causing him to revise the proportions of his females as well,[36] and their posture is patterned after that of the *Apollo Belvedere* so that

in a 'translation' by Pollaiuolo. Even from a purely stylistic point of view this drawing is considerably closer to Dürer's final versions than are the woodcuts in Apianus. Comparing, for example, the rear view of Apianus' *Hercules* (Plate 70) with Dürer's painting (Plate 66), we can observe that the torso is not thrown so far forward; that the advancing leg is less markedly bent; that the other is not tightened at the knee; that the foreshortened foot is drawn in very different manner; and that the most important part of the back is covered by the lion's skin. We must conclude, first, that Dürer was not influenced by the Hercules statue reproduced in the two Apianus woodcuts; second, that he cannot be held responsible for these woodcuts themselves. That this is also true of the other Apianus illustrations which have been attributed to him will be demonstrated in an Excursus (p. 330 ff.).

35. I borrow this felicitous phrase from Warburg, op. cit., p. 176.

36. For the priority of Dürer's studies in feminine proportions and their subsequent (but temporary) modification in favour of the

they are commonly referred to as the 'Apollo group'.[37] Since the original attributes of the *Apollo Belvedere* – which, discovered at Rome about 1496, can have come to Dürer's knowledge only through an Italian drawing – could not be ascertained at the time, he interpreted it at first, not as a 'regular' Apollo conquering evil by means of his bow or aegis but as a god of health, identified as such by the attributes of snake and goblet, who may be designated as either 'Apollo Medicus' or 'Aesculapius' (drawing L.181, our Plate 75). Then he transformed this god of health into the sun-god Sol, majestic with sceptre and solar disc (drawing L.233, our Plate 76), whom he originally intended to represent as an isolated figure in an engraving. Before carrying out this intention, however, he became acquainted with Barbari's engraving *Apollo and Diana* under the influence of which he converted the Sol into a 'regular' Apollo and placed a Diana at his side.[38] In the end, he gave up all these ideas and placed the classical figure in the service of a Biblical theme: the ultimate result was the *Fall of Man* of 1504 (engraving B.1, our Plate 80) where the examples of perfect

Vitruvius canon, see Panofsky, *Dürers Kunsttheorie*, p. 84 ff. The *Reclining Nude* (drawing L.466, dated 1501), her pose patterned after that of the so-called *Amymone* (engraving B.71) and, therefore, familiar to Dürer before he could have seen a classical *Circe*, now lost, who 'nuda incumbebat innixa dextro bracchio', approximately dates this intrusion of the Vitruvius canon – entailing a square rather than rectangular proportioning of the chest – upon the system established in such earlier specimens as the drawings L.37/38, L.225/226 (dated 1500) and R. Bruck, *Dürers Dresdner Skizzenbuch*, Strassburg, 1905, Pls. 74/5.

37. E. Panofsky, 'Dürers Darstellungen des Apollo und ihr Verhältniss zu Barbari', *Jahrbuch der preussischen Kunstsammlungen*, XLI, 1920, p. 359 ff. [The interpretation of the drawing L.181 as 'Apollo Medicus' rather than 'Aesculapius' was suggested by K. T. Parker, 'Eine neugefundene Apollzeichnung Dürers', ibid., XLIV, 1925, p. 248 ff.]

38. The transformation of the Sol (short-haired, with sceptre and solar disc) into a 'regular' Apollo (with flowing locks, bow and arrows) is recorded in an 'auto-tracing' corrected in freehand (drawing L.179). In 1505, Dürer reverted to the Apollo and Diana theme, on an entirely different basis, in the engraving B.68; cf. Panofsky, ibid.

masculine and feminine beauty are juxtaposed in one paradigmatic composition.

Dürer's 'Apollo group', then, begins with an *Aesculapius* or *Apollo Medicus* and ends with an *Adam*. But this is no reason to deny, as had been done by Hauttmann, the influence of the *Apollo Belvedere* in favour of a Roman *Mercury* which, shortly before or after 1500, had been discovered in Augsburg and had passed into the possession of the well-known humanist, Conrad Peutinger (Plate 71).[39]

The question whether this '*Augsburg Mercury*' (now in the Maximilian-Museum at Augsburg) or the *Apollo Belvedere* was the prototype of Dürer's 'ideal male' can evidently not be answered by a comparison with the Adam in the *Fall of Man*, who, we recall, marks the very end of the development and, as observed by Wölfflin,[40] fuses the posture of Dürer's previous figures with that of Barbari's *Apollo*.[41] Rather we must start at the beginning, that is to say, with either the 'Sol' drawing L.233 or, better yet, with the 'Aesculapius' or 'Apollo Medicus' drawing (L.181), which we have reason to consider as the earliest member of the whole series. This drawing must be compared with the '*Augsburg Mercury*', on the one hand, and with the *Apollo Belvedere*, on the other; and in examining the latter, we should consult, instead of a modern photograph, a contemporaneous rendering such as might have come to Dürer's attention – not, of course, a profile view as it appears in the *Codex Escurialensis* on folio 53,[42] but a front view as given on folio 64 of the same manuscript (Plate 77).[43]

39. Hauttmann, op. cit., p. 43 ff.

40. Wölfflin, op. cit., p. 366.

41. Therefore the 'firm stance' of the Adam can no more argue against the influence of the *Apollo Belvedere* than the fact that his head is turned the other way. For the relation between the Adam and the woodcut reproduced in Apianus' *Inscriptiones*, p. 422, see the Excursus, p. 330 ff.

42. H. Egger, *Codex Escurialensis*, Vienna, 1906.

43. This second rendering was apparently overlooked by Hauttmann, who maintains that a drawing after the *Apollo Belvedere* which could

From this comparison it is evident that Dürer's 'pre-Adamite' figures, no matter whether we consider the 'Aesculapius' or the Sol, are as like the *Apollo Belvedere* as they are unlike the *Augsburg Mercury*. They have in common with the *Apollo Belvedere*, first, the characteristic balance of the arms – the raising of the left responding to the lowering of the right; next, the turning of the head toward the side of the free leg; finally, and above all, the stance, which may be described as a graceful stride rather than a static pose;[44] in this respect the movement of Dürer's figures resembles the *Escurialensis* drawing more closely than it does the original statue. It should not be objected that he could have borrowed this stance from any other classical figure posed in what is known as a *contrapposto* attitude: strange though it may seem, the *Apollo Belvedere* is fairly unique and cannot be replaced at random, so to speak – least of all by the *Augsburg Mercury*. In this rather mediocre work both arms are lowered; the head is turned to the side of the supporting rather than of the free leg; and instead of the active, long-legged stride we have an apathetic pose of rest, the free leg only slightly moving to the side and hardly at all toward the rear. The thighs, emphatically diverging in the Dürer figures as well as in the *Apollo Belvedere*, are almost parallel; and the feet, placed at nearly identical angles in relation to the frontal plane, do not appreciably differ as to their relative position on the ground. It is impossible that Dürer could have interpreted the *Augsburg Mercury* in such a manner that his interpretation disagrees therewith in precisely those characteristics in which it agrees with the *Apollo Belvedere*.

In certain respects, to be sure, Dürer's 'Aesculapius' and

have furnished Dürer with a model for his ideal figures 'would have to be fundamentally different from all known ancient renderings of the statue' – a statement, incidentally, which could be refuted, apart from the *Codex Escurialensis*, by the engraving by Nicoletto da Modena (B.50, *c.* 1500).

44. That this position of the feet was important to Dürer is evident from its accentuation by a cast shadow in the drawing L.233.

Sol do differ from the Apollo of the *Escurialensis* drawing: in the strict frontality of the chest, in the method of indicating the muscles, in the foreshortening of the feet, and in a certain deceleration of the rhythmical movement (the right contour, for example, follows a nearly straight, vertical course instead of undulating in soft curves). These differences – which, by the way, would exist also in relation to the *Augsburg Mercury* – are, however, not inexplicable. The frontality of the chest is a necessary result of the geometrical scheme of construction employed by Dürer for all the figures in question,[45] and the other differences can be accounted for, I think, by the supervening influence of an engraving which we know was available to, and used by, Dürer at the time: Andrea Mantegna's *Bacchanal with the Vat* (B.19, our Plate 79). This engraving shows, near the left-hand margin, the figure of a bacchant holding a cornucopia in his right hand and with his left reaching up to a bunch of grapes. The impression of this figure seems to have merged in Dürer's imagination with that of the *Apollo Belvedere*. Just as Dürer found it necessary to improve upon the Italian prototype of his Hercules painting and his Apollo and Daphne woodcut[46] on the basis of Pollaiuolo's *Rape of the Sabine Women*, so did he find it necessary to improve upon whatever Italian copy of the *Apollo Belvedere* was available to him on the basis of Mantegna's splendid nude (which in turn reflects the impression of classical statuary).[47] Since in

45. For this, cf. L. Justi, *Konstruierte Figuren und Köpfe unter den Werken Albrecht Dürers*, Leipzig, 1902, and above, p. 131.

46. Such 'double stimuli' are not unusual in Dürer's work. See, e.g., the relationship of his *Amymone* to the group on the left in Mantegna's *Battle of the Sea Monsters* (copied by Dürer in the drawing L.455) and to Barbari's engraving *Victory*; or the relationship of his engraving B.75 (the '*Four Witches*') to Barbari's engraving *Victory and Fame*, and his own studies from life, assembled in the drawing L.101 (E. Schilling, 'Dürers vier Hexen', *Repertorium für Kunstwissenschaft*, XXXIX, p. 129 ff.).

47. Perhaps a Dionysus (cf. particularly Clarac, op. cit., No. 1619b). Professor Fischel has called my attention to a mural in the Casa de'

'archaeological' representations of classical monuments not much attention is given to anatomical detail at this time, no copy of the *Apollo Belvedere* could provide more than a *schema*, as it were, which had to be supplemented from other sources. In such anatomical details as the knee joints, the handling of the contours and, most particularly, the design of the feet Dürer therefore adhered to the Mantegna engraving which, like its companion piece, the *Bacchanal with Silenus*,[48] must have been known to him from as early as 1494 or 1495, and which occupied his mind precisely at the time when he was working on the 'Apollo group'. He used the bacchant's cornucopia in three different places: in the Bookplate for Pirckheimer (woodcut B.app.52), in the dedication page of the *Libri amorum*,[49] and in one of the studies in feminine proportions[50] – that is to say, in works produced around 1500 and one of which is particularly close to the earliest members of the 'Apollo group' in subject as well as in time.[51]

However, if Dürer's earliest attempt at rationalizing the proportions and posture of the 'perfect male' is based upon a copy after the *Apollo Belvedere*, why does it not appear in the guise of a 'regular' Apollo? As paradoxical as it may seem, the answer is: just because it is based upon a copy after

Vetti in Pompeii which shares with Mantegna's bacchant even the motif of the cornucopia; another version of this figure could have been known in the Renaissance.

48. Engraving B.20; cf. Dürer's drawing L.454.

49. Woodcut P.217; cf. A. Lichtwark, *Der Ornamentstich der deutschen Frührenaissance*, Berlin, 1888, p. 9.

50. Bruck, op. cit., Plates 70/71; for the date of this drawing, cf. Panofsky, *Dürers Kunsttheorie*, p. 90, Note 1.

51. The St George in Dürer's Paumgärtner Altarpiece, another figure which Hauttmann attempts to derive from the *Augsburg Mercury*, may also go back to Mantegna's Satyr, which has everything that Dürer might have learned from the Augsburg sculpture; from a compositional point of view, the saint's dragon is certainly more similar to the Satyr's cornucopia than to Mercury's *marsupium*. Cf. also below, Note 26, p. 325.

the *Apollo Belvedere*. With both hands missing in the original and the quiver unrecognizable in any frontal rendering,[52] the *Apollo Belvedere*, as Dürer and his humanist advisers could know him, was identified by only one attribute: the snake conspicuously sliding up the tree trunk behind him. And neither Dürer nor his friends can be blamed for misinterpreting this snake – as we now know, Apollo's Python, added by the ancient copyists[53] – as the well-known symbol of health, belonging with equal right to 'Apollo Medicus' and Aesculapius.[54]

Thus even the iconography of Dürer's first 'ideal' figures would seem to argue for, and not against, their derivation from the *Apollo Belvedere*.[55] Dürer did not go out to meet the Antique; the Antique went out to meet Dürer – by way of an Italian intermediary.[56]

52. See, for example, our Plate 77.

53. W. Amelung, *Die Sculpturen des vatikanischen Museums*, II, Berlin 1908, p. 257.

54. For a much more serious misunderstanding of a serpent, see the Appendix to Apianus' *Inscriptiones* (fol. 6), where an *Infant Hercules Strangling the Snakes* is interpreted as '*The Second Son of Laocoön*'.

55. It is quite true that Dürer did not represent a 'regular' Apollo until relatively late; but he did not represent Mercury at all – except for the drawings L.420 and L.652, which are derived, not from the Augsburg sculpture but from a drawing by Hartmann Schedel after Cyriacus of Ancona. That the *Apollo Belvedere* itself does not appear in Apianus' publication can be accounted for by the fact that this enterprise is essentially a corpus of inscriptions, the illustration of which, laying no claim to completeness, was limited to such material as happened to be at hand (see Apianus' own remark, p. 364).

56. I also disagree with Hauttmann's contention that the woodcut B.131 (*The Rider with the Lansquenet*) derives from a Roman tombstone which until 1821 could be seen in a small street at Augsburg and is illustrated in Marx Welser, *Rerum Augustanarum libri VIII*, Augsburg, 1594, p. 226 (Hauttmann, op. cit., p. 40). Even had this monument, not mentioned before 1594, been accessible one hundred years earlier, its connexion with Dürer's woodcut would not be acceptable. The woodcut, it is true, does seem to presuppose a model the direction of which has been reversed (although the fact that the rider holds the reins with his left hand is in itself by no means unusual); but this model is found in one of Dürer's own works. In the middle ground of

III CLASSICAL ANTIQUITY AND THE MIDDLE AGES:
'Helios Pantokrator' and 'Sol Iustitiae'

Dürer's peculiar situation in regard to classical antiquity
comes into focus when we consider his representations of

a drawing known as *'The Pleasures of the World'* (L.644) is seen a rider
in nearly identical movement, likewise accompanied by a dog and a
running man who, though differently dressed and equipped, resembles
the second figure in the woodcut in every other respect. There is no
doubt that the woodcut was developed from this small triad which
Dürer singled out for an independent representation anticipating the
Four Horsemen of the Apocalypse. In addition, all the criteria supposedly
peculiar to Dürer's woodcut are in reality quite typical of Northern art
(see, for example, apart from numerous representations in engravings,
paintings and seals, the small St George relief by Adam Krafft, re-
produced, e.g., in G. Dehio, *Geschichte der deutschen Kunst*, II, Berlin
and Leipzig, 1921, No. 340). Even the gesture of the arm extended to-
ward the rear has closer parallels in Northern representations than in
the Roman tombstone (where it appears, not as an expressive gesture,
but as a mere equestrian action). We find it, in particular, in repre-
sentations of the Legend of the Three Quick and the Three Dead (cf.
below, p. 355 ff.); for a nearly contemporary instance, see, for ex-
ample, a miniature in the Berlin Kupferstichkabinett (reproduced in
K. Künstle, *Die Legende der drei Lebenden und der drei Toten*, Freiburg,
1908, Pl. IIIa), where one of the three young men stopped on their way
by three ghastly corpses gallops away with a similar gesture of fear or
repugnance. Quite possibly Dürer's invention originated from repre-
sentations of this kind which were particularly popular toward the
end of the fifteenth century; his drawing teaches the same lesson as
does the Legend of the Three Quick and the Three Dead, except that
the thoughtless young people neither flee from Death, nor are engaged
by him in philosophical dialogue but – unbeknownst to themselves –
are threatened by his hidden presence.

Apart from all this, Hauttmann's suggestion is unacceptable on
chronological grounds. The woodcut B.131 cannot possibly be dated
after *c.* 1497 – the Oxford drawing is even one or two years earlier –
whereas Dürer's alleged first visit to Augsburg, according to Hautt-
mann's own chronology, could not have taken place until 1500 (op.
cit., p. 37). This first trip to Augsburg, incidentally, is purely con-
jectural: the Portrait of Jacob Fugger must be excluded from the dis-
cussion because it is a work of the years 1518–20; see, apart from all
stylistic considerations, the inscribed date (1518) on the preliminary
study in the Berlin Kupferstichkabinett (L.826).

the planetary sun-god. Even before he planned to depict him as a member of the pagan Pantheon, resplendent in Apollonian beauty (Plate 76), he had portrayed him in an engraving of *c.* 1498 (B.79, our Plate 82) which lends expression to the Christian belief in redemption and retribution. And while the pagan image – classical in form as well as content – is based upon a Quattrocento copy of the *Apollo Belvedere* which appears to have come into Dürer's possession in Nuremberg, the Christian image – thoroughly medieval in every respect – reflects the impression of a Gothic sculpture which had attracted his attention in Venice. Thus, curiously enough, Dürer brought back from Italy, where so many Greek and Roman originals were available to him, the inspiration for a medieval work; at home, depending only on Renaissance copies of classical models, he penetrated the meaning of the Antique and produced a work permeated with true classical feeling.

The sun-god, Helios or Sol as distinct from Apollo, had not played an overly important role in Greek religion at the time of Pericles or Plato. But under Asiatic and Egyptian influence he rose to supreme magnificence in the Hellenistic age. The arts paid homage to him by wonderful temples and countless images, and fervent prayers were offered to him: "Ἥλιε Παντοκράτορ, κόσμου πνεῦμα, κόσμου δύναμις, κόσμου φῶς (' All-Ruler, Spirit of the World, Power of the World, Light of the World').[57] It was the natural climax of a development extending over centuries when Aurelian proclaimed the 'Never-Vanquished Sun' ("Ἥλιος ἀνείκητος, ' Sol Invictus') the supreme divinity of the Roman Empire.[58]

It is in this interpretation that the sun-god, juxtaposed with Diana, appears in Dürer's drawing L.233 (Plate 76): proudly erect, nobly proportioned, beautifully poised, digni-

57. F. Cumont, 'Mithra ou Sarapis kosmokrator', *Comptes Rendus des séances de l' Académie des Inscriptions et Belles-Lettres*, 1919, p. 322.

58. *Idem, Textes et Monuments figurés relatifs aux Mystères de Mithra*, Brussels, I, 1899, p. 48 ff. Further, H. Usener, 'Sol invictus', *Rhein-isches Museum für Philologie*, LX, 1905, p. 465 ff.

fied by the sceptre – a true Pantokrator. This sun god is thoroughly classical even in iconography; in fact, it is in its iconographical aspects – and *only* in its iconographical aspects – that Dürer's drawing would seem to reflect a direct influence of the Antique. As we have seen, it was not a matter of course for him to interpret the *Apollo Belvedere* as a solar divinity; nor could he know without expert instruction the difference between a late-medieval and a classical sceptre (σκῆπτρον) which is, by definition, a 'staff' rather than the complex object carried by the rulers of Dürer's own time. And I should like to propose that both the general idea of presenting the *Apollo Belvedere* as a Helios Pantokrator and the specific concept of a sceptre shaped like a plain, long staff and crowned with a kind of pomegranate were suggested to Dürer by classical coins.[59] On the coins of the Imperial period the sun-god occurs in countless variants: in bust form, as a charioteer 'in quadriga', and in the guise of a ceremonial statue. Where he is especially designated as *Sol invictus*, he raises his right hand in solemn benediction,[60] while in his left he holds the orb, the whip or the thunderbolt,[61] and on the coins of Asia Minor, especially in Phrygia and Cappadocia, he carries, in addition, a sceptre crowned with a sphere or fruit. When Dürer had abandoned the 'Aesculapius' or 'Apollo Medicus' version and asked his learned friends about another possible interpretation, they could have easily referred him to a coin like this; even four hundred years later, a great German scholar, Hermann Usener, commented on the 'family likeness' that exists between representations of the *Sol invictus* and the *Apollo Belvedere*. I reproduce a coin of the city of Aizenis (Plate 78)[62]

59. I wish to thank Dr Bernhard Schweitzer for calling my attention to this field.

60. For the meaning of this gesture, see F. J. Dölger, *Sol salutis*, Münster, 1920, p. 289.

61. For the various types of Sol on coins, see Usener, op. cit., p. 470 ff.

62. *British Museum, Catalogue of the Greek Coins of Phrygia*, Barclay V. Head, ed., 1906, Pl. V, 6 (Text, p. 27); cf. also the coins from Caesarea

which corresponds to Dürer's drawing in every respect – except for the fact that he, in accordance with medieval tradition,[63] substituted a solar disc for the solar orb: the imperatorial attitude of the Antique was no longer within his reach.[64]

The religious experience of late antiquity was so closely allied to astral mysticism, and so thoroughly imbued with the belief in the omnipotence of the sun-god, that no new religious idea could gain acceptance unless it was either invested with solar connotations from the outset – as was the case with Mithras worship – or else acquired such solar connotations *ex post facto* – as was the case with Christianity. Christ was to triumph over Mithras; but even He could triumph only after – or, rather, because – His cult had absorbed some of the vital features of sun worship, from the

in Cappadocia (*British Museum, Catalogue of the Greek Coins of Galatia, Cappadocia and Syria*, Warwick Wroth, ed., 1893, Pls. VII, 12; IX, 6, 7; X, 6, 14; XI, 11; XII, 3).

63. See, e.g., the Sol illustrated in our Plate 83; further, F. Saxl, 'Beiträge äu einer Geschichte der Planetendarstellungen', *Der Islam*, III, p. 151 ff., Fig. 15, upper right.

64. When the sun-god is represented together with the Emperor, it is the Emperor who receives the sceptre and the orb, while the god who crowns him must be content with the whip: cf. the coin of Constantine the Great reproduced in Hirsch, *Numismatische Bibliothek*, XXX, 1910, No. 1388. That Dürer could become acquainted even with rarer classical coins is not surprising. Because of their historical and epigraphical interest and relatively easy accessibility, classical coins were favourite collectors' items of the German humanists. For Peutinger's collection, see Hauttmann, op. cit., p. 35. That Pirckheimer, too, owned a 'considerable collection of Greek and Roman coins' is attested in his biography (chiefly composed by his great-grandson, Hans Imhoff III), which forms the Introduction to Pirckheimer's *Opera*, M. Goldast, ed., Frankfurt, 1610. Pirckheimer composed a numismatic treatise *De priscorum numismatum ad Norimb. monetae valorem aestimatione* (*Opera*, p. 223 ff.) and planned to publish a complete list of emperors from Julius Caesar to Maximilian I, which Dürer should have illustrated on the basis of their coins (*Opera*, p. 252 ff.).

date of his birth (25 December)[65] down to the tempest that
lifts Him to heaven (in Revelation).[66] The Church itself
sanctioned this union between Christ and the sun from the
very beginning; but in doing so, it opposed to, and finally
substituted for, the cosmological[67] sun-god a moral one: the
Sol invictus became a *Sol Iustitiae*, the 'Never-Vanquished
Sun' a 'Sun of Righteousness'.[68]

This substitution was not difficult to accomplish. First,
paganism itself had tended to spiritualize the physical sun
into an 'intelligible Helios';[69] second, the sun-god had of
old been endowed with the character of 'judge';[70] third, and
most important, this equation of 'sun' and 'justice' could
be confirmed by a saying of the prophet Malachi: 'Et orietur
vobis timentibus nomen meum Sol Iustitiae', 'But unto you
that fear my name shall the Sun of righteousness arise. . . .'
Today we tend to interpret such a sentence metaphorically;
in former centuries it had a perfectly literal meaning. The
'sun of righteousness' represented not so much the imper-
sonal idea of justice as a personal sun-god – or solar daemon
– in his capacity of judge;[71] St Augustine had to warn vigor-

65. See H. Usener, 'Sol invictus', p. 465 ff.; idem, *Das Weihnachts-
fest*, Bonn, 1899 (and 1911), *passim*.

66. See F. Boll, *Aus der Offenbarung Johannis*, Leipzig and Berlin,
1914, p. 120.

67. Cf. the invocation of the priests of Heliopolis quoted above, p.
299.

68. Usener, 'Sol invictus', p. 480 ff.; Cumont, *Textes et Monuments*,
I, p. 340 ff., particularly p. 355 f.

69. For the 'intelligible' "Ηλιος, see O. Gruppe, *Griechische Mytho-
logie (Handbuch der klassischen Altertumswissenschaft*, V, 2), II, 1906, p.
1467.

70. The function of 'judge' is already attributed to the Babylonian
sun-god Šamaš; hence the planet Sol is occasionally equipped with a
sword in Arabic representations (cf. Saxl, op. cit., p. 155, Fig. 4). This
type recurs here and there even in Germany (cf. A. Schramm, *Der
Bilderschmuck der Frühdrucke*, III, *Die Drucke von Johannes Baemler in
Augsburg*, Leipzig, 1921, No. 732).

71. 'Is it so astonishing then that the devout multitude did not
always observe the subtle distinctions of the Doctors and, in obedi-

ously against carrying the identification of Christ with Sol so far as to relapse into paganism.[72] But these very pagan implications of the *Sol Iustitiae* formula endowed it with an irresistible emotional impact; from the third century on it was one of the most popular and effective metaphors in ecclesiastical rhetoric;[73] it played a large role in sermons and hymns;[74] and it has its place in the liturgy up to this day;[75] to the early adherents of Christianity it was 'a triumphant invocation' by which they 'were moved to almost drunken ecstasy'.[76]

As the Christian concept of *Sol Iustitiae* – Christian in spite of the fact that it was rooted in Babylonian astrology, Graeco-Roman mythology and Hebrew prophecy – competed with the pagan concept of *Sol invictus* in the mind of late antiquity, so did these two concepts compete in the imagination of Albrecht Dürer. But in the era of newly born Christianity the Biblical Sol displaced the pagan, whereas, in the age of the Renaissance, the pagan Sol displaced the Biblical until a final fusion of the two ideas was achieved – which happened when Dürer, after having converted the Apollonian sun-god into an Adam, transformed him into the resurrected Christ in several prints (e.g., the woodcut B.45, our Plate 81) and permitted the analogy between the Saviour and 'Phoebus' to be stressed in a poem printed on the back of one of them.[77]

ence to a pagan custom, rendered to the radiant star of day the homage which orthodoxy reserved for God?' (Cumont, *Textes et Monuments*, p. 340).

72. ibid., p. 356.

73. ibid., p. 355. Further, J. F. Dölger, op. cit., p. 108.

74. Examples in Dölger, ibid., pp. 115, 225.

75. Usener, 'Sol invictus', p. 482.

76. ibid., p. 480.

77. [See also the engraving B.17 and the woodcut B.15. The verso of the woodcut B.45 bears the poem (composed by Benedictus Schwalbe, called Chelidonius) referred to in the text:

> *Haec est illa dies, orbem qua condere coepit*
> *Mundifaber, sanctam quam relligione perenni*
> *Esse decet domino coeli Phoeboque dicatam.*

The engraving B.79 (our Plate 82) is normally referred to as '*The Judge*' or '*Justice*'.[78] 'Justice', however, was usually represented as a woman, occasionally winged; and how can we account for the lion, the fiery halo, and the three flames that burst from the 'Judge's' eyes?

All these questions are answered as soon as we realize that the subject of Dürer's engraving is the *Sol Iustitiae*, conceived, to be sure, as the Apocalyptic avenger rather than the merciful judge, and for this very reason strongly appealing to the spirit of the late fifteenth century. We can even name the literary source by which this interpretation was conveyed to Dürer: the *Repertorium morale* of Petrus Berchorius (Pierre Bersuire), whose '*Moralized Ovid*' has been mentioned on two previous occasions. After a lengthy exposition of the now familiar identity between Christ and the sun, this theological dictionary, one of the most popular books of the later Middle Ages, gives a description of the *Sol Iustitiae* which would appear as a literal paraphrase of the Dürer engraving were it not more than a century and a half earlier – a description which Dürer is all the more likely to have known as Berchorius' *Repertorium* had been printed by his own godfather, Anton Koberger, in 1489 and appeared in a second edition (1499) exactly at the same time as did the engraving:

Further I say of this Sun [viz., the 'Sun of righteousness'] that He shall be inflamed when exercising supreme power, that is to

Qua sol omnituens cruce nuper fixus et atro
Abditus occasu moriens, resplenduit ortu

('This is the day on which the Creator began to make the world, dedicated, according to perennial belief, to the Lord of Heaven and Phoebus. On this day the all-seeing Sun, affixed to the cross, hidden and dying when the sun set in darkness, splendidly reappeared when it rose.')]

78. Preparatory drawing L.203. Thausing's attempt to explain the engraving as a disconnected conglomeration of individual Apocalyptic motifs (op. cit., I, p. 319 [English translation, I, p. 310]) fails to do justice to Dürer's intention.

say, when He sits in judgement, when He shall be strict and severe ... because He shall be all hot and bloody by dint of justice and strictness. For, as the sun, when in the centre of his orbit, that is to say, at the midday point, is hottest, so shall Christ be when He shall appear in the centre of heaven and earth, that is to say, in Judgement [note the equation of the astrological notion, *medium coeli*, with the theological notion, *medium coeli et terrae*, presumed to be the seat of the Judge!]. ... In summer, when he is in the Lion, the sun withers the herbs, which have blossomed in the spring, by his heat. So shall Christ, in that heat of the Judgement, appear as a man fierce and leonine; He shall wither the sinners and shall destroy the prosperity of men which they had enjoyed in the world.[79]

These words make us see how the imagination of the late Middle Ages, troubled by Apocalyptic visions and, at the same time, filled with the notions induced by the increasingly powerful influx of Arabic and Hellenistic astrology, reactivated the ancient image of the *Sol Iustitiae* into terrifying vitality. That sun whom the Early Christian era had still been able to visualize in Apollonian beauty assumed the powers of a planetary daemon while acquiring the majesty of the supreme Judge: he was conceived as the *judex in iudicio* but also the *sol in leone* (the zodiacal 'mansion' of the sun in which he 'reaches the height of his power'), 'hot and inflamed' as the blazing star and 'bloody and severe' as the Apocalyptic god of vengeance.

Only the power of a Dürer could translate this concept

79. *P. Berchorii dictionarium seu repertorium morale*, first printed Nuremberg 1489 and 1499, and frequently thereafter, under 'Sol': 'Insuper dico de isto sole [sc., iustitiae], quod iste erit inflammatus, exercendo mundi praelaturam, sc. in iudicio, ubi ipse erit rigidus et severus ... quia iste erit tunc totus fervidus et sanguineus per iustitiam et rigorem. Sol enim, quando est in medio orbis, sc. in puncto meridiei, solet esse ferventissimus, sic Christus, quando in medio coeli et terrae, sc. in iudicio apparebit. ... Sol enim fervore suo in aestate, quando est in leone, solet herbas siccare, quas tempore veris contigeat revivere. Sicut Christus in illo fervore iudicii vir ferus et leoninus apparebit, peccatores siccabit, et virorum prosperitatem, qua in mundo viruerant, devastabit.'

into an image. He could do it because, as in the cases of the *Apocalypse* and the *Agony in the Garden*,[80] he had the courage to be literal within the framework of a style aspiring to the sublime. He rendered the *inflammatus* of the Berchorius text by the same palpable flames which he had used in illustrating the Biblical 'and his eyes as flames of fire'.[81] He interpreted the astronomical localization *quando est in leone* as denoting a figure seated upon a lion as upon a throne; and in order to characterize the Christ-Sol as a *homo ferus ac leoninus*, he transformed Him, to use his own expression, into 'the leonine man':[82] he endowed Him with an expression both fierce and fearful which imparts to His face a weird resemblance with the woeful physiognomy of the – in turn somewhat anthropomorphic – animal. '*Sol iustitiae*', then, 'Christ as Sun-God and Supreme Judge', would seem to be the title which does justice to the iconographical attributes as well as to the mood of Dürer's engraving. For what greater tribute could we pay to the expressive power of this small print than to identify its content with a concept which fuses the grandeur of the Apocalyptic judge with the strength of the mightiest force of nature?

Considering the engraving from a purely art-historical

80. Drawing L.199, woodcut B.54.

81. See the woodcut B.62, where the number of flames is reduced to two because only the eyes, not the whole face, are described as 'tamquam flamma ignis' (Revelation 1 : 14). The dry plants at the feet of the Judge in the engraving may allude to the 'herbs withered by the sun-god as the sinners are withered by Christ'.

82. Lange and Fuhse, op. cit., p. 371, line 22: 'Wie wohl man zu Zeiten spricht, der Mensch sicht lewisch oder als ein Bär, Wolf, Fuchs odere in Hund, wie wohl er nicht 4 Füss hat als dasselb Tier: aus solchem folgt nit, dass solche Gliedmass do sei, sondr dass Gmüt gleicht sich darzu' ('One says at times that a man looks leonine, or like a bear, wolf, fox or dog, although he does not have four feet like the animal in question. But from this it does not follow that he has such limbs; rather [we mean that] his character resembles theirs'). Dürer thus changes the physiognomical interpretation of the correspondence between humans and animals (cf. Leonardo da Vinci and Giovanni Battista della Porta) to a psychological one.

point of view, we may derive its iconography, on the one hand, from the traditional medieval representation of the 'judge' who, according to prescribed custom, dispenses justice while sitting with legs crossed;[83] on the other, as already hinted at, from a piece of sculpture with which the artist had become acquainted in Italy (Plate 83). Normally in Western art the planetary divinities are represented standing, enthroned, on horseback, or riding in a chariot,[84] but not, as here, seated on their respective signs. This type was peculiar to the Islamic East[85] and could take root in Europe only where oriental influences were as potent as in Venice. Here, right on the corner of the Piazzetta and the Riva degli Schiavoni, two of the capitals on the Palace of the Doges show the seven planets represented in such a manner that as many as possible are seated on their zodiacal signs: Venus on the bull, Mars on the ram, and Sol on the lion.[86] We have no reason to doubt that Dürer remembered this isolated[87] but

83. To limit ourselves to Dürer's own work: see the Pilate in the woodcut B.11, and the Emperor in the woodcut B.61. The seated posture with crossed legs is expressly prescribed to judges in the *Rechtsordnung* of the city of Soest (N. Beets, 'Zu Albrecht Dürer', *Zeitschrift für bildende Kunst*, XLVIII, 1913, p. 89 ff.).

84. See F. Lippmann, *The Seven Planets* (trans. Florence Simmonds, *International Chalcographic Society*, 1895); Saxl, op. cit.; *idem*, *Verzeichnis astrologischer und mythologischer illustrierter Handschriften des lateinischen Mittelalters in römischen Bibliotheken* (*Sitzungsberichte der Heidelberger Akademie der Wissenschaften*, phil.-hist. Klasse, IV), 1915; A. Hauber, *Planetenkinderbilder und Sternbilder*, Strassburg, 1916.

85. See Saxl, 'Beiträge', p. 171. The best-known representation of Sol mounted on his lion is found in an Arabic manuscript at Oxford, *Codex Bodleianus* Or. 133. [A Turkish copy of this manuscript, produced in the sixteenth century, can be consulted in the Morgan Library in New York, MS. 788.]

86. Reproduced in Didron, *Annales Archéologiques*, XVII, 1857, Plate following p. 68.

87. There are two types of representations which should not be confused with that under discussion here:

a. The Planet on a throne consisting of two symmetrically addorsed zodiacal animals (cf., e.g., Guariento's frescoes in Padua, reproduced in *L'Arte*, XVII, 1914, p. 53). This type may have come into being by

conspicuous work when designing his print, which agrees with the Venetian capital not only in a general way but also in such details as the posture of the lion 'passant guardant', the flaming halo encircling the head of the sun-god and the raised left arm which in the engraving appears as the right.[88]

It does not diminish Dürer's greatness if one of his most impressive inventions can be traced back to earlier sources both with respect to subject matter and compositional motifs. Only Dürer, and only the Dürer of the *Apocalypse*, could have charged a singular but comparatively insignificant figure with so exalted a content and, conversely, cast so grand but unsubstantial an idea into visible form.[89]

the incorporation of the zodiacal signs into the customary *sella curulis*. Cf. also the *Venetia* in the Palace of the Doges or the Angels of Justice on the capital near the Porta della Carta.

b. The Planet seated on an animal with which he is connected mythologically but not astrologically: for instance, Jupiter sitting on an eagle in the Tübingen manuscript adduced above (Hauber, op. cit., No. 24). This type directly derives from classical tradition: cf. Saxl, *Verzeichnis* . . ., Fig. VIII.

88. That the engraving is reversed in relation to the capital may be considered as further evidence of a connexion.

89. Just as Dürer's *Melencolia I* was copied by numerous subsequent artists but grasped in its full complexity by none, so the engraving B.79 was appropriated by the sixteenth century, but with only fractional understanding. The Sol picture in the Frankfurt Calendar of 1547 illustrated in our Plate 84 (G. Pauli, *Hans Sebald Beham* Strassburg, 1901, p. 49; for earlier occurrences in broadsheets, see Saxl,' Beiträge', p. 171, Note 1) is nothing but a woodcut paraphrase of Dürer's *Sol Iustitiae* (Plate 82), and the borrowing is all the more obvious as none of the other planets are seated on their zodiacal signs; they all appear in ordinary Western guise. The symbols of Justice, however, were lost in the process of adaptation: instead of assuming the 'judge's posture' with crossed legs, the planetary ruler sits with legs apart; instead of the sword, he holds the customary sceptre; instead of the scales, an Imperial orb. But even so the very fact that Dürer's engraving could be adapted for a representation of the Planet Sol in the sixteenth century tends to support the interpretation here proposed.

[While this woodcut reduces Dürer's *Sol Iustitiae* to a sun-god deprived of his judicial significance, a number of other sixteenth-century representations, notably a wood-carved group by Hans Leinberger

IV THE FUNDAMENTAL QUESTION

In one of the ironical invectives which Goethe occasionally directed against the Romantic realists who scorned the Antique he expressed himself as follows: 'Die Antike gehört zur Natur, und zwar, wenn sie anspricht, zur natürlichen Natur; und diese edle Natur sollen wir nicht studieren, aber die gemeine?'[90] ('Classical art is part of nature and, indeed, when it moves us, of natural nature; are we expected not to study this noble nature but only the common?').

By means of this peculiar terminology, almost impossible to duplicate in English, Goethe substitutes for the notion of 'idealism' normally applied to classical art a special concept of 'naturalness'. There is, he means to say, a distinction between 'common' nature (which may be described as 'nature in the raw') and 'noble' nature. The latter, however, differs from the former only by a higher degree of purity and, as it were, intelligibility, but not in essence. It is, on the contrary, a more 'natural' nature; and in rejecting the 'common' in favour of the 'noble', classical art does not, according to Goethe, repudiate nature but reveals her inmost intentions.

In thus reformulating the academic doctrine of the *beau idéal* (and thereby resolving the conventional antithesis of 'naturalism' and 'idealism' into two kinds of naturalism, 'noble' and 'common'),[91] Goethe evidently uses the words

preserved in the Germanisches Nationalmuseum at Nuremberg, reduces him to a judge deprived of his solar implications; see the excellent article by Kurt Rathe, cited above, p. 10.]

90. Goethe, *Maximen und Reflexionen*, M. Hecker, ed., 1907 (*Schriften der Goethe-Gesselschaft*, Vol. XXI), p. 229.

91. Even in our everyday speech we use the word 'natural' not only to describe all that belongs to nature, but also in a pregnant and, at the same time, laudatory sense which almost amounts to the same thing as 'noble simplicity' or 'harmony'. By a 'natural' gesture, for example, we understand a gesture which is neither clumsy nor affected but re-

'nature' and 'natural' in what is known as a pregnant sense ('nature' and 'natural' as opposed to 'reality' and 'real').[92] In this, he would seem to have followed the well-known definition of Kant: 'Natur ist das Dasein der Dinge, sofern es nach allgemeinen Gesetzen bestimmt ist'[93] ('Nature is the existence of things in so far as it is determined by general laws'). And if we are careful to limit our conception of classical art to those of its manifestations which we are wont to consider as 'classical' in the narrower sense of the term (roughly speaking, its manifestations from the Temple of Olympia and the Parthenon to the Mausoleum and the Altar of Pergamon, and everything dependent thereon), we can well understand – and, to a degree, accept – what Goethe had in mind.

As the world of the physicist or entomologist comprises the sum total of special events or specimens each of which is considered only as exemplifying either a law or a class, so does the world of the classical artist comprise the sum total of types each of which represents a number of individual cases[94] – 'particulars' reduced to 'universals' not by discursive abstraction but by intuitive synthesis.[95]

sults from a complete accord between what is intended to be expressed and the form expressing it.

92. Thus the style of classical antiquity might be characterized as 'naturalistic idealism'. Without this qualification the concept of 'idealism' would characterize not only the 'classical' style which, by 'ennobling' what Goethe calls 'common nature', hopes to do justice to nature as such, but also such styles as do not attempt to do justice to nature at all.

93. Kant, *Prolegomena*, 14.

94. The so-called 'theory of selection', dramatized in the incessantly repeated and often ridiculed tale of Zeuxis' attaining to perfection by combining the 'most beautiful parts' of five (or seven) virgins (cf. also the story of the 'fraw Florentina' in the forty-seventh chapter of the *Gesta Romanorum*, which undoubtedly derives from this ancient anecdote), may thus be considered as a materialistic rationalization of an aesthetic principle which in itself was correctly observed.

95. The contrast between 'nature' and 'reality' has been misinterpreted, I believe, by W. Worringer (*Genius*, I, 1919, p. 226). In his

This *typenprägende Kraft* ('type-coining power') of classical art – which could even supply prototypes for the representation of the God-man Christ because it had invested all possible subjects with forms both universally valid and saturated with reality – is evident in every medium. As the system of Greek architecture lends exemplary expression to the properties and function of inanimate matter so does the system of Greek sculpture and painting define typical forms of the character and behaviour of living creatures, particularly man. And not only the structure and movement of the human body, but also the active and passive emotions of the human soul were sublimated, in accordance with the precepts of 'symmetry' and 'harmony', into noble poise and furious battle, sweetly sad parting and abandoned dance, Olympian calm and heroic action, grief and joy, fear and ecstasy, love and hate. All these emotional states were reduced, to use a favourite expression of Aby Warburg's, to 'pathos formulae' which were to retain their validity for many centuries and appear 'natural' to us precisely because they are 'idealized' as compared to reality – because a wealth of particular observations had been condensed and sublimated into one universal experience.

Thus to have captured and ordered the multitude of phenomena is the eternal glory of classical art; at the same

well-known antipathy to all 'classic-organic' art, this author contends that the transformation of reality into nature is an act of 'rational cognition', defining 'reality' as 'nature not as yet penetrated by comprehension in terms of natural laws, not as yet digested and polished by the routine procedures of *ratio* aiming at natural laws, ... not as yet defiled by the original sin ('Sündenfall') of rational cognition.' Actually, the classical transformation of 'reality' into 'nature' is neither less an act of creative intuition nor more an act of mere cognition than is the modern subordination of 'reality' to a mood or emotion. 'Reality' is the sum total of objects seen from a particularizing point of view; 'nature', the sum total of objects seen from a generalizing point of view. But in the realm of artistic activity one point of view is as 'creative' as the other. As Gustav Pauli once splendidly put it: 'The *ratio* of classical art is instinctive.'

time, however, it was its insurmountable barrier. Typification necessarily implies moderation; for where the individual is accepted only in so far as it corresponds to those 'general laws' which, according to Kant and Goethe, define the 'natural', there is no place for extremes. From Aristotle to Galen, Lucian and Cicero, classical aesthetics insists on harmony (συμμετρία, ἁρμονία) and the mean (τὸ μέσον); and every period which aspired to the measureless was either indifferent or hostile to the Antique. Greek architecture was incapable of evoking a vision of preternatural space (be it preternatural in the sense of weightless suspension, as in Byzantine churches, or Gothic verticalism) instead of expressing the organic balance of natural forces; and the Greek formulae for representing the human figure had to be rejected where either hieratic rigidity or unbounded movement was required. For, as the classical 'beauty pose' is rest tempered by movement, so is the classical 'pathos motif' movement tempered by rest; so that in classical art both action and inaction appear subjected to one and the same principle, unknown before, the *contrapposto*. Nietzsche was right in stating that the Greek soul, far from being all 'edle Einfalt und stille Grösse' ('noble simplicity and quiet grandeur'), is dominated by a conflict between the 'Dionysian' and the 'Apollonian'. But in Greek art these principles are neither inimical nor even divisible; they are united 'through a miracle of the Hellenic will'. In it there is neither beauty without movement nor pathos without moderation; the 'Apollonian', one might say, is 'Dionysian' *in potentia* while the 'Dionysian' is 'Apollonian' *in actu*.

Thus we can see why the German Renaissance movement was in no position to absorb classical art directly: not so much because there were not enough classical monuments but because the Antique was not as yet an 'object of possible aesthetic experience' from the standpoint of the Northern fifteenth century. For, when the international tradition of the Middle Ages had lost its power and national proclivities

asserted themselves more freely, the North had developed an attitude so diametrically opposite to that of classical art that any direct contact became impossible.

That 'classical art in the narrower sense' tends toward the typical can be accounted for, apart from other considerations, by the fact that it is fundamentally plastic – that its vision is limited to tangible bodies which, if not combined into continuous groups, maintain complete isolation and self-sufficiency. Accordingly, that principle of coordination or unification on which all artistic production is based must operate within the plastic bodies themselves. Isolated from its surroundings, each figure must contain in itself both unity and multiplicity, and this is possible only if it exemplifies or typifies a multitude of cases.

Northern fifteenth-century art, on the other hand, is particularistic and pictorial. Observing the luminary phenomena produced by the interaction of tangible and limited bodies with intangible and unlimited space, it seeks to fuse both into a homogeneous *quantum continuum*,[96] and to produce – preferably in the media of painting and the graphic arts but also, by a certain *tour de force*, in those of sculpture and architecture – pictorial images held together by the unity of a subjective 'point of view' and of an equally subjective 'mood'.[97] Where classical art, cutting off the particular ob-

96. Cf. for this, A. Riegl, *Die spätrömische Kunstindustrie*, Vienna, 1901, and 'Das holländische Gruppenporträt', *Jahrbuch der kunsthistorischen Sammlungen des Allerhöchsten Kaiserhauses*, XXIII, 1902, p. 71 ff. According to this great scholar it was in the art of the Germanic Low Countries, representing the Northern *Kunstwollen* at its purest, that the unification of solid bodies and incorporeal space was more strongly aspired to and more effectively realized than elsewhere. It is interesting to note that it was Arnold Geulincx, a native of Antwerp and an immigrant into Holland, who protested most vigorously against any distinction between corporeal and incorporeal quantities; in his opinion 'free' space is no less 'corporeal' than space taken up by material objects, since both are part of a homogeneous *corpus generaliter sumptum*.

97. The contrast between the classical and the Northern conception of art may be compared – to use Windelband's term – to the contrast

jects from universal space, could achieve unity in multiplicity only by investing each of them with a representative, or typical, significance, Northern fifteenth-century art, incorporating the particular objects with universal space and thus assured of a multiplicity *a priori*, could accept them as particulars: it was not necessary to look upon the individual case as a *pars pro toto* when it enjoyed the status of a *pars in toto*.

This subjective and particularizing spirit of Northern fifteenth-century art (which Dürer characterized in his well-known remark that every German artist wants 'a new pattern, of a kind never seen before')[98] could operate in two spheres, both outside Goethe's 'natural' or 'noble' nature and, for this reason, complementary to each other: the spheres of the *realistic* and the *fantastic*, the domain of intimate portraiture, genre, still life and landscape, on the one hand, and the domain of the visionary and phantasmagoric, on the other. The world of mere reality, accessible to subjective sensory perception, lies, as it were, *before* 'natural' nature; the world of the visionary and phantasmagoric, created by equally subjective imagination, lies *beyond*

between 'nomothetical' and 'idiographic' systems of knowledge. Classical art corresponds to the natural 'sciences', which see abstract (viz., quantitative) and universal laws realized in an individual case (for example, the law of gravity in the falling apple); Northern art corresponds to the humanistic, that is to say, historical, disciplines which view the individual case as a link in a greater, but still concrete (viz., qualitative) and, within its wider scope, still individual' sequence' (for example, the changes in the statutes of a particular guild as an instance of the 'process of development' from the Middle Ages to modern times). Where the natural scientist proceeds idiographically (e.g., when a geographer describes a particular mountain), he may be said to consider this mountain not as a part of nature in general but as a phenomenon *sui iuris*, as something that has evolved, and not as something that has been caused. Conversely, where the humanist proceeds nomothetically (e.g., when a student of economic history attempts to establish certain laws for which universal validity is claimed), he may be said to operate as a would-be scientist.

98. Lange and Fuhse, op. cit., p. 183, line 29.

'natural' nature. Small wonder that Dürer could produce, at the same time, the *Apocalypse* and such genre engravings as the *Rustic Couple* or the *Cook and His Wife*;[99] and a comparison between a Grünewald devil and the *Medusa Rondanini* makes it abundantly clear that classical art bestowed beauty – or, to use that other expression, 'naturalness' – even upon the demoniacal.

Thus, even if Germany and the Low Countries had been flooded with classical originals, the German and Netherlandish artists would not have had any use for them: they would have overlooked or disapproved of them just as the Italian Renaissance overlooked or disapproved of Byzantine and Gothic monuments. True, from the fifteenth century on, the Northerners, too, devoted a concerted effort to a revival of classical antiquity, and the sixteenth century was an age of humanism in France, in Germany and in the Lowlands no less than in Italy. The German humanists delved deep into ancient history and mythology, wrote classical Latin and good Greek,[1] translated their family names into Greek or Latin,[2] and assiduously collected the physical remnants of

99. In Dürer's engraving B.94, *The Young Couple and Death*, one may perceive a meeting of both tendencies in one and the same work.

1. See, e.g., G. Doutrepont, *La Littérature française à la cour de Bourgogne*, Paris, 1909, p. 120 ff.

2. This humanist custom explains a difficult passage in Dürer's letter (Lange and Fuhse, op. cit., p. 30, line 24 ff.). In a wonderful mixture of Latin and Italian, Dürer jestingly expresses admiration for a diplomatic feat of Pirckheimer's, who had manfully stood up to the '*Schottischen*', that is to say, the troops of the robber baron Kunz Schott, arch-enemy of Nuremberg: 'El my maraweio, como ell possibile star uno homo cusy wn contra thanto sapientissimo Tiraybuly milytes.' [The orthography has been revised after E. Reicke, *Wilibald Pirckheimers Briefwechsel*, I, Munich, 1940, p. 386. It may be noted that this competent scholar, excusably unfamiliar with my essay as published in 1922, still considers the passage as inexplicable (p. 388).] '*Tiraybuly*' is comprehensible only as a proper name (which is also indicated by the capital letter) and represents nothing but a humorously 'greacicized' transcription of the name Kunz, probably started by Pirckheimer: Kunz = Konrad = Kühnrat ('Bold Counsel') = Thrasybulus. The 'sapientissimo Tiraybuly milytes' are, consequently,

what was characteristically designated as '*Sacrosancta Vetustas*'. But the object of all this diligence was classical subject matter rather than classical form.

In the North, the *rinascimento dell'antichità* was, at the beginning, essentially a literary and antiquarian matter. The artists remained, up to Dürer, completely aloof; and the original exponents of the movement, the scholars, were apparently unable or unwilling to appreciate, or even to consider, classical monuments from an aesthetic point of view. Even in the most learned and perceptive of the Northern humanists the lack of interest in the artistic aspects of 'Sacred Antiquity' is truly astonishing. Peutinger was probably the greatest German collector and antiquarian of his day but what he really cared for was classical epigraphy, iconography, mythology, and cultural history. We know that Dürer's best friend, Willibald Pirckheimer, owned an important collection of Greek and Roman coins; but he exploited it only for a treatise on the comparative buying power of Roman and Nuremberg currency.[3] In the drafts of prefaces which Dürer solicited from his humanist friends (but, fortunately, never used) we find the customary references to great artists of antiquity whose names were known through Pliny, but not one word on the artistic, or even educational, merit of the preserved monuments.[4]

The discovery of that *Augsburg Mercury* which looms so large in this essay was of such interest to Peutinger (who, we

synonymous with the '*Schottischen*', and the entire sentence may be translated: 'And I marvel how a man like you can hold his own against so many soldiers of the most cunning Kunz (Schott).' That it was not uncommon in the sixteenth century to render the name Konrad as Thrasybulus is evidenced, e.g., by the fact that the jurist Conrad Dinner employed the pseudonym 'Thrasybulus Leptus' (Jöcher, *Gelehrtenlexikon*, Pt. II, col. 130).

3. See above, Note 64, p. 301.

4. Lange and Fuhse, op. cit., pp. 285–7, 329–35. It is characteristic that Dürer presumes Pirckheimer to be interested in Italian art only in so far as it deals with 'stories' (subjects) 'particularly amusing in connexion with your studies' (Lange and Fuhse, p. 32, line 26).

remember, acquired the object for himself) that he devoted to it a report of many pages. Let us compare the beginning of this report with a passage from a letter in which an Italian, Luigi Lotti, describes a comparable event, the finding of what seems to have been a small replica of the Laocoön group in 1488. In Peutinger's report we read:

Conrad Mörlin, Abbot, learned of a stone dug up by the workmen there and carved into an image of Mercury, *without inscription*. [The god], his head winged and encircled with a circular diadem, had winged feet and was quite nude except for the fact that a mantle hung from his left side. Here [viz., on Mercury's left] stood also a cock, looking up to him, and on his other side there lay an ox or bull, over whose head Mercury extended his pouch with his right hand; in his right he held the caduceus [adorned with] serpents or snakes which, on the upper part, were bent back in a circle while they were tied into a knot in the middle and finally turned their tails back toward the handle of the caduceus.[5]

Luigi Lotti writes the following:

He has found three beautiful little satyrs, mounted on a little marble base, all three of them caught in the coils of a big serpent. In my opinion they are most beautiful, so that one believes he hears their voices; they seem to breathe, to cry out and to defend themselves with certain wonderful gestures; the one in the middle you almost see falling and dying.[6]

5. *Epistola Margaritae Velseriae ad Christophorum fratrem*, H. A. Mertens, ed., 1778, p. 23 ff., quoted in part by Hauttmann, op. cit., p. 43: 'Chuonradus Morlinus, abbas . . . lapidem ilic ab operariis effossum Mercuriique imagine sculptum, *sine literarum notis* comperit, hunc scilicet capite alato et corona rotunda cincto, pedibus alatis et corpore toto nudum, nisi quod a latera sinistro ipsi pallium pendebat, hinc etiam ad pedes gallus suspiciens stabat, et ad latus aliud subsidebat bos, siue taurus, super cuius caput manu dextra Mercurius marsupium, sinistra vero tendebat caduceum draconibus, siue serpentibus, parte supreiori ad circulum reflexis, in medio caduceo nodo conligatis, et demum caudis ad caducei capulum revocatis.'

6. G. Gaye, *Carteggio inedito d'artisti*, I. Florence, 1839, p. 285 (frequently quoted and similarly interpreted by Warburg): 'Et ha trovati tre belli faunetti in suna basetta di marmo, cinto tutti a tre da

The difference is extraordinary. The Italian shows a marked indifference to the subject matter and historical details; but all the keener is his susceptibility to the artistic quality ('in my opinion, they are most beautiful') and the emotional values, particularly the lifelike expression of physical suffering.[7] The German author concentrates upon purely antiquarian problems; he is satisfied with establishing that the excavated figure represents a Mercury, correctly equipped with head-wings, foot-wings, pouch and caduceus, and accompanied by the animals sacred to him (though the 'ox or bull' is in reality a goat). The first question asked concerns the presence of an inscription, and the most circumstantial part of the physical description is devoted to the caduceus. And after that, the report trails off into an interminable discussion of the symbolical meaning of the attributes and the genealogy of the god himself; he is traced back to the Egyptian Thoth and finally connected with the German Wotan (here called 'Godan', allegedly the old German for 'God').

This passage is characteristic of the initial reaction of the North to the Antique. A classical work of art is considered as enormously important for scholarship in all its aspects, but not experienced as a thing of beauty; and it could not be so experienced because the Northern *Kunstwollen* had no point of contact with that of classical antiquity. The sketchbook of Jacopo Bellini, the *Codex Escurialensis*, the *Florentine Picture Chronicle*, the engravings of Nicoletto da Modena, Marcantonio Raimondi and Marco Dente da Ravenna are paralleled in Germany only by the antiquarian compilations of Hart-

una grande serpe, e quali meo iudicio sono bellissimi, et tali che del udire la voce in fuora, in ceteris pare che spirino, gridino et si fendino con certi gesti mirabili; quello del mezo videte quasi cadere et expirare.' Cf. also the numerous, often excellent, appreciations of the Vatican Laocoön group compiled by K. Sittl, *Empirische Studien über die Laokoongruppe*, Würzburg, 1895, p. 44 ff.

7. The impression of spontaneity is, of course, enhanced by the fact that Luigi Lotti writes in Italian.

mann Schedel and Huttich, and the 'Inscriptiones' by Peutinger and Petrus Apianus. Thus in the woodcuts with which works of this kind were illustrated[8] a purely antiquarian spirit prevailed even if the prints were made with the avowed intent of 'reproducing' original classical sculptures. Attention was paid, first, to those monuments which themselves contained an inscription; second, to those which served to illustrate a name or concept occurring in an inscription; third, to those which were thought to be of interest because of specific iconographical features. What was demanded of these illustrations was, therefore, not an adequate reproduction of the artistic effect, but a clear and accurate rendering of that which seemed remarkable from an epigraphical and historical point of view.

True, even in Italy the illustrators of classical works of art could not help altering the stylistic character of the originals. But they did not ignore it: they saw their aesthetic qualities through the eyes of their own period, *but they saw them*. From the beginning of the Renaissance every Italian rendering of a classical original, good, bad or indifferent, has a direct aesthetic relationship to its model and is primarily intended to do justice to its formal appearance. The Northern woodcut, on the contrary, claims to be not so much the reproduction of a classical work of art as the record of an archaeological specimen. Even after Dürer had opened Northern eyes to classical movement and proportions, the German scholars – and many a German artist as well – remained as unfamiliar with the physiognomy of classical works of art as, for example, the modern European is with Negroes or Mongolians, in whom he can perceive general characteristics but not individual peculiarities. I shall show that the illustrator of Apianus' *Inscriptiones*, compiled by the most competent German classicists, could pass off a Dürer drawing, altered only with respect to iconographic accessories, as a reproduction

8. The illustrations in Hartmann Schedel's '*Collectanea*' and '*World Chronicle*' are, needless to say, not drawings after the original monuments but derive from other drawings.

of a classical *Athlete* (Plates 85–7) and could present to the world Dürer's 'Adam', just as superficially adapted to an archaeological purpose, as Peutinger's *Mercury* (Plate 74).[9] As in Hartmann Schedel's '*Nuremberg Chronicle*' of 1493, the curiosity of the public continued to be satisfied with illustrations which were partially or wholly imaginary. In iconographical matters, the illustrations had to be correct and explicit (whereas the '*Nuremberg Chronicle*' could still employ the same woodcut for totally different cities), and the readers of Apianus demanded something like 'classical beauty'. But, and this is the point, they did not care whether or not this beauty was that of the original.[10]

To approach classical art *qua* art, then, the North depended on an intermediary; and this intermediary was the art of the Italian Quattrocento, which had succeeded in reducing the two non-addable elements to a common denominator.

On the one hand, Italian art, heir to the Antique, was congenitally inclined to stress the plastic and the typical rather

9. See below, p. 334 ff.

10. This is why the illustrations of the books on epigraphy exhibit such a lack of appreciation for the classical style *qua* style. See, as particularly extravagant specimens, the woodcuts in Apianus' *Inscriptiones*, pp. 364 and 503. Missing parts were unhesitatingly restored wherever they seemed to be essential, and everything that had only formal significance was carelessly omitted. And with one well-founded exception (Apianus, p. 507) the woodcuts in Huttich, Peutinger and Apianus never indicate the fragmented condition of a sculpture. The left hand of the *Augsburg Mercury* was added, yet the niche, important for the artistic effect, is omitted. Two generations later, when Marx Welser had the figure engraved for his *Rerum Augustanarum libri VIII* (op. cit., p. 209, misprinted into 190, our Plate 72), the situation had taken a completely different turn. Here the illustrator tries to do justice to the actual appearance of the monument, from the pose down to the damages by breakage or corrosion; and if he omits anything, he does so at the expense of iconographical significance rather than of artistic effect: while being aware of the importance of the niche, he neglected the head wings. For a more detailed study of the Apianus illustrations, see below, p. 330 ff. [and, above all, the article by Phyllis Williams, cited above, p. 10].

than the pictorial and the particular. The Italian Quattro-
cento subscribed – at least in theory and, to a degree, in
practice – to all such classical postulates as quantitative and
qualitative harmony,[11] decorous and appropriate move-
ment[12] and unequivocal mimetic expression;[13] even the light
tended to be exploited for modelling and clear dissociation
of plastic volumes rather than for a chiaroscuro effect that
would unify these volumes with the ambient space. On the
other hand, however, the Italian Quattrocento shared with
the Northern fifteenth century one basic premise which did
not apply in the Middle Ages: on both sides of the Alps, art
had become a matter of direct and personal contact between
man and the visible world.

The medieval artist, working from the *exemplum* rather
than from life,[14] had to come to terms primarily with tradi-
tion and only secondarily with reality. Between him and
reality there hung a curtain, as it were, upon which previous
generations had outlined the forms of people and animals,
buildings and plants – a curtain that could be lifted now and
then but could not be removed. Hence, in the Middle Ages
the direct observation of reality was normally limited to de-
tails, supplementing rather than supplanting the use of trad-
itional schemes. The Renaissance, however, proclaimed
'experience', *la bona sperienza*, as the root of art: each artist

11. See the *locus classicus* in L. B. Alberti's *Trattato della pittura*
(*Kleinere kunsttheoretische Schriften*, H. Janitschek, ed. [*Quellenschriften
für Kunstgeschichte*, XI], Vienna, 1877), p. 111.

12. See, for example, Alberti, ibid., p. 113. Similarly, Leonardo da
Vinci, *Trattato della pittura* (*Das Buch von der Malerei*, H. Ludwig, ed.
[*Quellenschriften für Kunstgeschichte*, XV–XVII], Vienna, 1881), Art. 283.

13. Alberti, ibid., p. 121. Alberti, Leonardo (particularly op. cit.,
Art. 380 ff.) and Lomazzo (*Trattato dell' Arte della Pittura*, Milan, 1584,
II, 3 ff.) developed a systematic theory where a definite expression is
assigned to every state of the soul, even to 'mixed emotions'; this
amounts, of course, to a reduction of the individual to the typical.

14. Cf., in this connexion, J. von Schlosser, 'Zur Kenntnis der
künstlerischen Ueberlieferung im späten Mittelalter', *Jahrbuch der
kunsthistorischen Sammlungen des Allerhöchsten Kaiserhauses*, XXIII, 1902,
p. 279 ff., particularly p. 280.

was expected to confront reality 'without preconceptions' and to master it – in every work anew – of his own accord.[15] The decisive innovation of *focused perspective*[16] epitomizes a situation which focused perspective itself had helped to bring about and to perpetuate: a situation in which the work of art had become a segment of the universe as it is observed – or, at least, as it could be observed – by a particular person from a particular point of view at a particular moment.[17] 'The first is the eye that sees; the second, the object seen; the third, the distance between the one and the other,' says Dürer after Piero della Francesca.[18]

This new attitude placed Italian and Northern art, all differences notwithstanding, on a common foundation; and it was precisely the method of perspective, developed and accepted with equal zeal on both sides of the Alps, which sealed this union. Perspective, realizing as it does the space around and between figures, postulates, however 'plastic' the intent of the practitioner may be, at least a minimum of

15. The theory of art developed in the Renaissance was intended to aid the artist in coming to terms with reality on an observational basis; medieval treatises on art, conversely, were largely limited to codes of rules which could save the artist the trouble of direct observation of reality (see, e.g., Cennini's prescriptions for applying shadows to the face).

16. In the context of this essay it is comparatively unimportant whether or not the perspective method employed by the artists was based on exact mathematical construction.

17. This process reflects a general development. The 'open-mindedness' of the postmedieval scientist or scholar, based on experimental or philological methods and not committed to 'authority', may be compared to the independence with which the post-medieval artist chooses – and, having chosen, systematically adheres to – his perspective 'viewpoint'. It is no accident that the present age, which in art opposes nothing so passionately as focused perspective (even where it is handled as unmathematically as in Impressionism), questions the value of 'exact' science and 'rationalistic' scholarship – two forms of intellectual knowledge analogous to a perspective form of artistic perception. [This note was written in the heyday of German Expressionism and anti-intellectualism, whether Marxist or proto-Nazi.]

18. Lange and Fuhse, op. cit., p. 319, line 14.

pictorial realism, of attention to light and air, even of mood. Thus, the relationship of the Early Renaissance artists to classical antiquity was dominated by two antithetical impulses: while wanting to revive it, they were compelled to transcend it. That they were second to none in their enthusiasm for an *antichità* which they acclaimed not only as the legacy of a glorious past but also as a means of achieving a glorious future goes without saying; it is significant that the great masters of the first generation – Donatello, Ghiberti, Jacopo della Quercia – endeavoured to emulate classical forms even while their thematic material was still predominantly Christian. On the other hand, however, the Quattrocento was in no wise out of sympathy with the aspirations and achievements of the North. As the Northern sculptors pictorialized the relief by converting it into a kind of theatre stage, so did Ghiberti and Donatello pictorialize it by subjecting it to the rules of perspective. And the Italian painters and engravers came to be dependent on 'the Flemings' (who, from their point of view, included the Germans) to such an extent that, in the field of art, the balance of trade may be said to have been overwhelmingly in favour of the North throughout the fifteenth century.[19] The same Pollaiuolo who untiringly repeated the classical 'pathos formulae' painted landscapes *alla fiamminga* and clothed his David in an up-to-date costume the fur and velvet of which are rendered with the loving care of a Netherlander; as often as not a combination of classicizing 'idealism' and Northern 'realism' is aspired to in one and the same picture.[20] Italian Renaissance art thus represents an adjustment of two antithetical tendencies. During the fifteenth century these tendencies coexisted, so to speak, and were often reconciled only by compromise; at the beginning of the

19. For the positive evaluation of Netherlandish painting in the Italian Quattrocento, see Schlosser, *Kunstliteratur*, pp. 95 f.; Warburg, op. cit., I, pp. 177–216.

20. Cf., for instance, Warburg, 'Francesco Sassettis letztwillige Verfügung', op. cit., I, p. 127 ff.

Cinquecento they were harmonized into a short-lived union;[21] and this union was to break up in the seventeenth century. The terminal points of the development which begins in the Quattrocento are marked, on the one hand, by the followers of the 'unintellectual and uninventive' 'realist', Caravaggio,[22] on the other, by Classicism.[23]

Owing to this inherent dualism, now, Italian Quattrocento art was qualified to 'mediate', as it were, between the aesthetic experience of the North and the Antique. It translated, and could not help translating, the language of classical art into an idiom which the North could understand: the Renaissance renderings of classical statues are not so much copies as reinterpretations – reinterpretations which, on the one hand, retain the 'ideal' character of the prototypes but, on the other, modify it in a spirit of comparative realism. Even where we are faced with the purely archaeological – as we would say, 'documentary' – rendering of a specific piece of classical statuary (as opposed to free inventions or studies after models posed in classical fashion), we can observe a fundamental change. Posture and expression are altered according to the taste of the period and even of the individual artist.[24] The play of the muscles is detailed on the basis of experiences gained by drawing from life or by anatomical study. The marble-smooth surface is animated by

21. Cf., e.g., Raphael's *Deliverance of St Peter* and *Expulsion of Heliodorus*.

22. According to a remark by Bernini (R. F. de Chantelou, *Journal du voyage du Cavalier Bernin*. . ., E. Lalanne, ed., 1885, Paris, p. 190).

23. The Renaissance theorists, writing in a period still capable or at least desirous of harmonizing these antithetical tendencies, considered verisimilitude as compatible, even synonymous, with devotion to the *maniera antica*. The theorists of the seventeenth century, having become conscious of a conflict between the sculptural and the pictorial, the universal and the particular, could no longer blind themselves to the fact that imitation of the Antique and imitation of reality were contradictory principles; Bernini (ibid., p. 185) actually forbids beginners to work after the live model since reality, as compared to the Antique, was 'weak and puny'.

24. See F. Wichert, *Darstellung und Wirklichkeit*, 1907, *passim*.

coloristic and pictorial methods. The hair seems to flutter or to curl; the skin seems to breathe; iris and pupil are always restored to the unseeing eyes.

In such a form – and only in such a form – could the Antique become accessible to the North as an aesthetic experience: as long as Northern art itself was not as yet prepared to look upon classical monuments with Renaissance eyes, it could apprehend them only in an Italianate transformation. From a tradition already permeated with such Italo-classical elements to the original Antique – or, from a tradition not as yet so permeated to what may be called a Quattrocento Antique: these were the only two directions in which the North could advance. And this makes us see that Dürer, the first to build this road to the Antique, was not as yet in a position to proceed on it. If ever a great artistic movement can be said to be the work of one individual, the Northern Renaissance was the work of Albrecht Dürer. Michael Pacher had been able to adopt certain important achievements of the Italian Quattrocento; but only Dürer was capable of perceiving, through the Italian Quattrocento, the Antique. It was he who imparted to Northern art a feeling for classical beauty and classical pathos, classical force and classical clarity.[25] And if that poor illustrator of Apianus, striving to represent classical sculptures in a particularly beautiful and genuine-looking style, could think of nothing better than to fall back upon Dürer's drawings and prints, his action bears witness to the fact that all the Northern artists of the early sixteenth century – he as well as a Beham or even a Burgkmair[26] – were forced to resort to

25. It is not for the historian to decide whether Dürer, in thus reforming German art, 'poisoned its roots'. He who deplores the fact that Dürer imbued Northern art with his *antikische Art*, or that Rubens was influenced by Michelangelo and Titian, is just as naïve and dogmatic – only with an inverted sign, as it were – as those rationalistic critics of old who could not forgive Rembrandt for *not* going to Italy. [Again it should be borne in mind that this essay was written about 1920.]

26. According to Hauttmann (op. cit., p. 49), Hans Burgkmair's *St Sebastian* of 1505 (Nuremberg, Germanisches Museum) also derives

Dürer in much the same way as Dürer had been forced to resort to Pollaiuolo and Mantegna. We can observe how his 'antikische Art' spread not only through Germany but even to the Netherlands. Only recently it has been shown that Jan Gossart, famed as the first Flemish 'Romanist', was actually indebted to Dürer for his first introduction to 'the world of Southern form'.[27]

Dürer's followers could approach the Antique directly because they already were Renaissance artists; Dürer himself could not because he had to start the Renaissance movement himself. Martin van Heemskerck or Marten de Vos could face the classical world, as it were, in the posture of Romans. For Dürer the genuine Antique remained inaccessible because he had first to absorb the Italianized Antique. These epigones could start from Dürer; Dürer himself had to start from Michael Wolgemut and Martin Schongauer; and from them no direct road led to antiquity. It must not be forgotten that Dürer, for all his 'longing for the sun', was, and in many ways remained, a Northern artist of the Late Gothic period. His remarkable gift for plastic form was matched by an equally remarkable perception of the pictorial, his strong preoccupation with proportion and clarity, beauty and 'correctness', by an equally strong impulse toward the subjective and the irrational, toward microscopic realism and

from the *Augsburg Mercury*. However, even though this would have been possible from a practical point of view, Burgkmair preferred the guidance of Dürer to that of the Antique: in the position of the legs, the turn of the head and the emphatic modelling (see particularly the muscles of the leg) his St Sebastian clearly derives from Dürer's Adam (as already noted by H. A. Schmid in Thieme-Becker, *Allgemeines Lexikon der bildenden Künstler*, V, p. 253). When photographs of the Sebastian, the Adam and the Mercury (in the original, of course, and not in the Apianus variant) are placed side by side, the facts of the matter speak for themselves.

27. F. Winkler, 'Die Anfänge Jan Gossarts', *Jahrbuch der preussischen Kunstsammlung*, XLII, 1921, p. 5 ff. One could establish an actual itinerary for the Antique during the Renaissance: the Italians translate it from Latin and Greek into Italian, Dürer from Italian into German, Gossart from German into Netherlandish.

phantasmagoria. True, Dürer was the first Northerner to produce 'correct' and scientifically proportioned nudes; but he was also the first to produce genuine landscapes. He is not only the author of the *Fall of Man* and the *Hercules*, but also of the *Great Piece of Turf* – and the *Apocalypse*. Even in his more mature years Dürer was never to become a pure Renaissance artist,[28] and how little he was a pure Renaissance artist in his youth is indicated by the way in which he retained his independence as a landscapist even when directly copying Italian paintings or prints;[29] and, even more so, by the way in which he exploited his *antikische* studies in works destined for publication as engravings or woodcuts. The statuesque form of the *Apollo Belvedere* was either exposed to the 'contradictory light' of a cloudy nocturnal sky reflecting the fitful glare of a solar disc or set off against the penumbral darkness of a forest.[30] And where the classical postures and gestures were used without a thorough change in form, they were invested with an entirely different content. The pagan beauty of the *Apollo Belvedere* was either lifted to the sphere of the Christian religion or lowered, as it were, to the level of everyday life. His pose was employed, we recall, for the Adam in the *Fall of Man* (Plate 80), as well as for the Resurrected Christ (Plate 81), but also for a *Standard-Bearer* (engraving B.45), where his Olympian stride, calmed down to supernatural dignity in the *Resurrection*, is charged with the momentum of vigorous physical action.

Analogous observations can be made in Dürer's use of the 'pathos motif' exemplified by the Dying Orpheus. We should expect it to reappear in the same context for which it had been invented, in scenes of violence and death where the victim, beautiful even *in extremis*, tries to defend himself against destruction. Such, however, is not the case. Where

28. Compare, for example, his *Melencolia I* with that of Hans Sebald Beham (engraving B.144).

29. See above, p. 285.

30. See, on the one hand, the drawing L.233 (Plate 76); on the other, the engraving *The Fall of Man* (Plate 80).

people really die – in the *Slaying of Abel* or in the cataclysm of the Apocalypse – Dürer resorts to very different postures, contorted and horrible or acquiescent and devout, but not 'beautiful'. In the Apocalypse series the Orpheus pose occurs only once, in a fantastically draped figure so small that it was overlooked by most observers (including this writer) until 1927 and representing not so much a man dying as one of those who 'hid themselves in the dens and in the rocks of the mountains' (Rev. 6:15).[31] [Later – when the *Apollo Belvedere* was converted into the Resurrected Christ – the Dying Orpheus was transformed into a Christ Carrying the Cross (woodcut B.10).] And in one case Dürer went so far as to completely reverse the original significance of the figure: in the drawing known as the *Madonna with a Multitude of Animals*[32] one of the 'Shepherds in the Fields', overwhelmed with joyful surprise, goes to his knees and lifts his arm as though protecting himself from the celestial radiance of the angels, in precisely the same way as does the Orpheus felled by the Maenads and vainly trying to ward off their death-dealing blows.[33]

To conclude: there is not one single case in which Dürer

31. Classical 'pathos figures' may still be characterized in the words of Lessing (*Laokoon*, Chapter II): 'Es gibt Leidenschaften, und Grade von Leidenschaften, die sich im Gesichte durch die hässlichstee Verzerrung äussern, und den ganzen Körper in so gewaltsame Stellungen setzen, dass die schönen Linien, die ihn in einem ruhigeren Stande umschreiben können, verloren gehen. Dieser enthielten sich also die alten Künstler entweder ganz und gar, oder setzten sie auf geringere Grade herunter, in welchen sie eines Masses von Schönheit fähig sind.' ('There are emotions, and degrees of emotions, which express themselves by the ugliest contortions of the face, and force the whole body into such violent positions that the beautiful lines which are able to describe it in a more peaceful attitude are lost. The ancient artists either refrained entirely from these emotions, or reduced them to a milder degree in which they were still susceptible to a measure of beauty.')

32. Drawing L.460.

33. The sheep dog, too, derives from a large composition, viz., the *St Eustace* (engraving B.57), or, more accurately, from the preparatory drawing used in this engraving.

can be shown to have made a drawing directly from the Antique, either in Germany or in Venice or Bologna.[34] He found the Antique only where – according to his own splendidly frank avowal – it had already been revived for generations:[35] in the art of the Italian Quattrocento, where it confronted him in a form altered according to contemporary standards but, for this very reason, comprehensible to him. If we may speak by way of a simile: he faced classical art in much the same way as a great poet who understands no Greek might face the works of Sophocles. The poet, too, will have to rely on a translation; but this will not prevent him from grasping Sophocles' meaning more fully than does the translator.

34. The case of the three lions' heads in the Europa drawing L.456 (exceptional in itself since we are chiefly concerned with human figures) is dubious at best. Whether they are copied from a sculpture at all is a matter of controversy (see, on the one hand, H. David, *Die Darstellung des Löwen bei Albrecht Dürer*, Diss. Halle, 1909, p. 28 ff.; on the other, S. Killerman, *Albrecht Dürers Tier- und Pflanzenzeichnungen und ihre Bedeutung für die Naturgeschichte*, 1910, p. 73). But even in the event that Dürer did copy a piece of sculpture, his model can no longer be determined, and was not necessarily a classical work. The *Leoncini* often referred to in the recent literature must be dismissed as eighteenth-century works (Ephrussi, op. cit., p. 122). O. Hagen's attempt to connect Dürer's St Sebastian (engraving B.55) with a Roman *Marsyas* ('War Dürer in Rom?' *Zeitschrift für bildende Kunst*, LII, 1917, p. 255 ff.) is hardly worth considering, especially since there is no evidence to show that Dürer ever visited Rome.

35. Lange and Fuhse, op. cit., p. 181, line 25.

Excursus

The Illustrations of Apianus' '*Inscriptiones*' in Relation to Dürer

As has been noted at the beginning, any investigation of the development of Dürer's 'Apollo group' should start with the '*Aesculapius*' or '*Apollo Medicus*' (drawing L.181, our Plate 75) and the *Sol* (drawing L.233, our Plate 76), both datable about 1500/1501. In his attempt to derive the whole series from the *Augsburg Mercury* (Plate 71), Hauttmann starts with the Adam of 1504 (Plate 80). But even so he would hardly have formed his theory had he compared Dürer's figures with the classical original (Plate 71) rather than with the woodcut, purporting to render it, in Apianus' *Inscriptiones Sacrosanctae Vetustatis* of 1534 (Plate 74). In this woodcut the messenger of the gods does bear a remarkable resemblance to Dürer's Adam. In both figures the left (free) leg moves sharply to the side and back; the contour of the right shoulder descends in an elegant curve; the left hand is raised to the height of the shoulder and sharply bent forward at the wrist, holding the caduceus in the case of Mercury, and the branch of a mountain ash in the case of Adam.

All these similarities, however, exist only between Dürer's engraving and the Apianus woodcut, and not between Dürer's engraving and the Augsburg sculpture. In the latter, the stance of the figure is totally different: the right hand is not raised and sharply bent at the wrist but gently lowered and grasps the caduceus, not in the middle but at the lower tip, as is the case in all comparable Roman monuments. That Dürer's engraving, dated 1504, should have been influenced

330

by the Apianus woodcut, published in 1534, is manifestly impossible. Hauttmann, however, credits Dürer with both: according to him, it was Dürer himself who had made a drawing of the *Augsburg Mercury* – a drawing subsequently used both for the Adam in his own engraving and the Mercury in the Apianus woodcut. In this hypothetical drawing, Hauttmann assumes, Dürer remodelled the stance and contour of the figure and with respect to the position of the left arm became so confused as to interpret 'the part of the mantle hanging between the arm and the body as an arm lowered and bent', mistaking 'its angular edge for an elbow'. This, we are asked to believe, forced him to raise and twist the left hand, and from this series of errors there resulted the Adam seen in the engraving of 1504.

It is, to begin with, not a good idea to explain an unusual and somewhat puzzling motif by a prototype in which this motif does not occur. But even apart from this, Hauttmann's hypothesis would complicate rather than answer the question. According to him, Dürer was familiar with the true position of the left arm in the Augsburg relief when painting the Paumgärtner Altarpiece, where the arm of the St George is lowered rather than raised. Dürer's engraving of 1504 would thus be based on an error of interpretation already avoided in a painting of around 1502. Granted that Dürer as an archaeologist may have wavered between the two interpretations; as an artist, he would have been free to choose between them. What could have forced him to decide in favour of the Apianus variant which, when applied to the Adam, was to produce, in Hauttmann's own words, so 'unnatural' and 'forced' a result?

In point of fact, the position of Adam's right arm – which corresponds, of course, to the left in all preliminary drawings – can be explained by the intrinsic history of the engraving itself. It was developed, we recall, from the 'Sol' drawing L.233 (Plate 76), which anticipates the final result even with respect to the lighting. When Dürer had decided to combine the 'ideal male' with the 'ideal female' into a

representation of the Fall of Man, he naturally wished the figure of Adam to retain the beautifully rhythmical movement prefigured in the *Apollo Belvedere* – the arm on the side of the standing leg lowered, the arm on the side of the free leg raised – and to preserve, as far as possible, the strict frontality required of a paradigmatical specimen in human proportions. In two intermediary drawings (L.475 and L.173, the latter dated 1504 and directly preceding the engraving) the pose is established in final form. In these two drawings Adam's forearms are indicated only in outline, but it is evident that Dürer, at this point, had already been compelled to introduce a second tree (second, that is, in addition to the Tree of Knowledge that separates Adam from Eve): since one of Adam's hands had to stay raised but could no longer carry something (as in the cases of the 'Sol' and 'Aesculapius' drawings), it had to hold on to something,[36] and this something could only be the branch of a tree.

It is quite true that, as Hauttmann puts it, the position of Adam's right arm was 'not invented so that he might hold on to the branch'; but it does not follow that it was derived, by way of misinterpretation, from the *Augsburg Mercury*. Rather the branch – or, for that matter, the whole tree – was invented to motivate the required position of Adam's right arm.[37] [And I may add that Dürer was careful to justify the addition of this second tree on iconographical grounds (a fact unknown to me when this article was first published): in characterizing it, in contrast to the fig tree in the centre, as a mountain ash, he designated it as the Tree of Life as opposed to the Tree of Knowledge – the Tree of Life to which

36. After some vacillation, Dürer decided to leave Adam's lowered hand completely empty.

37. This position was studied in the drawing L.234, made after a model grasping a stick. Why Hauttmann should consider this stick as an argument for Dürer's acquaintance with the *Augsburg Mercury* is difficult to see. The stick is an ordinary studio prop (cf., e.g., Dürer's own drawings in the 'Dresdner Skizzenbuch', Bruck, op. cit., Pls. 11, 12) which has nothing to do with the caduceus of Mercury.

Adam 'holds on' as long as he is still free not to accept the fatal fruit.][38]

How, then, are we to explain the similarity which does exist between the Dürer engraving and the Apianus woodcut? In my opinion, not by the assumption that Dürer fashioned his Adam after the pattern of the *Augsburg Mercury*, but that the Apianus illustrator remodelled the *Augsburg Mercury* after the pattern of Dürer's Adam.

As is well known, Apianus' *Inscriptiones* is largely based upon material compiled by the humanists of the preceding generation – Choler, Pirckheimer, Peutinger, Celtes, Huttich – and, in part, published in book form before; the monuments of the Augsburg diocese had been published by Peutinger, those of the diocese of Mainz by Huttich.[39] Apianus thus functioned as an editor-in-chief, as it were; and the woodcut designer whom he employed for the illustra-

38. [The ash tree was held in special veneration (or, as so often in comparable cases, looked upon with superstitious fear) in the Northern Middle Ages – perhaps because it was dimly remembered that, according to the *Edda*, the first man had been made of an ash tree whereas the first woman had been made of an elm.] Hauttmann's iconographical notions are, I regret to say, even less tenable than his stylistic arguments. Assuming the antlered animal behind Dürer's Adam to be a deer, he proposes to connect it with Mercury's goat: since the latter, according to Horapollo and others, symbolizes procreative masculine power and the deer bears similar implications, '*salacitas* was a common denominator' between Adam and Mercury. In the first place, however, the animal in Dürer's engraving is not a deer but an elk, famed for gloomy apathy rather than sexual prowess (see H. David, 'Zwei neue Dürer-Zeichnungen', *Jahrbuch der königlich preussischen Kunstsammlungen*, XXXIII, 1912, p. 23 ff.). In the second place, we happen to know that the Augsburg experts themselves mistook the goat reposing at the feet of their Mercury for an 'ox or bull' (see above, p. 317). [For what would seem to be the true significance of the animals in Dürer's *Fall of Man*, see Panofsky, *Albrecht Dürer*, I, p. 85; II, p. 21, Note 108.]

39. *Inscriptiones vetustae Romanae, et eorum fragmenta in Augusta Vindelicorum et eius dioecesi cura et diligentia Chuonradi Peutingeri ... antea impressae nunc denuo revisae*, Mainz (Schöffer), 1520 (combined with Huttichius: *Collectanea antiquitatum in urbe atque agro Moguntino repertarum*). The first edition of Peutinger's work (published in 1506 by Ratdolt in Augsburg) is not illustrated.

tions, instead of making drawings of the original monuments, had merely to revise the illustrative material already on hand. At no time – except perhaps in the case of small, easily transportable *objets d'art* – did he work after the original; all he had to do was to improve upon the awkward woodcuts found in the publications of Huttich and Peutinger and to redesign the even clumsier drawings, not as yet published, which had been contributed by itinerant scholars. To achieve this improvement – and, at the same time, a greater uniformity of style[40] – the woodcut designer had recourse to Dürer, not only in such purely graphic devices as the system of hatchings or the treatment of hair and drapery but also in postures, gestures and anatomy. He systematically searched for Dürer drawings and prints which might be used to bring his illustrations 'up-to-date'.

On page 451, for example, there is a woodcut purporting to illustrate an allegedly antique cameo discovered by Conrad Celtes; one of the figures, however, is literally duplicated in one of Dürer's woodcuts in Celtes' *Libri amorum*. And since this book was published in 1502, while, according to the text, the cameo was not discovered until 1504, the Apianus Master must have borrowed the figure from the woodcut in the *Libri amorum* in order to improve his direct model – presumably a sketch made by the discoverer – according to the standards of 1534.

The same procedure can be observed in the case of the so-called *Athlete from the Helenenberg*, now preserved in the Vienna Museum, which had been found in 1502 and was acquired by the Cardinal Archbishop Lang of Salzburg (Plate 86). The woodcut in Apianus' *Inscriptiones* (our Plate 87) is an exact mirror image of a Dürer drawing (L.351, our Plate 85),[41] except for the inscription, the attributes and the

40. The remaining stylistic differences within the woodcuts are not, in my opinion, due to a plurality of designers; they can be explained by the heterogeneous character of the material on hand.

41. Th. Frimmel, 'Dürer und die Ephebenfigur vom Helenenberge', *Blätter für Gemäldekunde*, II, 1905, p. 51 ff.

different position of the raised forearm. Dürer's constructed figure, a regular member of the 'Apollo group', could never have been copied from the original bronze. We can assume only that the woodcut designer, having to work from an inadequate sketch, had recourse to the Dürer drawing which in some way or other – perhaps from Pirckheimer's estate – had come into the possession of Apianus and seemed suitable because it represented a classical-looking nude. The copyist gives himself away in the crude design of the axe placed in the left hand of the statue and, above all, in the clumsy alteration of the right forearm which, in order to correspond to the original at least approximately, had to be rendered outstretched instead of holding a club. In making this alteration, the woodcut designer neglected properly to foreshorten the forearm, which thus appears much too long in relation to the upper part of the arm; he seems to have borrowed it, without suitable adjustment, from Dürer's *Treatise on Human Proportions*.[42]

In this case, Hauttmann himself has understood the situation quite correctly: '... when comparing the drawing L.351,' he says, 'with the *Athlete from the Helenenberg* as illustrated in Apianus, we recognize the Düreresque stylization of the woodcut rather than feel obliged to assume an influence of the statue on Dürer.' These words, however, are true, not only of this particular woodcut but of all the 'Düreresque' illustrations in the *Inscriptiones*; and they are particularly true of the woodcut representing the *Augsburg Mercury* in its relation to Dürer's Adam.

This can be demonstrated by comparing the woodcut of Apianus' *Inscriptiones* of 1534 (Plate 74) with that in Peutinger's *Inscriptiones* of 1520[43] (Plate 73). According to Hauttmann, both are based on the same model – in his opinion a drawing by Dürer – which was distorted in the earlier

42. See, for example, Dürer, *Vier Bü-her von menschlicher Proportion*, Nuremberg, 1528, fols. H IV or G V b.
43. Peutinger, op. cit., fol. B I.

woodcut but rendered more adequately in the later one. This view, however, is untenable. Two woodcuts based on the same drawing may, and often do, conspicuously differ from each other; but these differences are always uniform throughout. Here, on the contrary, we have a clear-cut division. In the stance and in the modelling of the torso and legs the two versions differ as radically as is possible in two renderings of one and the same object. In the inclination of the head, the features of the face, the hairdress, the caduceus, and the winged helmet,[44] however, they agree perfectly. From this we must conclude that the woodcut of 1534 cannot possibly be based on the same drawing as that of 1520; it presupposes a new drawing, produced *ad hoc*, in which motifs found in the woodcut of 1520 were combined with others, supplied by a second source. And this second source was Dürer's *Fall of Man*.

The Mercury as he appears in the woodcut of 1520 has nothing in common with Dürer's Adam precisely because this woodcut, for all its clumsiness, is factually closer to the original than that of 1534. It retains the Roman figure's quiet, somewhat lazy stance, its angular shoulders (which bring to mind Pliny's phrase *figura quadrata*) and, above all, its rather indistinct modelling. While the woodcut of 1534, like Dürer's *Fall of Man*, shows the muscles concentrated into firm, sharply defined convexities, the woodcut of 1520 shows comparatively unified, undifferentiated surfaces. It was the Apianus Master who assimilated the Mercury to Dürer's Adam *ex post facto*, as it were: it was he who contrasted a nearly vertical standing leg with a free leg stepping both sideways and back (whereas the legs in the woodcut of 1520 are nearly parallel, the hip curving outward and the enormous feet placed in approximately the same plane); who

44. Cf., in contrast, another *Mercury*, preserved at Rome and illustrated in Apianus, op. cit., p. 230. The two woodcuts representing the *Augsburg Mercury* also agree in showing the left foreleg of the goat in a frontal position; in the original, as in the later engraving in Marx Welser's *Monumenta* (our Plate 72), it appears in foreshortening.

slenderized and tightened the proportions;[45] who formed the sweeping, articulated contour which emphasizes the contrast between the calf and the knee, the forearm and the elbow; who drew the foreshortened foot precisely as it appears in Dürer's engraving and even tried to imitate Dürer's peculiar lighting in heavily shading the right side of the figure but casting a shadow over the lower part of the left leg.

The inference is that Dürer was not responsible for either of the two Mercury woodcuts. The woodcut of 1520 cannot be attributed to him because it has nothing whatsoever to do with his style; the woodcut of 1534 cannot be attributed to him because considerable portions of it are mechanically taken over from the other, earlier woodcut.[46] In short, the Mercury of 1534 is a pastiche of the Mercury of 1520 and Dürer's Adam,[47] and we can even see where the pieces of this patchwork were joined: at the neck, where the cervical muscle, copied from Dürer's engraving, does not properly connect with the head taken over from the earlier woodcut.

The lesson to be learned from this somewhat tedious discussion is not only that Dürer was not personally involved in the preparation of the antiquarian pursuits which ultimately resulted in the publication of Apianus' *Inscriptiones* and,

45. Except for the fact that the head-wings have been redrawn so as to conform to the position of the head instead of being displayed in symmetrical front view. The two other attributes are only somewhat improved with regard to design and proportions.

46. That the Apianus illustrator worked from the printed publication of Huttich and Peutinger and not, as might be supposed, from the preparatory drawings, is evident from the fact that he occasionally spared himself the trouble of reversing his models, so that his woodcuts show the object in reverse; see, e.g., the so-called *Acorn Stone* (Huttich, fol. C I = Apianus, p. 474) and the tombstone of Curio Sabinus (Huttich, fol. D IV v. = Apianus, p. 482).

47. It should be noted that the Apianus Master had recourse to Dürer's Adam in at least two other cases: the Neptune, p. 456, and another Mercury, p. 464.

more specifically, was not responsible for the misinterpreta-
tion of the left arm of the *Augsburg Mercury*;[48] it also makes
us see, as in a flash, how Dürer's *antikische Art* was looked
upon by his Northern contemporaries. [When the Apianus
Master emended the reproduction of a classical Mercury
after the model of Dürer's Adam, he acted, *mutatis mutandis*,
like that skillful but not too high-principled Venetian sculp-
tor who, about the same time, produced what was supposed
to be a Greek original of the fifth century B.C. by combining
two draped figures borrowed from a Periclean *stele* with two
impressive nudes copied after Michelangelo, the *David* and
the *Risen Christ* in S. Maria sopra Minerva (Plate 88).[49] In
the eyes of the German woodcut designer a Dürer figure was

48. The artist responsible for this misinterpretation was the illus-
trator of Peutinger's *Inscriptiones* of 1520. Presumably active at May-
ence, he depended on a sketch transmitted to him from Augsburg and
may be forgiven for having reconstructed the right arm of the *Mercury*
after the fashion of a pose most common in classical (and later)
imagery; he may, in fact, have been guided by a Roman monument,
then preserved at Mayence, which he himself had drawn for Huttich's
publication, the tombstone of a soldier named Attio (Huttich, op. cit.,
fol. B II, repeated in Apianus, op. cit., p. 470). This tombstone is now
lost; but that in this case, at least, the designer did not commit an error
is demonstrated by an independent sketch preserved in the Biblioteca
Ambrosiana at Milan, Cod. D. 402, inf., fasc. 1.

Nothing, then, supports the assumption that Dürer himself partici-
pated in the preparation of Apianus' corpus. Its illustrator exploited
Dürer's drawings *ex post facto*, and this is also true of the frontispiece,
which shows an Allegory of Eloquence ('*Hercules Gallicus*') and is
based on Dürer's drawing L. 420. There is even reason to believe that
this frontispiece, like the initials and borders, was not specially made
for the Apianus volume. Thematically it is suited neither better nor
worse to the contents of this particular book than to those of any other,
and it looks rather faint even in copies in which the actual illustrations
are very clear and fresh; the inference is that it was printed from a much-
used block.

49. [For this relief, preserved in the Kunsthistorisches Museum at
Vienna and unknown to me when this essay was first published, see
Panofsky, *Hercules am Scheidewege* (cited above, Note 3, p. 182), p. 32,
Fig. 26.]

what a Michelangelo figure was in the eyes of the Venetian forger (and, incidentally, in those of Vasari): a work as classical as – in fact, more classical than – a genuine product of Greek or Roman antiquity.]

7
Et in Arcadia Ego: Poussin and the Elegiac Tradition

I

In 1769 Sir Joshua Reynolds showed to his friend Dr Johnson his latest picture: the double portrait of Mrs Bouverie and Mrs Crewe, still to be seen in Crewe Hall in England.[1] It shows the two lovely ladies seated before a tombstone and sentimentalizing over its inscription: one points out the text to the other who meditates thereon in the then fashionable pose of Tragic Muses and Melancholias.[2] The text of the inscription reads: *Et in Arcadia ego*.

'What can this mean?' exclaimed Dr Johnson. 'It seems very nonsensical – I am in Arcadia.' 'The King could have told you,' replied Sir Joshua. 'He saw it yesterday and said at once: "Oh, there is a tombstone in the background: Ay, ay, death is even in Arcadia."'[3]

To the modern reader the angry discomfiture of Dr Johnson is very puzzling. But no less puzzling is the quick understanding of George III, who instantly grasped the purport of the Latin phrase but interpreted it in a manner dissimilar to that which seems self-evident to most of us. In contrast to Dr Johnson, we are no longer stumped by the phrase *Et in Arcadia ego*. But in contrast to George III, we are accustomed

1. C. R. Leslie and Tom Taylor, *Life and Times of Sir Joshua Reynolds*, London, 1865, I, p. 325.
2. See E. Wind, 'Humanitätsidee und heroisiertes Porträt in der englischen Kultur des 18. Jahrhunderts', *Vorträge der Bibliothek Warburg*, 1930–31, p. 156 ff., especially p. 222 ff.
3. Leslie and Taylor, loc. cit.

to reading a very different meaning into it. For us, the formula *Et in Arcadia ego* has come to be synonymous with such paraphrases as 'Et tu in Arcadia vixisti', 'I, too, was born in Arcadia', 'Ego fui in Arcadia',[4] 'Auch ich war in Arkadien geboren',[5] 'Moi aussi je fus pasteur en Arcadie';[6] and all these and many similar versions amount to what Mrs Felicia Hemans expressed in the immortal words: 'I, too, shepherds, in Arcadia dwelt.'[7] They conjure up the retrospective vision of an unsurpassable happiness, enjoyed in the past, unattainable ever after, yet enduringly alive in the memory: a bygone happiness ended by death; and not, as George III's paraphrase implies, a present happiness menaced by death.

I shall try to show that this royal rendering – 'Death is even in Arcadia' – represents a grammatically correct, in fact, the only grammatically correct, interpretation of the Latin phrase *Et in Arcadia ego*, and that our modern reading of its message – 'I, too, was born, or lived, in Arcady' – is in reality a mistranslation. Then I shall try to show that this mistranslation, indefensible though it is from a philological point of view, yet did not come about by 'pure ignorance'

4. This form of the phrase is found in Richard Wilson's picture (in the collection of the Earl of Strafford), cited below, p. 364 f.

5. This is the beginning of Friedrich Schiller's famous poem *Resignation* (quoted, for example in Büchmann, *Geflügelte Worte*, 27th ed., p. 441 f., with many other instances from German literature), where the frustrated hero has renounced Pleasure and Beauty in favour of Hope and Truth and unsuccessfully requests compensation. In English dictionaries of quotations, the passage is often erroneously ascribed to Goethe (by way of confusion with the motto superscribed on his *Italienische Reise*, for which see below, p. 366); cf., e.g., Burt Stevenson, *The Home Book of Quotations*, New York, 1937, p. 94; *A New Dictionary of Quotations*, H. L. Mencken, ed., New York, 1942, p. 53 (here with the equally erroneous assertion that 'the phrase begins to appear on paintings in the XVI century'); Bartlett's *Familiar Quotations*, Boston, 1947, p. 1043.

6. Jacques Delille, *Les Jardins*, 1782, quoted, e.g., in Büchmann, loc. cit., and Stevenson, loc. cit.

7. *The Poetical Works of Mrs Felicia Hemans*, Philadelphia, 1847, p. 398. See below, Note 49, p. 364.

but, on the contrary, expressed and sanctioned, at the expense of grammar but in the interest of truth, a basic change in interpretation. Finally, I shall try to fix the ultimate responsibility for this change, which was of paramount importance for modern literature, not on a man of letters but on a great painter.

Before attempting all this, however, we have to ask ourselves a preliminary question: how is it that that particular, not overly opulent, region of central Greece, Arcady, came to be universally accepted as an ideal realm of perfect bliss and beauty, a dream incarnate of ineffable happiness, surrounded nevertheless with a halo of 'sweetly sad' melancholy?

There had been, from the beginning of classical speculation, two contrasting opinions about the natural state of man, each of them, of course, a 'Gegen-Konstruktion' to the conditions under which it was formed. One view, termed 'soft' primitivism in an illuminating book by Lovejoy and Boas,[8] conceives of primitive life as a golden age of plenty, innocence and happiness – in other words, as civilized life purged of its vices. The other, 'hard' form of primitivism conceives of primitive life as an almost subhuman existence full of terrible hardships and devoid of all comforts – in other words, as civilized life stripped of its virtues.

Arcady, as we encounter it in all modern literature, and as we refer to it in our daily speech, falls under the heading of 'soft' or golden-age primitivism. But of Arcady as it existed in actuality, and as it is described to us by the Greek writers, almost the opposite is true.

To be sure, this real Arcady was the domain of Pan, who could be heard playing the syrinx on Mount Maenalus,[9] and its inhabitants were famous for their musical accomplish-

8. A. O. Lovejoy and G. Boas, *Primitivism and Related Ideas in Antiquity*, Baltimore, I, 1935.

9. Pausanius, *Periegesis*, VIII, 36, 8: 'Mount Maenalus is particularly sacred to Pan so that people assert that Pan could be heard there playing the syrinx.'

ments as well as for their ancient lineage, rugged virtue, and
rustic hospitality; but they were also famous for their utter
ignorance and low standards of living. As the earlier Samuel
Butler was to summarize it in his well-known satire against
ancestral pride:

> The old Arcadians that could trace
> Their pedigree from race to race
> Before the moon, were once reputed
> Of all the Grecians the most stupid,
> Whom nothing in the world could bring
> To civil life but fiddleing.[10]

And from a purely physical point of view their country
lacked most of the charms which we are wont to associate
with a land of ideal pastoral bliss. Polybius, Arcady's most
famous son, while doing justice to his homeland's simple
piety and love of music, describes it otherwise as a poor,
bare, rocky, chilly country, devoid of all the amenities of
life and scarcely affording food for a few meagre goats.[11]

10. Samuel Butler, *Satires and Miscellaneous Poetry and Prose*, R.
Lamar, ed., Cambridge, 1929, p. 470.

11. Polybius, *Historiae*, IV, 20. For further authors emphasizing the
negative aspects of primordial simplicity, see, for example, Juvenal,
who characterized a peculiarly boring orator as an 'Arcadian youth'
(*Saturae*, VII, 160) and Philostratus, *Vita Apollonii*, VIII, 7, who calls
the Arcadians 'acorn-eating swine'. Even their musical achievements
were disparaged by Fulgentius, *Expositio Virgilianae continentiae*, 748,
19 (R. Helm, ed., Leipzig, 1898, p. 90), who by *Arcadicae aures* (the
reading *Arcadicis auribus* is better documented than, and preferable to,
arcaicis ayribus) meant 'ears not susceptible to real beauty'. The much
discussed question as to whether there had existed in Arcady a genuine
pastoral or bucolic poetry preceding Theocritus' *Idylls* now seems to
have been decided in the negative. In addition to the literature ad-
duced in E. Panofsky, 'Et in Arcadia Ego; On the Conception of
Transience in Poussin and Watteau', *Philosophy and History, Essays
Presented to Ernst Cassirer*, R. Klibansky and H. J. Paton, eds., Oxford,
1936, p. 223 ff., see now B. Snell, 'Arkadien, die Entstehung einer
geistigen Landschaft', *Antike und Abendland*, I, 1944, p. 26 ff. An article
by M. Petriconi, 'Das neue Arkadien', ibid., III, 1948, p. 187 ff., does
not contribute much to the problem discussed in this essay.

Small wonder, then, that the Greek poets refrained from staging their pastorals in Arcady. The scene of the most famous of them, the *Idylls* of Theocritus, is laid in Sicily, then so richly endowed with all those flowery meadows, shadowy groves and mild breezes which the 'desert ways' (William Lithgow) of the actual Arcady conspicuously lacked. Pan himself has to journey from Arcady to Sicily when Theocritus' dying Daphnis wishes to return his shepherd's flute to the god.[12]

It was in Latin, not in Greek, poetry that the great shift took place and that Arcady entered upon the stage of world literature. But even here we can still distinguish between two opposite manners of approach, one represented by Ovid, the other by Virgil. Both of them based their conception of Arcady to some extent on Polybius; but they used him in diametrically opposed ways. Ovid describes the Arcadians as primeval savages, still representing that period 'prior to the birth of Jupiter and the creation of the moon', to which Samuel Butler alludes:

> *Ante Jovem genitum terras habuisse feruntur*
> *Arcades, et Luna gens prior illa fuit.*
> *Vita ferae similis, nullos agitata per usus;*
> *Artis adhuc expers et rude volgus erat.*[13]

'The Arcadians are said to have inhabited the earth before the birth of Jupiter; their tribe was older than the moon. Not as yet enhanced by discipline and manners, their life was similar to that of beasts; they were an uncouth lot, still ignorant of art.' Very consistently, Ovid makes no mention of their one redeeming feature, their musicality: he made Polybius' Arcady even worse than it was.

Virgil, on the other hand, idealized it: not only did he emphasize the virtues that the real Arcady had (including the all-pervading sound of song and flutes not mentioned by Ovid); he also added charms which the real Arcady had never possessed: luxuriant vegetation, eternal spring, and

12. Theocritus, *Idylls*, I, 123 ff. 13. Ovid, *Fasti*, II, 289 ff.

inexhaustible leisure for love. In short, he transplanted the bucolics of Theocritus to what he decided to call Arcadia, so that Arethusa, the fountain nymph of Syracuse, must come to his assistance in Arcady,[14] whereas Theocritus' Pan, as mentioned before, had been implored to travel in the opposite direction.

In so doing, Virgil accomplished infinitely more than a mere synthesis of 'hard' and 'soft' primitivism, of the wild Arcadian pine trees with the Sicilian groves and meadows, of Arcadian virtue and piety with Sicilian sweetness and sensuousness: he transformed two realities into one Utopia, a realm sufficiently remote from Roman everyday life to defy realistic interpretation (the very names of the characters as well as of the plants and animals suggest an unreal, far-off atmosphere when the Greek words occur in the context of Latin verse), yet sufficiently saturated with visual concreteness to make a direct appeal to the inner experience of every reader.

It was, then, in the imagination of Virgil, and of Virgil alone, that the concept of Arcady, as we know it, was born – that a bleak and chilly district of Greece came to be transfigured into an imaginary realm of perfect bliss. But no sooner had this new, Utopian Arcady come into being than a discrepancy was felt between the supernatural perfection of an imaginary environment and the natural limitations of human life as it is. True enough, the two fundamental tragedies of human existence, frustrated love and death, are by no means absent from Theocritus' *Idylls*. On the contrary, they are strongly accentuated and depicted with haunting intensity. No reader of Theocritus will ever forget the desperate, monotonous invocations of the abandoned Simaetha, who, in the dead of night, spins her magic wheel in order to regain her lover;[15] or the end of Daphnis, destroyed by Aphrodite because he has dared challenge the power of love.[16] But with Theocritus these human tragedies

14. Virgil, *Eclogues*, X, 4–6. 15. Theocritus, *Idylls*, II.
16. Theocritus, *Idylls*, I.

are real – just as real as the Sicilian scenery – and they are things of the present. We actually witness the despair of the beautiful sorceress; we actually hear the dying words of Daphnis even though they form part of a 'pastoral song'. In Theocritus' real Sicily, the joys and sorrows of the human heart complement each other as naturally and inevitably as do rain and shine, day and night, in the life of nature.

In Virgil's ideal Arcady human suffering and super-humanly perfect surroundings create a dissonance. This dissonance, once felt, had to be resolved, and it was resolved in that vespertinal mixture of sadness and tranquillity which is perhaps Virgil's most personal contribution to poetry. With only slight exaggeration one might say that he 'discovered' the evening. When Theocritus' shepherds conclude their melodious converse at nightfall, they like to part with a little joke about the behaviour of nannies and billy goats.[17] At the end of Virgil's *Eclogues* we feel evening silently settle over the world: 'Ite domum saturae, venit Hesperus, ite, capel-lae';[18] or: 'Majoresque cadunt altis de montibus umbrae.'[19]

Virgil does not exclude frustrated love and death; but he deprives them, as it were, of their factuality. He projects tragedy either into the future, or preferably, into the past, and he thereby transforms mythical truth into elegiac sentiment. It is this discovery of the elegiac, opening up the dimension

17. Theocritus, *Idylls*, I, 151 f.; V, 147 ff.

18. Virgil, *Eclogues*, X, 77: 'Come home, you've had your fill; the evening star is here; come home, my goats.' Cf. also *Eclogues*, VI, 84 ff.:

> *Ille canit (pulsae referunt ad sidera valles),*
> *Cogere donec ovis stabulis numerumque referre*
> *Iussit et invito processit Vesper Olympo.*

'[Silenus] sings, the echoing valleys wafting the sound to the stars, until Hesperus has ordered the flocks to be stabled and counted and, against Olympus' wishes, has pursued his course.' The *invito Olympo* ('Olympus' here used for 'the Olympians' as we use 'the Kremlin' for the Russian government) has to be construed as an ablative absolute: the gods regret that the relentless progress of the evening star puts an end to the song of Silenus.

19. Virgil, *Eclogues*, I, 83: 'And longer fall the shadows from the mountains high.'

of the past and thus inaugurating that long line of poetry that was to culminate in Thomas Gray, which makes Virgil's bucolics, in spite of their close dependence on Greek models, a work of original and immortal genius. The Daphnis motif, for instance, was used by Virgil in two of his *Eclogues*, the Tenth and the Fifth. But in both cases, tragedy no longer faces us as stark reality but is seen through the soft, coloured haze of sentiment either anticipatory or retrospective.

In the Tenth *Eclogue*, the dying Daphnis is boldly – and, it would seem, not without humour – transformed into a real person, Virgil's friend and fellow poet, Gallus. And while Theocritus' Daphnis is really dying because he has refused to love, Virgil's Gallus announces to a group of sympathizing shepherds and sylvan divinities that he is going to die because his mistress, Lycoris, has left him for a rival: she dwells in the dreary North but she is happy in the arms of her handsome soldier, Antony; he, Gallus, is surrounded by all the beauties of Utopia but wastes away with grief, comforted only by the thought that his sufferings and ultimate demise will be the subject of an Arcadian dirge.

In the Fifth *Eclogue*, Daphnis has retained his identity; but – and this is the novelty – his tragedy is presented to us only through the elegiac reminiscences of his survivors, who are preparing a memorial ceremony and are about to raise a tombstone for him:

> A lasting monument to Daphnis raise
> With this inscription to record his praise:
> 'Daphnis, the fields' delight, the shepherds' love,
> Renown'd on earth and deifi'd above;
> Whose flocks excelled the fairest on the plains,
> But less than he himself surpassed the swains.'[20]

II

Here, then, is the first appearance of the 'Tomb in Arcadia', that almost indispensable feature of Arcady in later poetry and art. But after Virgil's passing, this tomb, and with it

20. Virgil, *Eclogues*, V, 42 ff., here quoted from Dryden's translation.

Virgil's Arcady as a whole, was to sink into oblivion for many centuries. During the Middle Ages, when bliss was sought in the beyond and not in any region of the earth, however perfect, pastoral poetry assumed a realistic, moralizing and distinctly non-Utopian character.[21] The *dramatis personae* were 'Robin' and 'Marion' instead of 'Daphnis' and 'Chloe', and the scene of Boccaccio's *Ameto*, where more than thirteen hundred years after Virgil at last the name of Arcadia reappears, is laid near Cortona in Tuscany. Arcadia is represented only by an emissary, so to speak, and this emissary – a shepherd named Alcesto di Arcadia – limits himself to defending, after the fashion of the conventional 'debates' (*concertationes* or *conflictus*), the Polybian and Ovidian ideal of rough and healthy frugality against the charms of wealth and comfort extolled by his rival, Achaten di Achademia from Sicily.[22]

In the Renaissance, however, Virgil's – not Ovid's and Polybius' – Arcady emerged from the past like an enchanting vision. Only, for the modern mind, this Arcady was not so much a Utopia of bliss and beauty distant in space as a Utopia of bliss and beauty distant in time. Like the whole classical sphere, of which it had become an integral part, Arcady became an object of that nostalgia which distinguishes the real Renaissance from all those pseudo- or proto-Renaissances that had taken place during the Middle Ages:[23] it developed into a haven, not only from a faulty reality but also, and even more so, from a questionable present. At the height of the Quattrocento an attempt was made to bridge the gap between the present and the past by means of an allegorical fiction. Lorenzo the Magnificent and Politian metaphorically identified the Medici villa at Fiesole with Arcady and their own circle with the Arcadian

21. For a brief summary of the development, see L. Levraut, *Le Genre pastoral*, Paris, 1914.

22. Boccaccio, *Ameto*, V (Florence edition of 1529, p. 23 ff.).

23. Cf. E. Panofsky, 'Renaissance and Renascences', *Kenyon Review*, VI, 1944, p. 201 ff.

shepherds; and it is this alluring fiction which underlies Signorelli's famous picture – now, unhappily, destroyed – which used to be admired as the *Realm of Pan*.[24]

Soon, however, the visionary kingdom of Arcady was re-established as a sovereign domain. In Boccaccio's *Ameto* it had figured only as a distant home of rustic simplicity, and the Medicean poets had used it only as a classical disguise for their own country life. In Jacopo Sannazaro's *Arcadia*[25] of 1502 Arcady itself is the scene of the action and is glorified for its own sake; it is revived as an emotional experience *sui generis* and *sui juris* instead of serving as a classical pseudonym for the poet's and his patrons' own surroundings. Sannazaro's Arcady is, like Virgil's, a Utopian realm. But in addition it is a realm irretrievably lost, seen through a veil of reminiscent melancholy: 'La musa vera del Sannazaro è la malinconia,' as an Italian scholar puts it.[26] Reflecting the feeling of a period that, for the first time, had realized that Pan was dead, Sannazaro wallows in those funeral hymns and ceremonies, yearning love songs and melancholy memories which occur in Virgil only occasionally; and his very predilection for triple rhymes, technically known as *drucciolo* (a few lines of this kind will be quoted later), endows his verses with a sweet, lingering plaintiveness. It was through him that the elegiac feeling – present but, as it were,

24. For an analysis of Signorelli's painting, see F. Saxl, *Antike Götter in der Spätrenaissance, Studien der Bibliothek Warburg*, VIII, Leipzig and Berlin, 1927, p. 22 ff.

25. For Jacopo Sannazaro's *Arcadia*, see M. Scherillo's illuminating introduction to his edition of 1888. Sannazaro's poem – first published at Venice in 1502 – is based on both Italian and classical sources (Petrarch and Boccaccio on the one hand, Virgil, Polybius, Catullus, Longus, Nemesius, etc., on the other), thereby resuscitating the Virgilian conception of Arcadia within the limits of a modern, more subjective *Weltanschauung*. Sannazaro's is the first postclassical pastoral actually staged *in* Arcadia, and it is a significant fact that the few allusions to the contemporary scene, the court of Naples, were added, or at least made explicit, only in the second edition of 1504.

26. A. Sainati, *La lirica latina del Rinascimento*, Pisa, 1919, I, p. 184, quoted by Saxl, ibid.

peripheral in Virgil's *Eclogues* – became the central quality of the Arcadian sphere. One more step and this nostalgic but as yet impersonal longing for the unbroken peace and innocence of an ideal past was sharpened into a bitter, personal accusation against the real present. The famous 'O bell'età de l'oro' in Torquato Tasso's *Aminta* (1573) is not so much a eulogy of Arcady as an invective against the constrained and conscience-ridden spirit of Tasso's own period, the age of the Counter-Reformation. Flowing hair and nude bodies are bound and concealed, deportment and carriage have lost touch with nature; the very spring of pleasure is polluted, the very gift of Love perverted into theft.[27] Here is the outburst of an actor stepping before the footlights and in the presence of all contrasting the misery of his real existence with the splendour of his role.

III

Almost exactly half a century later, Giovanni Francesco Guercino – not Bartolommeo Schidone, as stated in all 'Dictionaries of Familiar Quotations' – produced the first pictorial rendering of the Death in Arcady theme (Plate 90); and it is in this picture, painted at Rome between 1621 and 1623 and now preserved in the Galleria Corsini, that we first encounter the phrase *Et in Arcadia ego*.[28] There are reasons to believe that the subject was of special interest to Giulio Rospigliosi (later Pope Clement IX), whose family palace, which housed Guido Reni's *Aurora*, must have been frequently visited by Guercino when he composed his own,

27. Tasso, *Aminta*, I, 2 (E. Grillo, ed., London and Toronto, 1924, p. 90 ff.).

28. Guercino's picture is referred to as Schidone's in, for example, Büchmann, loc. cit.; Bartlett, loc. cit. (where, in addition, the inscription on Poussin's Louvre painting is misquoted as *Et ego in Arcadia vixi*); and Hoyt's *New Cyclopedia of Poetical Quotations* (which has the text right but translates it as: 'I, too, was in Arcadia'). For the correct attribution of the painting, see H. Voss, 'Kritische Bemerkungen zu Seicentisten in den römischen Galerien', *Repertorium für Kunstwissenschaft*, XXXIV, 1911, p. 119 ff. (p. 121).

Et in Arcadia Ego

more modern *Aurora* in the Casino Ludovisi; and Giulio Rospigliosi – a humanist, a lover of the arts, and a poet of no mean merits – may even be the inventor of the famous phrase, which is not classical and does not seem to occur in literature before it made its appearance in Guercinos' picture.[29] What, then, is the literal sense of this phrase?

29. For Giulio Rospigliosi, see L. von Pastor, *The History of the Popes*, E. Graf, tr. XXXI, London, 1940, p. 319 ff.; for his poetical works, G. Cavenazzi, *Papa Clemente IX Poeta*, Modena, 1900. He was born in 1600 at Pistoia but educated at the Jesuits' College at Rome, subsequently studied at the University of Pisa, and taught philosophy there from 1623 to 1625 (which, of course, did not prevent him from visiting Rome at intervals). Soon after, he seems to have settled in Rome (in 1629 he composed poems on a Barberini-Colonna wedding) and obtained high offices at the Curia in 1632. After nine years as papal nuncio in Spain (1644–53), he became governor of Rome (1655), was created cardinal in 1657, elected pope in 1667, and died in 1669. That this cultured and unselfish prince of the Church – who patronized the first 'Exhibition of Old Masters', organized by his brother, in the last year of his papacy (Pastor, p. 331) – was in some way involved with the *Et in Arcadia* subject is suggested by a passage in G. P. Bellori, *Le vite de' pittori, scultori, et architetti moderni*, Rome, 1672, p. 447 f. After having described Poussin's '*Ballo della vita humana*', now in the Wallace Collection at London, Bellori informs us that the subject of this *morale poesia* had been 'suggested by Pope Clement IX, when still a prelate', and goes on to say that the painter did full justice to the *sublimatà dell'Autore che aggiunse le due seguenti invenzioni*, to wit, '*La verità scoperta del Tempo*' (probably not identical with the painting now in the Louvre but with another version, transmitted through the engravings listed in A. Andresen, *Nicolaus Poussin*; *Verzeichnis der nach seinen Gemälden gefertigten Kupferstiche*, Leipzig, 1863, Nos 407 and 408, the latter dedicated to Clement IX) and '*La Felicità soggetta a la Morte*', that is to say, the *Et in Arcadia ego* composition. Barring a typographical error (omission of a *si* before *che aggiunse*), the 'exalted' *Autore* can only be Giulio Rospigliosi (for Poussin is referred to, at the beginning of the same sentence, as *Niccolo*): according to Bellori it was he, Rospigliosi, who 'added the two following inventions', that is to say, in addition to the *Ballo della vita humana*, the *Verità scoperta del Tempo* and the Arcadia subject.

The difficulty is that – as we know while Bellori probably did not – this subject had already been treated by Guercino between 1621 and 1623 while he was engaged upon his Aurora fresco in the Casino

As was mentioned at the beginning, we are now inclined to translate it as 'I, too, was born, or lived, in Arcady.' That is to say, we assume that the *et* means 'too' and refers to *ego*, and we further assume that the unexpressed verb stands in the past tense; we thus attribute the whole phrase to a defunct inhabitant of Arcady. All these assumptions are incompatible with the rules of Latin grammar. The phrase *Et in Arcadia ego* is one of those elliptical sentences like *Summum jus summa iniuria*, *E pluribus unum*, *Nequid nimis* or *Sic semper tyrannis*, in which the verb has to be supplied by the reader. This unexpressed verb must therefore be unequivocally suggested by the words given, and this means that it can never be a preterite. It is possible to suggest a subjunctive as in *Nequid nimis* ('Let there never be done too much') or *Sic semper tyrannis* ('May this be the fate of all tyrants'); it is also possible, though fairly unusual, to suggest a future as in Neptune's famous *Quos ego* ('These I shall deal with'); but it is not possible to suggest a past tense. Even more important: the adverbial *et* invariably refers to the noun or pronoun directly following it (as in *Et tu, Brute*), and this means that it belongs, in our case, not to *ego* but to *Arcadia*; it is amusing to observe that some modern writers accustomed to the now familiar interpretation but blessed with an inbred feeling for good Latin – for instance, Balzac,[30] the German Romanticist C. J. Weber,[31] and the excellent Miss Dorothy

Ludovisi. Bellori's brief account may have simplified a situation which might be tentatively reconstructed as follows: Bellori knew from Poussin that Giulio Rospigliosi had ordered the Louvre version of the *Et in Arcadia ego* and had informed Poussin that he, Rospigliosi, was the actual inventor of the subject. Bellori took this to mean that Rospigliosi had 'invented' the subject when ordering the Louvre picture; but what Rospigliosi had really claimed was that he had suggested it to Guercino (doubtless a frequent visitor to Guido Reni's *Aurora*) and, subsequently, asked Poussin to repeat it in an improved redaction.

30. Balzac, *Madame Firmiani*: 'J'ai aussi aimé, *et ego in Arcadia*.'

31. C. J. Weber, *Demokritos oder hinterlassene Papiere eines lachenden Philosophen*, n. d., XII, 20, p. 253 ff.: 'Gräber und Urmen in englischen

Sayers[32] – instinctively misquote the *Et in Arcadia ego* into *Et ego in Arcadia*. The correct translation of the phrase in its orthodox form is, therefore, not 'I, too, was born, or lived, in Arcady', but: 'Even in Arcady there am I,' from which we must conclude that the speaker is not a deceased Arcadian shepherd or shepherdess but Death in person. In short, King George III's interpretation is, grammatically, absolutely right. And with reference to Guercino's painting, it is also absolutely right from a visual point of view.

In this painting two Arcadian shepherds are checked in their wanderings by the sudden sight, not of a funerary monument but of a huge human skull that lies on a mouldering piece of masonry and receives the attentions of a fly and a mouse, popular symbols of decay and all-devouring time.[33]

Gärten verbreiten die nämliche sanfte Wehmut wie ein Gottesacker oder ein "Et ego in Arcadia", in einer Landschaft von Poussin,' and the same erroneous reading, now fairly well explained, occurs in the earlier editions of Büchmann's *Geflügelte Worte* (in the 16th edition, for instance, on p. 582).

32. Dorothy Sayers, 'The Bone of Contention', *Lord Peter Views the Body* (Harcourt Brace and Co., N.Y.), p. 139. This feeling for Latin grammar seems to be widespread among British mystery-story writers. In Nicholas Blake's *Thou Shell of Death*, XII (Continental Albatross Edition, 1937), p. 219, an elderly nobleman says: '*Et ego*, Superintendent, *in Arcadia vixi* – what?'

33. The significance of the mouse as a symbol of all-devouring time is already pointed out in Horapollo's *Hieroglyphica* I, 50 (now easily accessible in G. Boas, *The Hieroglyphics of Horapollo* [Bollingen Series, XXIII], New York, 1950, p. 80) and remained well known throughout the centuries (cf. the medieval allegory of human life known as 'The Tree of Barlaam'; according to Condivi, *Vita di Michelangelo*, cap. xlv, even Michelangelo is said to have planned the inclusion of a mouse in the iconography of the Medici Chapel). Viewed through the medium of 'Romantic irony' the motive of the Guercino picture looks as follows: 'Ein gar herrliches "Memento mori" ist . . . ein hübscher gebleichter *Menschenschädel* auf der Toilette. So ein leerer Hirnkasten . . . müsste Wunder tun, wenn die Macht der Gewohnheit nicht noch stärker wäre. . . . Man würde zuletzt das Dasein des Totenschädels ganz vergessen, wenn nicht schon zu Zeiten *eine Maus* ihn wieder lebendig gemacht . . . hätte' (C. J. Weber, loc. cit.).

Incised on the masonry are the words *Et in Arcadia ego*, and it is unquestionably by the skull that they are supposed to be pronounced; an old description of the picture mistakenly but understandably even places them on a scroll issuing from the skull's mouth.[34] The skull, now, was and is the accepted symbol of Death personified, as is borne out by the very fact that the English language refers to it, not as a 'dead man's head', but as a 'death's-head'. The speaking death's-head was thus a common feature in sixteenth- and seventeenth-century art and literature[35] and is even alluded to by Falstaff

34. Leslie and Taylor, loc. cit., with reference to Reynolds' portrait of Mrs Bouverie and Mrs Crewe: 'The thought is borrowed from Guercino where the gay frolickers stumble over a death's-head with a scroll proceeding from his mouth inscribed *Et in Arcadia ego*.' The 'scroll' allegedly proceeding from the mouth of the skull is obviously due to a misinterpretation of the mouse's tail. Only, as I don't know the Reynolds sketch (unfortunately the 'Roman Sketchbook', formerly belonging to R. Gwatkin, cf. Leslie and Taylor, op. cit., I p. 51, could not be located), I cannot tell whether Reynolds misinterpreted the picture or Tom Taylor misinterpreted the sketch. In any case this very misinterpretation shows that even at a comparatively recent period an unbiased observer of the Guercino composition naturally assumed that the words *Et in Arcadia ego* were voiced by the skull.

35. As to the significance of skulls and skeletons in connexion with the general conception of life and destiny, cf. R. Zahn, *81. Berliner Winckelmanns-Programm*, 1923; T. Creizenach, 'Gaudeamus igitur', *Verhandlungen der 28. Versammlung Deutscher Philologen und Schulmänner*, Leipzig, 1872; C. H. Becker, 'Ubi sunt qui ante nos in mundo fuere?', *Aufsätze zur Kultur- und Sprachgeschichte, vornehmlich des Islam, Ernst Kuhn zum 70. Geburtstage gewidmet*, 1916, pp. 87 ff. It appears that the original significance of those morbid symbols, occurring on goblets and table decorations before they appeared on sepulchral monuments, was a purely hedonistic one, viz., an invitation to enjoy the pleasures of life as long as it lasts, and only subsequently was turned into a moralistic sermon of resignation and penitence. This development took place in ancient Egypt as well as in the civilizations deriving from classical antiquity, both occidental and oriental. In them, the inversion of the original idea was chiefly due to patristic writing. In point of fact, the *Vita brevis* idea is characterized by an intrinsic ambivalence implying both the Horatian *Carpe diem* and the Christian *surge, surge, vigila, semper esto paratus* (refrain of a song of 1267). From

(2 *Henry IV*, *II*. 4) when he answers Doll Tearsheet's well-intentioned warnings as to his conduct: 'Peace, good Doll, do not speak like a death's-head; do not bid me remember mine end.'

This 'remember mine end' is precisely the message of Guercino's painting. It conveys a warning rather than sweet, sad memories. There is little or nothing elegiac about it, and when we try to trace the iconographic antecedents of the composition, we find them in such moralistic representations as the renderings of the Legend of the Three Quick and the Three Dead (known to all from the Camposanto at Pisa), where three young knights, setting out for a hunt, come upon three corpses that rise from their coffins and warn the elegant young men against their thoughtless enjoyment of life (Plate 89). As these medieval dandies are stopped by the coffins, so are Guercino's Arcadians stopped by the skull; the old description just mentioned even speaks of them as 'gay frolickers *stumbling over* a death's-head'.[36] In both cases Death catches youth by the throat, so to speak, and 'bids it remember the end'. In short, Guercino's picture turns out to be a medieval *memento mori* in humanistic disguise – a favour-

the later phase of the Middle Ages the 'speaking' skulls and skeletons became so common a symbol of the *memento mori* idea (in the Camaldulensian sense of this formula) that these motifs invaded almost every sphere of everyday life. Innumerable instances are not only to be found in sepulchral art (mostly with such inscriptions as *Vixi ut vivis, morieris ut sum mortuus* or *Tales vos eritis, fueram quandoque quod estis*), but also in portraits, on clocks, on medals, and, most especially, on finger rings (many instances adduced in the London Shakespeare edition of 1785 with reference to the notorious dialogue between Falstaff and Doll Tearsheet). On the other hand, the menace of a 'speaking skull' could also be interpreted as a hopeful prospect for the afterlife, as is the case in a short stanza by the German seventeenth-century poet D. C. von Lohenstein, in which the *Redender Todtenkopff des Herrn Matthäus Machners* says: *Ja/ wenn der Höchste wird vom Kirch-Hof erndten ein/ So werd ich Todten-Kopff ein Englisch Antlitz seyn* (quoted in W. Benjamin, *Ursprung des deutschen Trauerspiels*, 1928, p. 215).

36. See the passage quoted in Note 34, p. 354.

ite concept of Christian moral theology shifted to the ideal milieu of classical and classicizing pastorals.

We happen to know that Sir Joshua Reynolds not only knew but even sketched Guercino's painting (ascribing it, incidentally, to its true author instead of to Bartolommeo Schidone).[37] It is a fair assumption that he remembered this very painting when he included the *Et in Arcadia ego* motif in his portrait of Mrs Crewe and Mrs Bouverie; and this firsthand connexion with the very source of the phrase may account for the fact that its grammatically correct interpretation (as 'Even in Arcadia, I, Death, hold sway'), while long forgotten on the Continent, remained familiar to the circle of Reynolds and, later on, became part of what may be termed a specifically English or 'insular' tradition – a tradition which tended to retain the idea of a *memento mori*. We have seen that Reynolds himself adhered to the correct interpretation of the Latin phrase and that George III understood it at once. In addition, we have an *Et in Arcadia ego* composition by Giovanni Battista Cipriani (Plate 93), born in Florence but active in England from the end of his apprenticeship up to his death in 1785,[38] which shows the coat-of-arms of Death, the skull and bones, surmounted by the inscription '*Ancora in Arcadia morte*', which means: 'Even in Arcady there is Death', precisely as King George had translated it. Even the ironic iconoclasm of our own century still draws, in England, from this original, sinister conception of the *Et in Arcadia* theme. Augustus John, who

37. See Leslie and Taylor, op. cit., p. 260: 'I find a sketch of Guercino's picture in Reynolds' Roman notebook.' It was obviously from this sketch, probably bearing the usual explanatory note, that Tom Taylor learned about the Corsini picture and its author, and so surprising was this knowledge that a later biographer of Reynolds, ignorant as he was of the Guercino painting, ventured to state that Reynolds had been inspired by Poussin (W. Armstrong, *Joshua Reynolds*, übersetzt von E. von Kraatz, n.d., p. 89).

38. Cipriani produced, among other things, the illustrations of the famous Ariosto edition brought out by the Baskerville Press at Birmingham in 1773.

likes to designate portraits of Negro girls with such Arcadian names as 'Daphne', 'Phyllis', or even 'Aminta', has affixed the title *Atque in Arcadia ego* (the unorthodox *atque* expressing the 'even' still more emphatically than does the orthodox *et*) to a morbid, morning-after scene where Death has assumed the guise of a ghastly guitar player;[39] and in Evelyn Waugh's *Brideshead Revisited* the narrator, while a sophisticated undergraduate at Oxford, adorns his rooms at college with a 'human skull lately purchased from the School of Medicine which, resting on a bowl of roses, formed at the moment the chief decoration of my table. It bore the motto *Et in Arcadia ego* inscribed on its forehead.'

However, Cipriani, while faithful to the 'insular' tradition in the translation of the Latin phrase, drew from another source for his pictorial composition. A thoroughgoing eclectic, he expanded the landscape and added sheep, dogs, and fragments of classical buildings; he increased the personnel by seven figures of a, generally speaking, Raphaelesque character (five of them women); and he replaced Guercino's artless masonry and actual death's-head by an elaborately classicizing tomb, with the skull and bones carved upon it in relief.

In doing all this, this rather indifferent artist shows himself familiar with the innovations of that one man whose pictures mark the turning point in the history of the *Et in Arcadia ego* theme: the great French painter Nicolas Poussin.

IV

Poussin had come to Rome in 1624 or 1625, one or two years after Guercino had left it. And a few years later (presumably about 1630) he produced the earlier of his two *Et in Arcadia ego* compositions, now in the Devonshire Collection at

39. J. Rothenstein, *Augustus John*, Oxford, n.d., Fig. 71. The Negro portraits referred to are illustrated there in Figs. 66, 67, 69. According to a letter from Sir John Rothenstein, the titles given to Augustus John's works in his book were furnished orally by the artist.

Chatsworth (Plate 91). Being a Classicist (though in a very special sense), and probably conversant with Virgil, Poussin revised Guercino's composition by adding the Arcadian river god Alpheus and by transforming the decaying masonry into a classical sarcophagus inscribed with the *Et in Arcadia ego*; moreover, he emphasized the amorous implications of the Arcadian milieu by the addition of a shepherdess to Guercino's two shepherds. But in spite of these improvements, Poussin's picture does not conceal its derivation from Guercino's. In the first place, it retains to some extent the element of drama and surprise: the shepherds approach as a group from the left and are unexpectedly stopped by the tomb. In the second place, there is still the actual skull, placed upon the sarcophagus above the word *Arcadia*, though it has become quite small and inconspicuous and fails to attract the attention of the shepherds who – a telling symptom of Poussin's intellectualistic inclinations – seem to be more intensely fascinated by the inscription than they are shocked by the death's-head. In the third place, the picture still conveys, though far less obtrusively than Guercino's, a moral or admonitory message. It formed, originally, the counterpart of a *Midas Washing His Face in the River Pactolus* (now in the Metropolitan Museum at New York), the iconographically essential figure of the river god Pactolus accounting for the inclusion of its counterpart, the less necessary river god Alpheus, in the Arcadia picture.[40]

In conjunction, the two compositions thus teach a two-fold lesson, one warning against a mad desire for riches at the expense of the more real values of life, the other against a thoughtless enjoyment of pleasures soon to be ended. The phrase *Et in Arcadia ego* can still be understood to be voiced

40. The connexion between Poussin's earlier *Et in Arcadia* composition, viz., the painting owned by the Duke of Devonshire, and the New York Midas picture was recognized and completely analysed by A. Blunt, 'Poussin's Et in Arcadia ego', *Art Bulletin*, XX, 1938, p. 96 ff. Blunt dates the Duke of Devonshire version about 1630, with which I am now inclined to agree.

by Death personified, and can still be translated as 'Even in Arcady I, Death, hold sway', without being out of harmony with what is visible in the painting itself.

After another five or six years, however, Poussin produced a second and final version of the *Et in Arcadia ego* theme, the famous picture in the Louvre (Plate 92). And in this painting – no longer a *memento mori* in classical garb paired with a *cave avaritiam* in classical garb, but standing by itself – we can observe a radical break with the medieval, moralizing tradition. The element of drama and surprise has disappeared. Instead of two or three Arcadians approaching from the left in a group, we have four, symmetrically arranged on either side of a sepulchral monument. Instead of being checked in their progress by an unexpected and terrifying phenomenon, they are absorbed in calm discussion and pensive contemplation. One of the shepherds kneels on the ground as though rereading the inscription for himself. The second seems to discuss it with a lovely girl who thinks about it in a quiet, thoughtful attitude. The third seems trajected into a sympathetic, brooding melancholy. The form of the tomb is simplified into a plain rectangular block, no longer foreshortened but placed parallel to the picture plane, and the death's-head is eliminated altogether.

Here, then, we have a basic change in interpretation. The Arcadians are not so much warned of an implacable future as they are immersed in mellow meditation on a beautiful past. They seem to think less of themselves than of the human being buried in the tomb – a human being that once enjoyed the pleasures which they now enjoy, and whose monument 'bids them remember their end' only in so far as it evokes the memory of one who had been what they are. In short, Poussin's Louvre picture no longer shows a dramatic encounter with Death but a contemplative absorption in the idea of mortality. We are confronted with a change from thinly veiled moralism to undisguised elegiac sentiment.

This general change in content – brought about by all

those individual changes in form and motifs that have been mentioned, and too basic to be accounted for by Poussin's normal habit of stabilizing and in some measure tranquillizing the second version of an earlier picture dealing with the same subject[41] – can be explained by a variety of reasons. It is consistent with the more relaxed and less fearful spirit of a period that had triumphantly emerged from the spasms of the Counter-Reformation. It is in harmony with the principles of Classicist art theory, which rejected 'les objets bizarres', especially such gruesome objects as a death's-head.[42] And it was facilitated, if not caused, by Poussin's familiarity with Arcadian literature, already evident in the Chatsworth picture, where the substitution of a classical sarcophagus for Guercino's shapeless piece of masonry may well have been suggested by the tomb of Daphnis in Virgil's Fifth *Eclogue*. But the reverent and melancholy mood of the Louvre picture, and even a detail such as the simple, rectangular shape of the tomb, would seem to reveal a fresh contact with Sannazaro. His description of the 'Tomb in Arcadia' – characteristically no longer enclosing the reluctant shepherd Daphnis but a no less reluctant shepherdess named Phyllis – actually foreshadows the situation visualized in Poussin's later composition:

> *farò fra questi rustici*
> *La sepoltura tua famosa e celebre.*
> *Et da' monti Thoscani et da' Ligustici*
> *Verran pastori ad venerar questo angulo*
> *Sol per cagion che alcuna volta fustici.*
> *Et leggeran nel bel sasso quadrangulo*
> *Il titol che ad tutt'hore il cor m'infrigida,*
> *Per cui tanto dolor nel petto strangulo:*
> *'Quella che ad Meliseo si altera et rigida*

41. The importance of this habit is, in my opinion, somewhat over-estimated in J. Klein, 'An Analysis of Poussin's "Et in Arcadia ego"', *Art Bulletin*, XIX, 1937, p. 314 ff.

42. See, for example, H. Jouin, *Conférences de l'Académie Royale de Peinture et de Sculpture*, Paris, 1883, p. 94.

Si mostrò sempre, hor mansueta et humile
Si sta sepolta in questa pietra frigida.'[43]

'I will make thy tomb famous and renowned among these
rustic folk. Shepherds shall come from the hills of Tuscany
and Liguria to worship this corner of the world solely be-
cause thou hast dwelt here once. And they shall read on the
beautiful square monument the inscription that chills my
heart at all hours, that makes me strangle so much sorrow in
my breast: "She who always showed herself so haughty and
rigid to Meliseo now lies entombed, meek and humble, in
this cold stone."'

These verses not only anticipate the simple, rectangular
shape of the tomb in Poussin's Louvre picture which strikes
us as a direct illustration of Sannazaro's *bel sasso quadrangulo*;
they also conform in an amazing degree to the picture's
strange, ambiguous mood – to that hushed brooding over
the silent message of a former fellow being: 'I, too, lived in
Arcady where you now live; I, too, enjoyed the pleasures
which you now enjoy; I, too, was hardhearted where I
should have been compassionate. And now I am dead and
buried.' In thus paraphrasing, according to Sannazaro, the
meaning of the *Et in Arcadia ego* as it appears in Poussin's
Louvre painting, I have done what nearly all the Con-
tinental interpreters did: I have distorted the original mean-
ing of the inscription in order to adapt it to the new appear-
ance and content of the picture. For there is no doubt that
this inscription, translated correctly, no longer harmonizes
with what we see with our eyes.

When read according to the rules of Latin grammar
('Even in Arcady, there am I'), the phrase had been con-
sistent and easily intelligible as long as the words could be
attributed to a death's-head and as long as the shepherds
were suddenly and frighteningly interrupted in their walk.
This is manifestly true of Guercino's painting, where the

43. Sannazaro, *Arcadia* (Scherillo, ed.), p. 306, lines 257–67. Further
tombs occur in Sannazaro's poem on p. 70, line 49 ff., and p. 145, line
246 ff. (a literal translation of Virgil, *Eclogues*, X, 31 ff.).

death's-head is the most prominent feature of the composition and where its psychological impact is not as yet weakened by the competition of a beautiful sarcophagus or tomb. But it is also true, if in a considerably lesser degree, of Poussin's earlier picture, where the skull, though smaller and already subordinated to the newly introduced sarcophagus, is still in evidence, and where the idea of sudden interruption is retained.

When facing the Louvre painting, however, the beholder finds it difficult to accept the inscription in its literal, grammatically correct, significance. In the absence of a death's-head, the *ego* in the phrase *Et in Arcadia ego* must now be taken to refer to the tomb itself. And though a 'speaking tomb' was not unheard of in the funerary poetry of the time, this conceit was so unusual that Michelangelo, who used it in three of his fifty epitaphs on a handsome boy, thought it necessary to enlighten the reader by an explanatory remark to the effect that here it is, exceptionally, 'the tomb which addresses him who reads these verses'.[44] It is infinitely more natural to ascribe the words, not to the tomb but to the person buried therein. Such is the case with ninety-nine per cent of all epitaphs, including the inscriptions of the tomb of Daphnis in Virgil and the tomb of Phyllis in Sannazaro; and Poussin's Louvre picture suggests this familiar interpretation – which, as it were, projects the message of the Latin phrase from the present into the past – all the more forcibly as the behaviour of the figures no longer expresses surprise and dismay but quiet, reminiscent meditation.

Thus Poussin himself, while making no verbal change in the inscription, invites, almost compels, the beholder to mistranslate it by relating the *ego* to a dead person instead of to

44. See the discussion between W. Weisbach, 'Et in Arcadia ego', *Gazette des Beaux-Arts*, ser. 6, XVIII, 1937, p. 287 ff., and this writer, '"Et in Arcadia ego" et le tombeau parlant', ibid., ser. 6, XIX, 1938, p. 305 f. For Michelangelo's three epitaphs in which the tomb itself addresses the beholder ('La sepoltura parla a chi legge questi versi'), see K. Frey, *Die Dichtungen des Michelagniolo Buonaroti*, Berlin, 1897, No. LXXVII, 34, 38, 40.

the tomb, by connecting the *et* with *ego* instead of with *Arcadia*, and by supplying the missing verb in the form of a *vixi* or *fui* instead of a *sum*. The development of his pictorial vision had outgrown the significance of the literary formula, and we may say that those who, under the impact of the Louvre picture, decided to render the phrase *Et in Arcadia ego* as 'I, too, lived in Arcady', rather than as 'Even in Arcady, there am I', did violence to Latin grammar but justice to the new meaning of Poussin's composition.

This *felix culpa* can, in fact, be shown to have been committed in Poussin's own circle. His friend and first biographer, Giovanni Pietro Bellori, had given, in 1672, a perfectly correct and exact interpretation of the inscription when he wrote: '*Et in Arcadia ego*, cioè, che *il sepolcro si trova ancora* in Arcadia, e la Morte a luogo in mezzo le felicità'[45] ('*Et in Arcadia ego*, which means that the *grave is to be found* [present tense!] *even* in Arcady and that death occurs in the very midst of delight'). But only a few years later (1685) Poussin's second biographer, André Félibien, also acquainted with him, took the first and decisive step on the road to bad Latinity and good artistic analysis: 'Par cette inscription,' he says, 'on a voulou marquet que *celui qui est dans cette sépoulture a vécu* en Arcadie et que la mort se rencontre parmi les plus grandes félicitez'[46] ('This inscription emphasizes the fact that the *person buried in this tomb has lived* [past tense!] in Arcady'). Here, then, we have the occupant of the tomb substituted for the tomb itself, and the whole phrase projected into the past: what had been a menace has become a remembrance. From then on the development proceeded to its logical conclusion. Félibien had not bothered about the *et*; he had simply left it out, and this abbreviated version, quaintly retranslated into Latin, survives in the inscription

45. G. P. Bellori, loc. cit.

46. A. Félibien, *Entretiens sur les vies et les ouvrages des peintres*, Paris, 1666–85 (in the edition of 1705, IV, p. 71); cf. also the inscription of Bernard Picart's engraving after Poussin's Louvre picture as quoted by Andresen, op. cit., No. 417.

of a picture by Richard Wilson, painted at Rome in 1755: 'Ego fui in Arcadia.' Some thirty years after Félibien (1719), the Abbé du Bos rendered the *et* by an adverbial 'cependant': 'Je vivais cependant en Arcadie,'[47] which is in English: 'And yet I lived in Arcady.' The final touch, it seems, was put by the great Diderot, who, in 1758, firmly attached the *et* to the *ego* and rendered it by *aussi*: 'Je vivais aussi dans la délicieuse Arcadie,'[48] 'I, too, lived in delightful Arcady.' His translation must thus be considered as the literary source of all the later variations now in use, down to Jacques Delille, Johann Georg Jacobi, Goethe, Schiller, and Mrs Felicia Hemans.[49]

47. Abbé du Bos, *Réflexions critiques sur la poésie et sur la peinture* (first published in 1719), I, section VI; in the Dresden edition of 1760, p.48 ff.

48. Diderot, 'De la poésie dramatique', *Oeuvres complètes*, J. Assézat, ed., Paris, 1875–7, VII, p. 353. Diderot's description of the painting itself is significantly inaccurate: 'Il y a un paysage de Poussin où l'on voit de jeunes bergères qui dansent au son du chalumeau [!]; et à l'écart, un tombeau avec cette inscription *'Je vivais aussi dans la délicieuse Arcadie.'* Le prestige de style dont ils s'agit, tient quelquefois à un mot qui detourne ma vue du sujet principal, et qui me montre de côté, comme dans le paysage du Poussin, l'espace, le temps, la vie, la mort ou quelque autre idée grande et mélancolique jetée toute au travers des images de la gaieté' (cf. also another reference to the Poussin picture in Diderot's 'Salon de 1767', *Oeuvres*, XI, p. 161; later on the misplaced *aussi* became as much a matter of course in French literature as the misplaced *Auch* in Germany, as illustrated by Delille's *Et moi aussi, je fus pasteur dans l'Arcadie*). The picture described by Diderot seemed to bear out his well-known theory of the *contrastes dramatiques*, because he imagined that it showed the shepherds dancing to the sound of a flute. This error is due either to a confusion with other pictures by Poussin, such, for example, as the *Bacchanal* in the London National Gallery or the *Feast of Pan* in the Cook Collection at Richmond, or to the impression of some later picture dealing with the same subject. Angelica Kauffmann, for instance, in 1766 exhibited a picture described as follows: 'a shepherd and shepherdess of Arcadia moralizing at the side of a sepulchre, while others are dancing at a distance' (cf. Lady Victoria Manners and Dr W. C. Williamson, *Angelica Kauffmann*, London, 1924, p. 239; also Leslie and Taylor, op. cit., I, p. 260).

49. For Jacques Delille, Goethe and Schiller, see above, Notes 5, 6. As to Mrs Felicia Hemans (cf. Note 7, p. 341), the motto superscribed

Thus, while – as we have seen – the original meaning of *Et in Arcadia ego* precariously survived in the British Isles, the general development outside England resulted in the nearly universal acceptance of what may be called the elegiac interpretation ushered in by Poussin's Louvre picture. And in Poussin's own homeland, France, the humanistic tradition had so much decayed in the nineteenth century that Gustave Flaubert, the great contemporary of the early Impressionists, no longer understood the famous phrase at all. In his beautiful description of the Bois de la Garenne – 'parc très beau malgré ces beautés factices' – he mentions, together with a Temple of Vesta, a Temple of Friendship, and a great number of artificial ruins: 'sur une pierre taillée en forme de tombe, *In Arcadia ego*, non-sens dont je n'ai pu découvrir l'intention,'[50] 'on a stone cut in the shape of a tomb one reads *In Arcadia ego*, a piece of nonsense the meaning of which I have been unable to discover.'

We can easily see that the new conception of the Tomb in Arcady initiated by Poussin's Louvre picture, and sanctioned by the mistranslation of its inscription, could lead to reflections of almost opposite nature, depressing and melancholy on the one hand, comforting and assuaging on the other; and, more often than not, to a truly 'Romantic' fusion of both. In Richard Wilson's painting, just mentioned, the

on her poem appears to confuse Poussin's Louvre picture with one or more of its later variations: 'A celebrated picture of Poussin represents a band of shepherd youths and maidens suddenly checked in their wanderings and affected with various emotions by the sight of a tomb which bears the inscription "Et in Arcadia ego".' In the poem itself Mrs Hemans follows in the footsteps of Sannazaro and Diderot in assuming that the occupant of the tomb is a young girl:

> Was some gentle kindred maid
> In that grave with dirges laid?
> Some fair creature, with the tone
> Of whose voice a joy is gone?

50. Gustave Flaubert, 'Par les champs et par les grèves'. *Oeuvres complètes*, Paris, 1910, p. 70; the passage was kindly brought to my attention by Georg Swarzenski.

shepherds and the funerary monument – here a slightly mutilated *stele* – are reduced to a *staffage* accentuating the muted serenity of the Roman Campagna at sundown. In Johann Georg Jacobi's *Winterreise* of 1769 – containing what seems to be the earliest 'Tomb in Arcady' in German literature – we read: 'Whenever, in a beautiful landscape, I encounter a tomb with the inscription *Auch ich war in Arkadien,* I point it out to my friends; we stop a moment, press each other's hands, and proceed.'[51] And in a strangely attractive engraving by a German Romanticist named Carl Wilhelm Kolbe (Plate 94), who had a trick of constructing wondrous jungles and forests by magnifying grass, herbs or cabbage leaves to the size of bushes and trees, the tomb and its inscription (here, correctly, *Et in Arcadia ego* although the legend of the engraving consists of the erroneous 'Auch ich war in Arkadien') serve only to emphasize the gentle absorption of two lovers in one another. In Goethe's use of the phrase *Et in Arcadia ego*, finally, the idea of death has been entirely eliminated.[52] He uses it, in an abbreviated version ('Auch ich in Arkadien') as a motto for his famous account of his blissful journey to Italy, so that it merely means: 'I, too, was in the land of joy and beauty.'

Fragonard, on the other hand, retained the idea of death; but he reversed the original moral. He depicted two cupids, probably spirits of departed lovers, clasped in an embrace within a broken sarcophagus while other, smaller cupids

51. See Büchmann, loc. cit.
52. Cf. also Goethe's *Faust*, III, 3:

> *Gelockt, auf sel'gem Grund zu wohnen,*
> *Du flüchtetest ins heiterste Geschick!*
> *Zur Laube wandeln sich die Thronen,*
> *Arcadisch frei sei unser Glück!*

In later German literature this purely hedonistic interpretation of Arcadian happiness was to degenerate into the trivial conception of 'having a good time'. In the German translation of Offenbach's *Orphée aux Enfers* the hero therefore sings 'Als ich noch Prinz war von Arkadien' instead of 'Quand j'étais prince de *Béotie*'.

flutter about and a friendly genius illumines the scene with the light of a nuptial torch (Plate 95). Here the development has run full cycle. To Guercino's 'Even in Arcady, there is death', Fragonard's drawing replies: 'Even in death, there may be Arcady.'

Epilogue: Three Decades of Art History in the United States

Impressions of a Transplanted European

Even when dealing with the remote past, the historian cannot be entirely objective. And in an account of his own experiences and reactions the personal factor becomes so important that it has to be extrapolated by a deliberate effort on the part of the reader. I must, therefore, begin with a few autobiographical data, difficult though it is to speak about oneself without conveying the impression of either false modesty or genuine conceit.

I first came to this country in the fall of 1931 upon the invitation of New York University. I was then professor of the history of art at Hamburg; and since this Hanseatic city was always proud of its cosmopolitan tradition, the authorities were not only glad to grant me a leave of absence for one semester but subsequently consented to an arrangement whereby I was permitted to spend alternate terms in Hamburg and New York. Thus for three successive years I commuted, as it were, across the Atlantic. And when the Nazis ousted all Jewish officials in the spring of 1933, I happened to be in New York while my family were still at home. I fondly remember the receipt of a long cable in German, informing me of my dismissal but sealed with a strip of green paper which bore the inscription: 'Cordial Easter Greetings, Western Union.'

These greetings proved to be a good omen. I returned to Hamburg only in order to wind up my private affairs and to attend to the Ph.D. examinations of a few loyal students (which, curiously enough, was possible in the initial stages

368

of the Nazi regime); and thanks to the selfless efforts of my American friends and colleagues, unforgettable and unforgotten, we could establish ourselves at Princeton as early as 1934. For one year I held concurrent lectureships at New York and Princeton universities, and in 1935 I was invited to join the newly constituted humanistic faculty of the Institute for Advanced Study, which owes its reputation to the fact that its members do their research work openly and their teaching surreptitiously, whereas the opposite is true of so many other institutions of learning. I, too, have thus continued to teach in various places, with special regularity in Princeton and New York.

I am telling all this in order to make it perfectly clear that my experiences in this country are somewhat atypical in regard to both opportunities and limitations. As to the opportunities: in contrast to nearly all my colleagues, including the American-born, I was never hampered by excessive teaching obligations and never suffered from a lack of research facilities; in contrast to so many immigrant scholars, I had the good fortune of coming to the United States as a guest rather than a refugee; and, be it said with deepest gratitude, no one has ever made me feel the difference since my status suddenly changed in 1933. As to the limitations: I neither know the South beyond Asheville, N.C., nor the West beyond Chicago; and, much to my regret, have never been for any length of time in professional contact with undergraduate students.

I

Though rooted in a tradition that can be traced back to the Italian Renaissance and, beyond that, to classical antiquity, the history of art – that is to say, the historical analysis and interpretation of man-made objects to which we assign a more than utilitarian value, as opposed to aesthetics, criticism, connoisseurship and 'appreciation' on the one hand, and to purely antiquarian studies on the other – is a com-

paratively recent addition to the family of academic disciplines. And it so happens that, as an American scholar expressed it, 'its native tongue is German'. It was in the German-speaking countries that it was first recognized as a full-fledged *Fach*, that it was cultivated with particular intensity, and that it exerted an increasingly noticeable influence upon adjacent fields, including even its elder and more conservative sister, classical archaeology. The first book to flaunt the phrase 'history of art' on its title page was Winckelmann's *Geschichte der Kunst des Altertums* of 1764, and the methodical foundations of the new discipline were laid in Karl Friedrich von Rumohr's *Italienische Forschungen* of 1827. A full professorship was established at an even earlier date, 1813, at Göttingen, its first incumbent being the excellent Johann Dominic Fiorillo (in spite of his name a native of Hamburg). And in the course of the years the rapidly multiplying university chairs in Germany, Austria, and Switzerland were graced by men whose names have never lost their magic: Jakob Burckhardt, Julius von Schlosser, Franz Wickhoff, Carl Justi, Alois Riegl, Max Dvořàk, Georg Dehio, Henrich Wölfflin, Aby Warburg, Adolph Goldschmidt, Wilhelm Vöge. It was also characteristic that the major public collections were directed by men no less prominent as scholars than as administrators and experts, from Adam Bartsch and Johann David Passavant to Wilhelm Bode, Friedrich Lippmann, Max J. Friedländer, and Georg Swarzenski.

In emphasizing these facts I feel myself free from what may be suspected as retroactive German patriotism. I am aware of the dangers inherent in what has been decried as 'Teutonic' methods in the history of art and of the fact that the results of the early, perhaps too early, institutionalization of the discipline were not always desirable. I am convinced that every page by Leopold Delisle and Paul Durrieu, Louis Courajod and the Goncourt brothers, Montague Rhodes James (who wanted to be known as an 'antiquarian') and Campbell Dodgson, Cornelis Hofstede de Groot and Georges

Hulin de Loo outweighs a ton of German doctoral theses. And I can understand that from the point of view of an English gentleman the art historian is apt to look like a fellow who compares and analyses the charms of his feminine acquaintances in public instead of making love to them in private or writing up their family trees;[1] even now no permanent art historical chairs exist at either Oxford or Cambridge.[2] But the fact remains that at the time of the Great Exodus in the 1930s the German-speaking countries still held the leading position in the history of art – except for the United States of America.

II

Here the history of art had recapitulated within a few decades the development from Bellori and Baldinucci to Riegl and Goldschmidt much as the collecting activities of J. P. Morgan – beginning with small objects of enormous value in terms of material or working hours, and ending up with old-master drawings – had recapitulated the development from the Duc de Berry to Mariette and Crozat. Originally the private hobby of such men of affairs and letters as Henry Adams and Charles Eliot Norton (whose Harvard lectures were described by his son as 'Lectures on modern morals illustrated by the arts of the ancients'), art history evolved into an autonomous discipline from the beginning

1. As kindly brought to my attention by a former student residing at Oxford for the time being, it was just about eight months after this lecture had been delivered at the University of Pennsylvania that the British Broadcasting Corporation carried two speeches in defence of the history of art: N. Pevsner, 'Reflections on Not Teaching Art History' (*The Listener*, XLVIII, 1952, No. 1235, 30 October, p. 715 ff.); and E. Waterhouse, 'Art as a Piece of History' (ibid., No. 1236, 6 November, p. 761 ff.). These speeches, both very informative and the second extremely witty, were broadcast under the heading: 'An Un-English Activity?'

2. [I hear, in June 1955, that such a chair has now been established at Oxford. *Hosanna in excelsis.*]

of the twentieth century, and after the First World War (which *terminus post quem* is, of course, of portentous significance) it began to challenge the supremacy, not only of the German-speaking countries, but of Europe as a whole. This was possible, not in spite but because of the fact that its founding fathers – such men as Allan Marquand, Charles Rufus Morey, Frank J. Mather, A. Kingsley Porter, Howard C. Butler, Paul J. Sachs – were not the products of an established tradition but had come to the history of art from classical philology, theology and philosophy, literature, architecture, or just collecting. They established a profession by following an avocation.

At the beginning, the new discipline had to fight its way out of an entanglement with practical art instruction, art appreciation, and that amorphous monster 'general education'. The early issues of the *Art Bulletin*, founded in 1913 and now recognized as the leading art-historical periodical of the world, were chiefly devoted to such topics as 'What Instruction in Art Should the College A.B. Course Offer to the Future Layman?'; 'The Value of Art in a College Course'; 'What People Enjoy in Pictures'; or 'Preparation of the Child for a College Course in Art'. Art history, as we know it, sneaked in by the back door, under the guise of classical archaeology ('The Meleager in the Fogg Museum and Related Works in America'), evaluation of contemporary phenomena ('The Art of Auguste Rodin') and, characteristically, book reviews. It was not until 1919 (one year after the armistice) that it was permitted to lift its ugly little head in large print. But in 1923, when the *Art Bulletin* carried ten unashamedly art-historical articles and only one on art appreciation, and when it was found necessary to launch a competing periodical, the short-lived *Art Studies*, the battle was won (though occasional skirmishes may occur even now). And it was about this time that the European scholars, only a handful of whom had crossed the Atlantic thus far, began to sit up and take notice.

They knew, of course, that magnificent collections of all

kinds had been formed in the United States and that several very good art-historical books – to mention only Allan Marquand's numerous studies on the Della Robbia family (1912–22), Frederick Mortimer Clapp's two books on Pontormo (1914 and 1916), E. Baldwin Smith's monograph on Early Christian ivories in Provence (1918) – had been written in America. They also had heard rumours to the effect that remarkable studies of a technical nature were going on in several American museums and at a university called Harvard; that a wealthy lady in New York had founded a reference library containing thousands and thousands of photographs; and that, from as early as 1917, another university, named Princeton, was building up a comprehensive Index of Christian Iconography. This was partly taken for granted and partly considered peculiar. But in 1923 and 1924 there appeared, nearly simultaneously, A. Kingsley Porter's *Romanesque Sculpture of the Pilgrimage Roads*, which with one fell swoop revolutionized the accepted ideas as to the chronology and diffusion of twelfth-century sculpture on the entire European continent; Albert M. Friend's famous essay proposing to locate one of the most important and enigmatical Carolingian schools in the Royal Abbey of Saint-Denis; and Charles Rufus Morey's 'Sources of Medieval Style', which dared reduce the complexity of medieval art to three great currents much as Johannes Kepler had reduced the complexity of the solar system to three great laws. No European scholar – least of all the Germans and Austrians who, whatever may be said against them, were less afraid of foreign literature than most Italians and nearly all Frenchmen – could remain blind to the fact that the United States had emerged as a major power in the history of art; and that, conversely, the history of art had assumed a new, distinctive physiognomy in the United States.

The following decade – from 1923 to 1933 – saw what in retrospect will look like a Golden Age. Princeton, apart from excavating in Asia Minor as well as in France, and launching a great programme of manuscript publication,

cemented a lasting tradition of fastidious scholarship in Early Christian, Byzantine, and medieval art. Harvard trained a multitude of enthusiastic and sophisticated young men who manned an ever-growing number of ever-expanding museums. Chandler R. Post and Walter W. S. Cook established the long-neglected history of Spanish art as a field in its own right. Fiske Kimball embarked upon his epoch-making studies in the architecture and decoration of the Louis XIV, Régence, Louis XVI, and Rococo styles. William M. Ivins opened up new vistas in the interpretation and evaluation of the graphic arts. Richard Offner developed connoisseurship in the field of the Italian Primitives into the closest possible approximation to an exact science. A younger generation, now brilliantly represented by scholars such as Rensselaer Lee, Meyer Schapiro and Millard Meiss, gave the first proofs of its remarkable talents. The Museum of Modern Art, conceived by Alfred Barr, began its meteoric rise. And it was at the height of these developments that Hitler became the master of Germany.

III

In the New York of the early 1930s – especially if he came early enough to witness the final phase of the prohibition era and found himself surrounded by an atmosphere of cosy dissipation which is hard to describe and harder to remember without a certain nostalgia – the European art historian was at once bewildered, electrified, and elated. He feasted on the treasures assembled in museums, libraries, private collections, and dealers' galleries. He discovered that certain aspects of medieval painting and book illumination could be more exhaustively studied in this country than in Europe because, owing to a series of historical accidents, most of the pertinent material had found its way across the water. He was amazed that he could order a book at the New York Public Library without being introduced by an embassy or vouched for by two responsible citizens; that libraries were

open in the evenings, some as long as until midnight; and that everybody seemed actually eager to make material accessible to him. Even the Museum of Modern Art, originally housed on the twelfth floor of the Heckscher Building and later moved to a modest old brownstone dwelling on its present site, permitted visitors to leave unsnubbed in those days. Librarians and curators seemed to consider themselves primarily as organs of transmission rather than 'keepers' or *conservateurs*. Even more astonishing was the stupendous amount of activity in the art historian's world – activity not free from intellectual and social snobbery but always thoroughly stimulating: countless exhibitions and endless discussion; privately financed research projects, started today and abandoned tomorrow; lectures delivered not only in the seats of learning but also in the homes of the wealthy, the audience arriving in twelve-cylinder Cadillacs, seasoned Rolls-Royces, Pierce-Arrows, and Locomobiles. And beneath this glittering surface there could be felt the spirit of discovery and experimentation which, controlled by scholarly conscientiousness, lived in the work of the Kingsley Porters and the Charles Rufus Moreys.

Coming into its own after the First World War, American art history drew strength from what would have been a weakness twenty or thirty years before: from the cultural and geographical distance from Europe. It was, of course, important that the United States had emerged from the conflict as the only belligerent power with an unimpaired economy so that ample funds were available for travel, research facilities, and publication. But more consequential was the fact that the United States had come for the first time into active rather than passive contact with the Old World and kept up this contact in a spirit both of possessiveness and impartial observation.

Where the communications between the European countries, too close for speedy reconciliation and too poor for a speedy resumption of cultural exchange, remained disrupted for many years, the communications between Europe

and the United States had been kept intact or were quickly restored. New York was a gigantic radio set capable of receiving and transmitting to a great number of stations which were unable to reach each other. But what made the greatest impression on the stranger when first becoming aware of what was happening in America was this: where the European art historians were conditioned to think in terms of national and regional boundaries, no such limitations existed for the Americans.

The European scholars either unconsciously yielded to, or consciously struggled against, deep-rooted emotions which were traditionally attached to such questions as whether the cubiform capital was invented in Germany, France, or Italy, whether Roger van der Weyden was a Fleming or a Walloon, or whether the first rib-vaults were built in Milan, Morienval, Caën, or Durham; and the discussion of such questions tended to be confined to areas and periods on which attention had been focused for generations or at least decades. Seen from the other side of the Atlantic, the whole of Europe from Spain to the Eastern Mediterranean merged into one panorama the planes of which appeared at proper intervals and in equally sharp focus.

And as the American art historians were able to see the past in a perspective picture undistorted by national and regional bias, so were they able to see the present in a perspective picture undistorted by personal or institutional *parti pris*. In Europe – where all the significant 'movements' in contemporary art, from French Impressionism to International Surrealism, from the Crystal Palace to the 'Bauhaus', from the Morris Chair to the Aalto Chair, had come into being – there was, as a rule, no room for objective discussion, let alone historical analysis. The direct impact of the events forced the littérateurs into either defence or attack, and the more intelligent art historians into silence. In the United States such men as Alfred Barr and Henry-Russell Hitchcock, to name only two of the pioneers in this field, could look upon the contemporary scene with the same mix-

ture of enthusiasm and detachment, and write about it with the same respect for historical method and concern for meticulous documentation, as are required of a study on fourteenth-century ivories or fifteenth-century prints. 'Historical distance' (we normally require from sixty to eighty years) proved to be replaceable by cultural and geographical distance.

To be immediately and permanently exposed to an art history without provincial limitations in time and space, and to take part in the development of a discipline still animated by a spirit of youthful adventurousness, brought perhaps the most essential gains which the immigrant scholar could reap from his transmigration. But in addition it was a blessing for him to come into contact – and occasionally into conflict – with an Anglo-Saxon positivism which is, in principle, distrustful of abstract speculation; to become more acutely aware of the material problems (posed, for example, by the various techniques of painting and print-making and the static factors in architecture) which in Europe tended to be considered as the concern of museums and schools of technology rather than universities; and, last but not least, to be forced to express himself, for better or worse, in English.

In view of what has been said about the history of our discipline, it was inevitable that the vocabulary of art-historical writing became more complex and elaborate in the German-speaking countries than anywhere else and finally developed into a technical language which – even before the Nazis made German literature unintelligible to uncontaminated Germans – was hard to penetrate. There are more words in our philosophy than are dreamt of in heaven and earth, and every German-educated art historian endeavouring to make himself understood in English had to make up his own dictionary. In doing so he realized that his native terminology was often either unnecessarily recondite or downright imprecise; the German language unfortunately permits a fairly trivial thought to declaim from behind a woollen curtain of apparent profundity and, conversely, a multitude of meanings

to lurk behind one term. The word *taktisch*, for example, normally denoting 'tactical' as opposed to 'strategic', is used in art historical German as an equivalent of 'tactile' or even 'textural' as well as 'tangible' or 'palpable'. And the ubiquitous adjective *malerisch* must be rendered, according to context, in seven or eight different ways: 'picturesque' as in 'picturesque disorder'; 'pictorial' (or, rather horribly, 'painterly') as opposed to 'plastic'; 'dissolved', 'sfumato', or 'non-linear' as opposed to 'linear' or 'clearly defined'; 'loose' as opposed to 'tight'; 'impasto' as opposed to 'smooth'. In short, when speaking or writing English, even an art historian must more or less know what he means and mean what he says, and this compulsion was exceedingly wholesome for all of us. Indeed this very compulsion, combined with the fact that the American professor is much more frequently called upon to face a non-professional and unfamiliar audience than is his European confrère, went a long way to loosen our tongues, if I may say so. Forced to express ourselves both understandably and precisely, and realizing, not without surprise, that it could be done, we suddenly found the courage to write books on whole masters or whole periods instead of – or besides – writing a dozen specialized articles; and dared to deal with, say, the problem of classical mythology in medieval art in its entirety instead of – or besides – investigating only the transformations of Hercules or Venus.

These, then, are some of the spiritual blessings which this country has bestowed upon the immigrant art historians. Whether and in what way they may have been able to reciprocate is not for me to say. But I should like to mention that, from a purely temporal point of view, their influx has unquestionably contributed to the further growth of the history of art as an academic discipline as well as an object of public interest. No foreign art historian has, to the best of my knowledge, ever displaced an American-born. The immigrants were either added to the staffs of college or university departments already in being (museums were, for under-

standable but somewhat delicate reasons, not equally eager to welcome them), or were entrusted with the task of instituting the teaching of the history of art where it had previously been absent from the scene. In either case the opportunities of American students and teachers were widened rather than narrowed. And in one case a group of refugee scholars has been privileged to play a constructive role in a development that may well be called spectacular: the rise of the Institute of Fine Arts of New York University.

It grew out of the small graduate department which it was my good fortune to join in 1931, and which, at that time, had about a dozen students, three or four professors, no rooms, let alone a building, of its own, and no equipment whatsoever. Both lecture and seminar courses were held in the basement rooms of the Metropolitan Museum, commonly referred to as 'the funeral parlours', where smoking was forbidden under penalty of death and stern-faced attendants would turn us out at 8.55 p.m., regardless of how far the report or discussion had proceeded. The only thing to do was to adjourn to a nice speakeasy on Fifty-second Street; and this arrangement, laying the basis for several lasting friendships, worked very well for a term or two. But the days of speakeasies were numbered, and it was felt that the students of a big-town university needed a place, however small, where they might meet, smoke, and talk about their work during the day, without either drinks or professorial supervision, and in closer proximity to the Metropolitan Museum. Thus a tiny apartment was rented on the corner of Eighty-third Street and Madison Avenue, housing such lantern slides as had been accumulated by the individual lecturers and one of those standard sets of art books which could be obtained, upon request, from the Carnegie Corporation.

In the course of the next few years no fewer than five distinguished German refugees were called to permanent positions at what had now become the Institute of Fine Arts. Considerable funds were raised in mysterious fashion. And today this Institute, so far as I know the only independent

university organ exclusively devoted to graduate instruction in the history of art, is not only the largest but also the most animated and versatile school of its kind, occupying a six-storey building on East Eightieth Street, owning a workable library and one of the best collections of lantern slides, attended by well over a hundred graduate students advanced and enterprising enough to publish a scholarly periodical of their own, and counting among its alumni some of the most prominent academic teachers and museum men. All of which, however, would not have been possible had not the chairman, Walter Cook, shown an unparalleled combination of foresight, doggedness, business sense, self-effacing devotion, and lack of prejudice ('Hitler is my best friend,' he used to say; 'he shakes the tree and I collect the apples'), and had he not been given his chance by the providential synchronism between the rise of Fascism and Nazism in Europe and the spontaneous efflorescence of the history of art in the United States.

IV

I have just mentioned that the American scholar more frequently faces a non-professional and unfamiliar audience than does the European. On the one hand, this can be explained by general considerations. For reasons insufficiently explored by anthropologists, Americans seem to be genuinely fond of listening to lectures (a fondness encouraged and exploited by our museums which, unlike most of their sister institutions in Europe, think of themselves as cultural centres rather than as mere collections), and of attending conferences and symposia. And the 'ivory tower' in which a professor is supposed to spend his life – a figure of speech, by the way, which owes its existence to a nineteenth-century conflation of a simile from the *Song of Songs* and Danaë's tower in Horace – has many more windows in the comparatively fluid society of this country than in most others. On the other hand, the larger radius of professional activities

results, to some extent, from the specific conditions of academic life in America. And this brings me to a brief discussion of what may be called organizational questions – a discussion which will somewhat transcend my subject because what applies to the history of art applies, *mutatis mutandis*, to all other branches of the humanities.

One basic difference between academic life in the United States and Germany (I wish to limit myself to firsthand experience)[3] is that in Germany the professors are stationary and the students mobile, whereas the opposite is true in the United States. A German professor either remains in Tübingen until he dies, or he is called to Heildeberg and then, perhaps, to Munich or Berlin; but wherever he stays, he stays put. It is part of his duties to give at stated intervals, in addition to specialized lecture courses and seminars, a so-called *collegium publicum*,[4] that is to say, a series of weekly lectures

3. My comments on the organization of German universities (largely identical with that of the universities in Austria and Switzerland) refer, of course, to the period before Hitler, whose regime destroyed the very foundations of academic life in Germany and Austria. With some reservations, however, they would seem to be valid also for the period after 1945 when, so far as I know, the *status quo* was more or less restored; such minor changes as have come to my notice are mentioned in Notes 4 and 6, this page and p. 384. For further information, see the fundamental work by A. Flexner, *Universities, American, English, German*, New York, London, Toronto, 1930; and the entertaining account in E. H. Kantorowicz, 'How the Pre-Hitler German Universities Were Run', *Western College Association; Addresses on the Problem of Administrative Overhead and the Harvard Report: General Education in a Free Society*, Fall Meeting, 10 November 1945, Mills College, Cal., p. 3 ff.

4. Specialized lecture courses are given *privatim*, that is to say, the students have to register for them and pay a moderate fee per weekly hour for each semester. Seminars, on the other hand, used to be given *privatissime et gratis*, that is to say, the students did not pay any fee while the instructor, and he alone, had the right to accept the participants according to his requirements. Now, I learn, seminars (except for the most advanced ones, given for the special benefit of candidates for the Ph.D.) are subject to the same fee as the *privatim* lecture courses; but the instructor still enjoys the right of admission. In addition to the fees for individual courses, of which he must take a

dealing with a subject of more general interest, free of charge and open to all students, faculty members, and, as a rule, the general public; but he rarely ascends a platform outside his permanent habitat, except for professional meetings or congresses. The German student, however, his *abiturium* (final diploma of a recognized secondary school) entitling him to enrol at whatever university he pleases, spends one semester here and another there until he has found a teacher under whose direction he wishes to prepare his doctoral thesis (there are no bachelor's and master's degrees in German universities) and who accepts him, so to speak, as a personal pupil. He can study as long as he wishes, and even after having settled down for his doctorate he may periodically disappear for any length of time.

Here, as we all know, the situation is reversed. Our older colleges and universities, all private and thus dependent on that alumni loyalty which in this country is as powerful a force as public school loyalty is in England, reserve the right of admission and keep the undergraduates for four entire years. State institutions, though legally obliged to accept every accredited student from their state, maintain at least the principle of permanency. Transfers are looked upon with marked disapprobation. And even graduate students stay, if possible, in one and the same school until they acquire their master's degree. But, as if to make up, to some extent, for the ensuing sameness of environment and instruction, both colleges and universities freely invite guest lecturers and guest professors, now for one evening, now for some weeks, now for a term or even a year.

From the point of view of the visiting lecturer, this system has many advantages. It widens his horizon, brings him into contact with colleagues and students of greatly different types, and, after some years, may give him a delightful sense

minimum number while their choice is his own affair, the German student of a humanistic discipline pays only a registration fee for each term, plus an 'admission fee' which includes permission to use the library and seminars as well as the right to medical service, etc.

of being at home on many campuses much as the itinerant humanists of the Renaissance were at home in many cities or at many courts. But from the point of view of the student – the student, that is, who plans to take up humanistic scholarship as a profession – it has obvious drawbacks. More often than not he enters a given college because family tradition or financial reasons leave him no other choice, and a given graduate school because it happens to accept him. Even if he is satisfied with his choice the impracticability of exploring other possibilities will narrow his outlook and impair his initiative, and if he has made a mistake the situation may develop into a real tragedy. In this event, the temporary contact with visiting lecturers will hardly suffice to counterbalance the crippling effect of an unsuitable environment and may even sharpen the student's sense of frustration.

No sensible person would propose to change a system which has developed for good historical and economic reasons and could not be altered without a basic revision of American ideas and ideals. I merely want to point out that it has, like all man-made institutions, the defects of its qualities. And this also applies to other organizational features in which our academic life differs from that in Europe.

One of the most important of these differences is the division of our colleges and universities into autonomous departments, a system foreign to the European mind. In conformity with medieval tradition, the universities on the European continent in general, and those of the German-speaking countries in particular, are organized into four or five 'faculties': theology, law, medicine, and philosophy (the last-named frequently divided into mathematics and natural science, on the one hand, and the humanities, on the other). In each of these faculties there is one chair – only exceptionally more than one – devoted to such special disciplines as, to limit the discussion to the humanities, Greek, Latin, English, Islamic Languages, Classical Archaeology, or, for that matter, the History of Art; and it is, in principle, exclusively of the incumbents of these chairs, normally full

professors (*ordinarii*), that the faculties are composed.[5] The full professor forms the nucleus of a small group of what, very roughly, corresponds to associate professors (*extra-ordinarii*) and assistant professors (*Privatdozenten*)[6] over whom

5. After the First World War the German *Privatdozenten* and *extra-ordinarii* (cf. following note) won the right to be represented on the faculty by delegates who, of course, occupy their seats as representatives of their group, and not of their discipline, and are elected for only one year; when I was in Hamburg they even had to leave the room when matters pertaining to their discipline were discussed. As to the *etatsmässige extraordinarii* (cf. again the following note) the custom varies. In most universities they have a seat on the faculty only if their discipline is not represented by an *ordinarius*.

6. This correspondence is indeed a *very* rough one. On the one hand, the academic status of a *Privatdozent* (our 'instructor' has no equivalent in German universities) was and is more assured and dignified than that of even our associate professors without tenure in that he enjoys perfect freedom of teaching and is as irremovable from office as the full professor. On the other hand, this office carries, as its name implies, no remuneration (until quite recently in certain universities). Having been granted the *venia legendi* (permission to teach) on the basis of his scholastic merits (documented by a *Habilitationsschrift* and a paper read to the faculty) rather than having been 'hired' to fill a gap in the curriculum, the *Privatdozent* can claim only the fees paid by the students for his *privatim* lecture courses and seminars (cf. Note 4, p. 381). He receives a fixed salary only if he either obtains a *Lehrauftrag* (commission to teach) in a specified subject or accepts an assistantship, in which case he shoulders a goodly part of the work involved in the administration of the seminar or institute. Otherwise he depends on outside income or such subventions as may be obtained from official or semi-official foundations. The somewhat paradoxical nature of this arrangement became especially apparent during the difficult period after the First World War and may be illustrated by my personal experience. I had become (upon invitation) a *Privatdozent* at Hamburg University, founded in 1920, in 1921; and since I was the only 'full-time' representative of my discipline (other lectures and seminars being given by the directors and curators of the local museums), I was entrusted with the directorship of the nascent art-historical seminar and had the unusual privilege of accepting and examining candidates for the doctorate. I received, however, no salary; and when, by 1923, my private fortune had been consumed by the inflation, I was made a paid assistant of the very seminar of which I was the unpaid director. This interesting post of assistant to myself, created by a benevolent Senate because the

he has, however, no formal authority as to their academic activities. He is responsible for the administration of his seminar or institute; but the awarding of degrees and the admission or invitation of teaching personnel, regardless of rank and field, is decided upon by the whole faculty.

To one accustomed to our system of self-governing departments operating directly under the deities this time-honoured arrangement sounds rather absurd. When a candidate submits a doctoral thesis on the development of the diacritical signs in Arabic, the full professor of the history of art has a voice in the matter while the associate and assistant professors of Islamic Languages do not. No full professor, however unsuited for administrative work, can be relieved of his duty to conduct the affairs of his seminar or institute. No *Privatdozent*, however unsuccessful, can be discharged except by disciplinary action. He can neither be assigned a specific lecture or seminar course (unless he has accepted a special *Lehrauftrag* comparable to the contract of a 'Visiting Lecturer' here), nor can he legally be prevented from giving any lecture or seminar course he pleases, regardless of the comfort of his full professor, as long as he keeps within the limitations of his *venia legendi* ('permission to teach').[7]

But here again the American system has the faults of its

salary attached to an assistantship was somewhat higher than a *Lehrauftrag*, I held until I was appointed full professor, skipping the stage of *extraordinarius*, in 1926. Today, I learn, the *Privatdozenten* in some West German universities receive a stipend *ex officio*; but this entails a restriction of their previously illimited number, the extension of the minimum interval between doctorate and admission to a *Privatdozentur* from two years to three, and the introduction of an intermediary examination after which the candidate bears the beautiful title *Doctor habil* (*itandus*). The *extraordinarii* fall into two very different classes. They are either older *Privatdozenten* to whom a professorial title has been given by courtesy and without any material change of status, or *etatsmässige* ('budgeted') *extraordinarii* whose position is similar to that of the full professors, except for the fact that their salaries are smaller and that they have, as a rule, no seat on the faculty (cf. preceding note).

7. Cf. preceding note.

virtues (among the latter, incidentally, is a most healthy elasticity which permits, for example, older graduate students to do some teaching, either in their own university or in a neighbouring institution). The American associate or assistant professor has a full vote at departmental meetings; but he must give the courses which the department assigns to him. The affairs of the French Department cannot be interfered with by even the fullest professor of modern history or *vice versa*; but just this perfect autonomy of the departments entails two grave dangers: isolation and inbreeding.

The art historian may know as little of the diacritical signs in Arabic as the Arabist does of Caravaggio. But that the two gentlemen are bound to see each other every fortnight at a faculty meeting is good for them because they may have, or develop, a common interest in Neo-Platonism or astrological illustrations; and it is good for the university because they may have well-founded, if divergent, views about general policies which may be profitably discussed *in pleno*. The professor of Greek may know nothing of Chaucer and Lydgate; but it is useful that he has the right to ask whether the professor of English, in proposing a nice young man for an associate professorship, may not have inadvertently overlooked some other young man perhaps less nice but possibly more capable. In fact, our institutions of learning are becoming more and more acutely aware of these two dangers, isolation and inbreeding. The University of Chicago has attempted to coordinate the humanistic departments into one 'division'; other universities try interdepartmental committees and/or courses; Harvard goes so far as to make a permanent appointment in, say, the Department of Classics only after convoking an '*ad hoc* committee' composed of Harvard professors other than classicists and classicists from institutions other than Harvard. But to coordinate sovereign departments into a 'division' is about as easy as to coordinate sovereign states into an international organization, and the appointment of committees may be said to indicate the presence of a problem rather than solve it.

Needless to say, this difference between the 'departmental system' and the 'chair system', as it may be called, reflects not only a divergence in political and economic conditions but also a divergence in the concept of 'higher education' as such. Ideally (and I know full well that the European ideal has undergone, and is still undergoing, no less significant a change than the American reality), the European university, *universitas magistrorum et scholarium*, is a body of scholars, each surrounded by a cluster of *famuli*. The American college is a body of students entrusted to a teaching staff. The European student, unsupervised except for such assistance and criticism as he receives in seminars and personal conversation, is expected to learn what he wants and can, the responsibility for failure or success resting exclusively with himself. The American student, tested and graded without cease, is expected to learn what he must, the responsibility for failure or success resting largely with his instructors (hence the recurrent discussions in our campus papers as to how seriously the members of the teaching staff violate their duties when spending time on research). And the most basic problem which I have observed or encountered in our academic life is how to achieve an organic transition from the attitude of the student who feels: 'You are paid for educating me; now, damn you, educate me,' to that of the young scholar who feels: 'You are supposed to know how to solve a problem; now, please, show me how to do it'; and, on the part of the instructor, from the attitude of the taskmaster who devises and grades test papers producing the officially required percentage of failures, passes, and honours, to that of the gardener who tries to make a tree grow.

This transformation is presumed to take place in the graduate school and to reach perfection in the following years. But the sad fact is that the average graduate student (a really superior talent will assert itself in the face of any system) finds himself in a position which makes it more

difficult for him to achieve intellectual independence than it is for a certain group of undergraduates – those, that is, who, owing to their high scholastic standing, are freed from compulsory classes during their senior year.

It is the chairman of the department who assigns to the graduate student a number of courses and seminars each term (and far too many in most cases), in which he has to struggle for high marks. The subject of his master's thesis is, more often than not, determined by one of his instructors who also supervises its progress. And at the end he faces an examination, concocted by the whole department, which no single member thereof could pass in creditable fashion.

There is, by and large, any amount of good will on both sides; kindliness and helpful solicitude on the part of the teacher and – I speak from happiest experience – loyalty and responsiveness on the part of the student. But within the framework of our system just these engaging qualities seem to make the transformation from students into scholars so much the harder. Most graduate students in the humanities are not financially independent. In a society which, for good and sufficient reasons, rates the scholar considerably below the lawyer, the doctor, and, quite particularly, the successful businessman, it takes a strong will and something akin to obsession for the scion of a wealthy family to break down the resistance of his parents, uncles, and club friends when he proposes to follow a calling the highest possible reward of which is a professorship with eight or ten thousand dollars a year. The average graduate student, therefore, does not come from a wealthy family and must try to prepare himself for a job as fast as he can, and this in such a way that he is able to accept whatever offers. If he is an art historian, he expects his teachers to endow him with the ability either to enter any department of any museum or to give any course in any college; and the teachers do their best to live up to this expectation. As a result, graduate student and graduate teacher alike are haunted by what I should like to call the spectre of completeness.

In German universities this spectre of completeness – or, to be more polite, the preoccupation with the 'balanced curriculum' – does not exist. In the first place, the freedom of movement enjoyed by the students makes completeness unnecessary. The professors lecture on whichever subject fascinates them at the time, thereby sharing with their students the pleasures of discovery; and if a young man happens to be interested in a special field in which no courses are available at one university, he can, and will, go to another. In the second place, the aim of the academic process as such is to impart to the student, not a maximum of knowledge but a maximum of adaptability – not so much to teach him subject matter as to teach him method. When the European art historian leaves the university, his most valuable possession is neither the fairly uneven acquaintance with the general development of art which he is expected to acquire through lecture courses, seminars, and private reading, nor the more thorough familiarity with the special field from which the subject of his thesis has been taken, but an ability to turn himself into a specialist in whatever domain may happen to attract his fancy in later life. As time goes on, the world of the German art historian – and this writer is no exception – tends to resemble an archipelago of little islands forming, perhaps, a coherent pattern when viewed from an airplane but separated by channels of abysmal ignorance; whereas the world of his American confrère may be compared to a massive tableland of specialized knowledge overlooking a desert of general information.

After the final degree – and this is another important difference – the German art historian, provided he wishes to enter the academic career, is on his own for some time. He cannot be admitted to a teaching position before at least two or even three years have passed and he has produced a solid piece of work, the subject of which may or may not be connected with that of his doctoral thesis. And after having received the *venia legendi* he is, as mentioned earlier, at liberty to teach as much or as little as he sees fit. The young

American master of arts or master of fine arts, however, will, as a rule, at once accept an instructorship or assistant professorship which normally entails a definite and often quite considerable number of teaching hours and in addition – owing to a recent development which I consider unfortunate – imposes upon him the tacit obligation to prepare himself, as speedily as possible, for a doctor's degree as a prerequisite of promotion. He still remains a cogwheel in a machine, only that he now grades instead of being graded, and it is difficult for him to achieve that balance between teaching and research which is perhaps the finest thing in academic life.

Too often burdened with an excessive 'teaching load' – a disgusting expression which in itself is a telling symptom of the malady I am trying to describe – and no less often cut off from the necessary facilities, the young instructor or assistant professor is rarely in a position to follow up the problems encountered in the preparation of his classes; so that both he and his students miss the joyful and instructive experience which comes from a common venture into the unexplored. And never during his formative years has he had a chance to fool around, so to speak. Yet it is precisely this chance which makes the humanist. Humanists cannot be 'trained'; they must be allowed to mature or, if I may use so homely a simile, to marinate. It is not the reading matter assigned for Course 301 but a line of Erasmus of Rotterdam, or Spenser, or Dante, or some obscure mythographer of the fourteenth century, which will 'light our candle'; and it is mostly where we have no business to seek that we shall find. *Liber non est*, says a delightful Latin proverb, *qui non aliquando nihil agit*: 'He is not free who does not do nothing once in a while.'

In this respect, too, considerable efforts at improvement have been made in recent years. Most art departments no longer insist on absolute omniscience in their M.A.s, M.F.A.s, and even Ph.D.s, but allow one or two 'areas of concentration'. A breathing spell between the end of

graduate school and the beginning of a 'career' is provided, in a number of cases, by the Fulbright Fellowships (which are, however, limited to study abroad and are administered, as far as the final decisions are concerned, by a political rather than scholastic agency). The same Fulbright Fellowships are also open to scholars already in harness, if I may say so, and these can furthermore obtain a year or two of unimpended research by winning such awards as a Guggenheim Fellowship or a temporary membership with the Institute for Advanced Study, which considers this kind of service as one of its principal functions. Grants of this type, of course, take the incumbent out of teaching altogether. But even the problem of balance between teaching and research has, fortunately, begun to attract some attention. A few universities, notably Yale and Princeton, use special funds either for relieving promising faculty members from teaching altogether or, a more original approach, for cutting their teaching in half for a certain period without reducing their salaries.

VI

Yet much remains to be done. And nothing short of a miracle can reach what I consider the root of our troubles, the lack of adequate preparation at the high school stage. Our public high schools – and even an increasing number of the fashionable and expensive private schools – dismiss the future humanist with deficiencies which in many cases can never be completely cured and can be relieved only at the expense of more time and energy than can reasonably be spared in college and graduate schools. First of all, it is, I think, a mistake to force boys and girls to make a decision between different kinds of curricula, some of them including no classical language, others no mathematics to speak of, at an age when they cannot possibly know what they will need in later life. I have still to meet the humanist who regrets that he had to learn some mathematics and physics in his high

school days. Conversely, Robert Bunsen, one of the greatest scientists in history, is on record with the statement that a boy who is taught nothing but mathematics will not become a mathematician but an ass, and that the most effective education of the youthful mind is a course in Latin grammar.[8]

However, even assuming that the future humanist was lucky enough to choose the right curriculum when he was thirteen or fourteen (and a recent survey has disclosed that of the million pre-college students in New York City only one thousand take Latin and only fourteen Greek), even then he has, as a rule, not been exposed to that peculiar and elusive spirit of scholarship which Gilbert Murray calls *religio grammatici* – that queer religion which makes its votaries both restless and serene, enthusiastic and pedantic, scrupulously honest and not a little vain. The American theory of education requires that the teachers of the young – a vast majority of them females – know a great deal about 'behaviour patterns', 'group integration', and 'controlled aggression drives', but does not insist too much upon what they may know of their subject, and cares even less for whether they are genuinely interested or actively engaged in it. The typical German 'Gymnasial-professor' is – or at least was in my time – a man of many shortcomings, now pompous, now shy, often neglectful of his appearance, and blissfully ignorant of juvenile psychology. But though he was content to teach boys rather than university students, he was nearly

8. It may not be amiss to reprint in full Bunsen's statement, transmitted by an ear-witness who was a biologist: 'Im Anschluss an Gauss kam Bunsen auf die Frage zu sprechen, in welcher Weise man einen för Mathematik besonders begabten Jungen erziehen sole. "Wenn Sie ihm nur Mathematik beibringen, glauben Sie, dass er ein Mathematiker werden wird? – Nein, ein Esel." För besonders wichtig erklärte er die Denkerziehung durch die lateinische Grammatik. In ihr lernen die Kinder mit Gedankendinger umgehen, die sie nicht mit Händen greifen können, die jedoch einer Gesetzmässigkeit unterliegen. Nur so lernen sie es, mit Begriffen sicher umzugehen.' See J. von Uexküll, *Niegeschaute Welten; Die Umwelten meiner Freunde*, Berlin, 1936, p. 142.

always a scholar. The man who taught me Latin was a friend of Theodor Mommsen and one of the most respected Cicero specialists. The man who taught me Greek was the editor of the *Berliner Philologische Wochenschrift*, and I shall never forget the impression which this lovable pedant made on us boys of fifteen when he apologized for having overlooked the misplacement of a comma in a Plato passage. 'It was my error,' he said, 'and yet I wrote an article on this very comma twenty years ago; now we must do the translation over again.' Nor shall I forget his antipode, a man of Erasmian wit and erudition, who became our history teacher when we had reached the stage of 'high school juniors' and introduced himself with the words: 'Gentlemen, this year we shall try to understand what happened during the so-called Middle Ages. Facts will be presupposed; you are old enough to use books.'

It is the sum total of little experiences like these which makes for an education. This education should begin as early as possible, when minds are more retentive than ever after. And what is true of method is also true, I think, of subject matter. I do not believe that a child or an adolescent should be taught only that which he can fully understand. It is, on the contrary, the half-digested phrase, the half-placed proper name, the half-understood verse, remembered for sound and rhythm rather than meaning, which persists in the memory, captures the imagination, and suddenly emerges, thirty or forty years later, when one encounters a picture based on Ovid's *Fasti* or a print exhibiting a motif suggested by the *Iliad* – much as a saturated solution of hyposulphite suddenly crystallizes when stirred.

If one of our great foundations were seriously interested in doing something for the humanities it might establish, *experimenti causa*, a number of model high schools sufficiently endowed with money and prestige to attract teaching faculties of the same calibre as those of a good college or university, and students prepared to submit to a programme of study which our progressive educators would consider

exorbitant as well as unprofitable. But the chances of such a venture are admittedly slim.

Apart from the apparently unsolvable problem of secondary education, however, the immigrant humanist, looking back over the last twenty years, has no cause for discouragement. Traditions, rooted in the soil of one country and one continent, cannot and should not be transplanted. But they can cross-fertilize, and this cross-fertilization, one feels, has been initiated and is in progress.

There is only one point which it would be disingenuous not to touch upon, though it may seem indelicate to do so: the terrifying rise of precisely those forces which drove us out of Europe in the 1930s: nationalism and intolerance. We must, of course, be careful not to jump to conclusions. The foreigner is inclined to forget that history never repeats itself, at least not literally. The same virus produces different effects in different organisms, and one of the most hopeful differences is that, by and large, the American university teachers seem to wrestle against the powers of darkness instead of ministering to them; in at least one memorable instance they have even found the support of an alumni committee the voice of which cannot be ignored in the land.[9] But we cannot blind ourselves to the fact that Americans may now be legally punished, not for what they do or have done, but for what they say or have said, think or have thought. And though the means of punishment are not the same as those employed by the Inquisition, they are uncomfortably similar: economic instead of physical strangulation, and the pillory instead of the stake.

Once dissent is equated with heresy, the foundations of the apparently harmless and uncontroversial humanities are no less seriously threatened than those of the natural and social sciences. There is but one step from persecuting the

9. See the report of the Yale Alumni Committee 'On the Intellectual and Spiritual Welfare of the University, Its Students and Its Faculty', reprinted in full, e.g., in *Princeton Alumni Weekly*, LII, No. 18, 29 March 1952, p. 3.

biologist who holds unorthodox views of heredity, or the economist who doubts the divine nature of the free enterprise system, to persecuting the museum director who exhibits pictures deviating from the standards of Congressman Dondero or the art historian who fails to pronounce the name of Rembrandt Peale with the same reverence as that of Rembrandt van Rijn. But there is more to it.

The academic teacher must have the confidence of his students. They must be sure that, in his professional capacity, he will not say anything which to the best of his belief he cannot answer for, nor leave anything unsaid which to the best of his belief he ought to say. A teacher who, as a private individual, has permitted himself to be frightened into signing a statement repugnant to his moral sense and his intellect, or, even worse, into remaining silent where he knows he ought to have spoken, feels in his heart that he has forfeited the right to demand this confidence. He faces his students with a clouded conscience, and a man with a clouded conscience is like a man diseased. Let us listen to Sebastian Castellio, the brave theologian and humanist who broke with Calvin because he could not dissimulate; who for many years supported his wife and children as a common labourer rather than be disloyal to what he believed to be true; and who, by the force of his indignation, compelled posterity to remember what Calvin had done to Michael Servetus. 'To force conscience,' Castellio says, 'is worse than cruelly to kill a man. For to deny one's convictions destroys the soul.'[10]

10. R. H. Bainton, 'Sebastian Castellio, Champion of Religious Liberty, 1515–1563', *Castellioniana; Quatre études sur Sebastien Castellion et l'idée de la tolérance*, Leiden, 1941, p. 25 ff.

Index

Index

Index

Index

Institute for Advanced Study, 369, 391
Institute of Fine Arts, New York University, 379–80
Isidore of Seville, 70, 72, 194
Italy, 63, 74, 110, 208, 214, 223, 233–5, 264, 268, 273–5, 278–9, 282, 299, 315, 325
Iversen, E., 93
Ivins, W. M., 374

Jacobi, J. G., 364–6
James, M. R., 370
Jöcher, (*Gelehrtenlexikon*), 316
John, Augustus, 356
John the Scot, 72, 159–65, 179
Johnson, Dr, 340
Jolles, A., 97, 99
Joshua Roll, 207
Jouin, H., 360
Junker H., 188
Justi, Carl, 370
Justi L., 295
Juvenal, 343

Kaiser Friedrich Museum, Berlin, 59
Kalkmann, 92, 95, 96, 97, 99, 100, 105
Kant, 23, 264, 310–12
Kantorowicz, E. H., 381
Kauffmann, Angelica, 364
Kauffmann, H., 270
Kekulé von Stradonitz, R., 285
Killerman, S., 329
Killing of Nessus, Pollaiuolo, 286
Kimball, Fiske, 374
Kirfel, W., 186
Kladrub, 218, 230, 232
Klein, J., 360
Kleinsorge, J. A., 255, 258
Klingner, F., 258
Koch, H., 120
Köhler, W., 208
Kolbe, Carl W., 366
Krafft, Adam, 298
Krautheimer, R., 244
Kris, E., 220
Künstle, K., 298

Kunstwollen, 83, 89, 109, 318
Kurz, O., 211

Lactantius, 255, 257
Lange, K., and Fuhse, F., 278, 306, 314, 316, 322, 329
Lányi, Jenö, 211
Large Fortune, Dürer, 282
Last Supper, Leonardo, 54, 56, 61, 64
Lazzaroni, M., 220
Lee, Rensselaer, 374
Leidinger, G., 60
Leinberger, H., 308
Lenôtre, 219
Leonardo da Vinci, 28, 36, 43, 56, 82, 95, 122, 124–8, 130–31, 134, 230, 260, 306, 321
Leslie, C. R. and Taylor, Tom, 340, 354, 356, 364
Lessing, 328
Levraut, L., 348
Libellus de imaginibus deorum, 73, 193
Liberale da Verona, 288
Libri amorum, Celtes, 288, 296, 334
Libro, Vasari, 211–14, 253–4, 261, 262–3
Lichtwark, A., 296
Liebeschütz, H., 72, 73, 193
Ligorio, Pirro, 275
Lippmann, E. O. von, 281
Lippmann, F., 307, 370
Lohenstein, D. C. von, 355
Lomazzo, 121, 122, 123, 127 133, 190, 321
London, 181–3, 268, 300–301
Longo, M., 258
Loo, Georges H. de, 370
Lorenzetti, A., 172, 186, 210
Loreto, 230, 240
Lotti, Luigi, 317–18
Louis le Gros, 140–44, 170
Louvre, the, 182, 350, 352, 359, 361–2, 365
Lovejoy, A. O., 342
Luhn, J., 187
Lupus of Ferrieres, 26
Luther, 25–6

Index

Index

Index

Index

Scoti, Bertinelli, U., 244
Sculpture, 84–7, 97–101, 119, 154, 254, 260, 299, 323–5, 329, 330–32, 338
Seccadanari, Ercole, 236
Sedlmayr, H., 46
Seneca, 42, 185, 257–8
Serapis, 187–92, 194–7, 200–201
Serlio, S., 229, 234, 268
Servius, 70–72, 190
Seznec, J., 182, 187, 193–5
Siena, 266–9, 270–71, 272–3, 276
 Cathedral, 186, 190, 231, 238
Signorelli, 349
Silvani, G., 231
Simon Chièvre d'Or, 175
Simon, M., 106
Sittl, K., 318
Slaying of Abel, Dürer, 328
Sloan, Pat, 47
Slodtz, Michelange, 223
Smith, E. Baldwin, 373
Snell, B., 343
Sodoma, 266
Sol Iustitae, Dürer, 304, 308, 330–32
Sophocles, 42, 329
Springer, A., 231, 241, 284
Stained glass, 110, 116, 154, 166
Standard-Bearer, Dürer, 327
Stradano, G., 194
Strozzi, B., 63
Style, history of, 61–5, 66
Subject matter in art, 53–8, 66
Suger, Abbot, 140–59, 161–80
Swarzenski, G., 223, 365, 370
Swoboda, K. M., 109

Tasso, 350
Tavanes, Maréchal de, 183
Taylor, Tom, *see* Leslie, C. R.
Telekles, 98–9
Tempio Malatestiano, Alberti, 229
Terribilia, 228, 237–8, 241–3
Tertullian, 257
Tesi, Mauro, 241
Thausing, M., 280, 290, 304
Theocritus, 344–7
Theodoros, 98–9

Theory of Human Proportions, Dürer, 278, 335
Thiele, G., 70
Thieme-Becker, 187, 202, 326
Thompson, D'Arcy W., 136
Three Magi, van der Weyden, 59
Ticozzi, S., 254
Tietze, H., 109, 182, 216–17, 221–3, 241
Tietze-Conrat, E., 203, 283
Titian, 181–2, 187–8, 197, 201–4, 325
Tolnay, K., 69–70, 275
Trecento style, 207–9, 213, 260
Tuscany, 233, 274, 348

Uccello, Paolo, 261
Uexküll, J. von, 392
United States, art history in, 371–80, 390
 education in, 380–82, 386–95
Usener, H., 299–303
Utopia, 345–9

Valeys, Thomas, 73, 193
Varchi, B., 253
Varro, 105
Vasari, 67, 105, 210–13, 224–7, 229, 236, 244–56, 257–64, 266–7, 269, 273, 275, 339
Vecelli family, 203–4
Venice, 63, 68, 190, 234, 238, 307, 329
 St Mark's, 68, 238
Venturi, A., 187, 207
Venturi, L., 244, 251
Vicenza, 230, 238
Vico, G., 258
Vidoni, 241
Vienna, 217–18, 221–3, 334, 338
 St Stephen's, 223
Vignola, 231, 234, 236–7, 244, 267, 274
Villani, 209, 223
Villard de Honnecourt, 78, 110, 112–16, 118, 130,
Virgil, 74, 78, 269, 344–50, 358, 360, 362

Index

FOR THE BEST IN PAPERBACKS, LOOK FOR THE

In every corner of the world, on every subject under the sun, Penguin represents quality and variety – the very best in publishing today.

For complete information about books available from Penguin – including Pelicans, Puffins, Peregrines and Penguin Classics – and how to order them, write to us at the appropriate address below. Please note that for copyright reasons the selection of books varies from country to country.

In the United Kingdom: Please write to *Dept E.P., Penguin Books Ltd, Harmondsworth, Middlesex, UB7 0DA*

If you have any difficulty in obtaining a title, please send your order with the correct money, plus ten per cent for postage and packaging, to *PO Box No 11, West Drayton, Middlesex*

In the United States: Please write to *Dept BA, Penguin, 299 Murray Hill Parkway, East Rutherford, New Jersey 07073*

In Canada: Please write to *Penguin Books Canada Ltd, 2801 John Street, Markham, Ontario L3R 1B4*

In Australia: Please write to the *Marketing Department, Penguin Books Australia Ltd, P.O. Box 257, Ringwood, Victoria 3134*

In New Zealand: Please write to the *Marketing Department, Penguin Books (NZ) Ltd, Private Bag, Takapuna, Auckland 9*

In India: Please write to *Penguin Overseas Ltd, 706 Eros Apartments, 56 Nehru Place, New Delhi, 110019*

In Holland: Please write to *Penguin Books Nederland B.V., Postbus 195, NL–1380AD Weesp, Netherlands*

In Germany: Please write to *Penguin Books Ltd, Friedrichstrasse 10–12, D–6000 Frankfurt Main 1, Federal Republic of Germany*

In Spain: Please write to *Longman Penguin España, Calle San Nicolas 15, E–28013 Madrid, Spain*

In France: Please write to *Penguin Books Ltd, 39 Rue de Montmorency, F-75003, Paris, France*

In Japan: Please write to *Longman Penguin Japan Co Ltd, Yamaguchi Building, 2–12–9 Kanda Jimbocho, Chiyoda-Ku, Tokyo 101, Japan*

FOR THE BEST IN PAPERBACKS, LOOK FOR THE

PENGUIN DICTIONARIES

Archaeology
Architecture
Art and Artists
Biology
Botany
Building
Business
Commerce
Computers
Curious and Interesting
 Words
Curious and Interesting
 Numbers
Decorative Arts
Design and Designers
Economics
English and European
 History
English Idioms
Fairies
French
Geography

Geology
Historical Slang
Italian
Literary Terms
Microprocessors
Modern History 1789–1945
Modern Quotations
Physical Geography
Physics
Political Quotations
Proverbs
Psychology
Quotations
Religions
Rhyming Dictionary
Saints
Sociology
Telecommunications
The Theatre
Troublesome Words
Twentieth Century History

FOR THE BEST IN PAPERBACKS, LOOK FOR THE

A SELECTION OF PEREGRINES

The Uses of Enchantment Bruno Bettelheim

Dr Bettelheim has written this book to help adults become aware of the irreplaceable importance of fairy tales. Taking the best-known stories in turn, he demonstrates how they work, consciously or unconsciously, to support and free the child.

The City in History Lewis Mumford

Often prophetic in tone and containing a wealth of photographs, *The City in History* is among the most deeply learned and warmly human studies of man as a social creature.

Orientalism Edward W. Said

In *Orientalism*, his acclaimed and now famous challenge to established Western attitudes towards the East, Edward Said has given us one of the most brilliant cultural studies of the decade. 'A stimulating, elegant yet pugnacious essay which is going to set the cat among the pigeons' – *Observer*

The Selected Melanie Klein

This major collection of Melanie Klein's writings, brilliantly edited by Juliet Mitchell, shows how much Melanie Klein has to offer in understanding and treating psychotics, in revising Freud's ideas about female sexuality, and in showing how phantasy operates in everyday life.

The Raw and the Cooked Claude Lévi-Strauss

Deliberately, brilliantly and inimitably challenging, *The Raw and the Cooked* is a seminal work of structural anthropology that cuts wide and deep into the mind of mankind. Examining the myths of the South American Indians it demonstrates, with dazzling insight, how these can be reduced to a comprehensible psychological pattern.

FOR THE BEST IN PAPERBACKS, LOOK FOR THE

A CHOICE OF PENGUINS

Trail of Havoc Patrick Marnham

In this brilliant piece of detective work, Patrick Marnham has traced the steps of Lord Lucan from the fateful night of 7th November 1974 when he murdered his children's nanny and attempted to kill his ex-wife. As well as being a fascinating investigation, the book is also a brilliant portrayal of a privileged section of society living under great stress.

Light Years Gary Kinder

Eduard Meier, an uneducated Swiss farmer, claims since 1975 to have had over 100 UFO sightings and encounters with 'beamships' from the Pleiades. His evidence is such that even the most die-hard sceptics have been unable to explain away the phenomenon.

And the Band Played On Randy Shilts
Politics, people and the AIDS epidemic

Written after years of extensive research by the only American journalist to cover the epidemic full-time, the book is a masterpiece of reportage and a tragic record of mismanaged institutions and scientific vendettas, of sexual politics and personal suffering.

The Return of a Native Reporter Robert Chesshyre

Robert Chesshyre returned to Britain from the United States in 1985 where he had spent four years as the *Observer*'s correspondent. This is his devastating account of the country he came home to: intolerant, brutal, grasping and politically and economically divided. It is a nation, he asserts, struggling to find a role.

Women and Love Shere Hite

In this culmination of *The Hite Report* trilogy, 4,500 women provide an eloquent testimony of the disturbingly unsatisfying nature of their emotional relationships and point to what they see as the causes. *Women and Love* reveals a new cultural perspective in formation: as women change the emotional structure of their lives, they are defining a fundamental debate over the future of our society.

FOR THE BEST IN PAPERBACKS, LOOK FOR THE

A CHOICE OF PENGUINS AND PELICANS

Adieux Simone de Beauvoir

This 'farewell to Sartre' by his life-long companion is a 'true labour of love' (the *Listener*) and 'an extraordinary achievement' (*New Statesman*).

British Society 1914–45 John Stevenson

A major contribution to the Pelican Social History of Britain, which 'will undoubtedly be the standard work for students of modern Britain for many years to come' – *The Times Educational Supplement*

The Pelican History of Greek Literature Peter Levi

A remarkable survey covering all the major writers from Homer to Plutarch, with brilliant translations by the author, one of the leading poets of today.

Art and Literature Sigmund Freud

Volume 14 of the Pelican Freud Library contains Freud's major essays on Leonardo, Michelangelo and Dostoevsky, plus shorter pieces on Shakespeare, the nature of creativity and much more.

A History of the Crusades Sir Steven Runciman

This three-volume history of the events which transferred world power to Western Europe – and founded Modern History – has been universally acclaimed as a masterpiece.

A Night to Remember Walter Lord

The classic account of the sinking of the *Titanic*. 'A stunning book, incomparably the best on its subject and one of the most exciting books of this or any year' – *The New York Times*

FOR THE BEST IN PAPERBACKS, LOOK FOR THE 🐧

A CHOICE OF PENGUINS AND PELICANS

The Informed Heart Bruno Bettelheim

Bettelheim draws on his experience in concentration camps to illuminate the dangers inherent in all mass societies in this profound and moving masterpiece.

God and the New Physics Paul Davies

Can science, now come of age, offer a surer path to God than religion? This 'very interesting' (*New Scientist*) book suggests it can.

Modernism Malcolm Bradbury and James McFarlane (eds.)

A brilliant collection of essays dealing with all aspects of literature and culture for the period 1890–1930 – from Apollinaire and Brecht to Yeats and Zola.

Rise to Globalism Stephen E. Ambrose

A clear, up-to-date and well-researched history of American foreign policy since 1938, Volume 8 of the Pelican History of the United States.

The Waning of the Middle Ages Johan Huizinga

A magnificent study of life, thought and art in 14th and 15th century France and the Netherlands, long established as a classic.

The Penguin Dictionary of Psychology Arthur S. Reber

Over 17,000 terms from psychology, psychiatry and related fields are given clear, concise and modern definitions.

FOR THE BEST IN PAPERBACKS, LOOK FOR THE 🐧

A CHOICE OF PENGUINS AND PELICANS

The Literature of the United States Marcus Cunliffe

The fourth edition of a masterly one-volume survey, described by D. W. Brogan in the *Guardian* as 'a very good book indeed'.

The Sceptical Feminist Janet Radcliffe Richards

A rigorously argued but sympathetic consideration of feminist claims. 'A triumph' – *Sunday Times*

The Enlightenment Norman Hampson

A classic survey of the age of Diderot and Voltaire, Goethe and Hume, which forms part of the Pelican History of European Thought.

Defoe to the Victorians David Skilton

A 'Learned and stimulating' (*The Times Educational Supplement*) survey of two centuries of the English novel.

Reformation to Industrial Revolution Christopher Hill

This 'formidable little book' (Peter Laslett in the *Guardian*) by one of our leading historians is Volume 2 of the Pelican Economic History of Britain.

The New Pelican Guide to English Literature Boris Ford (ed.)
Volume 8: The Present

This book brings a major series up to date with important essays on Ted Hughes and Nadine Gordimer, Philip Larkin and V. S. Naipaul, and all the other leading writers of today.